Blessed and Beautiful

ROBERT KIELY

Blessed and Beautiful

PICTURING THE SAINTS

YALE UNIVERSITY PRESS
NEW HAVEN ✣ LONDON

PUBLISHED WITH THE ASSISTANCE OF THE LILA ACHESON WALLACE –
READER'S DIGEST PUBLICATIONS SUBSIDY AT VILLA I TATTI

Designed by Emily Lees

Printed in China

Library of Congress Cataloging-in-Publication Data
Kiely, Robert.
Blessed and beautiful : picturing the saints / Robert Kiely.
p. cm.
Includes bibliographical references and index.
ISBN 978–0–300–16277–6 (cloth : alk. paper)
1. Painting, Italian–Themes, motives. 2. Painting, Renaissance–Italy.
3. Christian saints in art. 4. Art and society–Italy. I. Title.
II. Title: Rereading the saints with help from the Italian masters.
ND1432.I8K54 2010
755'.630945–dc22
2010016379

A catalogue record for this book is available from The British Library

Frontispiece: Caravaggio, *Saint Francis in Ecstasy*, c.1596 (detail of fig. 103).

For

MAX, MOLLY, LUCY,
CLAIRE BEILIN, ANGELICA LEILIN,
MAJKA, MILO, AND CATHERINE ROSE

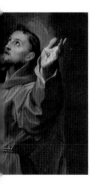

Acknowledgments

My mother had the good taste to marry an artist, and my father had the good sense to marry an Italian. So my first thanks go to my parents. They were born in the United States of America but their roots go back to Piedmont and Tipperary, evocative names, beautiful regions, famed in history and legend for saints, scholars, strong spirits and dialects, and some very good cheese. They taught me to look, listen, savor, and, only then, to choose.

Italy came into focus for me in 1956 when I was in the Navy and first saw Naples, Genoa, and Rome. But the true epiphany occurred while I was on my way home from active duty during a rainy November and spent a week in Florence wandering alone through damp streets, into chilly, dark, mostly empty churches and museums. I had a guidebook yet rarely consulted it and hardly knew where I was going. It did not matter. Everything pleased me. One afternoon, a little lost in the labyrinth of alleys in Oltrarno, I came upon the unspectacular façade of the Church of Santa Maria del Carmine and went in to get out of the rain. No one was there. All was in shadow, but somehow I stumbled into the Brancacci Chapel and put my lire into the coin machine to illuminate the walls. In a sudden burst of light, there were Adam and Eve in anguish; Saint Peter walking on what looked like the streets I had just come through; Jesus, a stern, handsome Floren-tine! In many ways, this book began there. I had never seen anything like it. I had never heard of Masaccio. I did not know that Michelangelo and many other artists of the time had come to study and admire there. But I did know that I was in the presence of some-thing rare, a profoundly moving witness to life, all the more touching because it was then

dim, unrestored, almost hidden from sight, as though patiently waiting to be noticed. (Art critics and historians had noticed and admired the frescos in this chapel for centuries, but I had studied English literature and knew nothing of this.)

There have been many trips to Italy since then, but the first prolonged and truly instructive one was in the spring of 1991 when Walter Kaiser, then the Director of Villa I Tatti, the Harvard University Center for Italian Renaissance Studies, invited me to be a Visiting Professor. Since I was working on a book on postmodern fiction, this was a gesture of exceptional generosity, sensitivity, and even foresight on his part. Although neither of us knew that a book on Italian painting would eventually emerge, I like to believe that Walter thought I had it in me. Walter and the other scholars at I Tatti could not have been more welcoming or encouraging. They were interested in my project; they also shared with me their own research and were a constant source of information and advice about books to read, paintings to see, and places to visit in and around Florence. I owe much to Karen-edis Barzman, Julian Kliemann, Thomas Roche, Michael Rocke, William Wallace, and especially to Paul Barolsky, who was a neighbor to my wife and me that spring. We had many good walks and talks together, sharing our interest in art and literature. Seventeen years later, completely by chance, I met Paul again at an I Tatti lunch. When I told him – a little apologetically, as an outsider to a field in which he is a distinguished expert – that I had nearly finished a manuscript on saints in Italian art, he agreed to read it and give me an honest assessment. Within a month, I received five pages of detailed commentary, enthusiastic encouragement, and specific recommendations about editors to whom I might send it. I cannot stress enough how important to me and this project, Paul's support has been. I was not sure what to do with what I had written until he spelled it out in the clear terms of a true scholar and friend.

Many others on the staff of the Villa I Tatti made our stay that spring memorable. Nelda Ferace and Alexa Mason became good friends; and in the beautiful Villa Papiniana, the late Osvaldo and Giancarla Tangocci did everything they could to make us comfortable, correct our Italian, and teach us the secrets of *ravioli nudi* and *risotto con carciofi*.

In the spring of 2009 I was lucky enough again to be invited to be a Visiting Professor at I Tatti, this time by Walter's successor as Director, Joseph Connors. Joe and his wife, Françoise, not only received my wife and me with warm hospitality but, during our months in Florence at the extraordinary Casa Morrill, they became good friends. As in our previous visit, the regular association with other scholars at lunches and lectures was a rare and instructive pleasure. Louis Waldman, Laura Giannetti, Guido Ruggiero, Erling Skaug, Carmen Bambach, Kathleen Christian, Renée Baernstein, Arielle Saiber, and Camilla Russell, among many others, provided collegiality and encouragement during the revision of this manuscript.

Colleagues and students at Harvard have been a steady source of erudition, advice, and friendship during the writing of this book. I am particularly grateful to Sissela and Derek Bok, Elaine Scarry, Philip Fisher, Peter Sacks, Jorie Graham, and Nicholas Watson, for

what they have written as well as for what they have said. Graduate students and under-graduates have also been part of the conversation. Some read draft chapters; all helped me imagine my ideal reader. Special thanks go to those who were my teaching assistants in large lecture courses: Arun Abraham, Allen MacDuffie, Andrew DuBois, Patrick O'Malley, and Rebecca Schoff. Of hundreds of memorable undergraduates, I want to mention a few of the best readers and writers in recent years: Alex Ross, Chris Meserole, Erwin Rosinberg, Carlos Zepeda, Blaine Saito, Leo Keliher, Getinet Betanyahu, Jay Minga, Ryan McKnight, and Ben Morgan.

I want also to thank friends on the faculty of Providence College – Aurelie Hagstrom, James Keating, and Suzanne Fornier – who welcomed my wife and me during the fall term of 2008 and offered encouragement when I gave two public lectures based on chapters from this manuscript.

Dennis Taylor and the editorial board of *Religion and the Arts* were kind enough to publish early versions of the chapters on Francis and Catherine of Siena. Seeing bits of the work in progress in print reminded me to keep writing.

I have been bothering some of my oldest and best friends with this project for years. In one way or another – reading chapters, suggesting changes and additions – they all helped. Barbara and Albert Gelpi, Marie and Andrew Foley, Jill Ker Conway, John O'Malley, S.J., James Keenan, S.J., Giovanni Felicioni, Elizabeth Walsh, R.S.C.J., John McDargh, Rosella Mamoli Zorzi, Paul Contino, Allan Christensen, Philip Rand, and the late, and much cherished, Catherine Morrisey and Joel Porte.

My editor, Gillian Malpass; my copyeditor, Katharine Ridler; my Research Assistant, Jennifer Harrison; and my designer, Emily Lees, have been indispensable. Their profes-sional talent and patience with a neophyte have been models of generosity.

My dear wife, Jana (who has been at my side in all of the churches and museums in which the pictures referred to in this book are housed), and our four children have not only put up with my obsessions with Italy and Italian art but also seem to have enjoyed cheering me on. Our eight grandchildren will be surprised to find themselves at the head of a book about saints but they – along with their grandmother and parents – have been a blessing nonetheless.

Introduction

CHOOSING THE
"BEAUTIFUL ONES"

"His branches shall spread and His beauty shall be as the olive tree."

Hosea 14 : 6

*"It is no small grace in a painter to be able to give a pleasing air to his
figures . . . Therefore choose the beautiful ones, and fix them in your mind."*

Leonardo da Vinci

Beauty and sainthood seem an unlikely pair. Saints may have beautiful souls but faces and
bodies are something else. Images come to mind of solemn, stiff, straight-laced indistin-
guishable elders lined up in rows; pale, gaunt, effete young men tortured by Roman sol-
diers; insipid, sad, and sexless women pursued by lecherous pagans. Such images do exist.

This book will look elsewhere in search of the saints. In fifteenth- and sixteenth-century
Italy, the beauty of the human form was celebrated and represented with a sustained surge
of pleasure and talent unmatched since the Golden Age of Greece. Saints were not left
out of the picture. Indeed, they were central to the picture – and, I shall argue, to the
celebration of and the pleasure in the human body. It is easy and tempting for a modern
viewer to assume that saints and their miraculous lives were used by artists simply as
excuses to lavish attention on anatomy and show off their talent. Clearly, some painters
took liberties with orthodoxy and trod a narrow line between pleasing and infuriating
their ecclesiastical and patrician patrons. Yet, with few exceptions, Italian painters of the
period were believing Christians. Even when not conventionally pious, they had profound

affection and reverence for the holy figures they painted. To see their productions as little more than high-level cheesecake or abstract design for design's sake would be to misread them in a peculiarly narrow and superficial way.

In his essay on "The School of Giorgione" (1877), Walter Pater anticipated trends in modern art, but he provocatively and deliberately ignored a crucial dimension of Renaissance painting when he insisted that "art is always striving to be independent of the mere intelligence . . . to get rid of its responsibilities to its subject or materials."[1] As Martin Kemp has remarked, "No Renaissance theorist would have deemed it thinkable to advocate the goal of 'art for art's sake' in the nineteenth century manner . . . Practitioners and theorists saw themselves as serving a higher truth, even if the perception of the nature of that truth and the means of revealing it might differ substantially."[2]

Religious paintings may have signified the pride and wealth of a patron, commune, or confraternity, but they were also genuine tokens of devotion, penance, thanksgiving, petition, and praise. In a sonnet celebrating the beauty of the young Tomasso Cavalieri, Michelangelo sees a bit of "heaven on earth" and restates a familiar Renaissance belief: "So from the sacred Fount whence all men come/Each earthly beauty takes its attributes."[3] Patrons and painters were in business, but it was a business built on shared beliefs if not of shared profit. Patrons and painters alike believed that saints were holy persons with exceptional powers of a specific and concrete nature. If you wanted protection against the plague, a husband for your unmarried daughter, safety during travel, victory in battle, you prayed to God, but you also invoked the aid of the saint whose specialty corresponded with your need. In *The Cult of the Saints: Its Rise and Function in Latin Christianity* (1981), Peter Brown pointed out that

> men and women, from the late fourth century onwards, turned with increasing explicitness for friendship, inspiration and protection in this life and beyond the grave, to invisible beings who were fellow humans and whom they could invest with the precise and palpable features of beloved and powerful figures in their own society . . . To seek the face of a fellow human being where an earlier generation had wished to see the shimmering presence of a bodiless power is no small change.[4]

Renaissance patrons and painters were acquainted with their saints through a rich and complex mix of scripture, liturgy, legend, chronicles, hymns, homiletics, poetry, and oral tradition. Each holy picture tells or refers to a story that has already been told in another medium, but pictures "tell" differently from words. Along with the literature by and about saints, a colorful and distinctive iconography arose in early Christian cultures in which holy women and men could be "seen" by those who had never known them in life but nonetheless could recognize them by particular gestures, attributes, costumes, or symbols. Not all Christians thought that a vivid iconography of heavenly beings was a good thing. Idol worship was forbidden by Mosaic Law. The more skilled the artist, the more likely that the image could become an object of adoration, a replacement for the

true saint or, what was worse, the true God. In 325 the Council of Nicaea cautioned against worshipping images rather than reverencing them as aids to devotion. Saint Augustine (354–430) – anticipating a number of later monastic reforms and the puritan side of the Protestant Reformation – thought that there should be no images at all in Christian churches.

The beauty and importance of icons in the Eastern Church was at first treated with suspicion in the West but when Bishop Serenus of Marseilles burned images in his diocese, Pope Gregory the Great sent him a letter of rebuke in 599 that established a principle that held for the Church for hundreds of years (and was reinforced in the sixteenth century by the Council of Trent):

> It is not lawful for anything made with hands to be adored, since it is written, "Thou shalt adore the Lord thy God, and him only shalt thou serve." But pictorial represen- tations can be made for the edification of an unlearned people who, though ignorant of letters, might learn what was done by turning their eyes to the pictured story . . . If anyone should wish to make images, by no means prohibit him, but by all means, forbid the adoration of images.[5]

As Gregory's letter makes clear, a relationship between text and image was assumed. The Gospel stories were written and recited before they were painted. Augustine's *Con- fessions*, Benedict's *Rule*, the letters of Catherine of Siena, reports about the heroic deeds of Sebastian and Rocco preceded their reputations as models of a virtuous life sufficiently established to be canonized, captured, copied, and displayed on the walls of churches and monasteries. In a few cases – such as that of Francis of Assisi who wrote little himself – pictorial representations seemed to flow as fast as or faster than the reproduction of texts about the saint. In all cases, the relationship between text and image was, and still is, complex, unstable, and open to interpretation. For the first sixteen centuries of Christi- anity, most Christians could not read. What they knew of scripture and the lives of the saints was what they heard from priests, parents, wandering preachers, storytellers; from the prayers and hymns of the liturgy; and, as Gregory understood, from pictures.

This is a book about the relationship of word and image, text and picture, imitation, invention, and interpretation. I explore some of the ways that paintings tell and retell, shape and reshape stories from scripture and hagiography. When the story is familiar, like Mary's visit to her cousin Elizabeth or the Baptism of Jesus, artists often defamiliarize and renew it so that one goes back to the written narrative, literally and graphically, with a fresh perspective. When the story is less familiar, like the transporting of the body of Saint Mark to Venice, the painters, like the Venetian merchants, take hold of it and bring it home.

Italian Renaissance painters, whether or not they were imitating or rejecting the work of their predecessors, were interpreters of texts, even if in some cases those texts were known only at second or third hand. Some artists of the period were well versed in the

classics, theology, and scripture. Most were craftsmen, not scholars. Education and habits varied. For example, on one hand, the Dominican friar Fra Angelico would have celebrated the feast days of saints and read, heard, and recited passages from scripture every day. In Florence, Fiesole, or Rome, he was never more than a few steps from a church or library. On the other hand, Michelangelo Caravaggio, though he lived for a while with cardinals who were his patrons, seems to have spent more time in taverns and street fights than in libraries or churches. Nevertheless, both painters were saturated with Christian lore. As a critic has pointed out, "Caravaggio's religious paintings were nourished by, as well as nourished, Counter-Reformation meditative techniques and liturgical piety."[6] The stories of Jesus, Mary, and the saints gave shape, texture, and color to the visual and imaginative sensibilities, as well as to the emotions and ideas that informed the lives of artists in and out of the cloister or studio.

At the height of the Italian Renaissance when literacy and literature were increasingly valued, paintings of religious subjects were still far more accessible to the average person than a parchment or book. Works of art themselves became so integral a part of a Christian's life that they were often treated as "texts" subject to quotation and citation, material grounds for imitation, testimony and witness, almost another form of theological proof, a graphic point of origin, firm as the wall of a church, clear as a candle or light from a window could make it. As several critics have noted, between texts and images "mutual inspiration and influence are evident."[7]

A favorite pastime among painters and poets was to debate the relative merits of their art, attempting to prove, in a hierarchical age, the supremacy of one form over another. Leonardo da Vinci, who seemed to be good at everything, insisted on the superiority of the visual arts:

> Painting surpasses all human works by reason of the subtle possibilities it contains . . . O poet, if you call painting "dumb poetry," then the painter may say of the poet that his art is "blind painting" . . . Inscribe in any place the name of God and set opposite to it His image; you will see which will be held in greater reverence.[8]

In his treatise *On Painting* (1435), Leon Battista Alberti simply asked, "Who can doubt that painting is the master art?"[9]

Today the controversy itself seems artificial and unnecessary, especially in the case of Christian art which, like the faith, is inseparable from story. One of the oldest, most often repeated, and plainest of Christian liturgical verses is, "Christ has died; Christ is risen; Christ will come again." No picture of Jesus, Mary, or the saints – however isolated or reconfigured – can be separated from that narrative or the Gospel stories that anticipate it.

As one reflects on the intersections of texts and paintings, it becomes clear that there are other "crossings" to be taken into account. Saints, by definition, are both ordinary human beings and extraordinary human beings with qualities that give them a special aura,

a halo, a resemblance to Christ, an intimacy with the divine that places them on a threshold between this world and the next. The narratives and paintings that I have chosen to examine negotiate this seemingly "straight and narrow" space with astonishing variety, liberality, and sophistication. What Gibbon and others have ridiculed as the "primitive" lives of saints are often complex tapestries of moral instruction, myth, human interest, history, and fantasy. Invention was not seen in the Middle Ages or Renaissance as the enemy of revelation but as its cohort.

Of course, a painter without imagination could hardly make much of a secular portrait or a landscape, never mind a saint. Paul Ricoeur could have been speaking of the most inventive and lyrical of religious paintings (or legends) when he referred to poetry as "a dimension of revelation . . . capable of furnishing a first approximation of what revelation in the biblical sense may signify."[10] For the painter, the poet, and the storyteller, "revelation" and "approximation" – whatever their spiritual significance – always have a mediated, material dimension. Paint and words necessarily "get in the way." For better or worse, they are the artist's "way." As makers of images, painters could not reproduce a saint without a wall, a board, a canvas, or a body. Their sacred art, especially during the Renaissance, is an imaginative approximation of Genesis (the creation of human beings in the image of God) and of the Incarnation (the taking on of flesh by the Son of God.) Leo Steinberg has demonstrated the crucial link between paintings that show the genitals of Christ with incarnational theology, the belief that in taking on manhood in every physical detail, Jesus redeemed human nature from sinful dualism and shame: "So much of this art is a celebration; so much of it proclaims over and over that godhead has nested itself in the infirmity of the flesh, so as to raise that flesh to the prerogatives of immortality."[11]

The once common and simplistic notion that as artistic interest in and skill at representation of the human body waxed, the spiritual and religious significance of paintings waned, overlooks the importance of the Incarnation in the theological currents of the Renaissance and a key (if periodically underestimated) element of Christian faith. Penitence, mortification of the flesh, and disparagement of the body have been recurring themes in the history of Christianity but they do not tell the whole story. In the *Summa Theologiae*, Thomas Aquinas wrote, "Our bodies were created by God, not as the Manicheans pretend, by some evil principle. So we can serve God with our bodies. And should love them with the charity with which we love God. Our body helps us to happiness, and that happiness will overflow into our bodies, so they too can be loved."[12]

In her luminous study *Image as Insight*, Margaret R. Miles has made the point with particular clarity (p. 36): "Christianity, understood not primarily as a nexus of ideas but as concrete participation in a body – 'the body of Christ' – provides a strong formulation of the centrality and significance of physical existence, in which human life itself is understood as given in physical existence – creation – and fulfilled only in physical existence – resurrection of the body."

Saints obviously had bodies, tall and short, large and small, male and female. Even when they mistreated them, or when they were mistreated by others, those bodies usually appeared extraordinarily attractive in Italian Renaissance painting. Representations of two of the most gruesome martyrdoms – Saint Lawrence roasted on a grill and Saint Sebastian shot full of arrows – tend to play down the pain and play up the grace of the nearly nude male body. Throughout *The Golden Legend*, the popular and influential thirteenth-century collection of saints' lives, the reader's attention is repeatedly called not only to the virtues of the saints but to their physical appeal. "Andrew is interpreted beautiful, or responding, or manly, from *ander*, which means male, man"; "Anastasia had three very beautiful serving maids . . . All three were Christians . . . Their clothing clung so tightly to their bodies that no one could take it off"; "John converted a handsome, headstrong man . . . He changed the branches of trees into gold and pebbles on the beach into precious stones"; a virgin of Antioch, by remaining out of public view, created great desire in men because "beauty that is heard about but not seen creates the greater desire"; when a Roman prefect caught sight of the fifteen-year-old Margaret guarding her sheep, "he burned with desire for her immediately."[13]

Echoes of the Hebrew Bible abound in these stories. When Jacob saw Rachel at the well, he kissed her and preferred her to her sister, Leah, because "she was beautiful and well-favored" (Genesis 29 : 17). When Joseph enters into service in the house of Potiphar, he is desired by his master's wife because "he is handsome and very good looking" (Genesis 39 : 6). In the Hebrew Bible, fidelity to the God of Abraham in combination with physical beauty typically leads to marriage and the increase of generations. For the early Christians, especially for some of the most revered saints, fidelity to Jesus usually meant remaining chaste, preserving one's body "for the Lord." It is understandable that this attitude has often been interpreted to mean a kind of neuterization, a desexing of the lives of Christian heroes and heroines. This is one way to look at it, but, as the legends of holy virgins in tight-fitting garments and beauty hidden behind a screen suggest, marriage and procreation are not the only channels for sexual expression.

Storytellers, painters, and poets who have reflected on the lives (and bodies) of Christian saints have rarely avoided (or wished to avoid) the erotic elements intrinsic to their subjects. For the modern viewer it is impossible to overlook the masochistic and sadistic elements in the aesthetic culture of Christian martyrdom, but to stop there can too quickly close down consideration of other possibilities and explanations for the behavior of saints. There is more to sainthood, its physical and aesthetic expression, than the perverse pleasure of the suffering body. Physical courage in the face of persecution cannot be discounted, nor simplicity of life – of diet, dress, dwelling – in periods of material excess, nor voluntary poverty when there were huge differences between rich and poor, nor willing exposure of the body to illness in the care of lepers and victims of plague, nor pacifism in time of war, nor a desire for a stable brotherhood or sisterhood in times of domestic instability, nor chastity when girls were "given" in marriage in early adolescence and mothers often died in childbirth before the age of thirty.

Saints, like many of the artists who painted them, went against the conventional behavior – sexual as well as social and political – of their times. That, of course, is part of their attraction and the attraction of all heroic figures. However, as writers and artists repeatedly show, the appeal of the saints is not merely in their sanctity (or "perversity") but also in their common humanity. Some critics have described images of saints as though they represented superhuman creatures: "Pictures of the saints . . . were never meant to emulate viable reality. They were aids to memory, representations of models of perfection, maps to the road to salvation."[14] This may be true in some cases, but, as Miles argues (pp. 68–9), it is by no means the rule: "The sacred figures of popular devotional texts and images were presented as ordinary people, with whom anyone could identify." Peter Brown has put it even more emphatically (p. 56): "The patron saint has the ancient quality almost of an unconscious layer of the self."

In the most fanciful legends and inventive paintings, the saints are recognizable: often gorgeous, always holy, usually brave but sufficiently imperfect and mortal to look like someone we know or might wish to know. Further, they do not all look the same. Although some traces of early stereotypical iconography can still be found in Renaissance portraits of saints, the differences among them are more striking than their similarities. In *On Painting*, Alberti wrote (pp. 92–3): "Complete beauties are never found in a single body, but are rare and dispersed in many bodies. Therefore, we ought to give our every care to discovering and learning beauty."

For the believer, the dispersal of beauty (and virtue) is like "abounding grace," a token of God's bounty, a sign of hope worthy of study because it gives pleasure and because it brings one closer to the realization of the total and self-contained beauty and virtue which is God's alone. That saints are expected to resemble Jesus is taken for granted, but it is equally important to understand that the resemblance is not complete in any one person. There are as many ways to be like Jesus as there are people. The communion of saints is not about the "election" of the few, but the invitation to all to see glimpses of sublime possibility for themselves in the mirror images of other good, but not perfect, lives. Gerard Manley Hopkins captures the idea in poetry:

> For Christ plays in ten thousand places,
> Lovely in limbs, and lovely in eyes not his
> To the Father through the features of men's faces.[15]

Hopkins imagines a Christ who reaches out, extends himself; he is not a fixed point but a mover, a player with many shapes and features. The poet's words disperse Jesus into what Christians understand as the Mystical Body, the Communion of Saints, not a static lineup of old men in white uniforms but a living and lively crowd of individuals, lovely in the eyes of God and (why not?) of one another. Given the generosity of this idea and the beautiful images and texts that it has engendered, it seems only right to ask where the modern reader and viewer fit into the picture.

Whenever I have placed a picture or a literary text – poem, play, or novel from another era – before my students, they ask, "How much do I need to know in order to read this?" No matter how carefully I try to balance my answer, I am torn between saying "Everything!" and "Nothing!" Of course, it would be wonderful to be able to recreate in one's brain and sensibility the mind of a cultured humanist of fifteenth-century Florence. Even if we now cannot achieve the goal perfectly, we can at least read what they read, study what they studied, walk in the cities and buildings they constructed. Not everyone in Florence was a cultured humanist, by a long shot, but, never mind, there is pleasure in the quest and reward in seeing in the art much that otherwise would have been missed or misread. John Shearman is surely right: "We cannot step right outside our time, avoiding . . . all contamination by contemporary ideologies and intervening histories; but such inevitable imperfection ought not to . . . discourage the exercise of the historical imagination."[16]

When I find my students paying more attention to the footnotes than the text, then I worry. I want them to look at what is in front of them now and describe in their own best words what they see and what they feel. I want to know whether they can construct their own bridge to the work, a vital connection that may be lacking in historical sophistication but alive with the experiential energy that frees art from even the best efforts at classification.

It would be preferable not to have to choose between these approaches. In this book about saints I want to take their religious significance seriously and to pay attention to the scriptural and legendary sources that would have been best known to artists and viewers of the Italian Renaissance. At the same time, I do not wish to pretend that I can (or wish to) divest myself of my own time and place. To risk misreading the past may be the price modern viewers have to pay for being alive in the present and trying to keep old pictures and old texts alive with us. In *Storytelling in Christian Art from Giotto to Donatello* (2006), Jules Lubbock sums up the challenge and the opportunity generously: "Because of its inherent indeterminacy, a story told in images is open to being narrated in a range of rich and varied ways, from different distances and points of view."[17]

As with all forms of representation (textual or visual), words by and about saints and pictures of their lives assume certain things about audiences. During the centuries before the invention of the printing press religious iconography served as a condensation of scripture, catechism, and devotional guide, what John Ruskin referred to as the "Book of Common Prayer" for the ordinary unlettered person. Yet it is also true that many of the greatest artistic projects were commissioned by highly educated patrons and were displayed in places where literate courtiers, to say nothing of scholarly Benedictines, Augustinians, and Dominicans, were at home. Both educated and uneducated, literate and illiterate, were familiar with the major narratives of the Christian culture of their day. They knew who the Virgin Mary and John the Baptist were, they knew the stories of their local patron saints, and they knew the life of Jesus. Religious paintings of the period, espe-

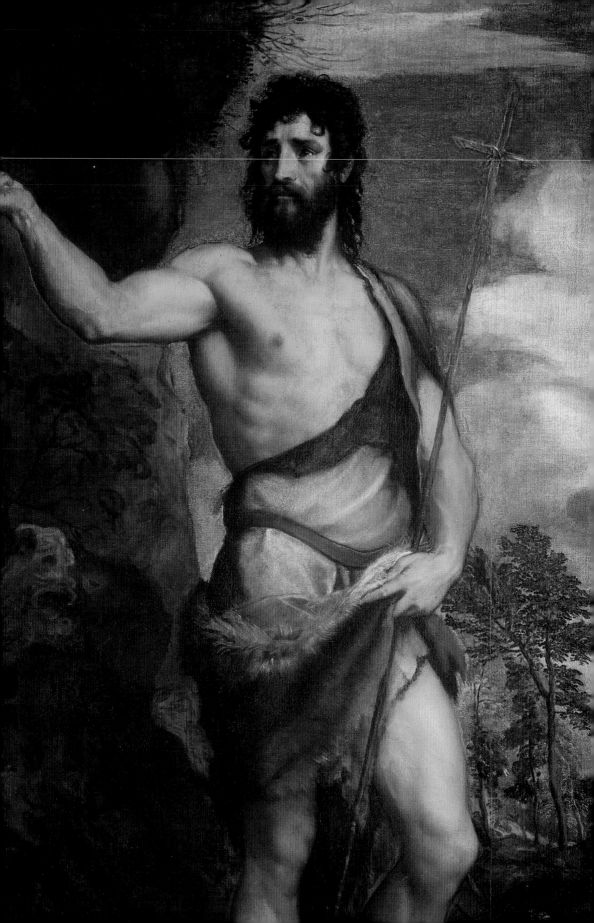

cially fresco cycles, are wonders of narrative invention, but their creators assumed at least an elementary knowledge of the stories on which they were based. Christian art was text-driven art. Without some knowledge of the key texts, the modern viewer is likely to become fixated on the surface and miss the spirit of the work.

Yet, there is the surface: the wall, the canvas, the paint. Most important for my purposes, there are the bodies, not just the souls, of the saints. We as viewers do not look through paintings or bodies; we look at them. Surviving centuries and the artists, patrons, and texts that engendered them, the painted faces and bodies of the saints appeal to us – attract and address us – in unauthorized ways as well as in ways long authorized by history and tradition. It is a truism that art is a product of culture. Without the Church and state, there would be no Italian Renaissance art. However, art is also a product of idiosyncrasy. Where would art be without the oddity of the artist and the viewer? "Originality" may be too charged a term to satisfy but long before the Romantics insisted on it, personality or peculiarity mattered. Artists are not all alike. Bodies – even when modeled on high, humanistic, mathematical, and anatomical principles – do not all look alike. Even the saints, who are supposed to look and behave according to pious convention, are repeatedly seen in Italian Renaissance pictures to be breaking the mold, in wonderful and surprising ways. It would be a shame, in the name of prudence, not to notice.

I first became interested in this project in 1990 when I lived in Tuscany as Harvard Visiting Professor at the Villa I Tatti Center for Italian Renaissance Studies and found myself, with the generous advice of learned art historians, spending more and more time visiting churches, monasteries, and museums. I was attracted and intrigued not simply by the extraordinary beauty of much that I saw but particularly by the enormous, astonishing, variety of ways of depicting figures of supposedly orthodox – that is, consistent and clear – significance. What I discovered were images often infused with tenderness, exquisite sentiment, erotic vigor but also ambiguity, irony, even humor, and not necessarily less inspirational because of this. I also discovered what art historians have always known: that in some periods, restrictions on subject matter, far from constraining artists, gave them a license, an excuse, to display their talent and idiosyncrasies with gusto. What is truly remarkable is not that a viewer can learn to recognize certain holy figures by an article of clothing, a key, a palm, a sword, and so forth, but that so many different faces, bodies, gestures, and personalities can inhabit the same paradigm. Different versions of a single saint can be both recognizable and yet dissimilar, familiar yet strange.

As a student of literature, I was most of all interested in the ways in which paintings of religious lives and events are related to the texts on which they are based. Many distinguished art historians have attended to this but their main interest is naturally the picture, its history, technique, and position in an aesthetic tradition. My interest brought me again and again back to words. For me, the paintings were the catalysts for rereading biblical, hagiographic, and theological texts. I saw paintings as critical analyses, interpretations, paraphrases, commentaries, book reviews, advertisements for books that I would

have read differently without them. Like all literary criticism, they contributed to, interfered with, changed, and complicated the way I read.

For its unparalleled variety, originality, and beauty, I have chosen the religious art of fifteenth- and sixteenth-century Italy on which to focus my attention. Of the hundreds of possible saints, I have decided to attend to ones that I like and find intriguing and who also have a body of literature and, of course, paintings or series of images associated with them and their lives. I begin with the Virgin Mary and John the Baptist, the two most revered and frequently painted figures in the Christian pantheon after Jesus. No attempt at coverage is made; I try instead to link particular scriptural, literary, and theological texts with paintings of unique beauty that challenge some of the most common stereotypes of the Virgin and the Baptist. Chapters follow on the changing reputation of Mary Magdalene; the "manliness" of the evangelist Mark, the martyr Sebastian, who has become the patron saint of gay men, and Rocco, who, with Sebastian, is the patron of plague victims. Given his influence on the study of Italian art and his importance as a literary and social critic, I devote a chapter to John Ruskin and his unusual way of looking at a painting of Saint Lawrence. I then consider Augustine, Benedict, and Francis, founders of great religious orders, monumental figures in Christian history, and utterly different personalities – the intellectual bishop, the author of a rule for monks, and the beloved friar, the Little Poor Man (*Il Poverello*) – who posed distinct and daunting challenges to painters as well as followers. The chapter on Catherine of Siena compares the vigor and strength of her character and writings with the insipidity of the portraits that were made of her. Finally, I examine the life, works by, and paintings of the youthful, mild, smooth-faced Louis of Toulouse and the fiery, fierce, gaunt Bernardino of Siena, as contrasts in Christian ideals of sainthood.

What I have learned is that religious iconography does not fix a revered personage, a noble idea, or a theological formulation within a rigid and static frame. On the contrary, pictures send those who are willing back to the engendering texts with new questions and a fresh perspective: that of the artist. The theologian can say what the saint's virtues were; the church historian can tell when and why he or she was canonized. The artist remakes the person and the story. The artist has to decide on short or tall, fat or skinny, ugly or beautiful, pathetic or powerful, blonde or brunette. The artist shakes the dust off the halo and sometimes omits the halo altogether. The artist takes doctrine and text into consideration but knows that he has to work through and around them in order to touch a person, saint or sinner, model or spectator. Surprised, refreshed, intrigued, the reader returns to texts with a mind colored and to some extent shaped by pigments and forms inspired, but in no sense constrained, by script.

Religious art carries on a conversation with scripture and canonical texts. This book enters into that conversation. It concentrates on texts, but images are always there between and beyond the lines.

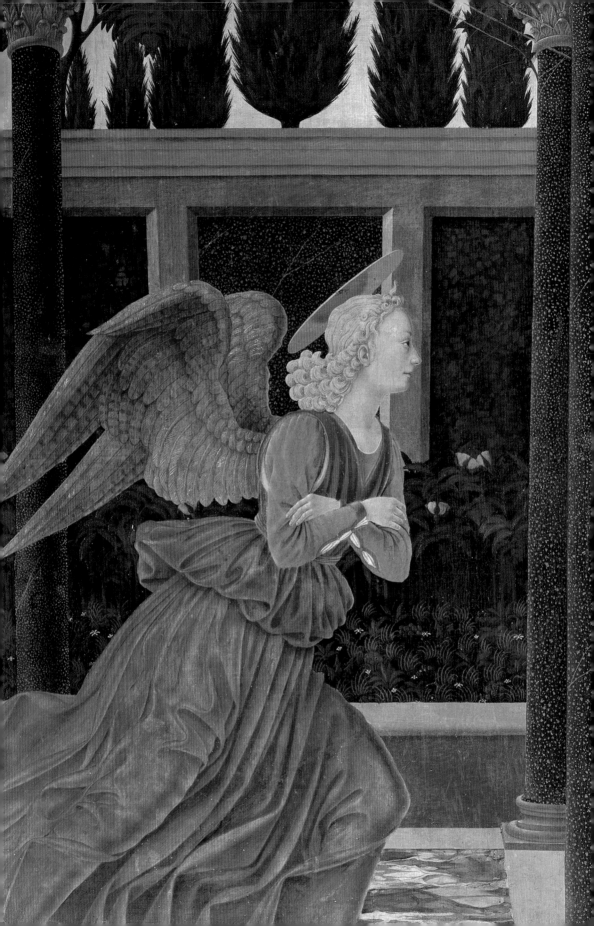

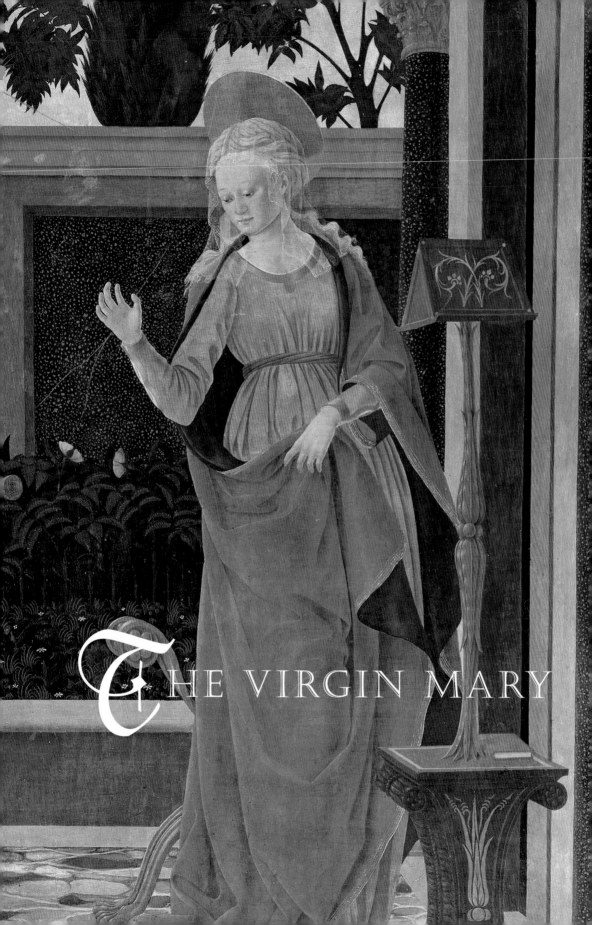

THE VIRGIN MARY

1

THE STANDING OF MARY

OPUS FORMOSIOR

"the principal and most beautiful work of creation"

Latin Hymn to Mary

Where does Mary stand? That is the question. In the lovely painting by Alessio Baldovinetti (fig. 1), she stands up to listen to the angel Gabriel announce to her that she will become the mother of the Savior of the world. Saint Bernard de Clairvaux said that she "stands between Christ and the Church."[1] But where exactly is that?

Of the hundreds, perhaps thousands, of hymns and songs dedicated to the mother of Jesus, a particularly striking one was sung at Matins on May 31 for the Feast of the Blessed Virgin Mary, Queen (now the Feast of the Visitation):

> *Rerum supremo in vertice*
> *Regina, Virgo, sisteris,*
> *Exuberanter omnium*
> *Ditata pulchritudine.*
>
> *Princeps opus formosior*
> *Verbo creanti praenitis,*
> *Praedestinata Filium,*
> *Qui protulit te, gignere.*
>
> At the summit of creation
> You stand as Queen, O Virgin,

Abundantly enriched
With the beauty of the universe.

As the principal and most beautiful
Work of creation, you shine
Before the creating Word, predestined
To bear the Son who made you. *DO*, II, 1831

In contrast to the many images of Mary humbly kneeling in prayer in depictions of the Annunciation or seated patiently with the infant Jesus on her lap, the "standing" of Mary here is made both literal and symbolic, an emphatic declaration of her solitary, upright, and superior position in the hierarchy of creation. Like many Latin liturgical hymns, the economy and apparent simplicity of language succeeds in conveying not only praise but also, in highly concentrated form, theological complexities begging for clarification. The Queen who is addressed in these lines is both on top of and part of creation; she appears to "shine" and therefore to exist "before" ("in front of" and "in anticipation of") the second person of the Trinity who created her but whom she will bear. Clearly this is no ordinary human being. Is she a goddess? Church tradition, if not official pronouncements, often seems to waver between "yes" and "no."

Saint John Chrysostom, reinforcing the claims of the hymn in a sermon read on Common Feasts of the Virgin, asks, "Where will you find her rival in holiness? Among Prophets, Apostles, Thrones, Dominations, Seraphim, Cherubim? No! For no creature, visible or invisible, can be found greater or more excellent than she" (*DO*, I, 959). Saint Peter Canisius similarly imagines Mary standing "so high above Angels and men that nothing can be higher or holier" (*DO*, II, 1834).

Sermons are not hymns, however. Sermons make claims, whereas hymns like the *Rerum Supremo* sing praises in which centuries of debate, definition, desire, paradox, and faith are crystallized (rather than resolved) in music and verse. What is extraordinary is that though liturgical poetry – measured, formally conventional, pious – bears no resemblance to that of Ezra Pound or Wallace Stevens, it does not avoid inconsistency, illogicality, or exaggeration but confronts them with breathtaking bluntness and beauty. In fact, beauty (*pulchritudo*), not logic, is what holds *Rerum Supremo* and its universe together in harmony. Mary is identified with that beauty. She inspires the hymn. Like it and the best of hymns, prayers, and paintings, she is an *opus*, an *opus formosior*.

At various stages in Christian history, different traits of Mary – her humility, chastity, regality – have been emphasized in sermons, conciliar and papal pronouncements, and iconography, but one characteristic – her beauty – has remained consistently in view. At first, this does not seem surprising. Of course, the mother of Jesus should be beautiful – but why? It is true that some female saints, Mary Magdalene and many of the early virgin martyrs, are referred to in early hagiography as beautiful. In the Hebrew Bible, Rachel and Bathsheba are also distinguished by their beauty. The New Testament, in contrast, pays

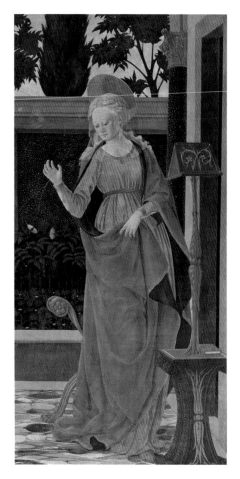

1 Alessio Baldovinetti, *Annunciation* (detail),
1447, Galleria degli Uffizi, Florence.

no attention to physical features. Painters, especially Italian Renaissance painters, made Jesus handsome, but the Gospels do not describe him; indeed, the most frequently quoted biblical allusion to the physiognomy of Jesus is Isaiah 53 : 2, the Suffering Servant: "He hath no form or comeliness; and when we shall see him, there is no beauty that we should desire him."

Mary, nonetheless, has always been associated with beauty. Long before Renaissance painters lavished their attention on her, liturgical verses, antiphons, homilies, and hymns sang of her loveliness. Echoes of the Song of Songs ring through Matins, Lauds, Vespers, and Compline on her feast days: *tota pulchra est* ("you are all fair"), *speciosa facta es et suavis in deliciis tuis* ("you are beautiful and sweet in your delights"). Mary is "sweet" and "glowing"; she "shines" and "glitters." She is resplendent, radiant, and without blemish.

Although relatively little is said of her in the Gospels, most people have a "picture" of Mary. As Jaroslav Pelikan has observed, "She has been portrayed in art and music more than any other woman in history."[2] In her influential study of what she considers negative aspects of the cult of Mary, Marina Warner acknowledged that the Virgin has inspired "some of the most moving poetry, some of the most beautiful paintings in the world."[3] In 1954 when declaring May 31 as one of her feast days, Pope Pius XII acknowledged that among the most telling "witnesses" of her "queenly dignity" were not only "the prayers of the liturgy, the innate sense of Christian people, [but also] works of art" (*DO*, II, 1836).

It may seem odd that a pope would remind the faithful (many of whom needed no reminder) that works of art do more than reflect belief; they actually help to shape it. As Pius recognized, in the history of the Church, and particularly in the history of popular veneration of Mary, the enormous influence of art is an obvious if complex phenomenon in the formation of religious sensibilities. Painting, sculpture, poetry, and music have played a huge role in communicating the distinctiveness of Mary and her place in the heavenly hierarchy. Even when artists "served" the purposes of the Church or were limited by its strictures, insofar as they were artists, they were bound to interpret, imagine, alter, strain, and stretch those purposes and, in more than a few instances, exceed those limits.

While artists depicting figures in the Christian narrative necessarily dealt in the particular, theologians and the formulators of Church teachings have tended to prefer generalization, abstraction, and logical rather than physical precision. The Mary of council documentation and papal declaration is invariably referred to as a model, of motherhood, virginity, faith, mercy, or of the Church itself. In elevating Mary to symbolic or allegorical status, ecclesiastical discourse risks obscuring the person while "clarifying" her theological significance. When defining her nature as closely as possible to that of Jesus without displacing him, Church scholars have commonly resorted to technical terminologies with "scientific" overtones and little or no aesthetic affect. For example, after attempting to settle the controversy over whether to call Mary "Mother of God" or "Mother of Jesus," the Council of Ephesus (431) decided for "Mother of God" because "the holy virgin bore in the flesh God who was united hypostatically with the flesh. For that reason we call her mother of God, not as though the nature of the Word had its existence from the flesh . . . but because he united to himself hypostatically the human and underwent a birth according to the flesh in her womb."[4]

Such language and reasoning may satisfy theologians. According to Pelikan, Ephesus made "the greatest quantum leap in the whole history of language and thought about Mary."[5] Yet theological terminology is unlikely to clarify things for a painter or move the hearts of believers. Perhaps the most striking case in point is the centuries-long debate over the innocence of Mary that eventually led to the declaration in 1854 by Pope Pius IX of the doctrine of the Immaculate Conception. As early as the eleventh century in English monasteries (and earlier in the Eastern Church) there were liturgical celebrations

of the Conception of Mary, but the question arose as to whether Mary was conceived without sin and therefore, like Jesus, was never subject to the Fall or in need of redemption. For many, this seemed to be claiming too much for Mary. Albert the Great (1206–1280) thought that the Blessed Virgin "was not sanctified before animation" and that it was heretical to affirm otherwise.[6] His star pupil, Thomas Aquinas (1225–1274), did not see how Mary could have been human without needing to be redeemed. "If Mary's soul was never infected with inherited sin that would prejudice the dignity of Christ as the savior of all mankind; but her purity was the greatest after Christ." But then, in a particularly fine splitting of hairs, the great doctor added: "Mary inherited sin but was cleansed from it before she was born."[7] Arguments raged on about "sanctification" and the timing of the "infusion of the soul into the flesh"; "sanctification before infusion and sanctification after infusion."

Clearly the question was where to place Mary on the scale between the human and the divine. One critic has stated the problem neatly: "It is impossible to tell a simple story about the Virgin Mary . . . She is a protean and unstable figure."[8] Although no council or pope ever presumed to equate her with Jesus or the Trinity, all efforts to situate her precisely seemed unable to avoid letting her slip into an all too human condition or raising her to precarious heights of power and virtue. As Warner observed, for "travelers from another planet" visiting Catholic churches and cathedrals, seeing Mary's image on the altar, "it would have been very difficult to understand that she was only an intercessor and not a divinity in her own right."[9]

For centuries, the circumstances of the Virgin's death as well as those of her birth came under scrutiny. Without evidence from scripture, preachers and theologians resorted to legend and abstract logic. If she was born without sin, it was argued that she must never have been subject to physical death but rather had been bodily raised up into heaven in what came to be called the Assumption. Although, like the Immaculate Conception, the Assumption was eventually pronounced (in 1950 by Pope Pius XII in *Munificentissimus Deus*) to be an article of faith, the consensus from tradition was by no means simple. The Council of Trent (1546) declared that "by a special privilege from God, the Church holds that the Blessed Virgin" was able "to avoid all sins, even those that are venial."[10] Nonetheless, the Dominican Pope Pius V (1566–72) insisted that "no one but Christ was without original sin, and therefore the Blessed Virgin had died because of the sin contracted by Adam, and had endured afflictions in this life like the rest of the just."[11]

Among the reforms of the Second Vatican Council, convened in Rome in 1962 by Pope John XXIII, the status of Mary was revisited and respectfully but emphatically modified. It was decided that no separate document would be devoted to her. Chapter VIII of *Lumen Gentium* (*LG*), The Dogmatic Constitution on the Church (1964), asserts (as had Aquinas) that while Mary "far surpasses all creatures," there is "but one Mediator . . . the man Christ Jesus" (*LG*, VIII, 60). Furthermore, "The Church does not hesitate to profess this subordinate role of Mary" (*LG*, VIII, 62). While liturgies, images, and devotions to Mary

are permitted, the Council "exhorts theologians and preachers of the divine word to abstain zealously from all gross exaggerations" (*LG*, VIII, 67). In a lecture delivered in 2001 on the ecclesiology of Vatican II, Cardinal Joseph Ratzinger (later Pope Benedict XVI) continued to stress Mary's role as a symbol of the Church. He institutionalized the person and gender of Mary by turning "her" into "it" and "we," the Church: "It is a woman. It is a Mother. It is alive . . . Only by being Marian, can we become the Church . . . Mary shows us the way."[12]

Whether glorified, subordinated, or allegorized, the Mary of formal Church declarations and theological distinctions is inevitably emptied of (or, at the very least, separated from) her aesthetic, emotional, and physical appeal. The very sound of the language – "hypostatic," "infusion," "immaculate," "privilege," "assumption," "Church" – is at odds with the lovely words of the Latin antiphons – "O clement, O loving, O sweet" (*O clemens, O pia, O dulcis*); "the root, the gate, the light" (*radix, porta, lux*) – of the *Salve Regina* and *Ave Regina Caelorum*, or of the echoes of Hebrew poetry: "lily among thorns," "the enclosed garden," "the star of the sea" of litanies and hymns. It seems that the image of the beautiful Mary, *opus formosior*, might have collapsed under the great weight of much institutional attention and revisionism. (For some, the bland, unbeautiful garden-variety statues of Mary are a sign of exhaustion if not permanent collapse of her once glorious vitality.) Yet the beauty of Mary has had an irrepressible capacity to reassert itself. While the efforts at theological definition may be earnest and admirable in their way, for believers and unbelievers alike, the most enduring, indeed unforgettable, Virgin is the Mary of poets and painters.

In "The Blessed Virgin Compared to the Air We Breathe," Gerard Manley Hopkins sees Mary in color and feels her in the "azured air," "the glass-blue days when every color glows;" he senses her presence as an essential protection and pleasure:

> I say that we are wound
> With mercy round and round
> As if with air: the same
> Is Mary, more by name,
> She, wild web. Wondrous robe,
> Mantles the guilty globe.[13]

James Joyce's Stephen Dedalus, much given to scholastic musings, thinks not of Aquinas but of the imaged Mary of litanies and liturgies when he sees a beautiful girl: "Eileen had long thin cool white hands too because she was a girl. They were like ivory; only soft. That was the meaning of *Tower of Ivory* but protestants could not understand it and made fun of it . . . Her fair hair had streamed out behind her like gold in the sun. *Tower of Ivory. House of Gold*."[14] Stephen's associations are unseemly and irreverent only if Mary is etherealized into an unimaginably unworldly abstraction. Fra Angelico, Titian, and Pontormo, to name a few of the great Renaissance painters, would not have been shocked. For them

too the gorgeous images of the legends and liturgies provided precedent and inspiration for a woman they could revere and perhaps desire, but, most of all, a woman they could see. As much as, perhaps more than, any council or pope, their work has been crucial in saving Mary from oblivion.

While theologians have scrutinized and debated the relative merits of Mary, her standing in Christian culture has risen to extraordinary heights, vacillated, and fallen (in areas most affected by the Protestant Reformation), risen again in the Catholic world in the period of the Counter-Reformation and again in the nineteenth century, and faltered if not fallen in the aftermath of the Second Vatican Council. Naturally, representations of Mary, in form, quality, and number, have reflected these changes. Images of the Virgin have ranged from the sublime to the saccharine, from the supremely individual to an undifferentiated banality. However, Italian Renaissance paintings of Mary are in a category apart. Like French medieval cathedrals dedicated to her, they possess a unique indelibility and power. Depicting Mary young and old, virginal and maternal, maidenly and majestic, they established an aesthetic permanence that reflects facets of her beauty, scriptural and legendary moments in her life, and, with a kind of prophetic insight, intimations of her monumental (and utterly human) ascents and descents.

In some ways, Mary is like the other figures around Jesus in the Gospels, a witness to the Good News, a secondary character who plays a supporting role in the drama of salvation. Yet Mary is also unique. She is the mother of the Lord whose body gives shape to his body and whose life story provides a "before-and-after" frame to the life of Jesus. Even without counting, one can assume that the greatest number of paintings of Mary are of the Annunciation, the Nativity, and variations on the theme of the Madonna and Child. But artists, like theologians, have also pondered Mary's significance apart from these familiar moments. As in all biblical narratives, there are gaps and silences, long stretches of text where Mary does not appear at all or, as at the Crucifixion, where she is silent and her appearance is overshadowed by the suffering of her son. Depictions of Mary kneeling in prayer or Mary enthroned with her infant or Mary floating on a crescent moon are scenes of a familiar Mary "settled" in her place of honor – a room, a chapel, a niche, a heavenly cloud.[15] What of the less familiar images of Mary not so settled, rising or falling, trying to stand on her own two feet, to find her balance between Christ and the Church, the human and the divine, the artist and the theologian?

There is nothing said of Mary's childhood in the Gospels but early tradition established that her parents were virtuous Jews, Anna and Joachim. Details of the story as told in the thirteenth-century *Golden Legend* underline not only Mary's dignity and goodness but, most importantly, her flesh and blood, "genetic," connection to Jesus:

> The glorious Virgin Mary took her origin from the tribe of Judah and the royal stock of David. Matthew and Luke do not set forth the lineage of Mary but that of Joseph – who had nothing to do with the conception of Christ – because the usage of the sacred writers . . . was to weave the series of generations of males, not of females. Never-

theless, the Blessed Virgin descended from the lineage of David: this is obvious because, as scripture testifies, Christ was born of the seed of David. Since, therefore, Christ was born of the Virgin alone, it is plain that the Virgin herself was born of David, through the line of Nathan.[16]

In reminding the reader of the uniqueness of the birth of Jesus ("born of the Virgin alone"), Jacobus de Voragine, like generations of authors and theologians before him, establishes the "royalty" of Mary and, by inference, the extraordinary nature of her womanhood empowered to bear a child without help from a man. In a prelude to the virgin birth of Jesus, the text places particular stress on the female role. Mary's royal blood comes from her mother and father; when her parents are unable to have children for the first twenty years of their marriage, it is thought (in contrast to most biblical precedent) to be Joachim's problem not Anna's: "When the priest saw [Joachim], he angrily ordered him away and upbraided him for approaching the altar of God . . . declaring that it was not proper for a sterile man . . . to stand among men who begot sons" (*GL*, II, 151). After an angel reassures poor Joachim that all will be well, Anna conceives and gives birth to Mary, her first child:

> When she was weaned at the age of three, her parents brought her to the Lord's Temple with offerings. Around the temple there were fifteen steps, corresponding to the fifteen gradual psalms, and because the Temple was built on a hill, there was no way to go to the altar . . . except by climbing the steps. The virgin child was set down at the lowest step and mounted to the top without help from anyone. (*GL*, II, 152)

This charming retrospective portrait of Mary on the ascendancy, though it appears in fresco cycles of the life of Mary, was not favored by artists to the extent that the Annunciation or Nativity were. It is not only a relatively rare scene of the child Mary, a Mary without Jesus, without Gabriel, without John, but a Mary on her way up. Two paintings, one by Paolo Uccello in about 1433 and another, painted a century later by Titian, capture the moment with peculiar grace, whimsy, and pathos. In both paintings little Mary looks very much alone.

According to tradition, the three-year-old Mary was left at the Temple to be raised among other girls until the age of fourteen when they were returned to their parents to be given in marriage. In Uccello's fresco (fig. 2) Mary's welcoming committee is not composed of other children, but a formidable group of male priests and elders. Two miniature children (angels?) wave her goodbye at the bottom of the steps, but Mary's journey upward is a solitary one into a sacred, not particularly cozy, realm. Little Mary, like her parents, wears a halo signifying her blessedness well before she could have known what was in store for her. She seems to be running eagerly up to her destiny in an act of faith and obedience. Uccello's pinks and blues are warm but the white marble looks cold and the steps leading to the "altar of holocaust" are steep for a child of three. Everyone keeps a respectful distance from the central figure, as if they are witnessing a sacrifice, which,

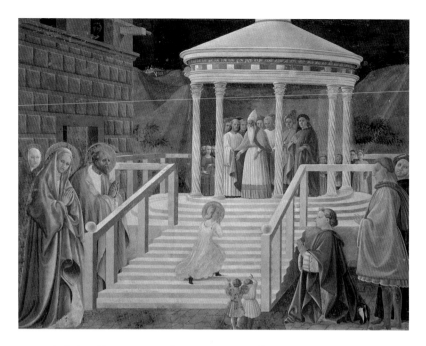

2 Paolo Uccello, *Presentation of Mary*, c.1433, Cappella dell'Assunta, Duomo, Prato.

indeed, they are. The resemblance of Anna in her blue mantle to the mature Mary and of bald, bearded Joachim to Joseph is no more coincidental than the resemblances in scripture of childless parents (like Sarah and Abraham, Elizabeth and Zacharia) who suddenly produce an offspring favored by God. Mary is not merely a link in the royal chain. She prefigures the Savior of the world.

Titian's Presentation (fig. 3) is on an entirely different scale from that of Uccello. Enormous changes in technique and the understanding of perspective and anatomy had occurred in the intervening century. Titian painted on a canvas that had to fit the charitable spirit and architectural space of a grand Venetian structure belonging to the Scuola di Santa Maria della Carità, a confraternity dedicated to the service of the poor and sick. Titian was particularly sensitive to the mission of the Scuola and to the decorations in the room that pre-dated his project. Carved into the ceiling was a Christ Pantocrator and the motto *Ego sum lux mundi* embossed in gold. Titian extends the "golden light" of Christ onto the figure of the child Mary who is shown, as in no earlier painting, not with a halo but surrounded by an aura of light, establishing "the theme of Theotokos [One Who Bears God or Mother of God]" framed in a mandorla, "a venerable sign of theophany."[17]

Here, the three-year-old Mary is already a long-haired beauty who ascends the Temple steps with the dignity of a princess. Unlike Uccello's child, who seems to be skipping or running, Titian's Mary appears to be going up gently, slowly, and deliberately, daintily holding her skirt to keep herself from tripping. The high priest's gesture is one of awe as

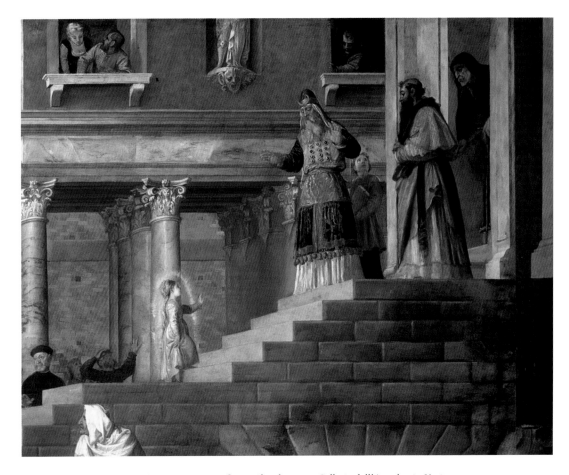

3 Titian, *Presentation of Mary* (detail), 1539, Gallerie dell'Accademia, Venice.

well as welcome. It is the little virgin who blesses him as she approaches. Although Titian's painting (from which the detail is taken) is huge and crowded with onlookers, Mary clearly dominates the scene. She is not merely the center of attention; her brilliance and grace of movement control a magnificent and potentially daunting architectural space. Uccello's Mary looks in danger of being swallowed up; Titian's Mary seems ready to keep going right past the priests to heights they could not attain or imagine.

Given the thousands of paintings of the Madonna and Child (in which Mary has accomplished her divinely ordained mission), it is worth pausing on these scenes of Mary as a child full of promise and independent vigor, upright, alone, standing or climbing toward a life of suffering and an afterlife of unparalleled glamor. Insofar as the Fathers of the Church always insisted on the full humanity of Mary, it is only natural that artists and others would have tried to imagine the young Mary as one set aside, "chosen," ultimately revered like a queen but, also like a queen, excluded from the ordinary life of her time.

Of course, no one knows what Mary's early life was like. Probably it was not very different from that of other girls of her time and class. It is all the more intriguing, therefore, to see artists struggling with precisely the same dilemma facing theologians. How to restore or imagine the humanity of one whom tradition had translated into the spheres? The little girl ascending the steps of the Temple going toward or straight through the hierarchical figures may bear little or no resemblance to the life and events of the historical Mary, but she has everything to do with the Mary of the imagination forever caught on the threshold between the human and divine.

Depictions of the young Mary bravely rising to the challenge of her calling and symbolically to her exalted station in the Christian pantheon serve as prelude and counterpart to scenes of the older Mary fainting with grief at the Crucifixion of her Son and symbolically falling from the transcendant heights of imperturbable perfection to which popular devotion (and early Church councils) raised her. In the Gospel of John, Mary is not said to be falling but standing by the cross: "Now there stood by the cross of Jesus his mother, and his mother's sister . . . and Mary Magdalene" (John, 19 : 25). Inspired by this scene, the *Stabat Mater*, a profoundly emotional thirteenth-century hymn, opens with Mary standing by her son:

> *Stabat Mater Dolorosa*
> *Iuxta crucem lacrimosa*
> *Dum pendebat Filius.*

> The sorrowing mother stood
> weeping at the cross
> On which was hanging her Son.[18]

It is true that in medieval iconography Mary is commonly shown standing at the foot of the Cross. For centuries theologians quarreled over whether Mary, maternal and human, collapsed at the sight of her Son on the Cross or whether Mary, Queen of Heaven, was above such emotional display. Some said that her faith "held her erect" and that it was an impediment to her "perfection" to depict the Mother of God fainting. However, a fourteenth-century Italian folksong lamented that "she lay on the ground unable to stand."[19] Inspired by Franciscan and Dominican spirituality and intent on dramatizing the pathos of the suffering Jesus and his mother, Renaissance painters frequently show Mary in a state of collapse. In two powerful and detailed paintings of the Crucifixion, Fra Angelico and Andrea Mantegna include a small knot of figures near the Cross but set apart from the other witnesses (figs. 4 and 5). The mother of Jesus, no longer a blooming maiden, is kept from falling – literally held up – by other women and the beloved disciple, John.

Fra Angelico's Mary Magdalene, identifiable by her long blonde tresses, kneels in reverence before the Virgin and is her main support. The "sinful" woman and the woman "without sin" meet in calamity. Female opposites of youth and age, innocence and experience, face each other in a kind of mirror image which shows the viewer the face of one

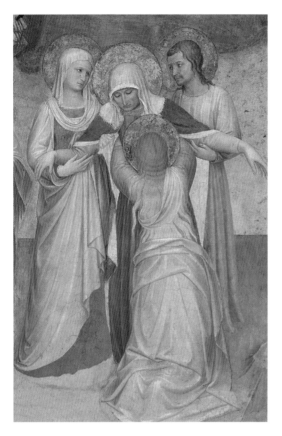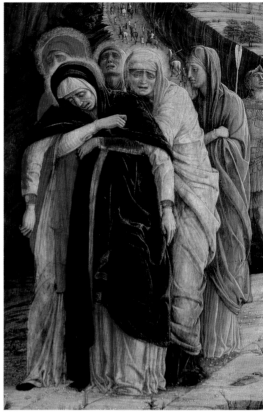

and the back of the head of the other. Both have haloes. John and the "other Mary" are sympathetic witnesses but the greater emotional and physical burden is on the two Marys.

Mantegna's Virgin seems to have fainted dead away. She is embraced, held up by a female figure in white who could be Mary Magdalene, though the Magdalene is more often clothed in red like the figure to the Virgin's right. The women's faces are like tragic masks. Gray paving stones, like those of a Roman road, provide no cushion for their feet. Mary's limp figure is shrouded in black.

In both paintings, Mary's posture expresses sorrow almost beyond enduring that at the same time resembles and unites with the sacrificial gesture of her Son. Fra Angelico extends the Virgin's arms in imitation of the arms of Jesus spread on the Cross. Mantegna anticipates, in the figure of Mary, Christ's descent from the Cross when his lifeless body is gently lowered by Joseph of Arimathea and the disciple John. While not the central figure in the paintings, Mary is, in fact, the central figure in her own cluster of friends. Paradoxically and fully in keeping with Christian belief, the more she resembles her divine

Son, the more natural, motherly, and human she appears. Parents, especially mothers, who have lost a child to war, sickness, or accident, would need little in the way of theology to see themselves in these representations of maternal grief. It would have been a rare mother in fifteenth-century Europe who had not lost a child.

Indeed the great theme of the *Stabat Mater* is the compelling (potentially healing) nature of empathy. The poet at first observes the scene and then enters into it, literally embodies it, through the person of Mary. Compassion for the mother's sorrow becomes a channel – a frail, approachable vehicle – to a greater understanding of and compassion for the suffering Jesus and, through him, for all human nature. Mary's misery reflects and redoubles the misery of Christ, demonstrating the extent of her and his love and the universality and immediacy of loss.

> *O quam tristis et afflicta*
> *Fuit illa benedicta*
> *Mater Unigeniti!*
>
> . . .
>
> *Quis est homo qui non fleret*
> *Matrem Christi si videret*
> *In tanto supplicio?*
>
> *Quis non posset contristarsi*
> *Christi Matrem contemplari*
> *Dolentum cum Filio?*
>
> O how sad and distraught
> Was that blessed woman,
> Mother of the Only-Begotten One!
>
> . . .
>
> Who would not weep
> To see the Mother of Christ
> In such misery?
>
> Who could keep from sorrowing with
> The Mother of Christ while contemplating
> The pain shared with her Son?

The role of Mary in this powerful medieval hymn (originally plainchant, later set to music by Joaquin des Pres, Pergolesi, Palestrina, Caldera, Haydn, Schubert, Verdi, Liszt, Dvorak, and many others) raises several of the most vexing questions about the role of Mary. Why is much of the poet's attention focused on her? Does she "magnify" the Lord or compete with him for the poet's reverence? Since the Latin requires no prepositional separation of Mother and Christ, the two terms are constantly joined almost as if denominating two persons with one identity – *Mater Unigeniti, Matrem Christi, Christi Matrem*. To

translate these titles as Mother Christ or Christ Mother would be bad Latin, but it would come close to the devotional reach of the poem. The key Latin term is *contristarsi*. There is no elegant English counterpart to this word. "To be sad with," "to empathize," "to feel pain with" sound lame by comparison. The identification of mother with son is as complete as language can make it. Yet the poet not only blurs the line between Mary and Jesus, he prays to cross that line himself:

> *Fac, ut ardeat cor meum*
> *In amando Christum Deum*
> *Ut sibi complaceam.*
> . . .
> *Tui Nati vulnerati*
> *Tam dignati pro me pati*
> *Poenas mecum divide.*
> . . .
> *Iuxta Crucem tecum stare*
> *Et me tibi sociare*
> *In plancto desidero.*

> Make my heart blaze
> In love with Christ God
> As you have felt with him.
> . . .
> With your wounded Child
> Who gave himself for my sins
> Let me share with you his pain.
> . . .
> By the Cross with you to stay
> To be with you
> I wish to weep.

Whether or not the Mary of the *Stabat Mater* is an aid to devotion or a distraction that calls attention away from the main event may be a matter of personal opinion and cultural formation, but there can be no question that here as in paintings and popular devotion she is a magnet for intense emotion. The psalmist cries from the depths; Job and Jeremiah and Isaiah lament; even Jesus weeps. But the religion of ritual and theology can seem a cool comfort: the white Temple steps, the altar of holocaust, the barren landscape of Fra Angelico's Crucifixion, the stone slabs under Mantegna's figures, the wood of the Cross are hard, cold facts. They are the objective conditions, the mortal architecture into which Mary, young and old, is introduced in a "supporting" role that warms and sometimes seems about to dominate the scene with absolutely natural, recognizable, human feeling and unfathomable beauty.

Between the legendary rising of the child Mary and the collapse of the mourning mother are the three central events of the Virgin's life as recorded in scripture: the Annunciation by the angel Gabriel that the young maiden had been chosen to give birth to the Savior; the Visitation by the pregnant Mary to her cousin Elizabeth who was carrying John the Baptist in her womb; and the Nativity, the birth of Jesus in Bethlehem. In most of the thousands of painted scenes of the Annunciation and Nativity, Mary is shown kneeling or sitting. The deferential Mary, who says to the angel, "Behold the handmaid of the Lord; be it done to me according to thy word" (Luke 1 : 38), is conventionally taken as a model of humility and obedience. It seemed right to artists as well as churchmen that she should be shown physically lowering herself to the will of God and his messenger.

The Visitation presents a somewhat different picture of Mary both in the Gospel of Luke and in several Renaissance paintings of the occasion. In the text describing the Virgin's visit to Elizabeth, there is no mention of Joseph or Gabriel. Mary goes of her own volition and perhaps alone. No reference to a companion is made. Further, Mary has more to say for herself than at any other point in the Gospels: "Mary arose in those days and went into the hill country with haste into a city of Judah. And entered into the house of Zacharia and saluted Elizabeth" (Luke 1 : 39–40). When Elizabeth welcomes her cousin with a blessing, Mary repeats the blessing, magnifying the Lord and herself with Him: "My soul doth magnify the Lord and my spirit hath rejoiced in God my Savior. For he hath regarded the low estate of his handmaiden: for, behold, from henceforth all generations shall call me blessed" (Luke 1 : 46–8).

According to the English translation of Luke, "Mary arose." It makes sense that Elizabeth also would have risen to greet her cousin. A picture of two pregnant women embracing comes naturally to mind. It is surprising, then, to hear in the sermon of Saint John Chrysostom read at Matins on the Feast of the Visitation no mention of Mary or Elizabeth except as "transportation" for a preordained meeting between their unborn sons: "When the Redeemer of our race had come to us, He hastened to his friend John while John was still in the womb. Breaking the barriers of nature . . . John saw him and cried out, 'I see the Lord who imposed the limits on nature . . . I need not wait until the time of my birth. Nine months is not necessary for me. He who is eternal is within me'" (DO, II, 1959). In the second sermon read at Matins, Saint Ambrose mentions the women but only as secondary, lesser carriers of the Word: "[Elizabeth] heard in the natural order; [John] leapt because of the mystery. She perceived Mary's coming; he, the coming of the Lord" (DO, II, 1962).

It seems extraordinary that in these homilies, words are put into the mouth of the embryonic John while the words of the expectant mothers recorded in Luke (which is read during the Divine Office) are omitted. "Nine months," "nature," "mothers" – like the dialogue between the female cousins – are set aside, if not totally dispensed with, in contemplating the spiritual significance of the visit, as if, in contradiction of the Incarnation, the physical and spiritual were separable. For painters, even as early as Giotto, the

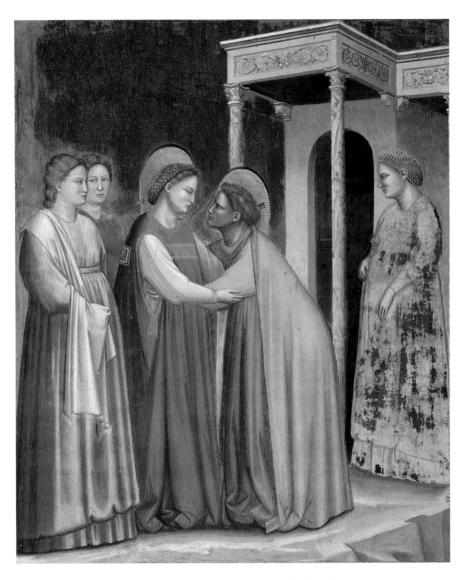

6 Giotto, *Visitation*, 1310, Scrovegni Chapel, Padua.

women's bodies, gestures, and importance were not so easy to overlook. Indeed, there is little indication that painters wished to overlook them.

Every woman in Giotto's painting (fig. 6) looks great with child. Giotto paints a woman's world in which Mary, a dignified, well-dressed and neatly braided young matron, stands tall while supporting and embracing her older cousin. The two women look directly into one another's eyes. They are plainly communicating. Jesus and John the Baptist, except by implication, are not shown.

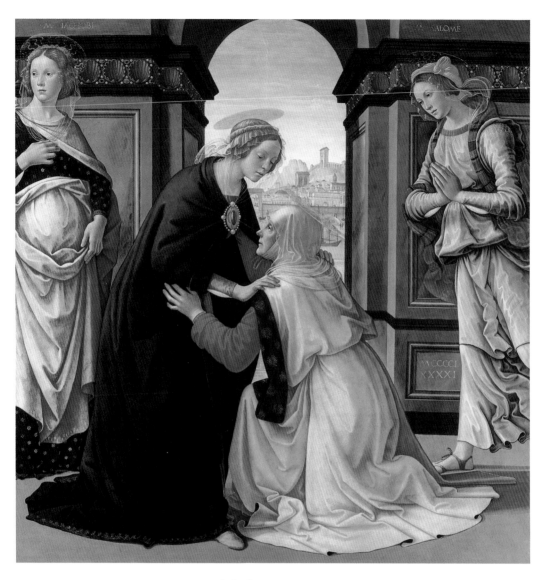

7 Domenico Ghirlandaio, *Visitation*, 1490, Louvre, Paris.

Nearly two hundred years later in a luminous painting by Domenico Ghirlandaio
(fig. 7), the basic elements of the scene, though stylistically enriched, remain essentially
the same. Elizabeth lowers herself while welcoming her stately cousin in the presence of
other women (Saints Mary Jacobi and Mary Salome), at least one of whom is also preg-
nant. Behind the women is an open arch, a feminine symbol, a sign of welcome to home
or temple, and, most importantly, a structural reminder that Mary is the Ark of the New
Covenant. Ghirlandaio's Mary is younger and more regal than Giotto's. A gorgeous brooch

pins her cloak; her cousin kneels in reverence; the women's eyes do not meet. A saintly woman stands to the right with hands clasped in prayer. The colorful richness of costume and architecture, the formality of gesture and symmetry of design give the painting a slightly artificial, ceremonial aura. Yet nature is not absent. Elizabeth's left hand rests lovingly on Mary's womb. A pretty, pregnant lady on the left modestly displays her rosily clad belly. Mary's young face is filled with tenderness. As she looks down at the kneeling Elizabeth she seems to be seeing herself in years to come. Ghirlandaio's picture is tender but less populist than Giotto's. With Florence seen through the stately arch of a palatial structure, the elegant Mary could also be a noble lady receiving a penitent servant or poor relation.

Surely the most arresting and original Visitation, which captures both the ordinary and extraordinary nature of the event, was painted by Jacopo Pontormo (fig. 9) a generation later. Pontormo's women burst with color and movement like a flame. They are elegant, tall, heroic figures embracing in a dance of stillness. Their robes flow and their ample forms almost seem to float. Their faces express an intense and fixed concentration of love and admiration. As in the Giotto (see fig. 6), there are female witnesses to the event, but Pontormo's grouping is unusual. The woman on the left is slightly separate from the other three. She watches and waits. The figure between Mary and Elizabeth is literally included in their meeting; she forms part of a trio. What could this mean? One thinks of classical images of the three Graces. Perhaps Pontormo wanted to depict three ages of woman – youth (Mary), middle age (Elizabeth), and old age (Anna). Art historians have suggested that the configuration was in imitation of a Dürer engraving of four witches.[20] More radically and perhaps unconsciously, Pontormo has depicted a female Trinity. Instead of Father, Son, and Holy Spirit, he has shown what looks like Mother, Daughter, and between them, in mesmerizing contemplation, the Holy Spirit that unites the two (fig. 8).

8 Jacopo Pontormo, *Visitation* (detail of fig. 9).

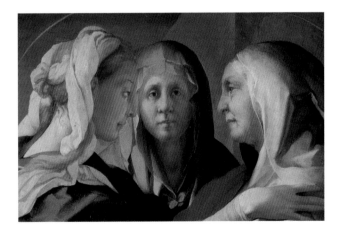

32

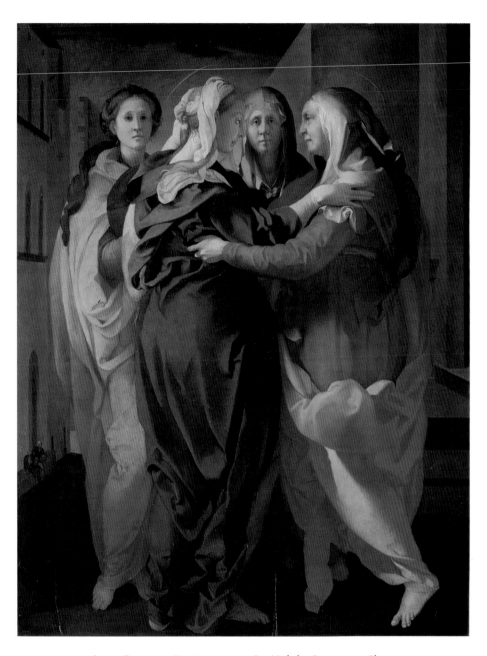

9 Jacopo Pontormo, *Visitation*, 1528–9, San Michele, Carmignano (Florence).

As in the Giotto and Ghirlandaio, Pontormo's Visitation is a gathering of women. In these paintings and in Luke's Gospel, Mary is not "alone of all her sex" but one with all her sex. Each figure is *enigmaticamente duplicato* ("enigmatically duplicated") as in a mirror in which the gestures and faces of the women respond to and reflect one another.[21] Exactly! Women are the actors and audience, the participants and observers, sisters (or cousins) in feeling and fact. While Mary and Elizabeth gaze at one another, the two other women look out of the picture as if anticipating and reflecting the images of the unknown (but gendered?) viewer. In scenes with the infant Jesus or Pietas in which she holds the body of her crucified Son, Mary embraces the Savior but when Mary herself is embraced, it is by other women, by Elizabeth, by Mary Magdalene, and the "other Mary." Demonstrating this again and again in paintings of the Crucifixion and Visitation, artists interpreted Luke, reflected popular sentiment, and foresaw the future of a mainstay of Marian devotion.

Famous male saints like Albertus Magnus and Bernard de Clairvaux held Mary in particular esteem and it was undoubtedly male clerks and monks who composed the earliest antiphons sung to Mary in the Divine Liturgy. Yet even the *Salve Regina*, one of the oldest and most beloved of Marian hymns, since the Middle Ages a favorite of celibate monks and Crusaders, has a distinct resonance if one imagines it sung by women rather than men.

Salve Regina, mater misericordiae; vita dulcedo, et spes nostra, salve. Ad te clamamus, exsules, filii Hevae. Ad te suspiramus, gementes et flentes in hac lacrimarum valle. Eia ergo, Advocata nostra, illos tuos misericordes oculos ad nos converte. Et Jesum, benedictum fructum ventris tui, nobis post hoc exsilium ostende. O clemens: O pia: O dulcis Virgo Maria.

Hail Holy Queen, mother of mercy, our life, our sweetness, and our hope. To thee do we cry, poor banished children of Eve. To thee do we send up our sighs, mourning and weeping in this valley of tears. Turn, then, most gracious Advocate, thine eyes of mercy toward us. And after this our exile, show unto us the blessed fruit of thy womb, Jesus. O clement, O loving, O sweet Virgin Mary.[22]

The hymn begins with a salutation, a greeting, like that of the angel Gabriel and like that of Elizabeth. "Blessed is the fruit of thy womb" are Elizabeth's words to her pregnant cousin. Then although both men and women are the "children of Eve," the omission of Adam's name seems to imply that he and his sex, while also banished, are less culpable than Eve and her sex. All women, including Mary, have a special relationship with and resemblance to the first woman. Jesus weeps over the death of his friend Lazarus, but "mourning and weeping" in the New Testament and in Christian art is more often associated with Mary and the women who weep for Jesus on the road to Calvary. Clearly, the Marian antiphons are for every Christian – male and female – to contemplate and sing. Yet, as the evangelist and the artists saw, the identification with Mary had a unique and powerful significance for women.

To reconstruct the life of Mary (or any human being) in a narrative of youth and age, joy and sorrow, expectation and disappointment, does not require a particularly great imaginative or theological leap. Considered in the passage of time, the contrasts in Mary's moods and postures appear not as contradictions but rather as chapters in an unfolding mystery. Still, Mary, like Jesus, is often spoken of in terms of paradox: humble/regal; weak/strong; maiden/mother. Mary is the "new" Eve; "Ave" to Latinists is the reverse of Eva. For devotional poetry and homiletics, such paradox is usually a sign of divine providence. In a famous sermon Saint Augustine centers the paradox in the female nature: "Through a woman came death; through a woman, life: through Eve, ruin; through Mary, salvation" (*DO*, 1, 985). But paradox can also have negative connotations of incoherence, illogic, illusion. In her study of Mary, Marina Warner wrote, "In the very celebration of the perfect human woman, both humanity and women were subtly denigrated."[23] This view may be shared by many, but it cannot stand as a readily demonstrable fact in the face of the countless numbers throughout Christian history who would say with equal confidence that in celebrating Mary, humanity and women have been uplifted. Scholarly pronouncements, like Church councils and Reformation declarations, have frequently attempted and failed to settle the question of Mary.

Poets and painters, however, have repeatedly reopened the long conversation about Mary, pouring out a seemingly inexhaustible array of images, many with pious caution, many others with passionate abandon. While Mary's "perfection" has been taken by some Christians as narrowly synonymous with her submissiveness, the earliest Marian hymns and several of the most stunning Renaissance paintings contain bold reminders of her extraordinary power, her "uprightness," in every sense of the word. The *Akathistos* (literally, "not sitting down"), a sixth-century Byzantine hymn in praise of the Virgin, parts of which filtered into the Latin rite, contains numerous epithets honoring Mary's unflinching strength and courage. In the fourth chant of the hymn, the shepherds come to the stable and address the new mother in Bethlehem: "Hail, O Protection against unseen foes!/Hail, O Key to the Doors of Paradise! . . ./Hail, the Unsilenced Voice of the Apostles!/Hail, the Undaunted Might of Martyrs!/Hail, O Steadfast Foundation of Faith!" Pagans who have been converted by Mary during her exile in Egypt sing to her in the sixth chant as the personification of the power of Yahweh in the Book of Exodus: "Hail, O Sea who drowned the symbolic Pharaon!/Hail, O Rock who quenched those who thirst for Life!/Hail, O Pillar of Fire who guided those in darkness!/Hail, O Shelter of the World, wider than the clouds!" In the twelfth and final chant, all humanity is invited to sing: "Hail, Unshakable Tower of the Church!/Hail, Unbreachable Wall of the Kingdom!"[24]

While it is unlikely that Italian Renaissance artists would have heard this hymn in its entirety, except possibly in Venice or Ravenna, they surely would have heard echoes of a similar piety in the shorter Latin antiphons that were sung in honor of Mary in Western churches and monasteries from the twelfth century. In the *Alma Redemptoris Mater* ("Beloved Mother of the Redeemer"), Mary is addressed as *Caeli porta, et Stella Maris*

10 Giacomo Jaquerio, *Madonna della Misericordia*, 1425–30, Castello di Fenis, Aosta.

("Gate of Heaven, and Star of the Sea"). The *Ave Regina Caelorum* ("Hail, Queen of Heaven"), celebrates Mary's might as "queen," "root," and "gate" in harmony with her renown and unparalleled beauty, *super omnes speciosa, valde decora*. In the *Praeclara Custos Virginem* ("Glory and Protector of Virgins"), Mary is "beloved star of the shipwrecked" and "tower impenetrable to the devil." When Italian artists heard "tower," "gate," "star," they or, at least, some of them were not imagining a submissive girl.

As in the Piedmontese Giacomo Jaquerio's fresco (fig. 10), paintings of the Madonna della Misericordia (Madonna of Mercy) differ in important ways from the depictions of the Assumption, Mary ascending into heaven (particularly popular after the Counter-Reformation), and the Virgin being crowned Queen of Heaven by Jesus. The Madonna of Mercy has her feet planted firmly on the earth. No fleecy clouds support her. Angels discreetly help hold up her cape but do not flutter around her. Mary stands straight and tall, forming a cross with her outstretched arms. In a bold painterly and theological move, the artist makes Mary's "cross" a sign of safety not sorrow, protection not agony. Jaqueiro's Mary is not a matron but a young woman with a trim hourglass figure. Beneath her in supplication are miniature members of the clergy, popes, bishops, monks, and nuns on her right and the laity, female, male, old, young on her left. This frescoed Mary is not simply on a wall; she is a wall – flat, rigid, unmoving. The artist has taken the images of the Virgin as "gate of heaven" and "door of paradise" with breathtaking literalness. His Mary "lets in" the faithful and "keeps out" harm.

11 Simone Martini, *Madonna della Misericordia*, 1308–10,
Pinacoteca Nazionale, Siena.

From the thirteenth century, paintings of the Madonna della Misericordia began to appear with increasing regularity in Italian churches. In times of plague, her powerful, merciful, and reassuring image assumed greater and greater importance as a protective haven for laity and clergy of all ranks. According to one scholar, her "towering presence" made her "an effective agent in her own right. Secure in the knowledge that God can deny her nothing, she has no need to consult him, but acts as a supreme and autonomous power."[25] More than a century before Jaqueiro painted his fresco, Simone Martini painted a more maternal, less rigid but no less stalwart Madonna of Mercy (fig. 11). If Jaqueiro's Mary is almost all cape, a defensive barrier, wall, or tent, the power of Martini's Mary is in her large and comforting hands.

Martini's faithful are closer to Mary than Jaqueiro's. They do not kneel but stand; their uplifted hands touch her robe. Clergy and laity are mixed; Mary protects, embraces, them all. Her long graceful fingers do more than hold open her cape; they hold her people close to her body. In both paintings, Mary is larger than life, a transcendant figure with a benign, somewhat mysterious half-smile as if she knows something that no one else quite grasps. Neither painting attempts to place the figures in a biblical or legendary narrative. There is no background setting. There is no sense of time. Mary is depicted as an immovable object holding herself and her people in eternal and serene equipoise.

Without the gift or burden of theological language – of needing to define "perfection," "conception," "infusion" – Renaissance painters of the Madonna of Mercy approached in their way what Dante attempted in his mystical vision of Mary in the *Paradiso* when Saint Bernard of Clairvaux speaks to him of the Virgin:

> *Riguarda omai ne la faccia che a Christo*
> *piu si somiglia, che la su chiarezza*
> *sola ti puo disporre a veder Christo.*

> Look now on that face that is most like
> The face of Christ, for only through its brightness
> Can you prepare your vision to see Him. *Paradiso*, xxxii, 85

> *Vergine Madre, figlia del tuo figlio,*
> *umile e alta piu che creatura,*
> *termine fisso d'etterno consiglio,*

> *tu se' colei che l'umana natura*
> *nobilitasti si, che 'l suo fattore*
> *non disdegno di farsi sua fattura.*

> Virgin Mother, daughter of your Son,
> more humble and sublime than any creature,
> fixed goal decreed from all eternity,

> you are the one who gave to human nature
> so much nobility that its Creator
> did not disdain His being made its creature. *Paradiso*, xxxiii, 1–8[26]

Like many comparisons, extended or compressed, in Dante's poetry (as well as in Bernard's devotional homilies and the poetry of liturgical antiphons), "that face most like the face of Christ" is both simile and reality, a stretch of language and an article of faith. For Dante, as for Bernard, Mary is not only "like" Jesus; she contains, reveals, and reflects Jesus. No phrase more simply and radically expresses this than Dante's *termine fisso*, the "fixed goal," which identifies Mary with the unmoving and immovable Godhead. No painting goes further in figuring this mystical view of Mary than the Madonna of Mercy of

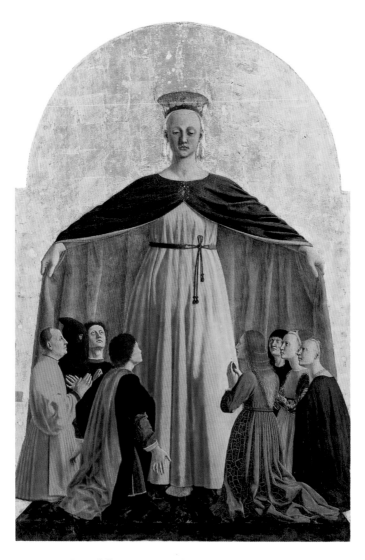

12 Piero della Francesca, *Madonna della Misericordia*, 1460–62,
Museo Civico, Sansepolcro.

Piero della Francesca (fig. 12). Here, Mary is iconic and human, plain and beautiful, mater-
nal and virginal, young and ageless, strong and delicate. Yet what is astonishing in the
painting is that the linguistic contradictions are dissipated into irrelevancy by the impos-
ing presence of the figure. Mary's arms are suspended between the rigid plane of a cross-
beam and the relaxed embrace of a mother; her expression is suspended between
trance-like indifference and tender solicitude; her dress is simple; even her crown is
unadorned, but her stance is definitely that of a queen; she is a full-bodied woman and a
"tower of ivory . . . impenetrable to the devil."

The painting was commissioned by the Confraternity of the Brotherhood of Mercy and set above an altar where the consecration of the bread and wine occurred and from which Communion was distributed to the faithful. Thus Mary is depicted as the "vessel" of the Lord. The kneeling members of the confraternity "could see themselves gathered beneath the cloak . . . in a circle around Mary seen in relation to the circular host and chalice rim."[27]

Piero's kneeling figures are closer to the viewer in position, size, and expression than the Lilliputians in Jaqueiro's and Martini's paintings. Although four women are on one side and four men on the other, the symmetry is complicated by subtle differences in place, posture, and shape. Indeed, their very "naturalness," their proximity to the viewer, their relative elasticity and recognizable imperfections of feature form both a bridge to and distance from the towering, impassive, supremely protective, but almost unapproachable Madonna. Maurizio Calvesi has described the painting as a "perfect metaphysical expression of volume . . . a sort of dome, or *Ecclesia*, a reassuring allegory of the Church itself . . . The Virgin's headgear represents the dome's lantern, her arms the ribs of the vault."[28]

In exaggerating the severity of the Virgin's headdress, Piero gives her a shaven, androgynous, strangely sexless appearance in sharp contrast with that of the long-haired young woman praying before her. It is as though the artist is attempting, in plastic terms, to involve himself and his praying figures in contemplating the mystery of Mary's transcendence and her sexuality (or lack of it). Perhaps while praying for safety, his kneeling women and men are also hoping for understanding, wondering whether the Virgin is, indeed, divinity in another form, born without sin, in the words of Saint John Chrysostom, of a perfection and "chastity more than human" (*DO*, 1, 958). Such claims have given Mary her unique status. They have also been the cause of the greatest controversies about her and the strongest negative reactions to the efforts of celibate men who have used her "immaculate" status to discredit and suppress a healthy expression of female sexuality. One critic sums up the problem as follows: "She was the model of ideal female behavior, but not a standard any woman could hope to attain."[29]

It is surprising that the poetry of the Marian liturgies – whatever the official pronouncements – confronted in their way some of the same tensions identified by modern critics. They not only praise but explore the metaphysical and physical Virgin with reassuring cadences and an aesthetic confidence in the power of language to sedate or awaken according to the disposition of the reader. For example, the first lesson sung at Matins on the Feast of the Visitation from the Song of Songs (2 : 1–15) contains some of the most sensuous lines in scripture:

I am the rose of Sharon, a lily of the valley . . . I delight to rest in my lover's shadow, his fruit is sweet to my mouth . . . I am faint with love. His left hand is under my head and his right arm embraces me . . . My lover speaks; he says to me, "Arise, make haste, my beloved one, and come, the winter is past . . . Arise my beloved, my beautiful one"

. . . My lover belongs to me and I to him; he browses among the lilies . . . like a gazelle or a young stag.

Rabbinical commentators and Church Fathers have written extensively about these passages as allegories of the love between God and Israel or Jesus and the Church, but, like paint, the words remain, vivid, concrete, sensuous, resistant to revision. When applied to Mary, as they are during her feast days, they introduce an erotic note impossible to ignore. Although explanatory homilies with spiritual, disembodied readings are interspersed throughout the Divine Office, antiphonal hymns and scripture itself repeatedly draw one back to felt realities, pictured space, and bodily presence: "Then said the Lord to me, 'This gate shall be shut, it shall not be opened, and no man shall enter into it because the Lord God of Israel has entered in through it. Therefore, it shall be shut. It is for the prince; only the prince may sit down in it'" (Ezekiel 44 : 1–3; DO, 1, 1669). This passage from Ezekiel read in the Office of the Blessed Virgin refers to the presence of God in the Temple sanctuary, interpreted in Christian tradition as the person of Mary. As in much Hebrew and Christian narrative, the symbolic and actual, the allegorical and physical, are virtually inseparable. The Temple was a real place of stone and mortar; Mary was a flesh and blood person. In attempting to transcend the "carnal" implications of the comparison, Saint Jerome in one of the "lessons" of the day only succeeds in making the sexual parallels more explicit:

> For Jesus entered the world as He entered the upper room, "the doors being closed"
> . . . "An enclosed garden, a fountain sealed was Mary.". . . Mary is the eastern gate
> of which Ezekiel speaks, always closed and luminous, whether concealing in itself
> or bringing forth from itself the Holy of holies. She is the gate through which the
> Sun of justice and our High Priest according to Melchisedech goes in and out
> DO, 1, 983).

What is one to make of this? Three choices suggest themselves. First and most in keeping with orthodox tradition, the passages from Song of Songs and Ezekiel can be taken as metaphorical approximations, signs and symbols of the mystery of God entering the world through a young woman who had never had sexual relations with a man. A second and more disturbing pre-Christian (or post-Christian) reading of these passages suggests that a taboo against Oedipal desire or the intercourse between a mortal and a divine being has been broken. Thirdly, more reassuring to ordinary mothers and fathers (and to ordinary sons and daughters), is that Mary – virtuous, pure, and holy – had, like other mothers, a husband who loved her, made love to her, and impregnated her.

Scholars and theologians, pious or skeptical, have tended to make choices about the nature of Mary's "perfection" while artists, if they cared to, could keep more than one dimension of Mary in play. The American poet, Jorie Graham, in a poem entitled "San Sepolcro," invites the reader to look with her at another Piero della Francesca painting, the *Madonna del Parto* (fig. 13), in which the young pregnant Mary parts her outer robe

to a slit that reveals nothing more than another lighter covering. The poet's voice is not conventionally pious; it is quiet, curious, and respectful of the privacy of "this girl by Piero della Francesca":

> There's milk on the air,
> ice on the oily
> lemonskins. How clean
> the mind is,
>
> holy grave. It is this girl
> by Piero
> della Francesca, unbuttoning
> her blue dress,
> her mantle of weather,
> to go into
>
> labor. Come, we can go in.
> It is before
> the birth of God. No one
> has risen yet[30]

Critics have noted the "monumentality" of Mary and the significance of her posture in Piero's painting, "standing straight with her shoulders thrown back and feet flat on the ground [as though she is a translation] of one of the Biblical texts used in Marian feasts: a psalm of Jerusalem: 'her foundations are the holy mountain . . . and the Most High keeps her strong.' "[31]

In contrast to Piero's *Madonna della Misericordia*, this Mary, despite her headdress, is strikingly feminine, young, expectant. A mathematically exacting draftsman, Piero has deliberately placed this Virgin with her body turned and slightly off center. The angels do not hold Mary's cape but draw back a curtain as if in a tent or pavilion. Piero and his presumed audience of merchants had a particular interest and skill in measuring quantity and space. Accustomed to evaluating objects (including cloth and paintings) on display, "the beholder's precise and familiar assessment of the pavilion mediates between his [*sic*] own position in the everyday and the mystery of the Virgin's conception."[32] One critic has admired "the staggering beauty and simplicity" of this "most unorthodox subject"; he sees Piero's Virgin as "the Tabernacle of the Holy Scriptures, as the Ark of the Covenant, not Old Testament, but New Testament, Jesus himself."[33]

Both observations seem accurate yet incomplete. The entire scene suggests an "opening" that is, at first sight, dramatic and total but, on second sight, partial, hidden, and subtle. Mary's delicate gesture is itself ambiguous. The Virgin is either unbuttoning her gown as Graham's poem suggests or closing it; displaying her pregnant belly or trying to protect it from the curious gaze of spectators. Is she exposing a part of herself? A wound? A new

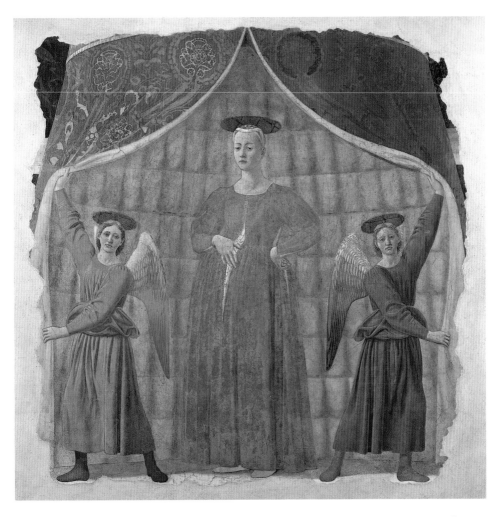

13 Piero della Francesca, *Madonna del Parto*, 1455–65, Museo della Madonna del Parto, Monterchi.

life? Mary's own gaze is modest, dignified, and a little sad. Her left hand supports her waist in the manner of pregnant women; but the gesture also carries a trace of pride and coquettishness. Piero has caught a beautiful young woman in a reflective, private moment suddenly thrust into full public view. The stagey scene and posturing angels seem to invite (or dare) the viewer to see the central figure as a sacred icon (almost an idol) beyond compare or a commonplace country girl with no right to be seen in her present state. Yet Piero's Mary defies such simple responses. She is an inviting and awe-inspiring figure of a woman not parading her sex but not ashamed of it either. If, as Graham's poem supposes, she is about to go into labor, Mary, in Piero's vision, seems eternally ready for the work ahead.

This is
what the living do: go in,
It's a long way,
And the dress keeps opening
from eternity

to privacy, quickening,
inside, at the heart,
is tragedy, the present moment
forever stillborn,
but going in, each breath
is a button

coming undone, something terribly
nimble-fingered
finding all of the stops.

For Graham, Piero's Mary (located in a cemetery chapel) is the focus of a meditation on the moment by moment, button by button, intersection of life and death, the almost imperceptible difference between the opening and the closing of time and the young girl's dress, of coming in and going out. Straight, tall, and still standing, Piero's and Graham's Mary is not a "settled" subject, reduced to a myth or elevated to divinity or casually recognized as one of us. Mary's "dress keeps opening from eternity," "going in," "coming undone." She is with us and beyond us. The poem and the painting turn out to be variations on the long, unfinished narrative of Mary's "place."

That narrative has included extravagant claims, but the excesses have not all been on the part of Mary's admirers. In *The Second Sex*, Simone de Beauvoir wrote, "For the first time in history, the mother kneels before her son; she freely accepts her inferiority. This is the supreme masculine victory . . . her defeat."[34] Clearly, de Beauvoir had been looking at paintings of the Nativity, not reading the Gospels where there is no mention anywhere of Mary kneeling before Jesus. As to mothers (and fathers) kneeling before their infant children – daughters as well as sons – it surely happened before, during, and after the time of Mary, especially when beds and cradles were close to the ground; and must happen still in societies that have never thought of Mary as the model mother, as well as in Christian cultures that do.

De Beauvoir's observation nevertheless calls attention rightly to the supremacy of Jesus in Mary's life. Although there are scenes in scripture and in art where Mary is shown without Jesus, there can be no debate about the fact that her significance, the meaning of her life is completely and utterly dependent on Jesus. To some, this may seem her weakness; to others, it is her unique strength. For the Christian, it is precisely what she has in common with the rest of humanity. Whether or not he is shown in the picture, Jesus, for the Christian, is always in the picture. Marina Warner seems surprised by this and, in

general, by the importance of her son in the life of Mary and of men in the lives of other women venerated by Christians: "Populated as the Catholic pantheon is . . . it cannot conceive of a single female saint independent of her relations (or lack of relations) with men."[35] While this statement is literally accurate, it is oddly oblivious to reality and logic. Women or men, saints or sinners, all have mothers and fathers; many have brothers and sisters; all except hermits spend their lives in relationships of one kind or another. "Relations or lack of relations" covers all the possibilities. Jesus himself lived in relationship with men and women; indeed, it is central to his life and teaching that people should help and love one another. Many of the greatest male saints have had intensely powerful relationships with women: Augustine with Monica, Benedict with Scholastica, Francis with Clare, Francis of Sales with Jeanne de Chantal. Many of the great female saints, Teresa of Avila, Thérèse de Lisieux, though they had fathers and father confessors, made their major contributions within communities of women.

Still, there can be no argument about Mary's reliance on Jesus. Mary's "standing" completely depends on him. Even when she seems to stand alone before his birth and after his death, it is because of Jesus that she is remembered, venerated, loved, resented, sung to, and imagined in paint and poetry. Yet it is also true that Jesus depended on Mary. Without Mary, Jesus does not enter the world of the living. Warner's observation might be turned around: it would be impossible to conceive of Jesus independent of his relations to women, especially his mother. The Venerable Bede states the orthodox position in a sermon read at Matins on Marian feast days: "If the flesh of God's Word is considered to have no connection with His Virgin Mother's flesh, then it is nonsense to pronounce a blessing on the womb that bore Him . . . He derived His flesh from His Mother's flesh" (*DO*, 1, 965–6).

In one of the loveliest paintings of Mary standing, Caravaggio shows her helping an entirely naked little Jesus to walk on the head of a snake (fig. 14). His flesh and her flesh are pliant, luminous, and alike. Anna, Mary's mother, the grandmother, watches from the shadows.[36] Jesus is in the keeping of two maternal figures depicted in the flesh. The young mother and the old mother, the full and brilliant body and the frail shadowed body, are shown as witnesses and conditions of the Savior's humanity. Mary holds onto Jesus. It is her bare foot that steps on the serpent, showing her son the way and protecting him from the snake's venom. She is a figure of enormous dignity and beauty. In leaning slightly to support her son, she reveals the full breasts of her womanhood. Her sexuality and sustaining maternal presence seem, for a precarious split second, in perfect balance.

Caravaggio, who often used women and boys of the street for his models, was criticized by churchmen of his day for painting holy figures – especially Mary and Jesus – in a fashion that made them look disturbingly familiar, too tied to their flesh, too "human." Yet, despite tensions, Caravaggio was a remarkably creative and sensitive interpreter of Counter-Reformation piety. As one critic pointed out, "The direct contact between the sacred scene and the spectator, and his consistent humanization of Christ, the Virgin, and saints are Caravaggio's artistic response to and interpretation of [current meditative and devotional] practices."[37]

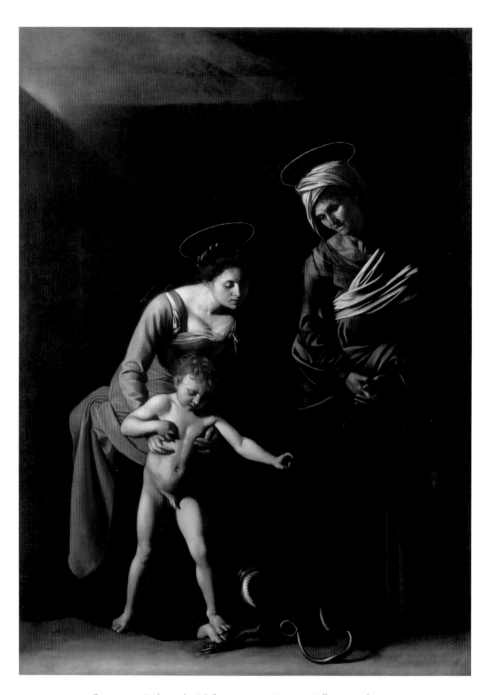

14 Caravaggio, *Madonna dei Palafrenieri*, 1605, Museo e Galleria Borghese, Rome.

Over time the arguments about Mary's nature have taken different shapes, but they never seem to stop. Nearly three centuries after Caravaggio painted his Mary, Jesus, and Anna, Nathaniel Hawthorne's Protestant American heroine in *The Marble Faun* registers dissatisfaction with Italian Renaissance Madonnas as she scours Rome for her ideal Virgin:

> She never found the Virgin Mother whom she needed. Here, it was an earthly mother, worshipping the earthly baby in her lap, as any and every mother does from Eve's time downward. In another picture, there was a dim sense, shown in the mother's face, of the divine quality of the child . . . But still, Hilda looked for something more, a face of celestial beauty, but human as well as heavenly . . . bright with immortal youth, yet matronly and motherly, and endowed with a queenly dignity, but infinitely tender, as the highest and deepest attribute of her divinity.[38]

Perhaps Hilda was not looking in the right place. Maybe the pale, prim New Englander could not see beauty in an Italian *ragazza* or Jewish peasant girl. She, like everyone else, seems to have wanted Mary to be perfect according to her own idea of perfection. Some modern viewers still cannot reconcile a womanly Mary with a holy Mary. One critic is not only shocked by Caravaggio but by the entire Italian Renaissance: "There is no reflection of divinity in the barely transfigured hearty and fecund Italian women whom they chose as models . . . As most sensitive critics have remarked, the type of the Virgin had lost her nobility."[39] That certainly puts hearty, fecund Italian women, Renaissance artists, and insensitive critics in their place. It also shows that, for some, a healthy body and a perfect spirit cannot coexist in the same person, especially not in the same woman.

For the early Church Fathers (and sundry popes and councils after them), the argument for Mary's "perfection" was focused to the point of obsession on the details of her physical virginity. In one of his most famous and furious polemics, Saint Jerome in *Against Helvidius* (c.383) excoriated the theologian Helvidius for daring to suggest that, though the birth of Jesus was miraculous, Mary and Joseph eventually had children together by the usual means. For Jerome (and according to the tradition that flowed from similar thinking), Mary's merit, her significance, her worthiness to be chosen by God depended on her remaining forever "untouched."[40] It is ironical, then, that for many others, it is precisely the Virgin of big hands, of compassion and a capacious mantle, full breasts and a wide reach, who has the power to hold, protect, comfort, console, intercede, and defend.

Celibate theologians clearly have had problems with Mary's body; they have created enormous problems attempting unsuccessfully to get around it. Artists, meanwhile, have met and imagined a flesh and blood Mary with a gusto and pleasure that do not preclude reverence. A verse sung at Vespers on one of Mary's feast days celebrates her ascendancy: "The Virgin Mary has scaled the skies. Alleluia!" Giotto, Fra Angelico, Piero, Pontormo, Caravaggio, Dante, and Hopkins (perhaps even Joyce and Graham) would probably not quarrel with that – but they have all added their own antiphon: "The Virgin Mary had her feet firmly on the ground. Alleluia! Alleluia!"

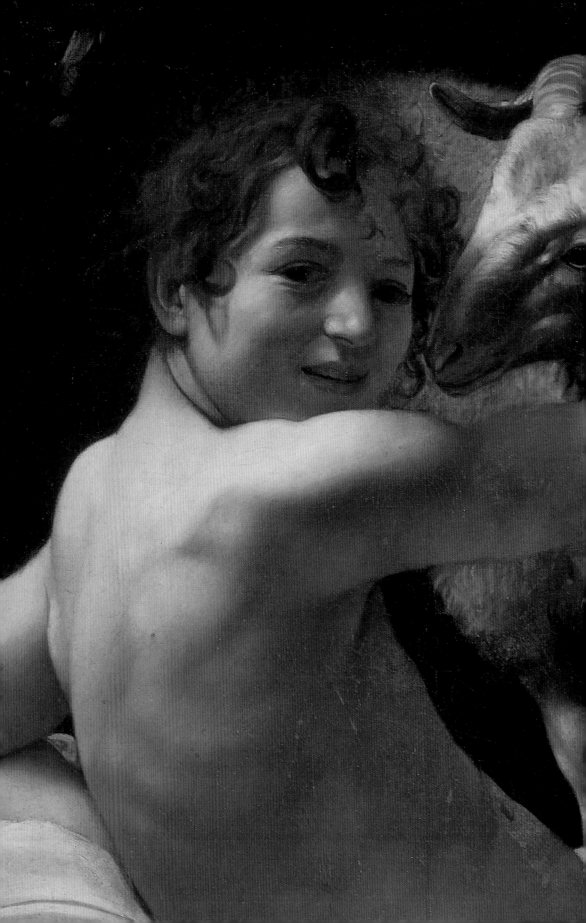

JOHN THE BAPTIST

2

A SAINT FOR ALL SEASONS

TAKING LIBERTIES WITH JOHN THE BAPTIST

In the Cappella Poggi of the Church of San Giacomo Maggiore in Bologna there is a fresco of John the Baptist that is perhaps the most astonishingly unconventional depiction of the saint ever painted. Pellegrino Tibaldi, in his *Annunciation of the Birth of John the Baptist* (c. 1551–3; fig. 15), shows a figure in angelic flight that is not an angel but John, a fully grown muscular man with a good head of hair and a beard, hurtling down from the throne of God in heaven toward earth. He stretches out his right hand and nearly touches Elizabeth, his mother, who looks up and waits with open arms while to the far right, leaning against a pillar, looking away, and seemingly oblivious to the great event taking place, is Zachariah, John's father.

Tibaldi departs from the account of the birth of John the Baptist in Luke's Gospel in several arresting ways. In Luke there are two annunciations of the birth of the Baptist: the angel Gabriel appears to Zachariah in the Temple (Luke 1 : 8–20) and, later, to Mary, to whom he reveals not only the birth of Jesus but of her cousin Elizabeth's son John (Luke 1 : 36–7). Gabriel does not appear to Elizabeth and, in fact, until the child is named, the father, not Elizabeth, is the parent on whom the evangelist focuses attention. Thus, Tibaldi goes well beyond Luke in depicting a heavenly figure reaching out to Elizabeth. In doing so, he does more than piously embroider Luke's narrative; he complicates the

15 Pellegrino Tibaldi, *Annunciation of the Birth of John the Baptist*,
c.1551–3, San Giacomo Maggiore, Bologna.

figure of John the Baptist in a way that embodies complexities that are hinted at in all
four Gospels and elaborated on both in Church tradition and in later secular literature.

By showing John as a beautiful but weightless male body suspended between heaven
and earth approaching Elizabeth, as painters have often shown Gabriel approaching Mary
on a more nearly equal plane, Tibaldi, awkwardly but plainly, reminds the viewer of the
Annunciation to Mary, thus conflating Gabriel with John, the messenger and the message,
God's emissary and the man, the androgynous angel and the masculine mortal. As will be
seen, this ambiguity of identity accompanies, one might say plagues, John almost from the

beginning. In this, as in many other ways, John seems to foreshadow and prefigure Jesus but again somewhat awkwardly. Although various heresies have emphasized Jesus as man or Jesus as God, orthodox Christianity has long insisted on Jesus as both, whereas for John the Baptist, tradition, if not doctrine, has tolerated an intriguing ambiguity of identity that has left him suspended, as in the fresco, somewhere between heaven and earth.

John may not have been thought divine, but in his lifetime he was mistaken for the Messiah, for a prophet returned from the dead, and for a creature of angelic, almost super-human innocence. In a bold gesture worthy of a Mannerist painter who loved dramatic gestures, Tibaldi adds yet another intriguing dimension to his free-falling Baptist by cir-cling his body with a billowing rose-colored robe that seems an unmistakable quote from Michelangelo's God the Father in the Sistine Chapel stretching out his hand to give life to Adam. Yet the saint's nude body is more like that of the young Adam than the Father whose mantle he appears to have borrowed for the trip.

It is an indication of the persistence of the Baptist's peculiarly ambiguous status that cen-turies after Tibaldi painted his fresco, Oscar Wilde and Albert Camus seized on the saint's susceptibility to contradictory interpretations in two famously disturbing works, Wilde's play *Salome*, first published in French in 1893, and Camus's novel *La Chute* (*The Fall*), pub-lished in 1957. Wilde's Iokanaan and Camus's Jean-Baptiste Clamence are walking contra-dictions or, more accurately, characters who elicit radically contradictory responses from those around them. The play, shocking and controversial in its own day (as was Richard Strauss's operatic version), turns the brief biblical account of John's death into a drama of psychosexual obsession. The Gospel of Matthew (14:6–11) tells that Herod had John imprisoned because the Baptist had criticized the king for marrying his brother's wife:

> On Herod's birthday, the daughter of Herodias danced before them and pleased Herod who promised to give her whatever she asked. Instructed by her mother, she said, 'Give me John's head on a platter.' The king was distressed, but because of his oath, he sent and had John beheaded. The head was brought in on a platter and given to the girl who presented it to her mother.

Wilde uses the narrative as a frame for exploring lust, fixation, and sadism unwittingly provoked by John (Iokanaan) and personified in the character of Salome. From the begin-ning of the play, the figure of the Baptist is ambiguous to the point of absurdity. In the opening scene, two soldiers guard the cistern where Iokanaan is held prisoner. They hear his voice: "He says ridiculous things," says one soldier. "No, he is a holy man . . . a prophet," says the other.[1] When Salome appears, she asks if the prisoner is "an old man." "No, princess, he is quite young," answers the first soldier. "One cannot be sure," says the second soldier (*S*, 13). When Salome has Iokanaan brought up to her, she describes him as "terrible," "wasted," and "thin." Yet she cannot take her eyes off the strange captive. In an obsessive litany of reversals, she alternates seductive flattery with abusive insults: "Thy body is white, like the lilies . . . Thy body is hideous . . . like a leper . . . a plastered wall

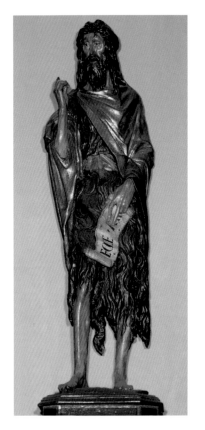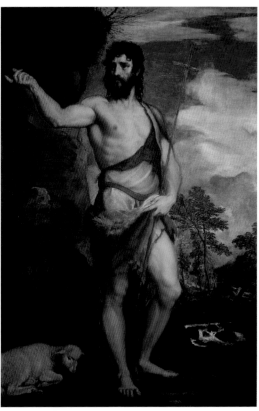

LEFT 16 Donatello, *John the Baptist*, 1438, Santa Maria Gloriosa dei Frari, Venice.
RIGHT 17 Titian, *John the Baptist*, 1540, Gallerie dell'Accademia, Venice.

. . . Thy hair is like clusters of grapes . . . Thy hair is horrible" (*S*, 21–3). Little wonder that it has been a challenge for directors, as for painters, to know whether to cast a freak or an Adonis in the role.

Biblical historians have attempted to describe John with the help of clues about the habits of Jewish ascetics of the period. For example, it was the consensus of the Jesus Seminar (1991–2) that the Baptist may "have dressed himself in a garment of camel hair with a leather belt around his waist . . . the traditional garb of a prophet."[2] One scholar has gone a little further: "We can imagine him, then, with his hair long and matted; a slim figure with sun-hardened skin, an old camel's hair-sackcloth tied around his waist with a strip of leather."[3]

Two famous Italian Renaissance portrayals of John, a painted statue in wood by Donatello (fig. 16) and a painting by Titian (fig. 17), take completely opposite views of the saint. Donatello's Baptist is gaunt and haggard. His shaggy camel's-hair cloak, dish-

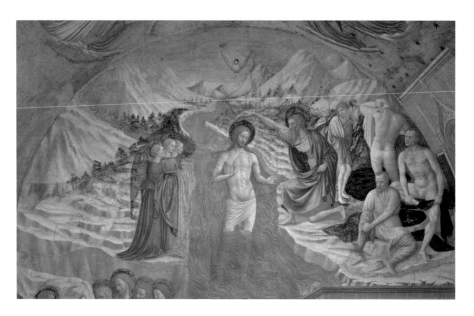

18 Masolino da Panicale, *Baptism of Jesus*, 1435, Castiglione Baptistery, Orlona.

eveled and limp like his beard and hair, covers all of his skeletal frame except for his stick-like legs and bony hands. His stance is stiff and rigid, his expression exhausted and accusatory. Titian's John is a virile, robust figure posing proudly like a Greek god or Roman emperor with right arm thrust out in a gesture of authority and his left foot resting comfortably on a pedestal-like stone. One art historian has observed that Titian's "definition of the saint's rippling muscles may suggest specific knowledge of Michelangelo's athletic ideals."[4] John's soft garment is draped in such a way as to leave most of his well-formed body nude. His left hand tucks up a fold of his tunic so as to show a shapely thigh. Although his expression is touched with sadness, everything else about Titian's John radiates strength, confidence, and wellbeing. He glows with masculine health; he is the embodiment of muscular Christianity.

In the century that separated Titian from Donatello, major changes in aesthetic representations of the human form, and consequently of religious figures, took place. Nevertheless, the two Baptists are emblematic of ambiguities and contradictions that are partially, but not entirely, explained by shifts in taste. Throughout the centuries John has not simply inspired different interpretations, he has provoked versions and revisions of himself at polar extremes.

How to distinguish him from Jesus? Should he look like Jesus' brother or cousin? Should he be better or less well dressed than the Savior? Masolino da Panicale decided, in a fresco in Orlona (fig. 18), to give John a longer beard than Jesus, thus making him look older. He placed John on a higher plane than Jesus, but John is kneeling while Jesus stands.

Whereas later artists show more and more of John's flesh whether or not he is baptizing, Masolino covers the Baptist's body in a generous pink cloak while showing Jesus in the river nearly nude. Masolino's fresco can be seen as a portrait of youth and age, a paternal blessing in which the mature prophet, bending rather awkwardly and precariously, anoints and yields to the young prince whose smooth pale body seems to curve and flow with the purifying water. Since the fresco is in a baptistery, it is appropriate that the figure of Jesus is closer to the font, the candidate for baptism, and the viewer than that of John the Baptist who presents the Savior while remaining beside and slightly – only slightly – behind him.

Piero della Francesca, in a less liquid, more mysterious arrangement, makes John and Jesus look stiff, solemn, rather dry, considering the circumstances, and much alike (fig. 19). Originally the central panel of an altarpiece in a chapel devoted to the veneration of the Baptist, the painting shows two figures that are the same height and build. John's hair is darker, but his beard and features are similar to those of his cousin; he could be Jesus' twin brother. He stands up close to Jesus, showing intimacy, not deference. Jesus is pale and nude (except for a loincloth) while John is clothed in something that could be camel's hair. In the Masolino fresco, John is clearly set to the side, apart from Jesus who is in the center. In the Piero, the two share the central position, looking like right-angle reflections of each other.

Everything about the Masolino Baptism is fluid, soft, celebratory, public, and generous. Jesus opens his arms in thanksgiving; the River Jordan opens out toward the viewer; the dove raises its wings as if applauding; even the men undressing on the right spread their limbs with unselfconscious ease. John the Baptist performs an essential role but does not overstep the limits of a supporting character. By contrast, Piero's Baptism is crisp and arid. His Jordan is little more than a puddle. Despite the nearby town (Borgo San Sepolcro?), the presence of three angels, and a figure disrobing in the background, the scene has an air of privacy, as though the transaction mainly, almost exclusively, involves the two central figures alone. John steps toward Jesus while Jesus, hands clasped in prayer, seems already to have entered another realm. The dove, wings spread straight out, the tree, and the Baptist's arms encompass Jesus. Yet John does not move aside or fade into obscurity. He is both acolyte and celebrant, an enabler whose body has not come to rest or perfect peace like that of the iconic Savior whom he resembles but does not touch.[5]

In pictures, as in texts, it seems to have been John's destiny to resemble other figures such as an angel, a prophet, the Messiah, or (strangely), according to the notoriously decadent late nineteenth-century artist Aubrey Beardsley, his nemesis, Salome. Beardsley added to the Baptist's "masks" in his illustrations for Wilde's *Salome* by depicting Iokanaan as an androgynous, less elaborately dressed twin of Salome with a huge pile of black hair, no beard, and an off-the-shoulder sheath with scant resemblance to a camel's hide (fig. 20). This solution makes good sense since in Wilde's version of the story of the Baptist in captivity, Iokanaan is a reflection of Salome's schizoid sexuality more than a character

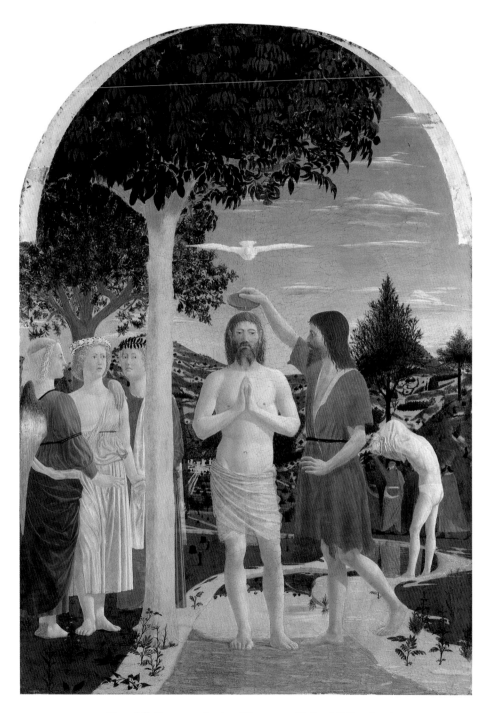

19 Piero della Francesca, *Baptism of Jesus*, 1442, National Gallery, London.

20 Aubrey Beardsley, *Salome and Iokaanan*, from the original
English edition of Oscar Wilde's *Salome*
(London: Elkin Mathews and John Lane, 1894).

with well-defined independent traits. Salome's horned headdress and bare navel and breasts look like sharp weapons but Iokaanan's stare carries a menace of its own. The two are locked in a gaze of mutual absorption and disgust in which innocence and corruption, seduced and seducer are indistinguishable.

In *The Fall*, a novel that epitomizes mid-twentieth-century existential ambivalence about everything, Camus names his protagonist – a successful lawyer who has witnessed a woman throw herself into the Seine without going to her rescue – after John the Baptist. Jean-Baptiste Clamence, who describes himself as "a false prophet crying in the wilderness and refusing to come forth,"[6] constantly reminds the reader of his link to John the Baptist while simultaneously undermining that link. In Camus's twentieth century, "a voice crying in the

wilderness" had come to mean a voice to which no one paid attention, the very opposite of its biblical meaning, since Matthew 3:5 relates that "the people of Jerusalem and all Judea were going out to him, and all the region along the Jordan and they were baptized . . . confessing their sins." Camus's Jean-Baptiste says that his "profession is double," that he is a "judge-penitent," one who simultaneously confesses and accuses, but his River Jordan is the cold Seine that takes a life, his wilderness a dingy bar in Amsterdam, and his congregation a solitary stranger, a bartender, a reader. Like Wilde's Iokanaan, he is also a physical conundrum. He speaks of his "charm" and of having been "favored by Nature as to my physique" (F, 17) yet he soon qualifies this: "With the face I now have, it's hard to believe I was charming" (F, 37). What face does he have now? The only answer is a "double-face, a charming Janus" (F, 47). In a coolly deconstructive move, he places his very presence in doubt: "I was . . . here without being here; I was absent at the moment when I took up most space" (F, 87). Even his last name defies clear identification. "Clamence" is a play on calling, crying, confessing, and clemency; accusing and forgiving.

It is easy in retrospect to see how Wilde's and Camus's characters epitomize obsessions, ambivalences, and morbidities associated with nineteenth-century decadence and twentieth-century existentialism. What has John the Baptist to do with this? Is there something in the scriptural representations of his character that suggests a dark and duplicitous figure, alternately seductive and repulsive, beautiful and "terrible to behold?" Or is John the Baptist a perfect innocent, "free from guilt" (as he is according to the hymn sung on the feast of his birth), a pure blank page, a clear mirror onto which others project their own sins, anxieties, and desires?

Both Wilde's and Camus's protagonists are accused (or accuse themselves) of inaction. Jean-Baptiste Clamence does not save the drowning woman; Iokanaan does not return the desperate advances of Salome. Addressing Iokanaan's severed head, Wilde's Salome accuses him of a kind of negative rape: "I was a virgin and thou didst take my virginity from me . . . Wherefore didst thou not look at me?" (S, 65). According to Salome, the more Iokaanan ignored her the more he aroused her, even to the point of having him murdered so that she could kiss his lips. Her morality seems quite faulty, but there is a logic in her psychology that puts the innocence of inaction into question. Camus's Jean-Baptiste comes right out and proclaims himself to be a passive/aggressive reflector: "The portrait I hold out to my contemporaries becomes a mirror . . . I pass from the 'I' to the 'we' . . . The more I accuse myself, the more I have a right to judge you" (F, 110).

It is clear that Wilde and Camus, like Tibaldi, Donatello, Titian, and Beardsley, saw in John the Baptist an ideal figure onto which to write their own questions and conflicting answers about the complications of human (and heroic) identity. In this respect at least, they all were faithful to the biblical texts which show again and again that people were confused about who John was. Responding to their confusion, Jesus sarcastically asks the crowds: "What did you go out into the wilderness to look at? A reed shaken by the wind? What then did you go out to see? Someone dressed in soft robes?" (Matthew 11:7–8).

According to the Gospel of John, some went directly to the desert and asked the man himself: "'Who are you?' He . . . confessed, 'I am not the Messiah.' And they asked him, 'What then? Are you Elijah?' He said, 'I am not.' 'Are you the prophet?' He answered, 'No.' Then they said to him, 'Who are you? Let us have an answer . . .' He said, 'I am the voice of one crying out in the wilderness'" (John 1 : 19–23). John's answer is both familiar and evasive. The priests and Levites would surely have recognized the lines from Isaiah, but this would only have told them that John was someone who could quote Isaiah. Was he also a new Isaiah or even the old Isaiah returned from the dead? Who could say?

One might argue that, despite some inconsistencies among the Gospels (as in the depictions of Jesus), there are enough common indicators to provide a fairly solid picture of who John was and of his function in the evangelical narratives. All of the Gospels describe John as a preacher living in the desert wilderness exhorting all those who would listen to him to repent their sins and lead a virtuous life. In accordance with a Jewish rite of purification, he baptized penitents with water in the River Jordan. When Jesus approached, John recognized him as one already pure and, with reluctance, at his bidding, baptized Jesus. All of the synoptic Gospels also refer to John's imprisonment by Herod. At the urging of Herodias, her daughter asks the king for John's head on a platter. John is beheaded and little more is heard of him.

Only Luke's Gospel gives an extensive account of John's ancestry and birth. His father, Zachariah, was a priest and his mother, Elizabeth, a descendent of Aaron and a cousin of Mary. As has been said, Gabriel appears to Zachariah to tell him that his wife will bear a son who is to be called John "who will be great in the sight of the Lord . . . Even before his birth he will be filled with the Holy Spirit. He will turn many of the people of Israel to the Lord their God" (Luke 1 : 14–16). When Mary visits her cousin and Elizabeth hears her greeting, "the child [John] leaped in her womb" (Luke 1 : 41).

Those details on which the Gospels agree seem sufficient to explain John's highly privileged place in the Christian narrative. He was an ascetic preaching in the desert who prepared the way for Jesus, gave witness to him when he came, and eventually was martyred for his outspoken convictions. It is implicit in Mark and Matthew and explicit in Luke and John that he "was sent from God" (John 1 : 6) as the last of the prophets to predict the coming of the Messiah. Why, then, has John presented himself to artists and writers as a problematic character? What is the trouble with John? In narrative terms, three peculiarities (by no means unique in biblical texts but noteworthy nonetheless) stand out in the presentation of John. First are the gaps in plotting the events of his life; second is the unusually high number of negatives and harsh words employed to distinguish him; and third and most important are the efforts made by all the evangelists to disclaim any competitive rivalry with Jesus or, worse, "the general problem of Jesus' subordination to John – at least during some period of Jesus' life."[7]

While it may be true that little is told of the infancy, childhood, and early youth of Jesus, enough information is given in Matthew 1 and Luke 2 to piece together a humble

birth, an infancy in exile, a childhood in a carpenter's family, and an episode of preaching in the Temple while still under the care of his parents. Although Luke provides an elaborate buildup to the birth of John, no infancy, childhood, or youth are shown. A fully grown John suddenly shows up. Mark's Gospel puts it most starkly: "John the Baptizer appeared in the wilderness" (Mark 1 : 4). After relating the genealogy and birth of Jesus, Matthew does the same: "In those days John the Baptist appeared in the wilderness" (Matthew 3 : 1).

Since Jesus is the protagonist of the story, one might simply pass over this neglect of John's early life as insignificant. However, Church commentators have not ignored the gap. In a homily still read on June 24, the Feast of the Birthday of John the Baptist, Saint Ambrose finds meaning in this lack:

> There is nothing said about his infancy because he did not know the drawbacks of infancy. And so in the Gospel we read nothing about him except his origin, the prophecy concerning him, his leaping in the womb, his voice in the desert. For he had no experience of infancy, he who passed up nature and age while he was still in his mother's womb and started right out with "the mature measure of the fullness of Christ."[8]

According to Ambrose, what might appear to some as a narrative lapse is in fact a sign of John's unique role in the history of salvation. John's infancy is not related because he seems not to have had one. What Ambrose means by "the drawbacks of infancy" (*infantiae impedimenta*) is not entirely clear, but the implication is that John, unlike Ambrose's disciple Augustine, did not experience the temptations and pitfalls of childhood and adolescence. Yet neither the Gospel lacunae nor the commentary of Ambrose stopped artists from depicting scenes from the apocryphal legends about John's early days. Some of the most charming and famous paintings of the Madonna and Child include the infant John the Baptist in the intimate company of Mary and the Baby Jesus whom, according to legend, he encountered on their way to and from Egypt.

The Baptist as a child is rarely depicted in paintings before the fourteenth century when stories from the East eventually made their influence felt, especially in Florence, whose patron saint was John. It is tempting to say that Renaissance artists pictured a little Baptist because they began to like painting babies and young boys. There are better reasons. A growing number of stories about John's childhood and adolescence, not an arbitrary interest in youthful anatomy, prompted painters to imagine the young Baptist. "Renaissance artists were not in the habit of introducing new representational forms casually and without a basis in tradition."[9]

In an original and mysterious composition, the *Virgin of the Rocks* (fig. 21), Leonardo da Vinci leaves the viewer momentarily uncertain about which is the infant Baptist and which the Messiah, since the slightly older child, with hands clasped in prayer (John), is caressed by Mary while the younger infant (Jesus) sits apart blessing his cousin and the

angel Gabriel points not to the little Messiah but to the infant Precursor. The painting was commissioned in Milan by the newly established Franciscan Confraternity of the Immaculate Conception to celebrate, after considerable controversy over the nature of the Virgin's sinlessness, the declaration by Pope Sixtus IV establishing a feast day on February 28 in honor of the Immaculate Conception of the Virgin Mary. Leonardo depicts the Repose on the Return from Egypt in which, according to legend, the young John the Baptist met the Holy Family on their journey back to the Holy Land.[10]

Leonardo's painting did little to calm the controversies that preceded his work. Some must have wondered where Joseph was and why John, who was supposed to be wandering alone in the desert, was still an infant. More seriously, the Franciscans did not like the fact that Gabriel is shown pointing to the Baptist rather than to Jesus. They refused to pay for this version in favor of a later one (now in London) in which that angelic gesture is eliminated. There are other peculiarities in the scene. The dark angular rocks are evocative of the rocks that were said to split at the Crucifixion or, for Franciscans, a reminder of the rocks at La Verna where Francis received the Stigmata. In any case, they are a strange, chilling backdrop to what otherwise looks like a family picnic. The naked babies must be cold and uncomfortable. Indeed, the warm circle of figures, despite their benign gazes, is oddly frozen and fractured. The arms and hands of the Virgin and the angel seem disconnected from their bodies. Furthermore, John and Jesus are in a peculiar relation to one another. True, John folds his hands in prayer and Jesus blesses him, but John looks down at the infant Savior while the Messiah looks up at his older cousin. The scene is composed of contraries: brilliant light and gloom, soft complexions and hard rocks, warmth and an airless chill, a loving group gathered together and yet separated by strange breaks in their links to one another. Mary, the central figure in the painting, tenderly brings the infants under her protection, but she does not raise Jesus, lower John, or close the considerable gap between them. Even in infancy, John seems to have caused some artists to wonder about him and his role in the life of Jesus.

Naked babies, even in cold places, were not altogether unknown in a culture that loved cherubs and roly-poly *putti* capable of inserting themselves into unlikely locations. Naked boys were something else. The young David became a favorite model in Renaissance representations of biblical heroes. Given the stories of his facing Goliath with a slingshot and no armor or dancing before the Ark in nothing but an ephod, this makes sense, but John the Baptist? Despite "having had no youth," he became another tender favorite. A legend that may have encouraged this tells that the boy hermit was wandering in the desert one day when all his clothes fell off and he stumbled on a camel skin with which to cover himself.[11]

John's interlude between outfits might have been brief, but it was irresistible to some artists. In some ways, Domenico Veneziano's boy Baptist (fig. 22) is as disconnected from his scriptural function as prophet and baptizer as is Leonardo's baby John in a dark cave. Both figures are recognizable but oddly displaced, unfinished, not quite yet what they are

21 Leonardo da Vinci, *Virgin of the Rocks*, 1483, Louvre, Paris.

22 Domenico Veneziano, *Saint John the Baptist in the Desert*, c. 1445.
National Gallery of Art, Washington, D.C.

supposed to become. Veneziano's Baptist is not preaching or baptizing. Innocent, unscathed, alone, and naked in a cold desert that looks like a glacial moonscape, he is changing costumes, as though on the verge of taking on his role in the story of salvation. A question that naturally arises is what exactly young John did behind the scenes while waiting to come on stage.

It is just the kind of question Michelangelo Merisi da Caravaggio loved. If the infant John of extra-biblical fiction appealed to Leonardo's predisposition to ambivalence, the idea of John as a prepubescent youth evidently reveling in *infantiae impedimenta* captivated Caravaggio, who returned to the subject again and again. In a surprising and appealing departure from the biblical narratives and from conventional iconography, the artist shows an adolescent John in a pose like that of his Narcissus absorbed in his own reflection (fig. 23). The young John is leaning down to drink at what appears to be a natural source. Instead of baptizing Jesus or penitents, Caravaggio's John is satisfying his thirst while his

23 Caravaggio, *John the Baptist at the Well*, 1604,
Collezione Bonella, Malta.

Christian "signature," the cross-staff, lies like a support under his hands. Is this just Car-
avaggio making use of a sacred figure for his own irreverent purposes? Or is this a more
interesting and complex conflation of physical desire, the thirst that everyone can feel,
with the kind of spiritual thirst of which Jesus speaks to the woman at the well in John
4 : 1 3–14: "Jesus said to her, 'Everyone who drinks of this water will be thirsty again, but
those who drink of the water that I will give them will never be thirsty. The water that I
will give will become in them a spring of water gushing up to eternal life.'" As often with
Caravaggio, neither reading rules out the other. In fact, though this painting imagines a
scene not specifically described in the New Testament, it is faithful to the way in which
scripture repeatedly unites the needs of body and spirit, as when the Israelites hunger and
thirst in the desert or the deer in Psalm 42 "longs for running water."

 An even more provocative and controversial portrait of John by Caravaggio shows a
somewhat younger child, perhaps eleven or twelve, on the cusp between boyhood and

youth (fig. 24). Half-lounging, half-crouching, like a nymph on a Baroque fountain or a diminutive version of one of Michelangelo's *ignudi* in the Sistine Chapel, the nude figure is half-turned toward the viewer revealing his genitals and a friendly (some would say flirtatious) smile. With his right arm, the boy is embracing not a little lamb but a fully grown ram with prominent curved horns which seems about to kiss him. Whatever might have passed for a wardrobe – gracefully draped red and white cloths and a soft swath of something that looks more like rabbit fur than camel skin – serves as a cover for the object (rock or bench?) on which the child is seated. Perhaps more than any other painting of the Baptist, this looks like a posed studio piece, a glowing display of youthful flesh against a velvety dark background. This is not unusual in the works of Caravaggio but why did he choose John the Baptist, the saint without a childhood and without sin, for this enticing, beautiful, and slightly naughty portrait of a boy who seems to have been caught doing something he should not have been doing? Scholars have long debated the identity of the child in this provocative painting. The Baptist is associated with a lamb, not a lusty-looking ram. Perhaps the figure is meant to be Isaac or David or Paris or a young shepherd (*pastor friso*) or none of the above but simply a boy prostitute Caravaggio found on the street.[12]

It is fitting that the identity of Caravaggio's boy with a ram should remain in question. Whenever John the Baptist seems about to be pinned down, he eludes precise and fixed classification. Since Mary and Elizabeth were related it does not seem far-fetched to imagine that Jesus and John might have known one another as children and even been playmates. In all Gospel accounts, John's unique status is based on his instant recognition of Jesus at the river. Yet, in Matthew 11 : 2–3, when John is imprisoned, "he sent word by his disciples and said to him, 'Are you the one who is to come, or are we to wait for another?' " This seems a strange question from the preacher who in John's Gospel (1 : 29) not only singles Jesus out when he approaches him across the Jordan but proclaims him to be "the lamb of God who takes away the sin of the world." Did the Baptizer forget the baptism, did the cousins have a falling out or did the evangelists get things mixed up?

Further, there are the intriguing but sparse details of John's beheading at the behest of the unnamed daughter of Herodias. Herod himself seems reluctant to order such a heinous act though it is he who has been singled out for condemnation by the Baptist. Why are the women more upset than he? Why the daughter? Why the dance? Why the platter? Little wonder that legends and paintings, well before Wilde's play, grew up around this strange and intriguing episode told with so few details. The man who did not suffer the "drawbacks" of infancy and adolescence seems to have had a powerful effect on people. What was the source of his attraction or repulsion?

Then there are the various negatives associated with the Baptist. As seen, in the Gospel of John he denies that he is the Messiah, Elijah, or the prophet. One of the first things Gabriel tells Zachariah in Luke is that his son "must never drink wine or strong drink" (Luke 1 : 15). Perhaps this prohibition is a sign of John's uprightness and sobriety, an indication that his prophecies will not be the ranting of a drunkard, but Zachariah is not con-

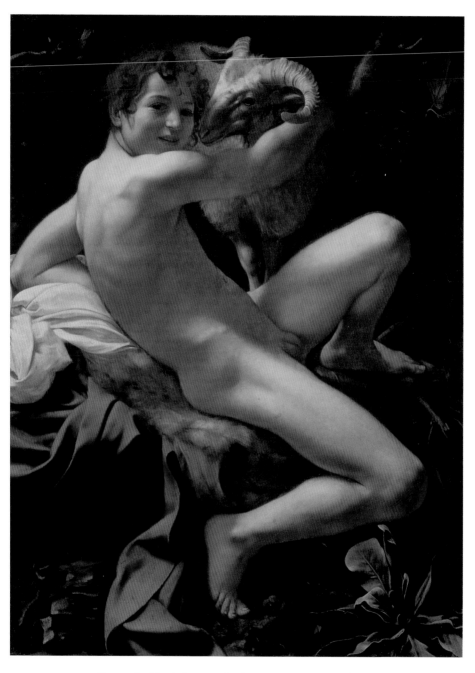

24 Caravaggio, *John the Baptist with a Ram*, 1602, Museo Capitolino, Rome.

vinced that in their old age he and Elizabeth will become parents of anyone, sober or otherwise. For his skepticism, he is punished: "But now," says Gabriel, "because you did not believe my words . . . you will become mute, unable to speak" (Luke 1 : 20). At the birth and naming of John, Zachariah's speech is restored and he blesses his son with beautiful and gentle words: "And you, child, will be called the prophet of the Most High: for you will go before the Lord to prepare his ways" (Luke 1 : 76). However, in both Luke and Matthew, John's own words are anything but gentle: "You brood of vipers! . . . Do not begin to say to yourselves, 'We have Abraham as our father' . . . Even now the ax is lying at the root of the trees . . . One who is more powerful than I is coming; I am not worthy to untie the thong of his sandals . . . His winnowing fork is in his hands, to clear his threshing floor, and to gather the wheat into his granary; but the chaff he will burn with unquenchable fire" (Luke 3 : 7–13). John's menacing words are part of a prophetic convention. He quotes Isaiah, then denies that he is Elijah, though Jesus says to his followers, "If you are willing to accept it, he is Elijah who is to come" (Luke 11 : 14).

Somehow John's identity in the Gospels keeps coming in and out of focus, alternating between a powerful individual with a strong voice of his own and a mere echo of a long prophetic tradition, a humble "unworthy" friend of the bridegroom and a passionate rival with a righteous anger and asceticism greater than those of Jesus. Each Gospel refers to the fact that John's followers were fasting whereas the disciples of Jesus (and Jesus himself) appeared to enjoy eating and drinking. Jesus speaks of John the Baptist as he does of no other figure: "Truly I tell you, among those born of women no one has risen greater than John the Baptist; yet the least in the kingdom of heaven is greater than he" (Matthew 11 : 11). No sooner does Jesus say something definitive about John than he seems to contradict himself in the next breath. To those listening this may have sounded like confusing praise. Jesus is clearly aware of John's reputation, "For John came neither eating nor drinking, and they say, 'He has a demon'; the Son of Man came eating and drinking, and they say, 'Look a glutton and a drunkard, a friend of tax collectors and sinners'" (Matthew 11 : 18–19).

What does this comparison reveal about John and his relation to Jesus? Is it true, as some have claimed, that "the Gospel writers were engaged in offensive damage control as regards Jesus' relationship with John"?[13] The most common interpretation is that Jesus acknowledges John's prophetic role while insisting that in the kingdom of heaven to which Jesus alone bears witness, John's "greatness" and fasting mean relatively little. In short, there is really no comparison between the two men. In Christocentric terms, this makes sense, though on the level of historical narrative it leaves John on a somewhat uncertain threshold between the wilderness and the kingdom. It seems plain in all of the Gospels that observers of John and Jesus were at times uncertain as to which of the leaders was the greater.

As always, on each of the occasions when he is questioned about John, Jesus praises him as a prophet but also uses the occasion to teach a lesson about the differences between them and their message. The Gospel of John (5 : 32–6) makes the distinction most explicit:

"There is another who testifies on my behalf," says Jesus, "and I know that his testimony to me is true. You sent messengers to John, and he testified to the truth. Not that I accept such human testimony . . . He was a burning and shining lamp, and you were willing to rejoice for a while in his light. But I have a testimony greater than John's.'" John himself is shown to be at pains to disavow anything like equality with Jesus. But even when his intent appears genuinely modest, his syntax and grammar can lead to misunderstanding. "'This is he of whom I said, "After me comes a man who ranks ahead of me because he was before me"'" (John 1 : 30). Like other passages in the Gospels, especially in John, this assertion confounds ordinary sequential chronology. If Jesus is God, he has existed throughout the ages even if, in historical time, John's preaching preceded his. However, a "worldly," common-sense reading of John's words could lead one to conclude that he is confused or even deliberately casting a net of contradictory terms over his listeners.

John attempts once more to clarify his position with respect to Jesus when a dispute arises about baptism. His followers who call him Rabbi, ask about "the one across the Jordan" who is also baptizing. John answers, "You yourselves are my witnesses that I said, 'I am not the Messiah, but I have been sent ahead of him.' He who has the bride is the bridegroom. The friend of the bridegroom, who stands and hears him, rejoices greatly at the bridegroom's voice. For this reason my joy has been fulfilled. He must increase, but I must decrease" (John 3 : 28–30). This certainly should qualify as a definitive answer to the doubts about John's status. If conventional temporal measures do not satisfy, then a quantitative measure (an increase or decrease in stature and numbers of disciples) should finally put all questions to rest. Yet even a statement as apparently plain as this has been open to bizarre and literal interpretation. In *The Golden Legend*, Jacobus de Voragine glossed John's words with a pious observation that also sounds like a sick joke: "Christ's body was heightened on the cross, John's was lessened by a head."[14]

Precisely because John was close to Jesus in age, time, place, circumstance, and, at least for a while, in a popularity that disturbed the religious authorities of the day, he enjoys a special status among the company of saints and yet must be carefully distinguished from the majesty of the Messiah. Not only has John been honored and memorialized from the earliest days of the Church but, as Augustine pointed out, "Apart from the most holy solemnity of commemorating the Savior's birth, the Church keeps the birthday of no other person except that of John the Baptist" ("A Sermon of Saint Augustine," *DO*, II, 1886). In fact, for centuries the Church has kept three occasions to honor John: June 23, the Vigil of his birthday; June 24, his birthday; and August 29, his beheading.

In the hymns, collects, prayers, and homilies recited and sung on these feast days, the titles most commonly given to John link him to Jesus as a prefix is linked to a noun: Herald of Christ (*Praenuntius Christi*); John the Precursor (*Ioannis Praecursoris*); He who goes before Him (*Ipse praeibit ante illum*); Precursor of the Lord (*Praecursor Domini*). Only Mary is more intimately, even physically, connected to Jesus than the one who recognized him while still in the womb and was privileged to baptize him with water. Like a prefix,

he is united to the noun but has no standing apart from the noun. This is clearly the theological point: John was the "lamp" but not the light; the "friend of the bridegroom" but not the groom; the "voice" but not the word. Perhaps quite naturally, this exalted yet subsidiary contingency has left open the way for commentators, artists, and writers to fill in the biographical gaps, to imagine John at polar extremes, as a physical being, a subject in his own right, a body momentarily detached from the Savior, a beautiful adolescent, a wild man of the desert, a rugged specimen, or, in sharp contrast, to treat him as if he were a mere annex, a figure of speech, a personification of a prophetic tradition, a voice with a shrunken body or no body at all.

Tintoretto, master of dark, glowing, and barely visible space, imagines a Baptism of Jesus in which the Baptist is almost lost in the gloom, while Jesus, the light of the world, radiates from the shadows (fig. 25). Following the symbolism of the Gospel of John, Tintoretto lets the Baptist fade as the Savior shines, "decrease" as Jesus "increases." In the diagonal from the figure of the Baptist through Jesus to the nursing woman at the lower right, the viewer can trace a line from the shadowy prophet through the Giver of Life, to new life; visually, from darkness through light to light.

As always, Augustine saw the problem and the opportunity to have it both ways, to interpret John allegorically without questioning his historical existence. In his homily read on the Feast of the Birthday of the Baptist, Augustine praises the man but accentuates John's role as a type rather than an individual: "John was a figure of the Old Testament and in his form he represented the Law" (*Ioannes autem figura fuit veteris Testamenti, et in se formam praetulit legis*). "John heralded the Savior as the Law preceded grace" (*Ioannes praenunciavit Salvatorem, sicut lex gratiam praecurrit*; *DO*, II, 1887). Even as Augustine brilliantly shows John to be an allegorical and transitional figure, a link between the Old and New Covenants, the ancient prophets and the Messiah, he highlights the need to explain this enigmatic figure, to find an appropriate framework for his unique position in the Gospels. Yet, if in Augustine there is an eagerness, perhaps an anxiety, about tying John down to a single dominant concept (the Law), there is an equally powerful tendency in other commentators to multiply John's titles until they spill over one another in a profusion of glorious but imprecise qualities. In a famous sermon the golden-tongued John Chrysostom calls the Baptist:

> school of virtues, the guide of life, the model of holiness, the norm of justice, the mirror of virginity, the stamp of modesty, the exemplar of chastity, the road of repentance, the pardon of sinners, the discipline of faith – John, greater than man, equal of angels, sum of the Law, sanction of the Gospel, voice of the apostles, silence of the prophets, lantern of the world, forerunner of the judge, center of the whole Trinity. (*GL*, II, 134)

Such a list seems excessive even within conventions of laudatory rhetoric. It overwhelms the person with praise, smothers the man with depersonalizing metaphors of a collective

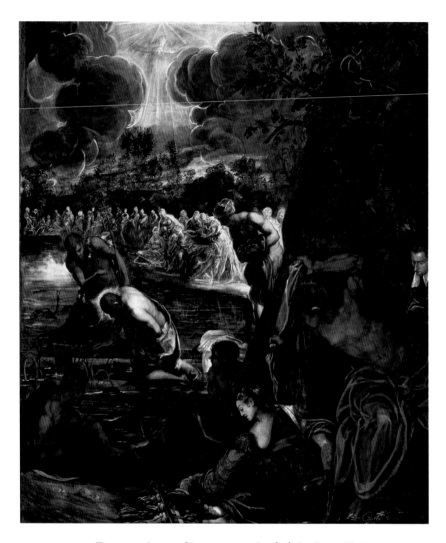

25 Tintoretto, *Baptism of Jesus*, 1579–81, Scuola di San Rocco, Venice.

and representative nature, virtually inundates the name of the Baptist with a baptism that resembles a flood. Surely no individual can be located within such an encyclopedic array. As if "school," "mirror," and "road" were not enough to obliterate the features of an actual human being, Chrysostom concludes his panegyric by calling John the "center of the whole Trinity." Since it would have been unthinkable, not to say arithmetically impossible, to suggest that the Baptist is somehow a fourth member of the Trinity, one is left imagining him as a cipher, the empty space within a closed triangle. Chrysostom's titles do not add up. They cancel one another out and extinguish any effort to picture John as a flesh and blood man.

In the thirteenth century, Jacobus de Voragine began his own commentary on the life of John with a list of titles. Although based more closely on scripture than Chrysostom's praises, these too present a diffuse though not unfamiliar mosaic of the saint as "prophet, friend of the bridegroom, lamp, angel, voice, Elijah, baptizer of the Savior, herald of the Judge, and forerunner of the King" (*GL*, 1, 328). Not surprisingly, the proliferation of John's attributes and roles has not been confined to theologians, storytellers, and painters. Historians since the eighteenth century have variously identified John not only as an ascetic and a prophet but also as a revolutionary and romantic.[15]

It seems that the more that is said about John the less clearly one can see him. The more he is praised and honored, the less visible he becomes as a person. Ambrose turns the man into a prefix, Augustine makes him a metaphor (*figura*), and John Chrysostom drowns him in a compendium of abstract virtues. If in Jesus the "Word was made flesh" (John 1 : 14), in the case of John, it often looks as though the flesh has been made into words which try simultaneously to connect him to and separate him from his incarnate Lord.

One more linguistic device that serves both to elevate John's status and reduce him to a single function is metonymy. He refers to himself as "a voice crying in the wilderness," thereby placing himself in the company of Isaiah and the prophets of the Old Testament while detaching his prophetic role from his physical presence. Like Camus's Jean-Baptiste, he seems to be "here without being here," a sound heard in the desert, an echo, a prefatory remark. John Chrysostom observes, "John was the voice itself, and by as much as the voice is close to the word (yet is not the word), by so much was John closer to Christ yet was not Christ" (*GL*, 1, 330). The old anxiety seen in the Gospels about presenting John's proximity to Jesus, without confusing him with Jesus, is still in evidence.

The parsing of John the Baptist has not been restricted to the symbolic. His head, as well as his voice, was separated from his body. Nothing could so literally (or gruesomely) have deprived him of a clear identity. No wonder that Wilde and Beardsley saw his decapitation as a rape, a castration, an unmanning, that left the severed mask all the more haunting and terrifying. Once again, Caravaggio reflects the strangeness of the biblical narrative by showing the Christ-like face of the Baptist's severed head as if caught in the middle of a question (fig. 26). Salome and the others in the scene appear disgusted and saddened by what they have done. A scene of grotesque horror is made oddly still and mournful, as though even in degradation (or especially in degradation) the Baptist has foretold the story and agony of the Lord.

Less familiar and much more peculiar than the "voice" or head as a metonymic association with John the Baptist is one that reduces him to a direction-finder or road-signal. Given his recognition of Jesus as the Messiah when he approached him on the banks of the Jordan, a tradition grew up that John actually pointed Jesus out in the crowd. In the responsorial prayer read on the Feast of the Baptist's birth, it is written "and he pointed out the Lamb of God; and enlightened the minds of men" (*DO*, II, 1888). Voragine explains that of the nine "privileges" enjoyed by John, three are extra-biblical: "The mother of the

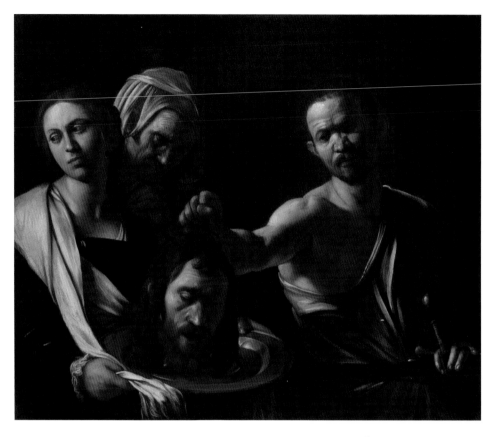

26 Caravaggio, *Salome with the Head of John the Baptist*, 1607, National Gallery, London.

Lord lifted him from the earth; he pointed out Christ with his finger; he foretold Christ's coming to the souls in Limbo" (*GL*, I, 330).

Identifying John as the one who "pointed out" Christ seems innocent, appropriate, and, in comparison with some other things that have been said about him, quite clear in meaning. Nevertheless, as the veneration of relics became an obsession in the early centuries of Christianity, rumors began to spread concerning the whereabouts of John's head and finger (the rest of his bones supposedly having been burned and scattered). Granted, John was not the only saint whose body parts became objects of what now seems a gruesome literal-mindedness in circumscribing the sacred. Still, reducing the "friend of the bridegroom" to a finger seems a peculiarly belittling and grotesque humiliation. Voragine reports with apparent relish that a holy woman of France who had a special devotion to the Baptist fasted and prayed until one day "she saw a wonderfully shining thumb lying on the altar" (*GL*, II, 139). As if that were not bad enough, "In no time, three bishops were present, each wanting a piece of the thumb." It seems that at last the Baptist, despite all

27–9 Details of John the Baptist. LEFT: Masaccio, *Saint Jerome and Saint John the Baptist*, 1428, National Gallery, London; CENTER: Veneziano, *Madonna and Child with Saints*, 1445, Galleria degli Uffizi, Florence; RIGHT: Raphael, *Madonna and Child* (Ansidei Altarpiece), 1505, National Gallery, London.

efforts to honor his memory, had been fetishized, trivialized, and diminished beyond all recognition (figs. 27–9). Voragine speaks of his finger being "translated" from monastery to church, from Milan to the Alps to Normandy. Indeed, John seems to have been translated from a prophetic, disruptive, potent presence to a digit.

No translation is final, however. Devotion to John did not stop with the disappearance of his head or the appearance of a relic. Perhaps he continued to appeal to all second fiddles, to the bridesmaids who never became brides, to the angry misfits howling in the wind, to loners who preferred the wilderness to the city. He certainly appealed to artists in the late Middle Ages and, especially, to those of the High Renaissance. Indeed, it could be argued that many of the variations in depicting John in fifteenth- and sixteenth-century Italian art owe as much to an increasingly humanistic appreciation of the human form and, specifically, to the immense influence of Michelangelo on representations of the male body as to John's sometimes mysterious and ambiguous role in scripture and Christian legend. It is certainly true that Titian and Caravaggio, not to mention Pellegrino Tibaldi, were all responding to Michelangelo as well as to John the Baptist.

Two obviously Michelangelesque paintings reveal how much liberty artists in the humanist tradition continued to take in imagining the Baptist, using him as a personifi-

30 Pordenone, *Blessed Lorenzo Giustiniani and Saints*, c. 1520,
Gallerie dell'Accademia, Venice.

cation of contrasting, even opposite, traits. Both paintings depict John as a sexual as well
as religious figure, a creature of beautiful features and form. Both also refer to John as
the one who pointed, showing an extended forefinger (not thumb) with phallic as well
as prophetic implications. In an altarpiece, the *Blessed Lorenzo Giustiniani and Saints*, Gio-
vanni Antonio de' Sacchis, known as Pordenone (1483–1539), places John to the right of
a narrow but crowded scene (fig. 30). Although Blessed Lorenzo is ostensibly at the center

of the composition, he is, in fact, neither at the actual nor figurative center. John the Baptist dominates the painting by virtue of his size, posture, his highlighted almost nude body, and his unmistakable resemblance to conventional representations of the bearded Jesus. John holds a book and a lamb in his left hand and points with the index finger of his right hand not at the lamb but at or just beyond the right ear of a kneeling Saint Francis whose adoration of the lamb looks much like adoration of the Baptist. Bernardino da Siena glares out from behind John. To the left, a somewhat recessed Saint Louis of Toulouse in bishop's robes points over Francis's head toward John.

One might say that Pordenone is doing what painters, especially Mannerist painters, often did with religious subjects. In an *ostentatio artis*,[16] he takes them out of their original narrative context and reassembles them in a way that would please him and his patrons. Still, most of the figures look as they are supposed to look. The diminutive bishop (Louis of Toulouse) in his mitre is clearly a bishop; the kneeling Francis in his tonsure and brown robe is clearly a friar; the bald figure in the rear scowling at the viewer is clearly the fiery Bernardino da Siena; whereas John, Apollonian in body, Herculean in triumphant pose, Christ-like in solemn demeanor, is several things at once. He gathers the whole scene to himself while Blessed Lorenzo, edged out of the center and raising his hand in stiff benediction (as if unsuccessfully trying to attract the viewer's attention), is ignored by all but two of the figures. Fingers point in all directions but the painter points to John: bold, masculine, magnetic, an uncanny, almost shocking, double of the risen Savior, especially the statue of the Risen Christ by Michelangelo in Santa Maria sopra Minerva in Rome.[17]

If Pordenone took liberties with John the Baptist by imagining him as a healthy, athletic Herculean Jesus, Leonardo da Vinci went to another extreme in what is thought to be his last painting (fig. 31). His Baptist, derived from an earlier depiction of Bacchus and possibly also influenced by Michelangelo – not by a statue of Jesus but by the Bargello statue of Bacchus[18] – is a soft, coy, effeminate figure smiling with head cocked in what appears to be an invitation or challenge to the viewer. His left hand holds up his camel-skin in a delicate gesture resembling that of a woman arranging her negligee. His right hand and index finger are raised as if to heaven or simply as a flamboyant display of a smooth, unmuscled limb. Perhaps even more than the *Mona Lisa*, this painting is a constellation of ambiguities, of reverence and irreverence, of mirth and sorrow, of youth and age, the warm and the cold, the feminine and masculine. His milieu is not the rough wilderness but the soft night. Art historians have called particular attention to Leonardo's use of shadow and light. One suggests that the dark background "demands of the viewer a more active participation in the functioning" of the picture. Another makes a convincing argument that the strange light on the figure is an allusion to John 1: "There was a man sent from God who came to bear witness to the light . . . but was not the light." John is pointing to the heavenly source of the light, thus the figure "which has a disturbingly erotic charge, nonetheless conveys a spiritual meaning."[19]

31 Leonardo da Vinci, *John the Baptist*, 1517, Louvre, Paris.

The painting has had a notoriously hypnotic effect on viewers, some of whom have found it threatening as well as seductive. In a typical mood of transgressive and vaguely muted delight, Walter Pater referred to the "delicate brown flesh and woman's hair no one would go out into the wilderness to seek, and whose treacherous smile would have

us understand something far beyond the outward gesture or circumstance."[20] Serge Bramly recalls Michelet's reaction: "This canvas attracts me, overwhelms me, absorbs me; I go toward it in spite of myself, like the bird toward the snake."[21] Commentators have explained the Bacchus connection not simply as a quirk of Leonardo's but as an example of the humanistic attempt to reconcile Christianity with paganism, as in Pierre Bersuire's *Ovid Moralized* (1509). Since Bacchus was killed and resurrected, he was compared to Christ; because he wandered in the desert, he was compared to the Baptist. Still, that the saint whose father was told by an angel that his son should "drink no wine or strong drink" would appear in the guise of Bacchus seems a gross perversion more than a minor humanist irony.

It turns out that Leonardo or someone pretending to be Leonardo carried the strained association between Bacchus and John the Baptist even further than his final painting suggests. In a drawing, *The Angel Incarnate* (fig. 32), brought to light in the 1990s in a private collection, Leonardo (or, more likely, a pseudo-Leonardo) provides one more link between an earlier Bacchus and the final painting of the Baptist. The tilt of the head, the smile, the long ringlets are similar to those of the later work, but in this sketch the androgyny of the figure is made shockingly explicit. A woman's breast is exposed by the left hand delicately pulling back a thin garment and the phallic potential of the raised arm and pointing finger is reinforced by a fully exposed and erect penis, which may have been added later by still another artist. However it happened, this angelic precursor to the Precursor is not simply an effeminate male but a hermaphrodite.[22]

Even if one discounts the authenticity of *The Angel Incarnate*, Leonardo's beautifully ambiguous transformation of Bacchus into the Louvre *Baptist* can itself be attributed to Leonardo being the familiar provocative, original, mysterious artist, as ambivalent about sexuality and religion as he was about life and art. Yet one comes back to the question originally posed: why John the Baptist? He was the forerunner, the baptizer, the friend of the bridegroom. He became the much revered patron of Florence. Everybody, possibly even the terrible Salome, seems to have loved him.

In Christian iconography and tradition, no one, except Mary, John the Evangelist and Mary Magdalene, is closer to Jesus than John, yet virtually every narrative, from the Gospels to later legends, hints at a "tension"[23] in their relationship and the potential "threat" that John posed to the authority of Jesus.[24] Furthermore, the Baptist, traditionally considered the "first" (after Mary) of Christian saints, was not a typical New Testament Christian since he did not live to see Jesus crucified and risen nor was he ever numbered among the disciples of Jesus. It seems to have been John's lot to be double but not duplicitous; not quite this, not quite that; some of both – Jew and Christian, rival and friend, Elijah and Bacchus, Isaiah and Narcissus, diva and doorman. In describing Pellegrino Tibaldi's fresco of a body hurtling through space in the *Annunciation of the Birth of John the Baptist* (see fig. 15), one art historian exclaims as if still surprised: "The bearded, flying `ure is not an angel, but John himself."[25]

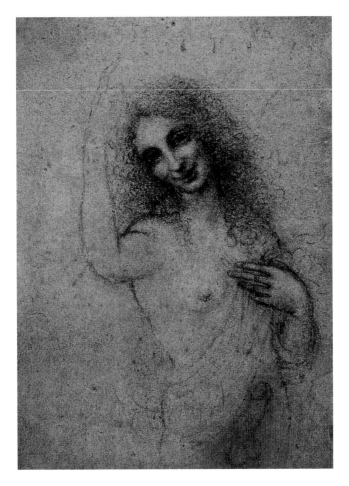

32 ?Leonardo da Vinci, *The Angel Incarnate*, *c.* 1516,
private collection.

How could artists help but love such a versatile, evasive, and malleable model? In paint-
ings as in the Gospels, John's identity is often open to question. One has to look twice
(at least) to be sure that he is not Jesus or a Greek god or an angel. He foreshadows and
resembles, but he is not the one who is expected. He steps up and then steps aside. In
short, he is the epitome, the symbol, and personification of a great one whose destiny it
is to be displaced. As such he was for Leonardo as he was for Tibaldi, Pordenone, Car-
avaggio, and Titian, Wilde and Camus, mortality's challenge to art and the artist, a desir-
able and fearsome reflection, an inspiration and a source of high anxiety to the stability
and authority of creative genius.

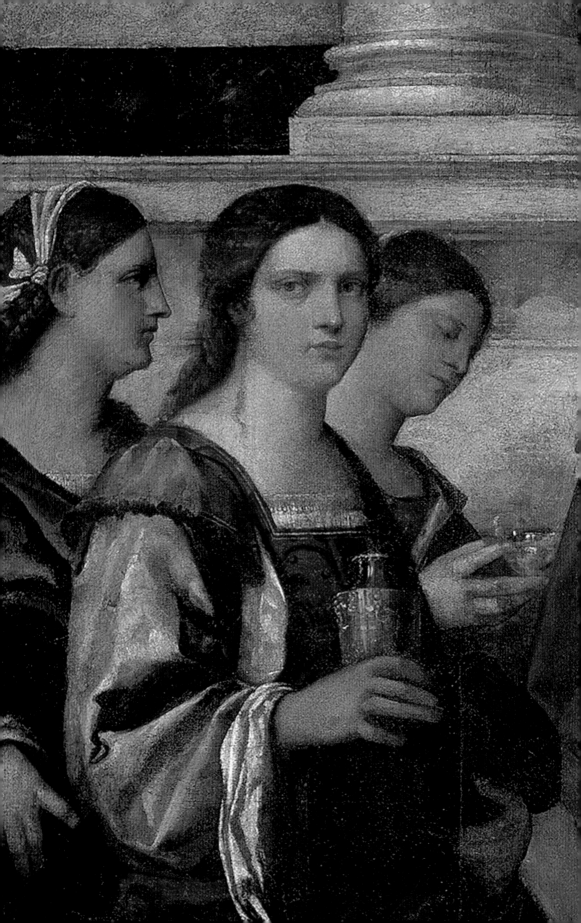

Mary Magdalene

3

RECOVERING
MARY MAGDALENE AND
THE DIGNITY OF WOMAN

APOSTOLA APOSTOLORUM

"If women's language had been so blameworthy and of such small authority, as some men argue, our Lord Jesus Christ would never have deigned to wish that so worthy a mystery as His gracious resurrection be first announced by a woman."

Christine de Pisan

Finding words for Mary Magdalene is a challenge of massive proportions. As Henry James wrote of Venice, "There is notoriously nothing more to be said on the subject. Everyone has been there."[1] Yet Magdalene, like Venice, continues to demand (and deserve) attention. Although it is not the purpose of this chapter to locate her bodily remains, the legendary claims of Ephesus, Saint Baume, and Vézelay, along with more than a dozen other sites where she is said to be buried, can serve as a metaphor and caution. Mary Magdalene seems to be everywhere and nowhere; everyone has an opinion about her; many claim to "possess" (understand) her; few have much certain evidence to support their claims. Artists have had a field day with her. No figure in the Christian pantheon except Jesus, the Virgin Mary, and John the Baptist has inspired, provoked, or confounded the imagination of painters more than the Magdalene. Perhaps the safest thing to say about Mary is that she is "one of the most controversial Christian saints."[2]

It is inevitable that heroic figures of the past will accumulate layers of myth and legend that enfold and cling to the original core of information about their lives. The claims, speculations, and traditions that have been "hung" on Mary Magdalene often resemble in

thickness and length the locks of hair that cover her body like a raccoon coat in certain Medieval and early Renaissance representations. It has been said that she was once a rich woman. It has been said that she was a prostitute. It has been said that she is the same person as Mary of Bethany. It has been said that she bathed the feet of Jesus with her tears and perfumed him with ointment. It has been said that she was married to Jesus. It has been said that she was the bride of John the Evangelist at the wedding in Cana and became so jealous when her groom ran off to follow Jesus that she became a whore. It has been said that she went to Marseilles in a boat and converted the French. It has been said that she lived in a cave for thirty years and was lifted to heaven by angels seven times a day. Where beneath all the heavy and patched up lining is Mary Magdalene? To try to "uncover" her would be rude and impossible but it may be possible, after all that has been said, to recover, with the help of scripture and artists, a believable woman, a person not an icon of sin and penance, a credible human being without so many of the dubious trappings.

She is identified by name eight times in the Gospels. Three evangelists name her as having been present at the Crucifixion (Matthew 27 : 56; Mark 15 : 40; John 19 : 25). All four place her at the tomb of Jesus the morning after his burial (Matthew 28 : 1–10; Mark 16 : 1–8; Luke 24 : 1–12; John 20 : 1–18); Luke names her as cured by Jesus of "seven demons" and as one of the women who supported him materially in his ministry (Luke 8 : 1–3). Her most important moment comes in John 20 : 1–18 when she is not only the first person to see the risen Lord but also has a conversation with him and the attendant angels and John and Peter:

> Early on the first day of the week, while it was still dark, Mary Magdalene came to the tomb and saw that the stone had been removed from the tomb. So she ran and went to Simon Peter and the other disciple, the one whom Jesus loved, and said to them, "They have taken the Lord out of the tomb, and we do not know where they have laid him." Then Peter and the other disciple set out and went toward the tomb . . . The other disciple outran Peter and reached the tomb first. He bent down to look in and saw the linen wrappings . . . Then Simon Peter came and went into the tomb . . . As yet they did not understand the scripture, that he must rise from the dead. Then the disciples went home.

> But Mary stood weeping outside the tomb. As she wept, she bent over to look into the tomb; and she saw two angels in white sitting where the body of Jesus had been lying . . . They said to her, "Woman, why are you weeping?" She said to them, "They have taken away my Lord, and I do not know where they have laid him." When she had said this, she turned around and saw Jesus standing there, but she did not know it was Jesus. Jesus said to her, "Woman, why are you weeping? Whom are you looking for?" Supposing him to be the gardener, she said to him, "Sir, if you have carried him away, tell me where you have laid him, and I will take him away." Jesus said to her, "Mary!" She turned and said to him in Hebrew, "Rabbouni!" (which means Teacher). Jesus said to

her, "Do not hold onto me, because I have not yet ascended to the Father. But go to my brothers and say to them, 'I am ascending to my Father and your Father, to my God and your God.'" Mary Magdalene went and announced to the disciples, "I have seen the Lord"; and she told them that he had said these things to her.

In the Latin Vulgate – the Jerome translation of the Bible, the standard in Western Europe from the fourth through the sixteenth centuries – the words of Jesus are given as *Noli me tangere*, translated into English, including in the King James Version, as "Do not touch me." It is a phrase, like "To be or not to be," made up of simple words with an apparently obvious meaning that has provoked an unending stream of speculation and interpretation from commentators. What did Jesus mean? Why did he say these words to one of his most devoted followers?

The explanation offered by Jesus, that he "has not yet ascended to the Father," still leaves room for questions. Why not a hug from a friend before he goes? Some practical and literal considerations come to mind but there are problems with all of them. Jesus may still be hurting after the scourging and Crucifixion and cannot bear to be touched even gently. Yet in John 20 : 27 he tells Thomas to put his hand in his wounds as proof that he is really there. Perhaps the risen Jesus is an apparition with no body but in Luke 24 : 37 he invites all his disciples, not only Thomas, to "touch" him and feel that he is not a ghost. Perhaps Jesus is in a hurry to go to the Father, but he actually remains on earth for another forty days visiting people. Perhaps Jesus worries, like other rabbis of the day, that the touch of a woman will defile him, but the Jesus of the Gospels is incorruptible. Perhaps Jesus thinks that Mary's passion has gotten the better of her and that her gesture may verge on the indecent, that she is not just saying hello but lunging passionately at him. Yet Jesus spent much of his public ministry with common folk and sinners; why would he be squeamish at this point?

If one adopts the more accurate translation of Jesus' words, "Do not cling to (hold onto) me," the options become somewhat clearer.[3] The fact that he is risen does not mean that he will remain forever in the flesh with his friends and followers. They must see that he has risen bodily from the dead and therefore can raise others, but they must also learn to get along without depending on his physical presence. He still has this lesson to teach and he would like Mary Magdalene to help him by being independent and faithful enough to go without him to the "brothers" and tell them what she has witnessed and what he has said. If one accepts this reading – certainly the one that follows most logically from the context – Jesus chose Mary Magdalene, before all the other disciples, not only to be the first to see him risen from the dead but to act as a teacher to the teachers, apostle to the apostles, *apostola apostolorum*.

Jesus probably often called his friends and followers by name but the evangelists record few such instances. The exceptions are Martha (Luke 10 : 41), Peter (especially Matthew 16 : 18, Luke 2 : 31, John 21 : 15), and Mary Magdalene. If, as seems likely, a direct address by name appears rarely because it is meant to highlight a particular affection and regard,

85

then Jesus' calling Mary by name in the garden outside his tomb is not only touching but historically significant. This moment in John, in addition to the other scriptural evidence based on those occasions when Mary Magdalene is named by the evangelists (as a supporter of Jesus who was healed by him, present at the Crucifixion and the tomb), suggests that she was a loyal and close disciple, an authority by virtue of witness to the most important events in the Christian history of salvation. All four Gospels say that Jesus entrusted her with the news of his Resurrection, telling her to report it to the brothers, though Mark and Luke relate that they did not believe her.

It must have come as a surprise, even a shock, to some of the male disciples that Jesus chose a woman, not one of them, to see him first and bear the astonishing news of his reappearance in the flesh. Yet they should not have been surprised. Jesus spent his public life confounding social and religious expectations by favoring the poor, consorting with sinners, befriending a tax collector, holding up a Samaritan as a model of virtue, refusing to condemn an adulteress, criticizing priests and lawyers. In many ways, he was acting out a principle that runs through the Hebrew scripture when against all the odds God chose Moses, Joseph, and David instead of the more obvious candidates for leadership because "the Lord does not see as mortals see" (I Samuel 16:7).

Clearly, the example of Jesus, who could look through distinctions of class, status, religion, age, and gender, was not easy for his disciples to understand or follow. Time did not make it easier. From the earliest days of Christianity commentators on John 20 have been ingenious in their capacity to ignore or distort the narrative facts in order to produce readings that turn the text, not to mention the teachings of Jesus, to their own purposes. In the fourth century, Ambrose, the Bishop of Milan and teacher of Augustine, explained in a homily that when Jesus told Mary Magdalene not to touch him, he really meant that women should not preach or teach in church:

> So what does *noli me tangere* mean? Do not put your hand on things too great, but go to my brothers, those who are more perfect . . . The Resurrection is not so easily understood except by the perfect; the prerogative of such faith is reserved to those who are most sure. I do not permit women to teach in church; they can ask questions of their husbands at home . . . Why then was Thomas allowed to touch Christ? He did not doubt the resurrection of the dead, but only the nature of the Resurrection.[4]

By placing the "I do not permit" in the first person, Ambrose seems to put words in the mouth of Jesus that Jesus never spoke. Furthermore, Ambrose makes it plain that the faith of the "brothers" is surer and more nearly perfect than that of Magdalene. In the mid-fifth century Pope Leo the Great specified as proof of the Resurrection the "rolled away stone" and the witness of "women and the apostles" but, unlike Jesus, he does not name Mary Magdalene. Without direct reference to *Noli me tangere*, he made an implicit distinction between Mary and the male disciples when he observed that Jesus "allowed himself to be touched with a loving and earnest touch" by those who desired proof of his

physical presence.[5] In the Decretals of 1140, Gratian extended the prohibition of a woman's "touch" by codifying regulations against women handling holy vessels, reading scripture, or serving at the altar during liturgies. Thomas Aquinas observed that Jesus could not have intended Mary Magdalene to preach to the apostles or anyone else since "preaching is not a woman's function."[6] Humbert of the Romans in 1277 gave four reasons why women should not preach, beginning with the assertion that "women lack sense" and concluding with one of the most common guilt-by-association arguments of all time: "Eve taught once and subverted the whole world."[7]

Over the centuries, Mary Magdalene became not only a figure of veneration but also a battleground on which theological and ethical matters of great importance were fought. If Jesus was really a man, might Magdalene have loved him as a man? Might he have desired Magdalene or been married to her? Jesus encouraged his followers to love one another as he had loved them. Did he really mean to include women (and foreigners, strangers, the poor, sinners) as well as, and with the same respect as, his male disciples? Christians have long debated what weight, if any, to give tradition in comparison with the Bible (*sola scriptura*) as the ultimate authority. Is the tradition that Magdalene is the same person as the repentant sinner who bathed the feet of Jesus in her tears (Luke 7:36–50) to be rejected because it cannot be verified by the Gospels? Christians have differed over the relative merits of faith, love, and works. Is the love that Mary felt for Jesus sufficient for her salvation and more efficacious than the works of Martha and the faith of Peter? There is still division over who has the right to preach and serve as ministers of the Gospel. Did Jesus intend that Magdalene preach to and with the apostles or did he fear that her words, like her "touch," would somehow be ill conceived or harmful? Other questions also arose: when Jesus cured Magdalene of "seven demons" (Luke 8:1–3), was he treating an illness like epilepsy or expelling the "seven deadly sins?" Are women more lecherous than men, as the Church Fathers taught, and is lechery the gravest of sins? Did Jesus really come back in the flesh and who actually saw him?

Virtually everyone who has ever had an interest in Jesus and the Gospels has had strong views on one or more of these questions. In a homily in 591, the learned, holy, and influential Pope Gregory the Great spoke for the Church when he established the tradition of the "composite" Magdalene, accepted in the Christian West for more than a thousand years. He placed emphasis not on Mary as a witness and friend of Jesus but on Mary the repentant sinner whose sins were distinctly sexual and feminine:

> We believe that this woman is Luke's female sinner, the woman John calls Mary, and that Mary from whom Mark says seven demons were cast out. And what did these seven devils signify, if not all the vices? . . . It is clear, brothers, that the woman previously used the ointment to perfume her flesh in forbidden acts . . . She had coveted with earthly eyes, but now through penitence these are consumed with tears. She displayed her hair to set off her face, but now her hair dries her tears . . . She turned the mass of her crimes to virtues.[8]

For many commentators and preachers, as apparently for Gregory (who addressed his remarks to "brothers" and to give hope to a Rome beleaguered by disease and corruption), not only was the penitent Mary joined to Mary the disciple and witness, but penitence took over her entire identity until her image became fixed in a permanent state of hysterical self-recrimination and fawning at the feet of Jesus. Susan Haskins has noted in a chapter entitled "The Weeper" that "from the thirteenth century, the penitent Magdalene became the most popular image of the saint in Italy."[9] The very name, Magdalene/Maudlin, came to mean "given to excessive weeping and sentimentality." Representations of the inconsolable penitent extended its reach beyond Italy and the Continent. In the Digby *Mary Magdalene*, an elaborate fifteenth-century English morality play (with forty speaking parts and nineteen locations), Mary weeps and sighs outside the tomb of Jesus: "Alas, I may no longer abide / For the dolor and distress that dwell in my heart." When Jesus appears and calls her by name, she behaves like Gregory's "Luke's female sinner": "Ah! Gracious Master and Lord, you it is that I seek! / Let me anoint you with this sweet balm! / Lord, long have you hidden yourself from me, / But now I will kiss you for my heart is beating!"[10] Little wonder, according to this embellished version of the biblical account, that Jesus recoils, saying, "Touch me not, Mary!" since it seems as though the ever-penitent, over-passionate sinner intends to make a scene.

In 1517 in his treatise *De Maria Magdalena*, the French Dominican Jacques Lefèvre d'Etaples argued against confusing Mary Magdalene with Mary of Bethany or Luke's repentant sinner.[11] Although he insisted that he did not wish to "diminish popular devotion but augment it," he and his scholarship were condemned by Church authorities. Most sixteenth-century Reformation and Counter-Reformation preachers were no more enlightened. They continued to treat (or, more often, dismiss) Mary as a repentant sinner, a weepy female, and unreliable witness. Martin Luther thought that "by themselves, women are absurd and foolish . . . [therefore in presenting Mary and the other women at the tomb] the Evangelist wanted to indicate that the Gospel brings this immense treasure for us, even if we are weak."[12] Luther did not think that Jesus intended Mary Magdalene or any other woman to preach or indeed speak in public: "The Holy Spirit, speaking through Saint Paul, ordained that women should be silent in churches and assemblies . . . What pig-sties could compare in goings on with such churches!" (*LW*, 62).

Ignatius of Loyola must have found the idea of Jesus and an emotional Magdalene alone in the garden altogether too embarrassing. In the *Spiritual Exercises* (1548) he ignores John 20:1–18 and says instead that "Jesus appeared to the Virgin Mary. Though this is not mentioned explicitly in the Scripture it must be considered as stated when Scripture says that He appeared to many others."[13] When Ignatius mentions Magdalene, he does so in reference to Mark 16:1–11, placing her in the company of other women, and then moves on quickly to Peter and Thomas. John Calvin had a clear and simple explanation for *Noli me tangere*; he, like Ignatius, doubted that Mary remained alone at the tomb:

We need not praise the women because they remained at the sepulcher while the disciples returned home; for the latter went home comforted and full of joy, whereas the women indulged themselves in pointless and stupid weeping. What kept them at the tomb was mere superstition, together with the feelings of the flesh . . . Now, since Christ allowed himself to be touched by his disciples, why did he forbid Mary? The answer is easy, if only we remember that Jesus did not repel them until they overdid their desire to touch him . . . The truth is that Jesus did not forbid them to touch him until he saw their stupid and excited desire to keep him here on earth.[14]

By grouping Mary Magdalene with the other women at the tomb of Jesus, male commentators relieved themselves of having to dwell on the intimacy (and possible awkwardness and importance) of a personal and private exchange between the risen Lord and Mary, and they also erased her singularity, identifying her as a stereotypical woman, "weak," "stupid," much given to "weeping" and "the feelings of the flesh."

That such views of women and of Mary Magdalene had been commonplace for centuries is made plain by one of the few known rebuttals by a laywoman in the fifteenth century. Christine de Pisan in *The Book of the City of Ladies* (1405) has Lady Reason respond to the proverb employed by men to "attack" women, "God made women to speak, weep, and sew:"

In answer to those who attack women for their habit of weeping, I tell you that if our Lord Jesus Christ . . . had believed that women's tears come only from weakness and simple-mindedness, the dignity of His most great Highness would never have been so inclined through compassion to shed tears Himself . . . He did not despise the tears of Mary Magdalene, but accepted them and forgave her sins, and through the merit of those tears she is in glory in Heaven.[15]

Although the author is here thinking of Mary as Luke's penitent sinner, she does not forget or dismiss the Mary of John 20 : 1–18:

If women's language had been so blameworthy and of such small authority, as some men argue, our Lord Jesus Christ would never have deigned to wish that so worthy a mystery as His most gracious resurrection be first announced by a woman, just as he commanded the blessed Magdalene, to whom he first appeared on Easter, to report and announce it to His apostles and to Peter, Blessed God, may you be praised, who, among the other infinite boons and favors which You have bestowed upon the feminine sex, desired that woman carry such lofty and worthy news. (Pisan, 28)

In singling out Peter and listing him last, Christine follows John's Gospel but she also implicitly questions the institutional tradition that places Peter as the first and most authoritative bearer of the Good News. While her reading of Magdalene sounds refreshingly clear and just in the twenty-first century, it has to be remembered that though she was a popular author, Christine's voice must have seemed faint and lonely among the

chorus of male preachers and theologians in the fifteenth and sixteenth centuries. Few people had access to a Bible and most people could not have read it if they did. Churchmen were the principal interpreters of scripture.

And, in Italy, artists.

Since Mary Magdalene and especially the scene with Jesus in the garden outside his tomb were fraught with various and contradictory interpretations, it is fascinating to see how painters "read" *Noli me tangere*. In decorating the cells of the Dominican monastery of San Marco in Florence, Fra Angelico and his assistants were particularly attentive to Dominican spirituality, the mystical stages of prayer enumerated in the thirteenth-century *De modus orandi*, and to the status of the occupants of certain corridors. According to William Hood, the cells of the clerics were painted with scenes emphasizing the mystical and meditative aspects of Saint Dominic's life and teaching; the cells of novices, painted with crucifixes, stressed penance; while the cells of lay brothers were less conceptual and more plainly historical in depicting biblical scenes. In Hood's opinion, cell number one, which shows the *Noli me tangere*, designed by Fra Angelico but probably painted by his assistant Benozzo Gozzoli in 1440, was occupied by the friar in charge of the formation and duties of lay brothers (fig. 33).[16]

If Hood is right, this scene is an interesting and curious choice for the friar in charge of those brothers who did the physical work of the community, cleaning, cooking, washing, and repairing. True, Jesus carries a hoe and was mistaken for a gardener. In Fra Angelico's day, the great cloister was probably filled with plants and there was ample space nearby for an orchard and vegetable garden. Jesus could be saying to Mary that he has "work" to do and cannot stop to chat. If so, the artist managed to endow this matter-of-fact moment with a magnificent spiritual serenity. Mary is not weeping or visibly shaken by the sight of Jesus. She kneels in dignified reverence and her gesture is a refined combination of greeting and prayer. She is neither forward nor humble but rather balanced in an attitude of recognition, regard, and self-composure. Despite the fact that his linen wrapping is supposed to have been left in the tomb, Jesus is fully clothed in stainless white robes and the position of his feet suggests that he is already beginning his ascent to heaven. He looks at Mary with regal kindness; his hoe could be a scepter or standard. There is no sign of displeasure or suppressed desire. Indeed, the elegant postures and pleasant exchange of looks suggests a minuet in which each partner knows his and her role. This is not a shocking or disturbing scene in which Mary overreacts but a quiet beginning of a heavenly dance.

Fra Angelico's Magdalene has a halo and a blessed calm. Her sins have been forgiven and, one might even say, in this painting, they have been forgotten. Sixteenth-century artists more often preferred to revisit the penitent sinner and imagine her meeting with Jesus at the tomb in ways that emphasized the physical beauty of the two figures and a dramatic, if momentary, conflict of perspective and intention. In an early painting, Titian displays his great skill in representing the human form expressing emotion (fig. 34). It could hardly be more radically different from the San Marco fresco.

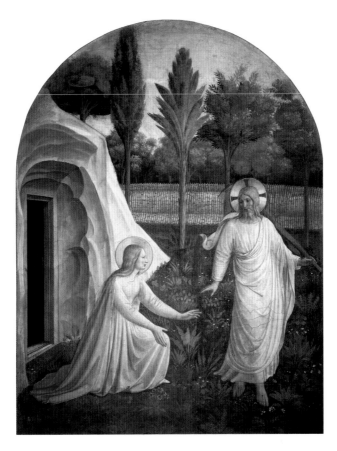

33 Fra Angelico (?Benozzo Gozzoli), *Noli Me Tangere*, 1440,
San Marco, Florence.

Once again, the scene suggests a dance, but here Jesus appears to play the role of the female partner, elegantly curtsying while modestly attempting to cover himself and avoid the touch of the woman kneeling as if she is making a proposal (or proposition). Mary is literally forward in the painting; her expression is imploring; her long hair and gorgeous red cloak are reminders of her former life of luxury. John's Gospel does not specify how or where Mary intended to touch Jesus, but painters cannot avoid the details. Titian leaves little doubt that, whatever her intentions, Mary was coming very close to the Lord's genitals. This is clearly what Titian's Jesus fears, as his gesture indicates. According to the reasoning of Leo Steinberg in *The Sexuality of Christ*, the knot in Jesus' loincloth could be both concealing and revealing an erection.[17] The tree behind Jesus and the position of his hoe support this view, but, whether or not this is the case, the painting lends an obviously erotic element to the episode. Two beautiful figures, one partially undressed, encounter one another alone in a lush and romantic setting.

34 Titian, *Noli Me Tangere*, 1511–12, National Gallery, London.

It would be easy to suppose that Titian has simply taken liberties with the Gospel for his own irreverent and worldly purposes, but to do so would be to apply puritanical standards to the religious sensibility of the period. There is a theological as well as an aesthetic rationale, in keeping with Church teachings about the Incarnation and Resurrection, to the belief that the risen Jesus revealed his full humanity to individuals according to their needs and abilities to "see": to Thomas through touching his wounds, to Peter and John through feeding them breakfast, to Mary Magdalene through exposing enough

35 Agnolo Bronzino, *Noli Me Tangere*, 1561, Louvre, Paris.

(not all) of his male flesh. A moving indication that Titian's painting continues to give hope
for a retrieval of life from the devastation of death is that it was the first work that the
British public voted to have returned to the National Gallery from the Welsh mine where
it had been hidden during the Second World War.[18]

Titian was by no means the last to weave natural human elements – physical beauty and
sexual potential – into an otherwise orthodox conception of the Resurrection as narrated
in the Gospel of John. In one of his last paintings (1561; fig. 35) for an altarpiece in the

Cavalcanti Chapel in the Church of Santo Spirito, Florence, Agnolo Bronzino carries the tendency a step further.[19] Whereas in the Fra Angelico and the Titian, the atmosphere is peaceful and private, the figures relatively calm and dignified, in Bronzino's painting the mood is theatrical, even melodramatic. Both Jesus and Mary Magdalene appear aroused, although in different ways, and they are not alone. There is an audience. Not only are there women and an angel still at the tomb in the background (perhaps representing an earlier moment in the story), but two women also hover near the leading players, gesturing, smiling, and whispering as if spying on and gossiping about the encounter.

True, the figures are twisting and turning in a way reminiscent of Michelangelo, but not everything can be blamed on Michelangelo. In more than one way, the positions of Jesus and Magdalene are the reverse of traditional depictions of the event, including a sketch by Michelangelo. A particularly young and beautiful Jesus approaches from the left (the usual entrance point of Magdalene). His red locks, delicate features, and glowing white skin seem to have borrowed some of the attributes of the repentant sinner with whom he exchanges tender looks. He appears to be running toward, not away from, Magdalene; the odd but graceful twist of his torso suggests a "turning away" that looks very much like a thrusting forward. Mary too is on the run, so much so that if both keep going (as the dynamic of their movement shows they must) they will surely collide. Although Mary's posture and gestures are wild, she is modestly attired in sober colors and her expression is one more of adoration than what Calvin called "stupid excitement."

Jesus, the "gardener" has evidently been a good gardener. He carries a shovel, not a hoe, and from the earth behind the two friends lovely flowers bloom. What could the aged and ailing Bronzino, the Mannerist painter of elegant, solemn, and sometimes stiff portraits of the rich, have been thinking? Elizabeth Pilliod has pointed out that when the picture was in its original setting in Santo Spirito, the spring morning light from a window would have illuminated the body of Christ when mass was being sung so that it would have seemed "to leave the painting to enter theatrically into the nave of the church."[20] Bronzino clearly composed his scene with the architectural and liturgical space in mind. However, as the ironies, ambiguities, and sexual puns (as in "Lo Sdegno" which means both "disdain" and "penis") in his poetry suggest, he was not averse to playful combinations of wit and solemnity, prurience and piety.[21] If the Resurrection means "life" or "new life," why not paint two beautiful young creatures on the verge of climax, on a collision course between passion and reticence, union and separation? As at a wedding, flowers are strewn beneath their feet and guests watch the couple with envy and admiration. In the background even the tomb is "alive" with possibility: on the right is the dark door of the sepulcher leading nowhere and on the left is an arch opening onto the soft and gorgeous hills of a landscape like paradise. Bronzino shows the Resurrection as a scene of questions, opportunities, pleasures, and risks, all in motion, like life, just as the artist or his patron, an old man facing his own death, might have liked to recall it.

36 Lavinia Fontana, *Noli Me Tangere*, 1581, Galleria degli Uffizi, Florence.

Given the readiness of male commentators to read "feminine" attributes – tears, over-excitement, superstition – in Mary Magdalene's behavior at the tomb, it is important to keep in mind not only the views of Christine de Pisan but also the perspective of the most successful and popular woman painter of the Italian Renaissance. Lavinia Fontana studied painting with her father Prospero in Bologna in the 1560s and 70s, supported her husband and children by painting, was invited to Rome by Pope Clement VII, painted portraits and religious scenes, and was the first woman to be invited to membership of the Roman Academy. Like all painters of the period, Lavinia shows the influence of male predecessors, especially Venetians, but her rendition of the *Noli me tangere*, while no radical departure in technique from a version by Correggio (now at the Prado), has several qualities that distinguish it from many others of the period and the preceding century (fig. 36).

Fontana's Jesus actually looks like a gardener. It would not have been "stupid" of her Magdalene to fail to recognize him at first. He wears a big hat and a rustic outfit; he is not young, beautiful, or half-naked. He neither thrusts himself at Mary nor pushes her away. His gesture is one of paternal blessing. Mary kneels like a dutiful daughter; her expression is loving; and her arms are open in surprise and greeting. The figure of Mary is as mature and dignified as that of Jesus. There is nothing wild, disheveled, or hysterical in her appearance. Fontana "expressly permits the viewer to experience the exchange between Christ and the Magdalen from the Magdalen's point of view."[22] She has a halo, and the perfume in her left hand seems more a sign of her identity as a saint than a prop ready for use. The scene has none of the erotic tension of Titian's and Bronzino's paintings. In fact, despite the women at the tomb in the background and the glow of the dawn, the dynamics and uncertainties of narrative are subsumed by an air of serene completion as if the sepia tones wash away all anxieties about the meaning of this meeting. Jesus' extended arm and open hand suggest not only a blessing but a sending forth, a commissioning reminiscent, in pictorial terms, of his command to the apostles to go and preach the gospel. Unlike many painters, Fontana appears not to have forgotten the lines in John 20 in which Jesus bids Mary "to go to the brothers and say to them, 'I am ascending to my Father.'"

In the long and tortured history of attitudes and legends about Mary Magdalene, no apparent contradiction of identities has been greater than that which posits the sobbing, silent, adoring penitent against the respectable and valued friend whom Jesus authorized before all others to speak of his Resurrection. It is possible to put the two pieces together as in *The Golden Legend*, which explains that fourteen years after the death of Jesus, Mary and several friends were put in a rudderless boat that drifted to Marseilles where Mary, "her manner calm, her face serene," preached to the infidels before going off alone to live silently in a cave for the next thirty years. As a narrative of different stages in a life, the sequence is not impossible to imagine. Jesus spent time in the desert as well as teaching in public places; Saint Francis, the tireless preacher, often retreated to the woods to be alone with his close companions; before beginning an active life in Rome and elsewhere, Saint Ignatius of Loyola underwent his conversion in a cave at Manresa. Even the accent on Mary as a penitent sinner, though historically dubious, need not have been altogether false or negative in its effect. As Gregory the Great must have known, her "example" gave hope to countless sinners who regarded themselves as beyond redemption. Like Augustine, another notorious but repentant sinner, Magdalene was a model of Christian conversion and the promise of salvation. In an early wood panel depicting Magdalene and scenes from her life (fig. 37), a small image on the left shows Magdalene and the risen Christ while opposite on the right she is seen preaching; that preaching gesture of Magdalene repeats the *Noli me tangere* (or blessing) gesture of Jesus in the scene on the left; the central figure covered in long hair also raises her hand in blessing in imitation of Christ; she holds a scroll that reads, "Do not despair those of you who are in the habit of sinning;

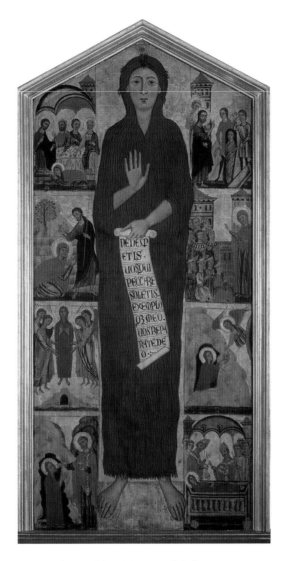

37 The Magdalene Master, *Symbol of Hope*, c. 1280,
Gallerie dell'Accademia, Florence.

follow my example and return to God" (*Ne desperitis vos qui peccare soletis exemploque meo vos reparate Deo*).

Augustine's reputation as a Christian icon provides a telling contrast with that of Mary Magdalene. Everyone knows from *The Confessions* that Augustine lived a reckless youth, burned with lust, and had a mistress before his conversion. Yet, despite Augustine's own protestations, his sinful past pales beside his stature as a bishop, preacher, theologian, Father of the Church. There is no iconography of the young Augustine naked and

disheveled in the fleshpots, no paintings of him – as he describes himself – thrashing about and wailing with remorse. Images of Augustine are most typically of a stately bishop whose soul (and body) have been wiped clean and clothed in the robes of authority. By contrast, though Jesus tells the penitent woman that her sins are forgiven, legends and pictures continued to show Mary with the traces, the taints, the marks of her sin still much in evidence as indelible signs of her identity.

As a woman, Mary Magdalene carried the mark not of Cain but of Eve. Her sin, as understood through the centuries, was integral to her sex. Jesus could forgive her but he could not (or at least he did not) keep her from being a woman and, what was worse, according to legend, an exceedingly beautiful, thus dangerous, woman. Augustine, who may have been a dashing youth, was typically imagined by artists as a mature, bearded, severe, grumpy cleric. In scenes of the Crucifixion or at the tomb of Jesus, Mary Magdalene can be recognized because she is young, blonde and voluptuous, the best looking woman in the picture.

Perhaps the most notorious portrait of any female saint is that which Ruskin called "the disgusting Magdalene of the Pitti Palace . . . stout, red-faced . . . dull, coarse,"[23] the young, buxom Mary painted by Titian between 1530 and 1535 (fig. 38). Discounted as pure sensuality by latter-day Ruskinians, the figure has been defended by several modern scholars as combining innocence with nubility. One critic has gone so far as to suggest that Titian made the saint "as sensuous as possible" to test the chastity of male viewers.[24] Rona Goffen has sought a middle way: "However sensual Titian's Magdalene may seem to modern viewers . . . it is incorrect to deny the saint's – and the Renaissance beholder's – pious emotion."[25] An Italian critic does not see what all the fuss is about since "the nudity of the Magdalene was not a novelty in its time" and, anyway, "*Chi ama e nudo di fronte di Dio e di fronte agli uomini.*" ("Whoever loves is nude before God and before men.")[26] The last word should go to a seventeenth-century French Jesuit who probably never saw Titian's painting: "This woman burns so with the love of God that she cannot bear to wear clothing."[27]

Even in those images, like the famous wooden statue by Donatello (fig. 39), that show Mary as a wraith withering away from fasting, the message is that her beauty was her bane, the cause and emblem of her downfall. It has been argued persuasively that Donatello's Magdalene is an image of "tenacity in the face of adversity," originally placed in a convent that cared for reformed prostitutes, and that it would have given a "message of hope to an audience of women trying to rebuild their lives."[28] Still, whether reflecting on the Magdalene of Titian or the Magdalene of Donatello, the oversexed or unsexed Magdalene, the overfed or underfed form, the voluptuous adolescent or the tenacious survivor, the viewer's attention is made to focus on the female body as synonymous with temptation and fall.

In both representations Mary's hair is shown to be unusually long and it serves as an article, perhaps her only article, of clothing. What is it covering? Presumably, it is cover-

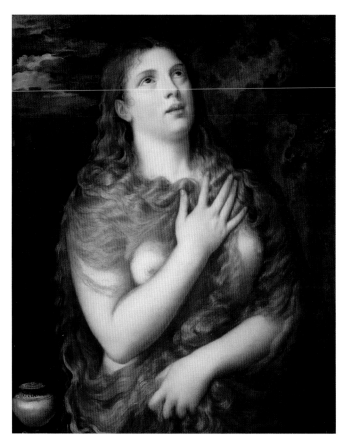 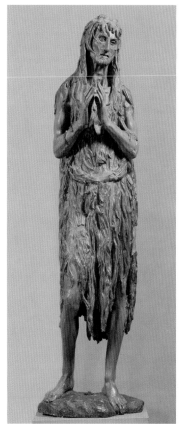

LEFT 38 Titian, *Mary Magdalene*, 1530–5, Palazzo Pitti, Florence.
RIGHT 39 Donatello, *Mary Magdalene*, 1457, Museo dell'Opera del Duomo, Florence.

ing her sin, but, if so, then that sin is synonymous with her body. Still, there is a problem. In the time of Jesus and again in Renaissance Italy, a woman's uncovered and unbound hair was a sign of her sexuality – indeed of her unrestrained sexuality normally to be seen only by her husband. The Mary Magdalene of Donatello and Titian is unable to conceal her womanhood except with another sign of her womanhood. Unlike Augustine, she is incapable of casting off her "old self" and donning a new one. In the same sermon in which he stated that *Noli me tangere* means that women should not preach, Ambrose does not dwell on or even mention Magdalene's particular sinfulness but only her sex:

> Since woman was the author of sin [*sicut in principio mulier auctor culpae*], . . . she was the first to see the Resurrection . . . Jesus calls her "woman." The one who does not believe is woman and thus is called by her bodily sex . . . God does not want only tears, but faith. In reality, she is not looking for Christ because she thinks he has been

taken away . . . Finally he calls her "Maria" – as he would call a disciple by name . . . But her faith is not total so she is not given permission to touch him.[29]

For Ambrose, it hardly matters whether Magdalene was the repentant sinner in Luke. It is enough that she was a woman. Although Augustine confesses to having stolen a neighbor's pears, it is clear that his greater temptation was lust, an expression of his masculinity. Yet the post-conversion Augustine was able to retain "masculine" virtues – vigor, courage, confidence – while putting aside his male sinfulness. Mary Magdalene's sex was not so easily bifurcated. Her self was her sin. It can be argued that Mary Magdalene did not become a great theologian and preacher like Augustine, that there is less to remember about her, and that the beauty and emotion attributed to her made for better stories and pictures than the works of a theologian. However, even these assumptions are questionable. The Gospel of Mary Magdalene, not part of the Christian canon, suggests that she was especially loved by Jesus and preached a complicated Gnostic message that Peter and Andrew did not like. Ironically, the woman who came to be identified with tears tells the male disciples "not to weep or grieve or be in doubt."[30] *The Golden Legend* summarized a long tradition that Mary had not only preached in Marseilles but that she was responsible for the conversion of the whole of Provence. Even the fifteenth-century Digby *Magdalene* morality play includes several scenes of the saint preaching in France, including herself among the apostles:

> All manner of tongues He gave us,
> So that we could understand every language.
> Now the disciples travel to diverse countries
> Here and yonder to preach and teach.[31]

It is understandable that these sources – a Gnostic gospel only recovered in 1896, a morality play, and a popular collection of legends – do not carry the weight of years of Church teaching and biblical commentary. Mary Magdalene weeping, Mary Magdalene kneeling, Mary Magdalene trying to cover her female flesh with her hair were firmly established images of this disciple for centuries. Finally (and remarkably), it was only in 1963 that the Church officially recognized the work of Jacques Lefèvre d'Etaples and later scholars. In the documents of Vatican II, the Feast of Saint Mary Magdalene on July 22 was proclaimed to be in memory "only of the one to whom Christ appeared after the Resurrection and in no sense the sister of Martha or the woman who was a sinner."[32] Is it too late? After all this time, the question remains whether it is or ever has been possible to "recover" a Mary Magdalene not covered in tears and shame, not hiding her woman's body beneath a blanket of hair; to see her instead as a disciple and friend of Christ's, not necessarily married to him or clinging to him but capable of standing up straight and speaking for herself.

As is often the case, in contrast with most theologians and preachers of the past, poets and artists have, here and there, provided clues to an answer that takes the traditions and

legends into account but challenges some of their formulaic and patriarchal assumptions. In a verse of an extraordinarily beautiful hymn still sung in the Easter liturgy, the thirteenth-century French poet and chancellor of Paris, Philippe de Grève, wrote:

> *O Maria, noli flere,*
> *Iam non quaeras alium;*
> *Hortulanus hic est vere . . .*
> *Intra mentis hortum quaere*
> *Mentis operarium . . .*
> *Tecum est,*
> *Quem diligis.*

> O Mary, do not weep;
> Look no further;
> The true Gardener is here . . .
> Seek in your own mind
> The workman of the mind . . .
> He is with you,
> He whom you love.[33]

The idea that Jesus is with Mary – actually within her mind and spirit – allows for a Magdalene no longer broken by sin or frozen in an eternal (or thirty-year) posture of exaggerated penance. In keeping with the symbolism of the garden in John, the Jesus of the hymn returns, as if to Eden, to re-cultivate original innocence. If Mary's mind or soul is that garden, then she represents not only Eve but also Adam and all of fallen nature redeemed by the death and Resurrection of Jesus. To keep her suspended in a limbo of guilt and imperfection, as the Church Fathers and Reformers did, is to doubt the efficacy of the Resurrection, the power of Christ to forgive sin and raise up the sinner with himself.

Like the French poet, some Italian Renaissance painters could see beyond the stereotype to a Magdalene who had stopped crying. In 1466 in a particularly striking fresco in the Church of San Francesco in Arezzo, Piero della Francesca painted a Magdalene of such dignity, grace, and intelligence that, except for the vessel of perfume, she has cast off all the emblems of her shame including her hairshirt, tears, and expression of self-abasement (fig. 40): Piero's Mary stands tall, firm, and calm; her eyes are cast down in peace and modesty, not shame; she holds her head up. There is no sign of "stupid excitement." She is beautifully, but not ostentatiously, clothed in green, the color of hope, white, the color of faith, and red, the color of love.[34] Her form is that of a mature young woman; her hands are strong and her grip firm. The crystal "vessel" could as well be a lantern as a jar, a light that she, like the other disciples, brings to the world. She is not at the foot of the Cross or with Jesus outside the tomb. She stands alone as, of course, she must often have done, and she looks steady on her feet.

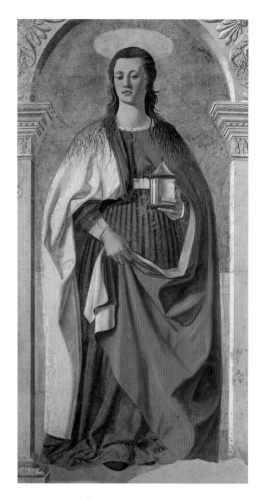

40 Piero della Francesca, *Saint Mary Magdalene*,
1466, San Francesco, Arezzo.

A modern scholar has aptly described Piero's *Magdalene* as having "a monumental grandeur, a priestly venerability" but then added that these attributes are "limited . . . by the profane touch of hair falling over her shoulder."[35] Once again, Mary's hair, the sign of her sex, seems to get in the way of her sanctity. Perhaps this is an accurate historical reading of Piero's intention, but perhaps not. Magdalene's hair in Piero's fresco hides nothing, including itself. Her hair, like her halo, could be another sign of Mary's glory. Centuries after the Greek Gnostic *Pistis Sophia* represented the Magdalene as a kind of "alter ego of Divine Wisdom"[36] and a century before the Counter-Reformation encouraged representations of her as a symbol of the Church Triumphant, Piero imagined, in the middle of the fifteenth century, a dry-eyed, stalwart Magdalene who looks as though she has gotten over saying she is sorry.

This Mary is a woman that could have been an illustration (if the poet could only have seen her) for John Donne's sonnet *To the Lady Magdalen Herbert, of St. Mary Magdalen*:

> Her of your name, whose fair inheritance
> Bethina was, and jointure Magdalo,
> An active faith so highly did advance,
> That she once knew, more than the Church did know,
> The Resurrection; so much good there is
> Deliver'd of her, that some Fathers be
> Loth to believe one woman could do this;
> But think these Magdalens were two or three.
> Increase their number, Lady, and their fame;
> To their devotion add your innocence;
> Take so much of th'example as of the name,
> The latter half; and in some recompense,
> That they did harbour Christ Himself, a guest,
> Harbour these hymns, to His dear Name address'd.[37]

Donne plays with the idea of the two or three Magdalenes in one without accepting or rejecting it. But what is most telling is that he does not single out her sin or penance but her "active faith," the good that was "deliver'd of her," and her privileged knowledge of the Resurrection. For the most part, Donne stays with scripture. He may or may not have been ironical in referring to the male apostles as "the Church," but, given the sectarian strife of his era and his move from the Church of Rome to the Church of England, he had good reason to wonder about competing claims of various "Fathers" on behalf of the "true" Church and the constant battles over who was "in" and who was "out."

Along with Piero's Magdalene and the poems of Donne and Grève, a painting by Sebastiano del Piombo does much to remind the viewer that the Mary of the Gospels might have been, indeed must have been, a person of strong character and conviction, a woman of intense and complex feeling much valued by Jesus (fig. 41). Sebastiano's Mary, like Piero's, stands tall and straight; she is not alone but very much at home in the company of a particularly distinguished group of saints, including John the Baptist, Augustine, John Chrysostom, Agnes, and Catherine. In his 1882 essay on Venice, Henry James recalls seeing Sebastiano's painting in the dimly lit Church of San Giovanni Crisostomo. He refers to the three figures at left as "Venetian ladies" and singles out for special praise, bordering on adoration, the woman in front (obviously Mary Magdalene holding the vessel of perfume):

> The foremost turns her face to the spectator. This face and figure are almost unique among the beautiful things of Venice, and they leave the susceptible observer with the impression of having made, or rather having missed, a strange, a dangerous, but a most valuable, acquaintance. The lady, who is superbly handsome, is the typical Venetian of

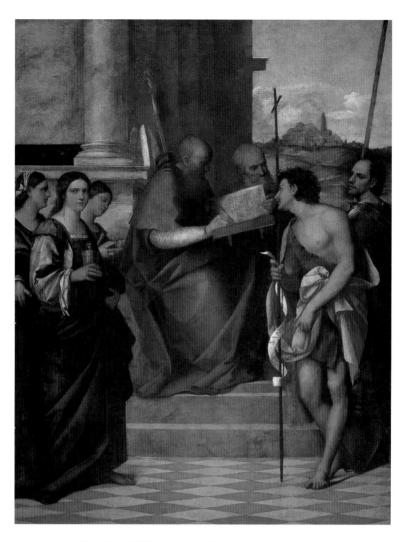

41 Sebastiano del Piombo, *Saint John Chrysostom with Saints*, 1509,
San Giovanni Crisostomo, Venice.

the sixteenth century, and she remains for the mind the perfect flower of that society. Never was there a greater air of breeding, a deeper expression of tranquil superiority. She walks a goddess – as if she trod without sinking the waves of the Adriatic. It is impossible to conceive a more perfect expression of the aristocratic spirit either in its pride or in its benignity. This magnificent creature is so strong and secure that she is gentle, and so quiet that in comparison all minor assumptions of calmness suggest only a vulgar alarm. But for all this there are depths of possible disorder in her light-coloured eye.[38]

It is hard to believe that Henry James did not realize that the figure he so admired was intended as a portrait of Mary Magdalene. Yes, he was right in saying that she was a Venetian lady of the sixteenth century since the model for the picture was surely a woman of that city and time. Perhaps he chose not to notice the Magdalene reference, thinking it an irrelevant distraction. Or perhaps he saw, as he often did in the women of his own fiction, beyond the beautiful surface into depths, strengths, and strange complexities of character unnoticed by less astute and demanding observers. In many ways, it seems appropriate that James would have such extraordinary admiration for and insight into this "lady" while seeming unclear about her identity as Magdalene. After all, it has been Magdalene's fate not simply to have mistaken Jesus for a gardener but to have been "mistaken" again and again throughout centuries as an image of the feminine *in extremis*, a biblical woman on the verge of a nervous breakdown. In looking so carefully and long at Sebastiano's painting, James sees not only an icon of aristocracy or a goddess but also a magnificent woman – gentle, calm, strong, mysterious – "recovered" to life by a small painting in a dark church.

In his aesthete's way, James repeats what Jesus does much more simply and disturbingly in the very passage in Luke 7 in which the woman with the alabaster jar of ointment (often incorrectly identified as Magdalene) bathes the Lord's feet with her tears. When his host, Simon the Pharisee, shows discomfort with Jesus' tolerance of the sinful intruder, Jesus, "turning toward the woman, said to Simon, 'Do you see this woman?'" (Luke 7 : 44). In this scene, Jesus does not turn away from the woman, he turns toward her. He does not say, "this sinner"; he says, "this woman." The woman with the alabaster jar may not be Mary Magdalene, but Jesus here suggests a way to recover Magdalene or any other saint or sinner with a "reputation." He looks at her and, in doing so, he invites his host to look for a person in her.

Painters and poets, like the Church Fathers and Reformers, have had their own agendas, but, at the very least, they have put a human face (with more than one expression) and a body (not always covered with her hair) on their imaginary Magdalene. The woman who remained close to Jesus even at the end of his life, but was forbidden to touch him after the Resurrection, continues to make an impression. In *The Man Who Died*, D. H. Lawrence has Magdalene leave the tomb of the risen Jesus in a Lawrentian confusion of disappointment, "rapture and wonder."[39] In *Jesus Christ Superstar*, Mary Magdalene sings the lament, "I don't know how to love him." Fra Angelico and Titian, Bronzino and Lavinia Fontana, Piero and Sebastiano, Grève, Donne, and James do better. They may not have gotten their "Magdalenes" just right, but they all recover some human dignity, pride, and complexity for a woman who, through no fault of her own, lost her importance as a beloved friend of Jesus and her stature as "apostle to the apostles" – not to mention her virtue – in the eyes of many men and women for centuries.

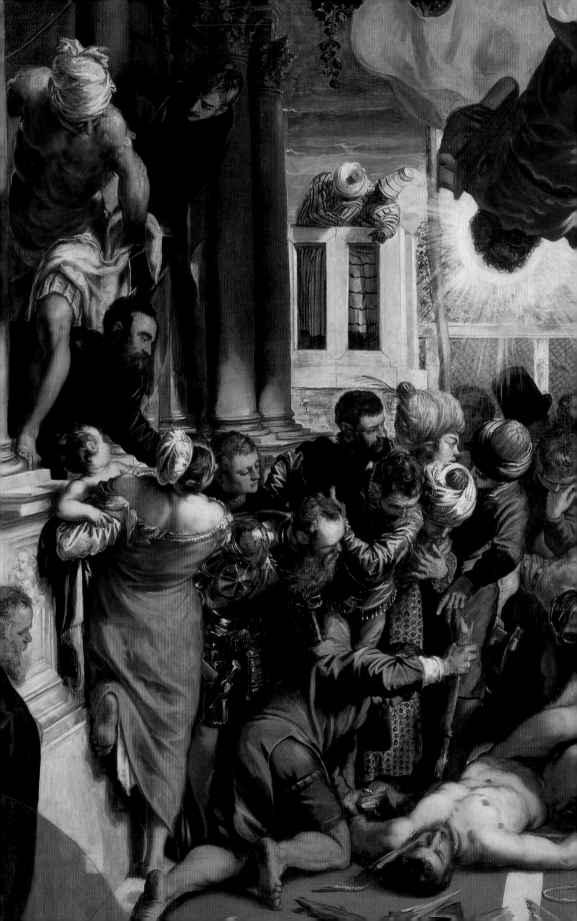

MARK, SEBASTIAN
AND ROCCO

4

Manliness and Saintliness

THE CASES OF MARK, SEBASTIAN, AND ROCCO

Ecce homo. "Behold the man!"
The Gospel of John

Christianity, according to Nietzsche, turned weakness and passivity into virtues. If the meek will inherit the earth, where can room be found for the bold, the brave, the man of action, the superman? "Christ does not resist those who are harming him."[1] For Nietzsche, Jesus became a model of resignation who held up martyrdom as the most honorable form of death and acquiescence ("turning the other cheek") as the recommended response to abuse. "Thou hast conquered, O pale Galilean," wrote Swinburne in "Hymn to Proserpine," "the world has grown gray from thy breath."[2] A modern scholar has suggested that Christianity, because of its emphasis on salvation in the next world, did not "engage the ambitions of manly men."[3] According to Swinburne and Nietzsche, Jesus not only gave in to brute force but also inspired generations of simpering, soft, masochistic "saints" who tried to imitate him by neglecting or punishing their own bodies and living lives of isolation and inaction. For Nietzsche, the values negated by the Christian ideal included "pride, exuberance, passion, adventure . . . the beauty, wisdom, power, splendor, and dangerousness of the type 'man'" (*WP*, 129). When Nietzsche says that Christianity produced "a feeble species of man," he seems to be referring primarily to males. "Why are we not disgusted by it as we are perhaps disgusted by the idea of the castrato? . . . The most robust kind of man . . . possessing manly virtue [is more likely to be found in] a Corsican or pagan Arab than in a pious Christian" (*WP*, 120).

109

According to this argument, Christian culture, art as well as literature, reflects a rejection of the healthy athleticism of "pagan" Greece and the courageous militancy of "pagan" Rome by depicting the body, especially the male body, depleted of strength. Christians "despised the body," says Nietzsche, and gave way to "that feminine instinct that always sides with virtue" (*WP*, 56, 131). One critic observed that "in Christian iconography the male nude is in a sense feminized – it is shown as passive and submissive . . . Church art glorifies masochism . . . The Christianized imagination, fearful of the flesh, can treat the naked body seriously only when it is brutalized . . . mortified, dying, or dead."[4]

Linking the feminine with the "passive and submissive," as this critic did (or "virtue," as Nietzsche did), is, of course, problematic. True, there is the obedient Virgin of the Annunciation and there are the countless female nudes of secular art lying lazily about on sofas, but, in religious painting, there is also Eve tempting Adam, Judith with the head of Holofernes, Delilah cropping Sampson's hair, Salome serving up the head of John the Baptist on a platter, and the Madonna of Mercy towering with her protective cloak over the citizens of various Italian city-states.

Setting aside for the moment whether the "feminine" is necessarily "passive and submissive," one might see some truth in the Nietzschean view when thinking, for example, of the many images of the Venetian favorite, Saint Sebastian. His nearly nude, young, pale form, with hardly a muscle in sight, is commonly shown tied to a tree or post. According to legend, he was shot full of arrows by order of the Emperor Diocletian. As time went on, artists tended to show fewer and fewer arrows and more and more flesh, thus displaying the tormented and inert male body as a thing of beauty.

Long before Venetians fell in love with Sebastian, however, they took the evangelist Mark as their patron, hero, and symbol. In considering whether saintliness and "manliness" – as Nietzsche and others have stereotypically defined it – might meet somewhere in the Christian scheme of things, the contrasting cases of Mark and Sebastian (with a nod to Rocco who is often depicted with Sebastian) are instructive. Everyone knows about the great cathedral of Saint Mark, Ruskin's beloved pile, and the Piazza of Saint Mark where Henry James's Merton Densher strolled with Kate Croy in *The Wings of the Dove*, but what about the saint? Why Mark? What did he have to do with Venice? What did he look like? Was he too a "passive and submissive" Christian milquetoast?

According to tradition, Mark was a disciple of Peter's who undoubtedly knew Jesus but was not one of the twelve apostles. He is thought to have been the young man who left his garment behind and fled naked, as told in Mark 14 : 51, when Jesus was arrested in the Garden of Gethsemane. Further, in the account of his life in *The Golden Legend*, Mark accompanied Peter to Rome, and was sent by Peter to preach in Alexandria where he converted many souls until he was imprisoned and dragged through the streets to his death. As saints' lives go, Mark's story does not seem remarkable. But the details are worth examining. Jacobus de Voragine, who thought, like many of his time, that names indicate character, begins his narrative by observing that Marcus means "heavy hammer that breaks

down the iron." He "strikes down the perfidy of the heretics, rings out the praises of God, and strengthens the Church."[5] This is a bold beginning and Jacobus does not let up. Mark amputated his thumb because he did not wish to be a priest (priests normally hold the consecrated host between their thumbs and index fingers). Yet this rash act neither unmanned Mark nor prevented Peter from ordaining him bishop. Mark's first convert in Alexandria was a cobbler who hammered his own hand while mending Mark's shoe that had fallen apart on his arrival in town. The cobbler cried out in pain, "One is God!" (a better translation might be, "Oh, God!"). Immediately, Mark spat on some clay and healed the cobbler's hand, thus making his first Egyptian convert. Gospel echoes are obvious but so is the humor and rough-and-tumble nature of the episode in which "the heavy hammer," down at the heel, does his work by projection, turns what might have been a curse into an apostrophe of praise, and shows with his own spit that Mark is a man of the people, an imitator of Christ.

Most of the other miraculous events recounted about Mark occur after his death, but they all call attention to a body that makes its presence felt in dramatically bold and often comic ways. When in 828 two Venetian merchants stole his corpse from its tomb in Alexandria, they wrapped the body in prosciutto and pork so that the Muslims would keep their distance while they loaded it onto their boat. Safely at sea, the merchants boasted to other passing ships that they had an evangelist in their cargo but when a skeptical sailor voiced his doubts, "Right away the ship that carried the saint's body turned itself around with astonishing speed, rammed the doubter's vessel, and could not be pulled loose until all aboard made it clear that they believed it was really Saint Mark's body" (*GL*, 1, 245).

Dead or alive, the "heavy hammer" is still a force to contend with. After a hurried and secret burial in a church column in Venice, the body seemed safe and still at last, but, no. Those few who knew where Mark had been concealed died and left their descendants uncertain about the location. After much searching and lamenting, "Lo and behold, in full sight and to the wonderment of all, the stones bounced out of the column and the casket that hid the saint's body was visible" (*GL*, 1, 245). Mark did not go gently; he rapped, he rammed, he bounced.

The most famous and, in its time, most controversial painting of Mark in action is Tintoretto's *Miracle of the Slave* commissioned by the brotherhood of the Scuola di San Marco in Venice (fig. 42). According to the story, a servant of a provincial master who had vowed to visit the tomb of Mark, was forbidden to do so, went anyway, and was subject to attempts at the most gruesome torture. First his eyes were to be put out by sharp sticks; failing that, his feet were to be cut off with hatchets; failing that, his teeth were to be smashed with hammers. All the cruel efforts failed because Mark, a stronger "hammer," was invoked by the servant, at which point the sticks fell to pieces, the "the tools melted," and the "iron forgot its strength" (*GL*, 1, 246–7).

Tintoretto takes full advantage of the high drama of the scene, surrounding the naked supine servant with a thick and restless crowd of onlookers and the upright figure of one

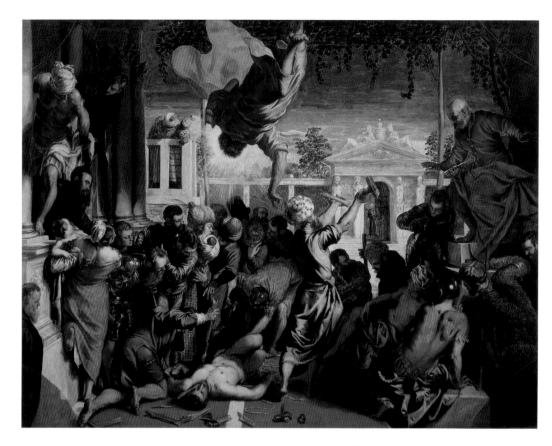

42 Tintoretto, *Miracle of the Slave*, 1548, Gallerie dell'Accademia, Venice.

of the executioners stretching out his arms to show the enthroned master the broken and impotent instruments of torture. Above it all, the figure of Saint Mark floats – or, more accurately, rushes down from the sky like Superman (not Nietzsche's but Siegel's and Shuster's) with cape unfurled – and saves the faithful servant.

It is possible to read this picture as yet again one of the many Christian treatments of the body as "passive and submissive," a masochistic glorification of torture and suffering. However, a painting so rich and complex suggests other more rigorous and persuasive interpretations. First of all, though the servant is unarmed, he is also unharmed; he is on the ground not because of passivity but disobedience; and his naked body amid the swirling of much cloth is the most arrestingly alive image in the crowd. Hippolyte Taine, who said that no other painting had left such an impression on his mind, described the "naked servant thrown upon his back" as having "a superb, virile, muscular body that palpitates."⁶ Mark not only comes to the aid of the servant but is also presented by the artist as a kind of double of the slave, a reversed celestial mirror image, not a puppeteer but a

comrade whose head, though in shadow, shows a similar crop of black curls and whose body turns in a correlative rhythm.

Whether or not one thinks the body of the servant "palpitates," it is clearly not the figure of a weak, deformed, or frail creature. In fact, the servant, like Mark in other of Tintoretto's paintings (and even in early mosaics), bears a strong resemblance to the artist. Stocky, "well-built," as *The Golden Legend* says of Mark (*GL*, 1, 244), with a head of thick curly black hair and a black beard, he looks like a Sicilian (Corsican?) farmer or a Venetian gondolier. Tintoretto, whose nickname reflects his coming from a family of cloth dyers, was often attacked for making his saintly figures look too much like artisans and workers. His paintings were criticized by Vasari for being "too free and loose" and by Aretino for showing hurried, broad brushstrokes in a seeming rush to be finished (*prestezza del fatto*) in contrast with the older Titian's more polished, careful, and "refined" technique. Initially, the *Miracle of the Slave* was rejected by the patrons in the Scuola di San Marco.

Tintoretto's "formal gymnastics," his "humorous erotic undertones," his inclusion of "high" and "low" elements in his paintings, and his *prestezza del fatto* were parts of a "conscious and continual revolution against the model provided by Titian for painting in Venice."[7] His family name was Robusti and robust he was in temperament, physique, and aesthetic approach. Taine may have overstated the matter when he called the artist's genius "savage and violent," his imagination a "furnace" (Taine, 313, 317), but few who have seen his work would deny that it is filled with energy and an almost overwhelming restlessness.

It is fair to say that Tintoretto fashioned Mark after his own image, but the old legends about Mark, especially in relation to Venice, also provided the painter with sturdy and congenial material.[8] One cannot overestimate the importance to the prestige and self-image of Venice of the translation of the evangelist's relics to the city in 828. Caught in power struggles between Byzantium and Rome as well as the ecclesiastical claims of supremacy of the bishoprics of Aquilea and Grado, Venice needed nothing short of divine intervention to bolster its growing importance as a mercantile and naval power. Difficult though it may be for the modern imagination to conceive, the bones of a long-dead body brought the aura of a living champion, protector, and patron. As Peter Brown wrote of the shrines of saints in Latin Christianity, "In a relic, the chilling anonymity of human remains could be thought to be still heavy with the fullness of a beloved person."[9] An Italian historian called the relics of Saint Mark "a treasure greater than all the gems and pearls obtained by industry and the most flourishing commerce." Mark's body was associated with wealth and with the political, cultural, and ecclesiastical independence of the city. "When the body of the saint, by divine gift and human will, was deposited in the shadows of the city, the long, difficult battle for independence was won, and won decisively."[10]

In the first volume of the history *Venezia Ducale* (1928), Mark's body is spoken of as if it were alive, an active and living hero who had come to the rescue of a whole people:

"Around this relic the Venetian spirit revived with marvelous energy because in it one not only saw but felt the living and speaking symbol of all the city's life . . . This potent new force in the consciousness of the community destroyed the disputes of the past and rebuilt the ideals of the future."[11]

For centuries, beginning with Jerome if not earlier, Mark, like the other evangelists, was identified with one of the four creatures of the Apocalypse; in his case the lion: *Marcus ut alta fremit vox per deserta leonis* ("Mark who roared with the loud voice of a lion in the desert"). On the banners and standards of the young republic the winged lion became a sign of power, pride, and divine favor. *San Marco e il grido di guerra, San Marco il grido di pace* ("Saint Mark is the cry of war, Saint Mark, the cry of peace"). Since the military and commercial might of Venice was associated with the sea, Mark quickly became known too as the protector of ships: *Tendit vela leo Marcus mari omnia circum* ("Mark the lion stretched his sails throughout the sea").[12] On the trip from Alexandria to Venice in 828 Mark was not content to lie quietly wrapped in prosciutto. Not only did he cause the ramming of the ship of the skeptical sailor, he told his own crew to lower their sails when a storm approached and where to pull ashore until the wind died down. It is not surprising that in early mosaics he is sometimes shown, not as dead weight but as the captain or at least the coxswain of the boat bearing him to Venice.

Venetians sustained their devotion to Mark well into the sixteenth century of Tintoretto and beyond. Undoubtedly, they would have seen in the legend of the miracle of the slave as well as in Tintoretto's painting a parable of the evangelist's symbolic rescue of their city. Since the chief executioner wears a turban, he would have been associated with Byzantium, and since the two women with infants appear to be a reference to the Slaughter of the Innocents, the master on his throne is a Herod-figure, an illegitimate, bloodthirsty ruler. Yet the slave, though innocent, is no infant. He is a burly Venetian empowered by his look-alike patron (and painter) to repel his attackers and spring into a newly realized life (and art form that became the pride of the city).

It was an essential element of Tintoretto's genius to seize on those transformative moments in a narrative, not the "before," not the "after," but the blazing instant in which the preliminaries and the resolution meet at a turning point. His figures swirl, twist, fly, writhe, reach, stretch, leap – bringing bursts of vitality to stories and bodies that had lain dormant for generations. After the *Miracle of the Slave*, the artist's most compelling painting of Mark in action is of him *Rescuing a Saracen from Shipwreck* (fig. 43)." According to *The Golden Legend*, Venetian merchants were in a Saracen ship that was caught in a storm. The Venetians jumped into a skiff, but the ship began to sink. One of the Saracen sailors called on Mark to help him, promised that he would convert, and was saved. But when the Saracen returned to Alexandria, he forgot his vow. Never one to hold his peace, Mark appeared to the Saracen and reproached him for his neglect. Filled with remorse, the Saracen made a pilgrimage to Mark's tomb, became a Christian, and, in the best touch of all, changed his name to Mark.

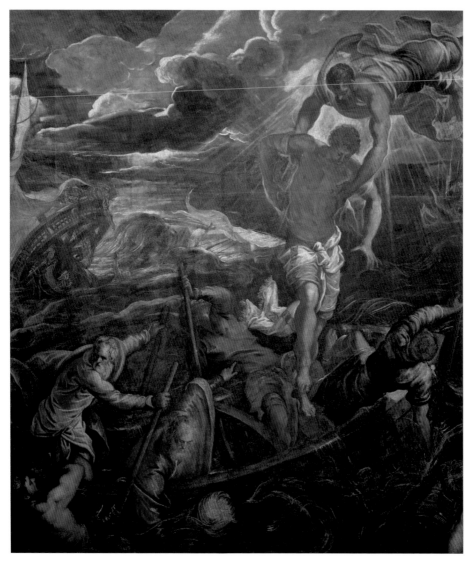

43 Tintoretto, *Saint Mark Rescuing a Saracen from Shipwreck*, 1562, Gallerie dell'Accademia, Venice.

Tintoretto does not attempt to look into the early life of the Saracen or his later years as a pious Christian. He chooses the exact moment when Mark appears out of the storm clouds and with his muscular arms plucks the Saracen like a feather from the churning sea. As a commentary on conversion, the picture, like the story, is both familiar and odd. Certainly, there are numerous biblical precedents to a story of salvation depicted as a rescue from danger at sea: Noah from the Flood, the Israelites from the Red Sea, Jonah from the Belly of the Fish, the apostles with Jesus in the storm. The saving of the Saracen's

body, like that of Jonah and the others, is a sign of God's power, but it is not an instant fulfillment of redemption. Conversion requires a voluntary act of the will, a moral and spiritual interpretation of the physical event on the part of the saved. All that is known about this Saracen is that he wants to live. In the skiff, a bearded figure, thought to be the donor Tommaso Rangone, leans over to pull up another Saracen whose turbaned head bobs up out of the waves.[13] Mark's Saracen is different. He wears no turban. In fact, he is the only figure in the painting who wears nothing but a linen garment (loosely wrapped and falling off). He is young and fair; the turn of his body suggests a combination of striking artistic antecedents – Jesus being lifted down from the Cross and Michelangelo's drawings of the risen Christ floating above the sleeping soldiers at his tomb.

As critics have pointed out, many of Tintoretto's figures were influenced by Michelangelo, but Tintoretto obviously knew his Mark and his Bible as well as if not better than he knew the works of Michelangelo. Having already painted his own image in both the slave and the saint, he clearly liked to show physical resemblances as commentaries on and signs of spiritual transformation. If, in the painting of the shipwreck, Mark seems to be coming to the rescue of a Saracen who looks a bit like Jesus and a bit like a neophyte, it could be because Tintoretto recalled the young, untested future evangelist in Mark's Gospel who fled naked from Gethsemane leaving his captured Savior and his linen garment behind. In this painting, as often in art, history is given another chance. The converted and revered Mark, the mature evangelist, comes down from the heavens to do what he had not done in life, save his Savior, and thereby save himself, his younger, fairer self, the soul on the verge of conversion, about to become, but not yet, Saint Mark.

Identities, events, and symbolic suggestions rush together in Tintoretto's paintings like the torsos, limbs, and draperies that twist and turn as in a whirlwind. *Prestezza del fatto*, "haste to be finished," seems just the right phrase for an artist who not only depicted speed but also produced vast, complicated paintings with a rapidity that astonished his patrons and infuriated his rivals.[14] In this too, the painter and the evangelist had something in common. Mark's Gospel is the shortest of the four and its narrative moves faster and more briskly than those of the other evangelists. Its transitions are abrupt and brief: the words "immediately," "suddenly," and "at once" appear frequently. In Mark 1, as in later chapters, things happen extremely quickly: John the Baptist baptizes Jesus, "And *immediately* on coming up from the water he saw the heavens open" (1:10); "And *immediately* the Spirit drove him forth into the desert" (1:12); Jesus calls his first disciples, "And *at once* they left the nets and followed him" (1:18); "And *immediately* on the Sabbath he went into the synagogue" (1:21). It is a narrative pace that takes the breath away. Little wonder that Tintoretto, finding in Mark a patron and soulmate, imagined the evangelist writing the Gospel as the painter painted his pictures with *prestezza del fatto*, as though on the run (fig. 44).

This painting is as close to a self-portrait of the artist at work as any of Tintoretto's pictures. He holds the Bible open with one hand while he paints with the other.[15] Of

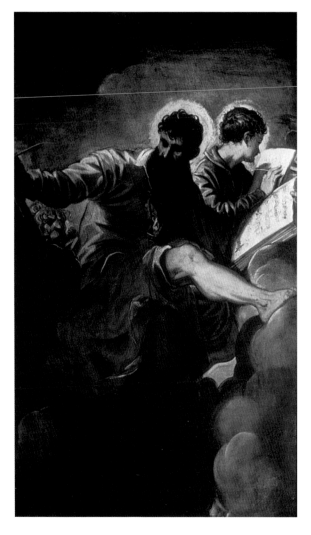

44 Tintoretto, *The Evangelists Mark and John*, 1557,
Santa Maria del Giglio, Venice.

course, he is also imagining Mark copying his Gospel from an earlier source or perhaps
writing so fast that he turns to a new page while still holding the one he has just finished.
The bare muscular leg and turning torso once again show the influence of Michelangelo
but they also make a point: that the vocation of the artist, like that of the evangelist (at
least, this evangelist, if not the demure young John who writes sedately beside him),
requires intense physical effort, that is, work. When Nietzsche wrote that Christianity is
the "hypochondria of those whose legs are shaky" (*WP*, 410), he could not have been think-
ing of Tintoretto's Mark.

117

The painter was clearly intent on showing Mark not only as his and Venice's patron, but as the working man's evangelist, a man's man, a "manly" saint. Is this, as Nietzsche might have insisted, a Renaissance aberration, a gross distortion of the Gospel message of humility and meekness? Jesus does not mention "manliness." Paul, though he sees different roles for men and women in society, says that in Christ there is neither "male nor female" (Galatians 3 : 28). Mark, like the other evangelists, takes for granted that there were different expectations about men and women in the times of Jesus. If a single-minded reader looked through the Gospel of Mark searching for signs of the "manliness" of Jesus, that is, of attitudes and behavior that would have been unlikely, if not impossible, for women of the time, he or she would find ample support for Tintoretto's perspective. Jesus calls fishermen, presumably active men strong enough to haul nets bursting with catch, to be his disciples (1 : 16–19). In his first recorded miracle, he tells a demoniac to "shut up" and when he heals the man, witnesses are amazed by his "authority" (1 : 23–7). Jesus preaches throughout Galilee (1 : 39), which would have meant walking great distances in the heat and sleeping wherever he could, a liberty unthinkable for most women. When he wishes to pray, he remains outside of town "in desert places" (1 : 45). He eats and drinks with sinners (2 : 16). He climbs a mountain (3 : 13) and says that "no one can enter a strong man's house" (3 : 27). When his mother and brothers come to call him home, Jesus asserts his independence from them (3 : 33–4). When his disciples wake him during a storm at sea, he impatiently asks, "Why are you afraid?" (4 : 40). As he becomes more and more popular, his enemies ask disparagingly: "Isn't this the carpenter?" (6 : 3). Jesus is not squeamish about food or the body and its natural functions: " 'Don't you realize that nothing that comes from outside can defile a man? For it does not enter his heart, but his belly and passes out into the drain.' Thus he declared all foods clean" (7 : 19). When Jesus gets angry, he overturns the tables of the money changers at the Temple (11 : 15) and tells the Sadducees that they do not know what they are talking about (12 : 24). On trial before the high priests, he is uncooperative and shows that he is not intimidated by their threats (16 : 9).

Theologians may emphasize other instances to suggest the divinity of Jesus. These passages make plain not only his humanity but also his gender and class. A carpenter who sleeps in the desert, climbs mountains, hangs out with fishermen and sinners, tells people to shut up, and knocks down tables was doing what no woman – certainly no well-behaved woman – of the period and place would have been likely to do. In Mark's Gospel, more succinctly and sharply than in the other Gospels, Jesus is shown to be a physically energetic, active, robust, and often blunt, radical, and fearless character. In modern terms, there is nothing intrinsically gendered about these traits. But they do not add up to a model that would discourage disciples from feeding or exercising their bodies and using them boldly to overcome hardship or to encourage them to live lives of passive submission to authority. Indeed, the life of Jesus, as told by Mark, is not lacking in several of Nietzsche's "values," including anger, wisdom, power, adventure, and danger.

In the early centuries of Christianity, there were devotees who fasted and lived lives apart from the world in imitation of Jesus in the desert, but there were many more who lived actively and bravely in a hostile world. Such was another favorite of the Venetians, Sebastian, a Roman soldier during the reigns of the emperors Maximian and Diocletian. Sebastian, unlike Tintoretto's Mark, is more often remembered by Renaissance artists as a youthful, androgynous beauty helpless before the rough treatment of the emperor's troops than as a "manly" prototype. By the nineteenth century, he had become a highly eroticized symbol of the forbidden pleasures and dangers of the love between men. Oscar Wilde took the pseudonym Sebastian Melmoth on his release from prison for sexual misconduct; Walter Pater wrote a story entitled "Sebastian von Storck"; Claude Debussy created an opera-ballet, "Le Martyre de Saint Sebastian," in 1911; in the twentieth century, Evelyn Waugh (in *Brideshead Revisited*) and Tennessee Williams (in *Suddenly Last Summer*) named their homosexual characters Sebastian; in 1976 Derek Jarman made *Sebastiane*, a film suggesting that the saint was tortured because he rejected the advances of his Roman commander. The association continues. "Sebastian remains the most frequently renewed . . . emblem of homosexual consciousness," seen by some as "a homosexual ideal" and by others as "a portrait of a tortured closet case."[16] One critic has called Sebastian "a paradigmatic queer."[17] However, though Sebastian's gay identity may have had a rebirth in the past 150 years, it is not a totally modern invention. In Shakespeare's *Twelfth Night*, Antonio seems to have a crush on Sebastian: "And to his image which methought did promise / Most venerable worth, did I devotion."

So what is it about Sebastian? His story, as told in *The Golden Legend*, does not at first appear to invite a particularly erotic reading. He was a soldier and evidently brave enough to prompt Emperor Diocletian to appoint him commander of his personal cohort. Sebastian accepted the post so that he could be sent to the sites of Christian martyrdom and give courage to the victims. When twin brothers are about to be beheaded for their faith, their wives and parents weep and beg them to recant but Sebastian breaks through the crowd and addresses them as "you strong soldiers of Christ" and tells them not to fear since the devil "while he catches is caught, while he binds he is bound, while he wins he loses, while he tortures he is tortured" (*GL*, 1, 98). This is the conventional rhetoric attributed to early Christian martyrs; it does not sound like the voice of the weak or passive character often portrayed in paintings. A possible "gay" touch that Wilde might have appreciated comes when, at the end of his speech, "a youth appeared at [Sebastian's] side and gave him the kiss of peace, saying, 'You will always be with me'" (*GL*, 1, 98–9) Saints, like artists, often perceive Jesus as an ideal lover, friend, companion.

When Sebastian goes on to destroy – pulverize – two hundred pagan idols, the emperor summons him and accuses him of disloyalty. Sebastian responds without apology: "I have always worshiped God who is in heaven and prayed to Christ for your salvation and the good estate of the Roman Empire" (*GL*, 1, 100). Infuriated, the emperor has Sebastian bound by his soldiers, tied to a post, and shot so full of arrows "that he looked like

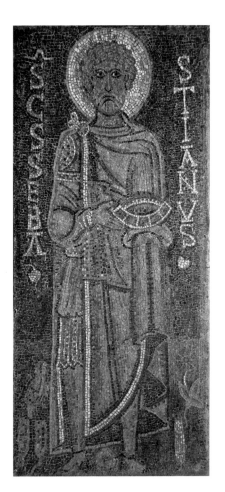

a porcupine." Left for dead, Sebastian recovers and appears on the steps of the emperor's palace a few days later. He is then clubbed to death and his body thrown into the Cloaca Maxima, the great sewer of Rome. A pious woman retrieves his body and has him buried in the catacombs. In the *Annals of the Lombards*, Sebastian is reported to have been efficacious in healing those suffering from the plague and over time he became revered as the patron of plague victims and soldiers.

At the end of the sixth century, Pope Gregory the Great proclaimed Sebastian as the third patron of Rome, elevating him to an honored position with Saints Peter and Paul. In the earliest known mosaics of Sebastian, he is shown not as a young soldier but as a bearded patriarch (fig. 45). For centuries he was seen as a solemn, stoic, fully clothed, asexual generic martyr until, in the thirteenth and fourteenth centuries, episodes of plague increased in number and severity in Italy, and Voragine's *Golden Legend* called dramatic attention to his heroic resistance to the torments of arrows which left wounds and scars like the sores of the dreaded disease.[18]

45 *Saint Sebastian*, seventh century, mosaic,
San Pietro in Vincoli, Rome.

In later medieval representations, Sebastian may be fully dressed or not, but the focus of attention is usually on the arrows, not the otherwise unremarkable body of the saint. An altarpiece painted by Giovanni del Biondo in 1374 was placed in the Duomo in Florence by order of the bishop (fig. 46). Del Biondo's bearded Sebastian resembles Jesus on the Cross, surrounded by soldiers, suffering but undefeated. The central panel is framed by two side panels depicting Sebastian being clubbed to death and miraculously retrieved from the great sewer of Rome as in a re-enactment of the Resurrection of Jesus. "For a populace constantly threatened with the return of the plague, the Passion-like drama which Sebastian undergoes takes on a salvific charge."[19]

It was in the fifteenth century, when Italian artists became more and more interested in and skilled at depicting the human form, that Sebastian came into his own as a model of male beauty. This raises the question as to whether a fascination with the body was simply another sign of a humanist revival antithetic to religious faith or whether Christian beliefs and the celebration of the human body can be understood as parts of a coherent dynamic. Vasari, the most influential art historian of the Italian Renaissance, takes it

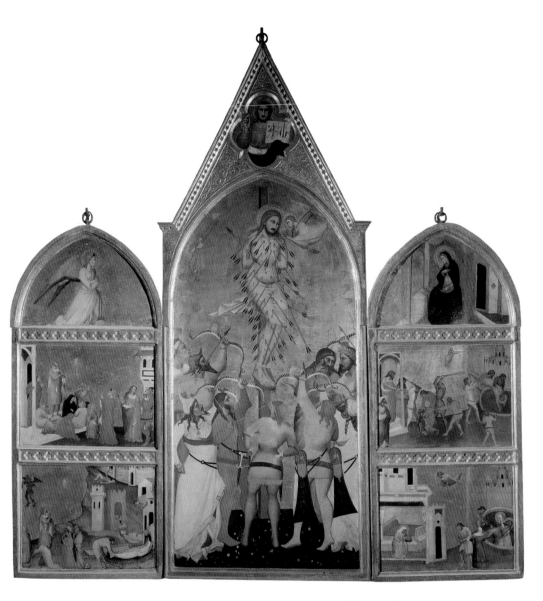

46 Giovanni del Biondo, *Martyrdom of Saint Sebastian*, 1374, Museo dell'Opera del Duomo, Florence.

for granted that the art of the period reflects religious feeling as well as a renewed pleasure in the beauty of the human body. In his life of Masaccio, he notes that the painter "made more use than other artists of nude figures" and also gave such feeling to "Saint Peter questioning Our Lord and the attentiveness of the apostles . . . that they look truly alive." Vasari counts among the gifts of Michelangelo "the knowledge of true moral philosophy" and praises the "love and devotion" he invested in the figure of Christ in his first

marble Pieta: "It would be impossible . . . to find a body possessing more beautiful members, or a nude with more detail in the muscles, veins, and nerves."[20]

Vasari was, perhaps, simply employing conventional rhetoric to praise the skills of artists and the artists themselves may have made use of religious subjects for purely secular aesthetic purposes. But it is much more likely that artists, like poets and philosophers of the period, found in the meeting of classical and Christian ideals a powerful challenge and inspiration to creativity. In his treatise *On the Dignity of Man*, Pico della Mirandola (1463–1494) describes human beings as "the most happy" and "most worthy of wonder" of all creatures. He imagines God saying to his new creation: "I have placed thee at the center of the world, that from there thou mayest more conveniently look around and see whatsoever is in the world . . . Thou, like a judge appointed for being honorable, art the molder and maker of thyself into whatever shape thou dost prefer. Thou canst grow downward . . . Thou canst grow upward from the soul's reason into the higher natures which are divine."[21] As a rewording of Genesis, this changes the tone while retaining much of the spirit of the Hebrew original. Human flesh is not just meat. It is not inert and it cannot be reduced to one substance or purpose. Creation is a challenge and an opportunity; the body is the medium of almost unlimited potential for greatness or mediocrity, beauty or ruin. In our own time, Leo Steinberg challenged the secular view that Renaissance paintings of a nude or nearly nude Jesus are "mere pretexts for exhibiting common humanity," as though that excluded all spiritual potential. Steinberg argued that the Renaissance love affair with the human form is in accord with the Christian belief that in Jesus God had taken on human shape and regained for it its original glory. Renaissance art "celebrates the restoral which the divine power brought off by coming to share man's humanity."[22]

Steinberg's focus was mainly on representations of the infant Jesus and Christ on the Cross. Is the almost nude Sebastian of the painters an odd man out, a gay exception with no genuine role in the Christian community of saints? A panel in a mid-fifteenth century polyptych by Piero della Francesca may help in trying to find an answer (fig. 47). Piero's Sebastian is a sturdy, stalwart, relatively impassive character who does not flinch or even seem to notice that several arrows are sticking into his nicely rounded but not particularly soft flesh. Piero's Sebastian stands his ground; though his hands are tied behind his back, no pillar or post and no tormentors are visible; his feet are firmly planted on what appears to be a marble floor; he looks up with assurance to the large figure of the Madonna of Mercy (in the central panel) who protects those below with the outstretched folds of her veil. Sebastian in this depiction seems less a figure of pathos than an exemplar of resilient faith undeterred by the stings of the flesh. With his neatly clipped hair and solid build, he looks like an athlete, perhaps a boxer, but, even more important to viewers of the time and evidently to Piero, would have been his resemblance to Christ stripped of his garments, tied to a pillar, and whipped before the Crucifixion, as traditionally depicted by artists, including Fra Angelico (fig. 48).

47 Piero della Francesca, *Madonna della Misericordia* Altarpiece
(detail showing Saints Sebastian and John the Baptist), 1460–62,
Museo Civico, Sansepolcro.

Fra Angelico's Jesus holds his head up and looks one of his persecutors in the eye. The golden light on his almost nude and gracefully curved body makes the figures on either side appear stiff, awkward, and uncomfortable. Nearly perfect symmetry of design, the glow of Christ's body and halo, the centrality of his figure, the emptiness of the room give the picture a formal, ceremonial aspect. On second glance, for a moment, the raised arms of the tormentors and the flimsy delicacy of the lashes look like a scene borrowed from the entry into Jerusalem when the crowds waved palms and saluted Jesus with hosannas. The painting does what Christian art often does: it compounds readings, layers reality with symbol, invests suffering with meaning and often, surprisingly, with beauty.

In 1440 before painting the Sebastian, Piero completed one of his greatest, most complex, and mysterious compositions, also a *Flagellation of Christ* (fig. 49). Critics have

48 Fra Angelico, *Flagellation of Christ* (painted for the Armadio degli Argenti), 1450,
Museo di San Marco, Florence.

long noted the geometric and architectural originality and skill of the composition, but
they have spent even more time proposing theories about the three figures conversing in
the right foreground. Some scholars have said that the three men in the foreground are
Italians, contemporaries of the painter involved in affairs of state and Church; others have
seen them as members of the Sanhedrin that condemned Jesus; some have seen the figure
in red as an angel or a soldier or the deceased illegitimate son of Federico da Montefel-
tro.[23] It would be only a slight exaggeration to say that in the course of these diverse the-
ories, the flagellation of Jesus – supposedly the point of the painting – has been lost.
Surely, whoever the three well-dressed men are, they present to the viewer a pictorial
affront to the "main subject." Or do they? What, in visual terms, is the main subject? Inside
an elegantly classical chamber, at a distance from the viewer and from those outside, the
Savior is tortured while out front three men, responsible for, unaware of, or unperturbed
by the events within, carry on a conversation. The painting is arresting in paradoxical
ways: it is breathtakingly balanced and unbalanced; symmetrical and asymmetrical;
moving and impassive; dynamic and static; deep and flat; crystal clear and unnervingly

49 Piero della Francesca, *Flagellation of Christ*, 1440, Galleria Nazionale delle Marche, Urbino.

obscure. At once pleasing and disturbing, Piero's painting is a triumph of design and of the paradox of Christ's and humanity's suffering as a subject of critical significance that can be "put to one side" but not completely eliminated from the scene of life as it goes about its business on the other side of the frame.

This brings me back to Sebastian. If Renaissance viewers and artists were bound to see a resemblance between the saint and the Savior – which is what sainthood is about – they would have been reminded, by the scenes of flagellation and of Saint Sebastian tied to a post, of the isolation of suffering. While the Crucifixion is the culmination of Christ's suffering, scripture and most paintings relate that his mother, Mary Magdalene, and John were nearby whereas during the flagellation he was alone with his captors. In another mid-fifteenth-century Italian painting, this time by Antonello da Messina, who may have seen Piero's Sebastian and Jesus while traveling in Central Italy, the absolute loneliness of Sebastian is even more striking than the suavity of his form (fig. 50).[24] Here, Sebastian does not appear to be in excruciating pain but neither is he, like Piero's Sebastian, standing up straight and casting his trusting eyes to the heavens. The tilt of his head and his

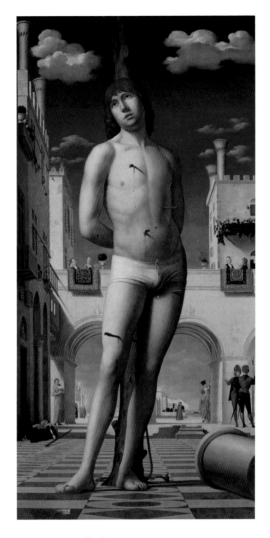

50 Antonello da Messina, *Saint Sebastian*, 1476,
Staatliche Gemäldegalerie, Dresden.

slack posture suggest resignation and sorrow more than acute physical suffering.
Antonello's Sebastian is young and alone. The artist also displays his talent for perspec-
tive and architectural framing; however, here the arches and walls do not enclose but
rather exclude the figure; the broken column, a conventional reminder of the fall of pagan
Rome, only adds to the feeling of desolation. At right in the recesses of the piazza, two
men chat as if completely unaware of the bound figure in the foreground. In Piero's paint-
ing the three men in conversation are on a plane closer to the viewer than Christ; here
the relationships are reversed. The chatting citizens are almost out of sight whereas Sebas-

tian in his isolation is nearly with the viewer. True, there are not many arrows and the smooth adolescent body is beautiful, but the almost surrealistic atmosphere of abandonment is what gives the painting its haunting originality and its clear link to and reminder of the "absent" and abandoned Savior.

In the many depictions of Sebastian, as in all paintings of religious subjects, attention is called to a narrative as well as to a particular body. Architectural and natural setting, lighting, props, costumes, and secondary figures as well as posture and facial expression tell or point to a well-known story or retell it in their own way. Clearly, in the case of Sebastian, the episode of the arrows, more than any other event in the saint's legend, is what captured the imaginations of artists and through them of the faithful. Although the fact that Sebastian survived the arrows comes as a surprise to modern viewers, it was a detail of no insignificance to those in the fifteenth and sixteenth centuries who saw and appealed to him as a protector against the plague. Since that horrendous blight showed itself and gave notice of its devastating progress in disfiguring marks on the flesh, depictions of a healthy body touched, but not destroyed or disfigured, by small wounds gave hope against hope in times threatened by epidemic.

The narrative aspect of Sebastian's martyrdom (especially the presence of Roman soldiers aiming arrows at him) gave way in the fifteenth century to an isolated image more suited to meditative devotion than to moral instruction, thus addressing the viewer's need "to engage in an intimate and emotional relationship with the holy figure."[25] By the end of the fifteenth century, artists continued to contemplate the scene of the arrows, but they seemed intent on displaying Sebastian's body as unscathed – smooth, clear, without blemish, aside from the few ineffective arrows placed like pointers that call attention to the uncorrupt nature of the saint's flesh. Perugino's *Saint Sebastian* is a prime example (fig. 51).

Inscribed on the lower edge of the panel is a quotation from Psalm 38 : 1–3: "O Lord, rebuke me not in thine anger . . . for thine arrows have struck fast in me . . . There is no health in my flesh because of thine indignation."[26] As a prayer uttered by or about a person suffering from the plague, this makes sense. Yet it almost looks as though a perfectly healthy Sebastian is resting comfortably against the column in this lovely scene with the serene hills and soft light lending an air of peaceful tranquility to the moment. The entire composition is without signs of stress. Sebastian is neatly centered; the rounded arch complements the curve of his shoulders; his expression is neither confident nor anguished, but vague and dreamy. His body is a harmonious combination of masculine and feminine features: the pectoral muscles and arms those of a young man, the slightly swelling hips and soft lines at the groin those of a young woman. Perugino seems to call attention to the sex of Sebastian and at the same time to leave its exact nature, like the space beneath the loin cloth, undetermined. His Sebastian is not only unperturbed by the arrows but also unmarked by the choices imposed by maturity and experience. He is Adam *and* Eve before the Fall, an object of nostalgia, desire, and faith held in perpetual abeyance.

127

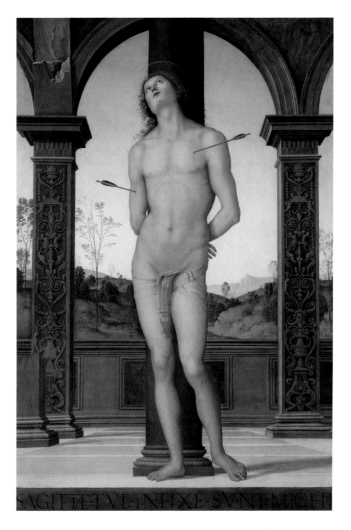

51 Perugino, *Saint Sebastian,* 1490–5, Louvre, Paris.

Around the same time, Liberale da Verona painted a Sebastian with many of the same features but with the elements in a less serene balance (fig. 52). Liberale's Sebastian is more voluptuous and sadder than Perugino's. He has the same long curly locks (not the clipped straight bangs of Piero's and Antonello's saint); his head is tilted toward the heavens but his eyes are sorrowful. The masculine and feminine physical traits – bony chest and shoulders, rounded hips and thighs – seem at odds. His posture is almost graceful but not quite: his upper body sags while his right foot is lifted as if about to run from the scene of his distress. Autumnal colors, a broken column, and a narrow alley of buildings (with no landscape in sight) confine Sebastian in a melancholy, airless frame. Most

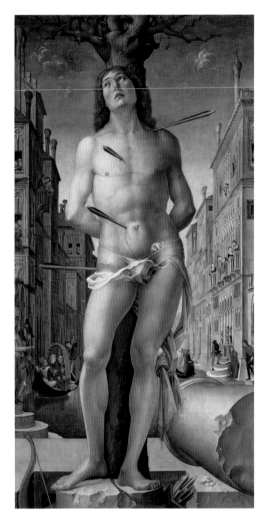

52 Liberale da Verona, *Saint Sebastian*, 1490–1,
Brera, Milan.

intriguing and puzzling of all is the elaborate play of flimsy cloth furled against gravity and "covering" but, in fact, calling attention to Sebastian's obviously male genitals. Liberale's arrows, though not numerous, are not innocuous. Two come dangerously close to Sebastian's not-so-private parts. In this painting, Sebastian is indeed suffering and what is particularly threatened is his masculinity.

Would it be fair, then, to say that with painters like Perugino and Liberale, representations of Sebastian lost their effectiveness as inspirations for religious hope and became instead objects of titillation? No doubt the body is on display and, one way or another, attention is called to the sexuality of the figure and particularly to the barely concealed

genital area. When seen by modern viewers in the Louvre or the Brera, these consider-
ations would probably be foremost, but what were they like in the culture and settings
of their own time or what are they like for a religious viewer today? When put this way,
the better question that follows does not pit pleasure in the sexualized body against Chris-
tian faith but asks whether and how they might coexist and reinforce one another.

In praising the Venetian masters, Bernard Berenson wrote that "although nominally they
continued to paint the Madonna and saints, [they] were in reality painting handsome,
healthy, sane people like themselves."[27] Berenson appears to assume either that, unlike
sixteenth-century Venetians, Mary and the saints were ugly, sick, and insane or that they
bore no resemblance to actual people. Of course, no cultured person of the Renaissance
or anyone today familiar with history and scripture would think this. Miraculous attribu-
tions and fanciful legends notwithstanding, the fundamental idea behind the communion
of saints was (and is) that they were flesh and blood human beings (attractive or unat-
tractive, tall or short, female or male) who provide models for what the rest of human-
ity might strive to be. The historian John O'Malley, s.j., in a postscript to Steinberg's
study of Christ's sexuality, noted that "one of the most striking characteristics of Renais-
sance theology was . . . its treatment of the mystery of the Incarnation . . . [when] the
Godhead assumed human flesh and became one with us." O'Malley continued: "Within
the *studia humanitatis*, the revival of epideitic rhetoric was crucial. This was the rhetoric
of panegyric that, in its pure form, rehearsed the life and deeds of its heroes. It was, there-
fore, essentially biographical or historical in its perspective. Sometime around the year
1400 it was applied to the saints."[28]

According to what O'Malley called an "incarnational theology," the body of Jesus was
human in every detail, a sign not only of the divine condescending to assume the state of
man but of the divine lifting the flesh of humanity to its potential for godliness. Despite
repeated institutional efforts to contain and repress sexuality and powerful, genuinely ide-
alistic ascetic movements, there has been almost from the beginning a deep (and many
would say equally orthodox) counter-tradition within Christianity that fixed its attentive
and passionate gaze on the adorable body of Christ and, within the wide range of its
boundaries, the desirable bodies of his saints. Understood in this light, the nearly nude
and often seductive Sebastians of Italian Renaissance painting are both implicit repudia-
tions of the Church's attempts to associate the body with shame and bold aesthetic cele-
brations of the Incarnation and the promise of bodily redemption. In reference to
Michelangelo's nude statue of the Risen Christ (now in Santa Maria Sopra Minerva in
Rome, its genitals "safely" covered with a loin cloth), Steinberg wrote: "Michelangelo's
naked Christs – on the cross, dead, or risen – are, like the naked Christ child, not shame-
ful, but literally and profoundly shame-less."[29]

Few painters of Sebastian show the two sides of Christianity's heroes – modestly clothed
and shamelessly naked – more assertively, wittily, or sensuously than Rosso Fiorentino in
his *Madonna and Child with Saints* (fig. 53). Everyone in the picture is well covered except

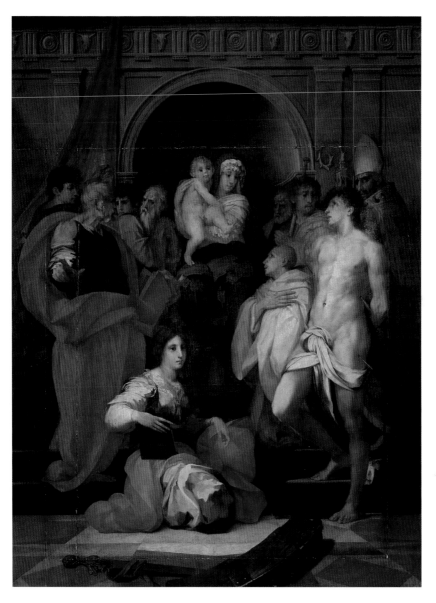

53 Rosso Fiorentino, *Madonna and Child with Saints*, 1522, Galleria Palatina, Florence.

the baby Jesus and Sebastian, whose gaze is so intense as he turns toward his naked little friend that he seems unconcerned that his loosely tied cloth is about to leave him altogether exposed in a fraction of a second. The light shines especially brightly on the glowing flesh of Jesus and Sebastian whereas the standing figures are all in shadow and their heads are turned this way and that as though something is distracting them from paying full atten-

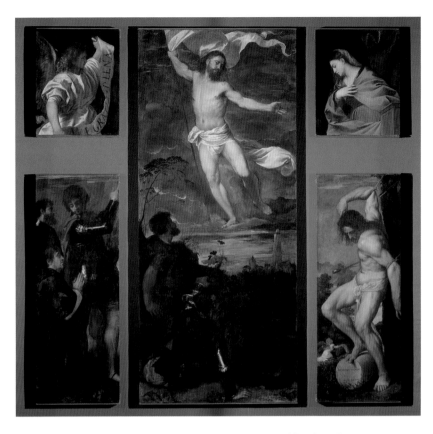

54 Titian, *Risen Christ with Sebastian and Saints* (Averoldi Polyptych), 1522,
SS Nazario e Celso, Brescia.

tion to the central figures of Mary and the child. Are they as disturbed about Sebastian's
state of undress as the mitred figure behind the young saint appears to be? We will never
know, but the painting makes two things clear: next to the perfectly relaxed, beautiful,
and adoring Sebastian, most of the other figures appear cloaked in darkness as well as
weighed down by their heavy draperies. Furthermore, Jesus and Sebastian not only share
the same flesh tones but the same innocent shamelessness about their bodies.

As Rosso's composition gorgeously insists, the link between the nude, supple, sexy
Sebastian and Jesus, however strained or shadowed by disapproving and bewildered
onlookers, is never completely broken. Surely aware of the slim, tender, and youthful
Sebastians of his contemporaries, the Venetian master Titian decided to make that point
in his own distinctive way. In his 1522 Averoldi Polyptych centered on the Resurrection,
Titian painted a Sebastian so strong, so "manly," so Promethean, and so like his risen Jesus
that it should have put to rest (at least temporarily) any doubts about Sebastian's mas-
culinity and his resemblance to his Savior (fig. 54). The Risen Christ, bursting with vigor

and health, dances free from mortality and the tomb with his handsome, shapely body intact. He stretches out his left arm and casts his eyes lovingly toward Sebastian who seems to be in the last throes of struggling to tear himself away from his bonds. It has been suggested that Titian signed his name on the broken column beneath Sebastian's right foot as a sign that his painting was superior to sculpture – even the great unfinished sculptures of Michelangelo's slaves which had served as models for "Titian's hulky, middle-aged Sebastian."[30] Titian's Sebastian looks like Titian's Jesus. In fact, he looks like Jesus on the Cross. He is not a fair, dreamy adolescent but a mature, muscular man. They suffer too, according to this picture. They also are like Jesus and worthy of his love (fig. 55).

Is this Titian's homoerotic fantasy or orthodox Christian thinking? Why not both? In *Queering Christ: Beyond Jesus Acted Up*, Robert E. Goss has recalled his days in a Jesuit novitiate: "In prayer, I imagined a naked Jesus as a muscular, handsome bearded man embracing me and became sexually aroused."[31] Although shocking to some Christians, this "confession" would have come as little surprise to Catherine of Siena, Teresa of Avila, John of the Cross, and many others, perhaps including the young disciple whom Jesus loved and who laid his head on the Lord's breast at the Last Supper. Even the great sculptor and goldsmith Benvenuto Cellini, who portrayed himself in his autobiography as a hot-tempered ruffian, imagined Jesus "in the form of a young man with light down on his cheeks. His face was marvelously beautiful."[32]

Renaissance artists developed varied and creative ways of showing a relationship between Sebastian and Jesus; they also did not shy away from imagining the saint in a physically suggestive rapport with another man. Long before the era of

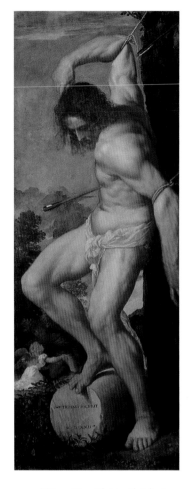

55 Titian, *Risen Christ with Sebastian and Saints* (detail of fig. 54, showing Saint Sebastian).

Pater and Wilde, painters seemed to delight in depicting a *sacra conversazione* ("sacred conversation"), a duet if not a dialogue, between Sebastian and his fellow patron of those suffering from the plague, Saint Rocco or Roche. Of course, in life, the two never met. Rocco was born of wealthy parents in Montpellier in 1295. According to *The Golden Legend*, he contracted the plague while on pilgrimage to Rome and decided to devote his life to nursing other plague victims and establishing hospices for their care. He was befriended by a young nobleman, Gotard, who became his beloved companion and, according to the Caxton translation of 1483, his intimacy with the saint was so close that he "joined him to Rocke sleeping."[33]

56 North Italian, *Saints Rocco and Sebastian*, 1490,
woodcut, Bibliothèque Nationale, Paris.

 While in *The Golden Legend*, the first signs of plague appeared under Rocco's arms, the tradition in art was to show the saint pointing to a sore on his thigh (fig 56). In the earliest renditions, the two saints seem to be unaware of each other.[34] Like statues in the niches of cathedrals, they stand together and apart, bound by their common patronage and sanctity but unrelated in historical time and consciousness. As artists strove for more naturalistic depictions of the human form, they sought, in grouping religious figures in one scene, to imagine ways in which they might relate to one another. The most obvious solution was to line up the saints with their attention focused on the central figures of Christ or the Madonna. However, as can be seen in the Rosso Fiorentino (see fig. 53), when the saints were a more mixed and motley crew crowded together in limited space, complex compositional choices had to be made. Certain decisions about posture, gesture, and facial expression produced the appearances of physical and psychological interactions among the blessed of varied (and probably not always intended) effects.

 Critics have pointed out that *sacra conversazione* implied "holy community" rather than actual conversation.[35] True, but it was inevitable in times of plague that Sebastian and Rocco would be shown together; and, within the aesthetic conventions of the late fifteenth and mid-sixteenth centuries, it seems to have been increasingly difficult to avoid showing them to be peculiarly "aware" of one another even in the presence of a third

57 Anonymous, *Saints Rocco and Sebastian*,
1476, San Pellegrino di Ripe.

figure. The nude saint pierced with arrows and the saint with an open sore in his thigh
had to cast their eyes up or down or – if not too audacious a thought – toward one
another. In a relatively early "dialogue," this is exactly the case. Rocco shows Sebastian his
wound and Sebastian looks (fig. 57).

Mary and the Infant Jesus look down from above but the two saints are absorbed in
one another or, more precisely, in Rocco's thigh. Sebastian's posture and the position of
his left arm seem to have less to do with his torment than with his deep interest in
Rocco's wound. Further, though Rocco has a manly leg and manly beard, his "sore," in
position and shape, comes close to resembling a vagina. (Surely, this is not a peculiarly
post-Freudian observation. It is hard to imagine any fifteenth-century Italian missing
this.) What could "Anonymous" have been thinking? Both figures retain their iconic
attributes, the wound and the arrows as badges of honor, the dress of the pilgrim and
the undress of the martyr as emblems of their heroism. In the tradition of *ostentatio vul-
nerum*, the showing of Christ's wounds as healing signs ("By his stripes we are healed"),
the showing of the injured flesh of the saints carried with it a message of bravery and
ultimate healing. As in many Renaissance variants on this subject, the "victims" look to
be in surprisingly good shape. They are also in shapes that defy or at least question sexual
stereotypes. Once again, the youthful Sebastian has the rounded belly and hips of a

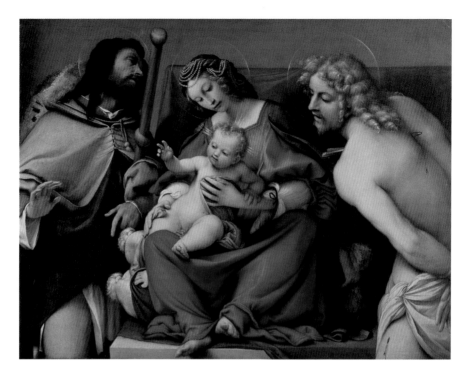

58 Lorenzo Lotto, *Madonna with Saints Rocco and Sebastian*, 1522, Contini Bonacossi, Florence.

woman and, even more startling, the rugged Rocco ("the boulder") exposes a private
part that looks disturbingly female.

Renaissance artists found in Rocco and Sebastian, as they had found in Jesus, Mary, and
a variety of saints, ample room for experimentation, play, and suggestive possibilities that
could remain faithful to devotional traditions while stretching their capacity to include
human predicaments and pleasures not always condoned by Church law. In the mid-
sixteenth century, Lorenzo Lotto and Giovanni Antonio Licinio, il Pordenone, composed
sacred conversations that could have served as patterns for what Eve Sedgwick has
described as "homosocial bonding," a triangle that includes a woman, but, in fact, serves
as a structure for bringing two men together in an otherwise forbidden (and denied) inti-
macy.[36] In Lotto's painting (fig. 58), Mary sits with the Infant Jesus between the two saints
whose postures indicate that they are attending to her. But, on closer inspection, the atten-
tion of Sebastian, like that of Jesus, is on Rocco's thigh. As always, Rocco is pointing to
his thigh but the wound has vanished or has been transferred to Sebastian whose thigh is
exposed in symmetry with Rocco's. The Virgin gives all her mind to the baby and pays
no attention to the two men. Rocco seems in ecstasy as he points down and gazes off into
space. Sebastian, with luscious blonde locks, leans almost rudely over the Virgin's knee
to get a better look at his fellow patron's thigh.

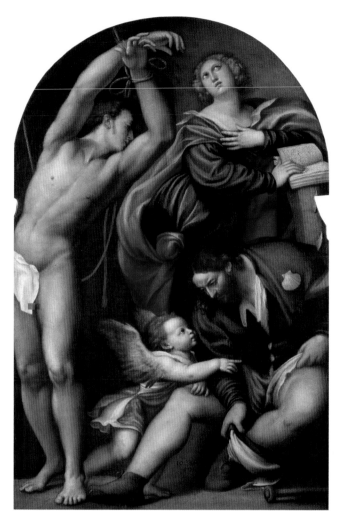

59 Pordenone, *Saints Sebastian, Catherine, and Rocco*, 1535,
San Giovanni Elemosinario, Venice.

Pordenone, who could make even the most unpromising subjects voluptuous, placed
Sebastian and Rocco with Saint Catherine of Alexandria (fig. 59) who appears even more
detached from the two men than Lotto's Madonna. As she looks up to the heavens, a par-
ticularly beautiful Sebastian, intent on displaying his nakedness while scrutinizing Rocco's
thigh, arches his body with luxurious abandon. Guiding the viewer's eye from the bright
and vertical Sebastian to the seated Rocco, an angel points to the pilgrim saint's ample
thigh, seemingly encouraging him to lift his trouser a bit higher since the crucial blemish
is not yet in view. Of all the paintings of Sebastian that might invite a "gay reading," this
one takes the prize not simply because once again Sebastian is a limber youth and Rocco

137

a bearded "hunk" but because the artist calls attention to the fact that both men are on the verge of exposing themselves in plain view of the other. As displays of healthy and beautiful bodies in the presence of an angel and a female saint, the two figures have not lost their iconic significance as reassuring signs in times of plague that, according to Christian belief, even the most tormented of bodies will be restored to their full glory. At the same time, this painting, like the many others of the two saints, together or apart, is a comment on masculinity, the male body at different stages of development, the male body with few or many resemblances to the female body, and the male body in intimate and interested relation to its counterpart. Even when the triangle is interrupted and complicated by other figures, even when Sebastian fixes his gaze on Mary and Jesus, as in Correggio's *Madonna di San Sebastiano* (fig. 60), the painter calls the viewer's attention away from and to the flesh, toward the heavenly feminine and back again to the mundane details of masculinity.

What finally can be said, with the help of paintings and texts, about "manliness" and saintliness? If "manliness" is conventionally understood as Nietzsche and Charles Kingsley seem to have understood it, as muscular, bold, and brave, there is good evidence in the Gospel of Mark and the legends and paintings that depict the Lion of Venice to qualify him as a "manly" saint. Sebastian and Rocco, like Mark, also risked their lives, their bodies, for their beliefs, one defying an emperor, the other caring for the sick and dying. As both the legends and the paintings demonstrate, the daring actions of these three, while incurring pain, need not be interpreted as resignation to meaningless suffering but as signs of hope in the ultimate resilience of bodies devoted to good works. Although the suffering body depicted as an object of beauty can be read as an instance of a sadistic religious aesthetic, it can also be read as the triumph of harmony over chaos. If beautiful forms, as Aquinas suggested, are taken as indications of God's grace, the male body, as well as the female body, can be displayed as a model of divine pleasure.

Renaissance artists read in the Gospels and legends of the saints an elasticity and generosity of perspective with regard to rich and poor, strong and weak, male and female, that gave them the freedom to imagine masculinity in more than one fixed shape or disposition. When in 1528 Castiglione describes his agile, ideal courtier enjoying sports with country men as displaying "a certain lovely freeness," he could have been describing the Roccos and Sebastians of Italian Renaissance paintings. True, Castiglione's expansiveness, like that of Titian, Tintoretto, Pordenone, and others, had its qualifications. The courtier should be "manly," not "soft and womanish," of "comely shape and countenance . . . [possessing] a certain grace . . . an air," and, of course, courage, so that "being pushed through the thigh with a pike . . . [he would think] it was the biting of a fly."[37] Was he thinking of Sebastian or Rocco?

Castiglione was seeking a symmetry of traits, a balance between strength and grace, refinement and vigor, good humor and dignity, sportsmanship and courage. Renaissance painters sought balance too. Fortunately, their ideas of balance, like their ideas of beauty

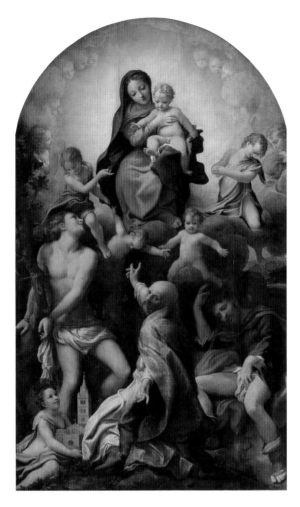

60 Correggio, *Madonna di San Sebastiano*, 1524–5,
Gemäldegalerie Alte Meister, Dresden.

and "manliness," were neither static nor free from imaginative play as well as a shared orthodoxy of spirit. In one of his most formal arrangements of Venice's favorite male saints, Titian places Sebastian and Rocco together beneath Mark seated on a pedestal (fig. 61). Mark is guarding the "plague saints." Rocco and Sebastian are paired, like the physicians Cosmas and Damian, but, of course, are not brothers. Although Mark's face is in shadow, his grizzly black hair and beard show quite clearly and he is seated, legs apart, with the ease of a general. A young Sebastian, whose lithe body is softly lighted, looks demurely over his left shoulder while shaggy, rugged Rocco points, as usual, to his exposed thigh. Damian looks at Cosmas; Cosmas looks at Mark; Rocco looks at Cosmas; Mark and Sebastian look at nobody. If this is a *sacra conversazione*, some of the characters

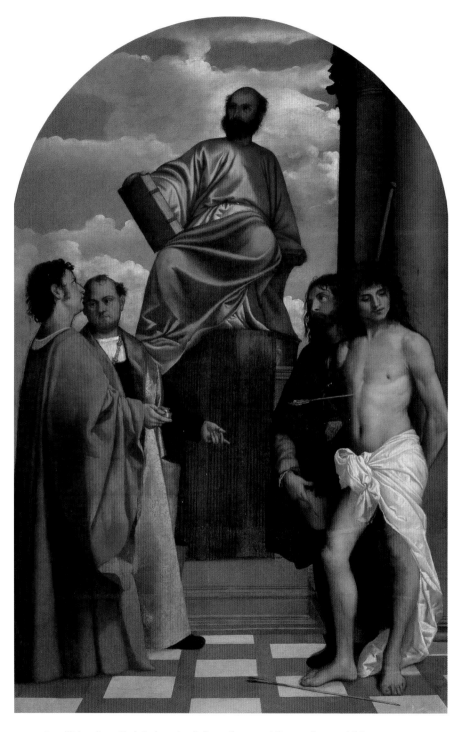

61 Titian, *Saint Mark Enthroned with Saints Cosmas and Damian, Rocco and Sebastian*, 1510,
Santa Maria della Salute, Venice.

seem not to be listening. Indeed, despite the formal arrangement of the figures, their relationship to one another is confused. The beautiful but uneven light and shade enliven but also break up the neat symmetry of the composition. However, the hands tell a story that the eyes and heads and shadows do not. The right hand of Cosmas, the left hand of Damian, and the right hand of Rocco all form a perfect diagonal pointing to Rocco's wound. But do they stop at Rocco's wound? Not quite. What meets the diagonal line of pointed fingers is Sebastian's well-turned leg.

What is going on in this picture?[38] Is it a code, a front for a subversive message? Hardly. It is what it seems to be: the great patron and protector of Venice is seated above four saints associated with healing. Yet this does not exclude or hide the fact that it is also a painting of five men of different ages, shapes, and conditions. The doctors look like scholars in dialogue; the enthroned evangelist holds his Gospel and shows his doge-like status as protector of the city; the pilgrim looks as though he has just returned from a hard journey; and Sebastian, well, Sebastian just looks beautiful – and healthy. His flawless body is the hope for healing that inspired the painting. The artist, through the hands of his figured emissaries, points to the beauty of that body. Within one scene and frame, art triumphs over the ravages of time; faith and science dispute the disfiguring progress of disease; and Venice, with "a certain lovely freeness," displays a handsome and healthy disregard for rigid Teutonic definitions of what it means to be a man.

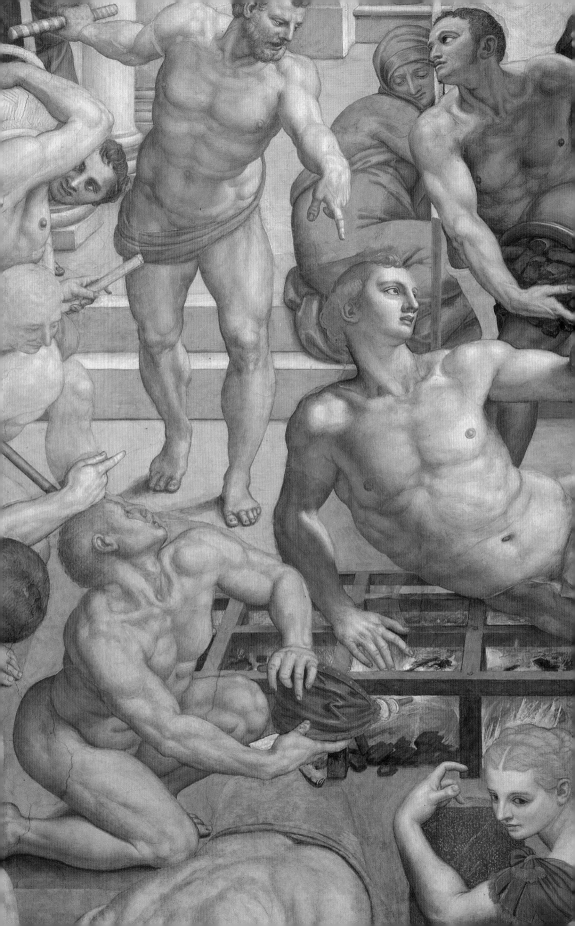

SAINT LAWRENCE

5

The Pearls of Saint Lawrence

What Ruskin Sees When He Looks at a Picture

Contemplata aliis tradere
(To pass on to others the things contemplated)
<div align="right">Motto of the Dominican Order of Preachers</div>

Affeto al suo piacer, quel contemplante
libero officio di dottore assunse.
(Although absorbed in his pleasure, the contemplative freely took on
the duty of teaching.)
<div align="right">Dante Alighieri, *Paradiso*, xxxii</div>

In *False Dawn*, the first of Edith Wharton's *Old New York* novellas, a young American on the Grand Tour in the 1840s encounters a blue-eyed Englishman gazing at the sky on an Alpine peak. When asked if he is interested in the form of cirrus clouds, the American admits that though he is interested in everything, his mind has not yet occupied itself with cirrus clouds. "His companion looked at him merrily. 'That,' said he, 'is no reason why you shouldn't begin to do so now! . . . For in order to be interested in things . . . it is only necessary to see them.' "[1]

After travelling to Florence and Venice with his new friend, the American returns home and presents his wealthy philistine father with a small collection of what were then known as Italian "primitives" – a Giotto, a Fra Angelico, a Piero della Francesca, and a Carpaccio. The old man, appalled by his son's unfashionable taste for obscure and unapproved

painters, demands to know what scheming foreigner had persuaded his naive son to waste family money on such worthless artifacts. "'Ruskin – John Ruskin,' said Lewis. Mr. Raycie's laugh, prolonged, gathered up into itself a fresh shower of expletives. 'Ruskin – Ruskin – just plain John Ruskin, eh? And who *is* this great John Ruskin, who sets God Almighty right in his judgments?'"[2]

By 1924, when *Old New York* was published, no new or old New Yorker with any claim to cultivation or business sense needed to ask who John Ruskin was or what a Giotto was worth. The humor, irony, and eventual pathos of Wharton's story turns partly on the self-satisfied ignorance and rigidity of an American capitalist but primarily on the immense influence of a writer who more than any other single critic of his time changed the way people in England and America looked at and thought about art. Although Wharton's Ruskin makes only a brief appearance in her story, he speaks as Ruskin wrote, with complete confidence and authority (though he too was a young man in his twenties in the 1840s) and with a seductive combination of invitation and command: "Begin now;" "It is only necessary to see," he says. In case one misses the association with a divine call – akin to Jesus's "Follow me" in the Gospels – Wharton includes an allusion to the Road to Damascus in the Alpine dialogue. *False Dawn* gives shape to conflicting views of Ruskin that continue to perplex: the magnetic appeal of the brilliant and earnest aesthete who wants to share his pleasure with everyone he meets, against the impossibly dogmatic moralist who sets himself up as a liberating messiah while in fact merely replacing one set of prejudices with another of his own devising.

Since Ruskin wrote voluminously, it is a temptation succumbed to by many editors to select the most attractive – that is, stylistically elegant, least dogmatic and meandering – bits of his prose and re-present him to the contemporary reader in a modified, compact, and presumably tolerable form. But this is a very un-Ruskinian thing to do. He loved awkward and seemingly unimportant detail and he rarely avoided controversial declarations or lengthy digressions. Ruskin at his "worst" is an essential component of Ruskin at his best. His power does not reside in laying down rules of aesthetics or morality (though constantly preoccupied with attempting to do so) but rather, like that of one of his most influential teachers, Saint Paul, his power derives from an extraordinary rhetoric rooted in a profound (and repeatable) experience of transformation. Although the terms sometimes shift, what Paul attributes to grace, Ruskin attributes to beauty. As with Paul and grace, it is not in Ruskin's definitions of beauty but in his *contemplation* of it that one uncovers his strength.

Transformation and contemplation are key to understanding Ruskin's relationship to works of art, especially Italian religious painting as he returned to it in his later years. It is no exaggeration to say that art saved his life, not just once but over and over again. Burdened by the memories of a lonely childhood, deprived of playmates, toys, and ordinary childish pleasures, shadowed through middle age by the presence of his overbearing puritanical parents, he suffered repeatedly and intensely from suicidal depression, lassitude,

insomnia, and periods of confused rage and fear.[3] Beautiful pictures and buildings did more than distract him or give him an excuse to think about something other than himself. Pictures, especially certain kinds of pictures, provided him with a means to confront and temporarily manage, literally give shape to, some of his deepest fears, angers, and desires. The layers of conflict – sexual, social, political, moral – are so prominent and numerous in Ruskin's life and writing that nothing is easier than showing what a self-contradictory person he was. What is remarkable is how frequently he was able to bring those contradictions into momentary, complex harmonies, less by means of logical argument than through a highly personal form of contemplation. The disapproving puritan confronted with a dazzling Botticelli *Madonna and Child* is not suddenly converted to Catholicism but he does, for a moment, become something new because of the painting and because of his own extraordinary willingness to stare, study, linger, gape at its beauty until it changes him. His harsh disjunctions and distempers fall away and the critic, for a sentence or paragraph or page, becomes a poet.

The process – the sometimes tortured but eventually contemplative process – by means of which Ruskin displays the transformative power of art is not merely a random series of subjective impressions but a methodology, a set of repeated patterns and strategies by means of which he approaches a painting, sculpture, or building and invites the reader to follow him.

Since Ruskin was adept at irritating as well as inspiring readers, one should probably start with the irritants: first, his dogmatism; second, his tendency to wander away from the subject; and, finally, his habit of fixing his attention on the margins of things. It is pointless to try to skip over Ruskin's opinionated and dogmatic assertions since they leap out from every three or four pages of his prose. In his discussion of "true" and "false" opinions concerning beauty in *Modern Painters*, he soars to great descriptive and analytical heights and then, in an instant, for a modern reader and indeed for many of his contemporaries, spoils the mood and the argument by advancing narrow and questionable opinions as though they were incontrovertible facts. For example, in his quest for universally acknowledged attributes of beauty, he dismisses in one sentence the experiences of an entire people and continent: "Respecting what has been asserted of negro nations looking with disgust on the white face, no importance whatever is to be attached to the opinions of races who have never received any ideas of beauty whatsoever."[4]

Coming from an Englishman writing in the 1850s, the racism and imperious assumption of cultural superiority are disturbing but not surprising. What undermines the logical structure of Ruskin's aesthetics, as in this extreme case, is his persistent mixing of prejudice with insight and his advancing of both indiscriminately as God's or Nature's truth. Critics have often contrasted the "brilliance of Ruskin's prose style" with the "crudity" of his methodology; one called *Modern Painters* "one of the most poetic, most brilliant, yet most wrongheaded volumes ever published."[5] The trouble is that what was "right" or "wrong" with Ruskin's head cannot be easily separated. Ruskin himself would have been

reluctant to accept the notion that poetry and brilliance can coexist with folly, or even madness, without being informed by them.

Turning to a less politically and culturally weighted assertion than that which treats differing views of beauty among races, Ruskin can be dogmatic even when discussing abstractions: "I assert positively, and have no fear of being able to prove, that a curve of any kind is more beautiful than a right line" (*MP*, II, v, 273). This idea is hardly new with Ruskin. It can be found in one form or another in Aristotle, Leonardo, and Hogarth, among others. However, Ruskin's tone makes you want to disagree with him, to conjure up Archimedes, or the desire for straight linearity in the designs of the Pyramids, or the beautiful illusion of straightness in a moonbeam, or the actualization of straightness in Cubist art. In short, the provocation of this kind of reaction is precisely one of the strengths of Ruskin's pedagogical prose. He is continually ready to start and restart an argument, to construct and reconstruct a thesis, but also to throw down the gauntlet. The main point is to make sure that the reader is still "with" him, not necessarily in agreement but in the density and dynamism and seriousness of his subject. "Art is no recreation," he often repeated. "It cannot be learned in spare moments, nor pursued when we have nothing better to do" (*MP*, II, i, 219).

It would be a mistake to think that Ruskin's dogmatism was merely a strategy intended to engage the reader. He clearly believed what he said at the moment of writing, though he was also capable of changing his mind and contradicting his own downright assertions. Ruskin knew what he was doing; more important to him than converting readers to his theories about beauty or the curve or the superiority of European culture was to persuade Victorians, on the lookout for high seriousness and utility, of the profound seriousness and usefulness of the study of art. For Ruskin, "man's use and function . . . is to be the witness of the glory of God" (*MP*, II, i, 221). For him that glory is nowhere more powerfully reflected than in art's representations of natural creation and, equally important, of its endless revelation of the divine source of creativity. "All Nature, with one voice – with one glory – is set to teach you reverence for the life communicated to you from the Father of Spirits. The song of birds and their plumage; the scent of flowers, their color, their very existence . . . and all the arts of men."[6]

Ruskin wanted his readers to take art seriously. He wanted to teach them to pay close and sustained attention to all of its components and manifestations, that is, to be like him in attitude if not in erudition. If we as readers pay as close attention to his language as he does to the brushstrokes of painters, we learn that his dogmatic utterances are rarely left unqualified or unchallenged on further consideration. It can hardly have escaped a critic as sensitive to language and obsessed by geometry that making a rule (even a "rule of thumb") about a curve is to place a strict and straight line in the service of that which it is not and cannot measure. Ruskin almost instantly deviates from the seeming stringency of his rule by arguing that what is most agreeable about every curve is that it "divides itself infinitely by its changes of direction" (*MP*, II, v, 273).

Dogma constrains and sets limits; the curve, by its nature, is in an unending process of change. Together they constitute Ruskin's prose style which obsessively classifies, catalogues, and lays down laws only to deviate from them. His rules are not mere excuses for digressions, however; they are springboards for them. How rigid it at first seems for a critic to be so insistent and emphatic about a curve or, in another section of *Modern Painters*, about infinity. Yet the rigidity gives way to something richer, more complex, more poignant. The curve "changes direction"; and "infinity," staunchly defended as a necessary ingredient of all beautiful art, is translated into a "white stroke under the sleeve," "a window open," "the door ajar" (*MP*, ii, v, 268). What had begun as a stubborn defense of a sterile abstraction becomes a lyrical witness to variety and possibility. Ruskin often seems to slam the door shut only to experience the exhilaration of throwing it wide open again.

A second irritant in Ruskin's critical "method" is his seeming inability to stay on a straight course. Hard as one may try, it is impossible to separate the blunt, abrupt, declarative Ruskin from the meandering, digressive, lyrical Ruskin who, in the opinion of some readers, is incapable of remaining on any single subject without veering off in a dozen different directions. It is true that with little or no provocation or connection with his ostensible topic, he is ever ready to deliver a sermon. Having read through the Bible with his mother every year as he was growing up, he developed a prose style interwoven with biblical quotations and tuned to scriptural harmonies and rhythms. Yet what is more striking still and more relevant to his persuasiveness as a critic is his habit of looking at a painting *as though it were scripture*, another version of God's self-revelation and therefore worthy not only of the most careful scrutiny, analysis, and interpretation but also of something more distinctive – a meditation, a departure from the letter of the text, the line and color of the painting, into another realm altogether. In *The Stones of Venice*, he wrote of Saint Mark's, "The whole church may be seen as a great Book of Common Prayer . . ." Before Gutenberg, the common people "had no Bible, and – Protestants do not often enough consider this – *could* have no other."[7]

Where painting is concerned, it is not true that Ruskin cannot stay on his subject. No art critic of his time literally dwelled with his subjects more persistently than Ruskin. His journals and letters, sketches and daguerreotypes are testimony to the hours, days, and months of sitting in damp churches, climbing ladders and scaffolding, all so that he could get close to and stay close to the pieces he was studying. When he departs from a work of art it is after a long looking at it, and the departure is not a change of subject but a meditation prompted by it, a kind of *midrash*, a rabbinical or priestly contemplation of the kind that only the holiest texts merit. Like another of his influential teachers, Saint Augustine, but unlike his evangelical parents, he honors the text (the painting) not by literalizing or allegorizing it, but by trusting it and his encounter with it to carry him into deep introspection and often highly subjective flights of "free" association. The beautiful painting, like the sacred text, enables and legitimates a liberating digression. Little wonder that Proust became an admirer and an early translator of Ruskin into French.

62 Giotto, *Saint Francis Rejects His Father*, 1325, Bardi Chapel, Santa Croce, Florence.

Examples of this meditative, digressive way of looking at and writing about painting abound in all of Ruskin's writing but they increase in number and intensity of feeling in the 1870s after some of his more severe depressions and, perhaps more importantly, after he had been able to separate himself (in large part if not completely) from the emotional dominance of his parents, both of whom had died by 1871. In *Mornings in Florence, Being Simple Studies of Christian Art for English Travellers*, delivered as lectures at Oxford and published in chapters between 1875 and 1877, Ruskin takes his reader into the Bardi Chapel in the Church of Santa Croce in Florence to examine frescos by Giotto of scenes from the life of Saint Francis of Assisi. (Ruskin made several visits to Assisi, slept in a Franciscan cell, befriended a learned friar, and developed a distinctly un-Protestant devotion to Francis, even carrying a fragment of the saint's rough habit as a relic with him until his death.[8]) Drawing a surprising analogy between a Greek vase and a Gothic chapel, Ruskin invites us to admire the whole space while circling around inside it since "the chapel is merely the vase turned upside down, and outside in."[9] Although he attends carefully to each scene, he dwells longest on the one highest up and most difficult to see from the floor. Young Francis, having given away his belongings and stripped himself naked, is denounced by his father before a crowd of onlookers and is partly covered by the cloak of a benevolent bishop (fig. 62). At first, Ruskin describes the scene with a detached sarcasm that appears to anticipate the reaction of an upright Victorian tourist who would find the whole episode embarrassing if not downright insane. "One of St. Francis's three great virtues being Obedience, he begins his spiritual life by quarrelling with his father. He, I suppose in modern terms I should say, 'commercially invests' some of his father's goods in charity" (*MF*, *Works*, XXIII, 343).

Ruskin carries on the disdainfully arch description so convincingly that it comes as a jolt when he suddenly stops and puts it aside like an outdated textbook: "I have read the picture to you as . . . the plain, common-sense Protestant" would read it. "If you are content with that view of it, you may leave the chapel . . . and Florence also; for you can never know anything either about Giotto, or her" (*MF*, *Works*, XXIII, 344). Suddenly the charming and good-natured guide has become severe and, if the reader happens to be a "common-sense Protestant," insulting. Given the disposition of his Oxford audience, such a tone took courage as well as supreme confidence. In any case, Ruskin does not let up. He promises to "re-read" the painting "from the mystic, nonsensical, and Papistical side." What he in fact does for the next several pages is to reread the painting in terms that have an unmistakable resonance with his struggle for independence from his own parents. He quotes Saint Paul's Epistle to the Ephesians instructing parents "not to provoke [their children] to wrath." Ruskin admits that the same epistle instructs children to obey their parents but insists with fervor that "it never said anywhere in the Bible, and never was yet said in any good or wise book, that a man's, or woman's" duty is the same (*MF*, *Works*, XXIII, 345).

As the passage proceeds it becomes clear that, for Ruskin, "obedience to God," as in the case of Francis and, by analogy, in his own life, means following one's own deepest longing rather than the dictates of a father or mother. This is no superficial rebellion, no "young cockney hopeful to have a latch-key and a separate allowance," but a person willing to sacrifice the approval of family and society in order to follow his true calling. As the meditation continues, Ruskin's voice becomes increasingly anguished and angry as he imagines the rejection suffered by Francis and by Christ. Like the chapel-as-Grecian-vase, the story has been turned upside down and outside in. It is now the parent who has rejected the child and not vice versa. Indeed, Ruskin more than imagines that rejection; he identifies it with his own until the subject of the discourse temporarily becomes the personal/impersonal "you" into which Ruskin, Francis, Jesus, and potentially the empathetic reader merge as one: "There will come a moment when the voice of man will be raised, with all its holiest natural authority, against you . . . the father and the master – the entire voice of your prudent and keen-sighted acquaintance – the entire weight of the scornful stupidity of the vulgar world, for *once*, they will be against you, all at one" (*MF*, *Works*, XXIII, 346).

It would be easy to argue that Ruskin merely makes use of Giotto's fresco in order to vent his own anger and frustration, that the painting is a kind of Rorschach ink blot onto which the critic reads whatever he wants. While there may be some truth in this, since Ruskin was frequently ridiculed in the press and isolated by his Oxford colleagues because of his "radical" ideas about art and politics, it is an incomplete description of what actually occurs in the way he looks at art. Before anything else, the paintings are always scrupulously studied and described. Then, as in the meditation on the Francis fresco, the painting under consideration is returned to when the reverie winds down. If there is a moment

of identification or a transformative insight, it is rarely confessional. (My biographical asides on Ruskin's reading of the Francis fresco depend largely on information not available to the audiences of his day.) What is "mystical" and "Papistical," in Ruskin's sense of those terms, about his reading of the painting, is that though anger and resentment are expressed, insofar as they are united with the subject and beauty of the fresco, they are freed from the limits of egotism. They are also freed from a prejudice that would judge Francis's actions as fanatical or insane. The critic's moment of insight or identification is a sharing that is personal in tone and almost sacramental in its implications. Ruskin presents himself as a witness to the transformative power of art. His is an exemplary case of willing and disciplined susceptibility to that power. He challenges (some would say "browbeats") the viewer and reader to study first and only then let the imagination soar.

Ruskin concludes his meditation by returning to Francis and Giotto but somehow painter and saint, like the "Protestant" and "Papistical" readings, have merged into one. When Ruskin observes that "St. Francis's renouncing his inheritance . . . is the beginning of Giotto's gospel of Works," it sounds for a moment as though his conversion to Popery has been complete. But not quite: "Unless the hardest of deeds be done first," he continues, "all other deeds are useless" (*MF*, *Works*, XXIII, 346).

Given his religious background and his extreme moral as well as aesthetic sensitivity, it was inevitable that Ruskin's long love affair with late medieval and early Renaissance Italian painting would confront him with Roman Catholic devotions and doctrines that were alien to him: the primacy of the Virgin Mary as mother and matriarch; devotions to saints and their heroic escapades; the emphasis on the Incarnation and consequent preoccupation with the body of Christ; the reliance on mystery and symbol, and most troubling of all, an iconography so elaborate, ancient, and beautiful as to have been endowed for centuries with attributes of the sacred:

> As all truly great religious painters have been hearty Romanists, there are none of their works which do not embody, in some portion of them, definitely Romanist doctrines. The Protestant mind is instantly struck by these, and offended by them . . . Thus most Protestants, entering for the first time a Paradise of Angelico, would be irrevocably offended by finding that the first person the painter wished them to speak to was Saint Dominic. (*SV*, *Works*, X, 126)

Ruskin was not the kind of critic who could restrict himself to the plastic surface of things, though he always began there. What is remarkable is the way in which what he himself calls "the common sense Protestant" view alters over the years from shock and disapproval to an often profound sympathy for the materiality of Catholic culture that signals an inner change, though not conversion. Even in his most affectionate moods, he remains a dissenter and, in keeping with his structural preoccupations, usually finds a way to de-center himself as a viewer of and would-be participant in the world of Catholic art. Anyone familiar with Ruskin's paintings and drawings of buildings knows how he favored

LEFT 63 Ruskin, *Part of the Façade of San Michele, Lucca,* 1845, Ashmolean Museum, Oxford.
RIGHT 64 Ruskin, *South Side of St. Mark's from the Loggia of the Ducal Palace,* 1850–1, private collection.

half-windows and broken arches, fragments of architraves and incomplete porticoes (figs. 63 and 64). It is as if he always entered churches, especially Italian churches, by a side door and remained off center, examining an obscure chapel in the transept while High Mass was being sung on the main altar.

The same tendency to get at central ideas from a fragmented, lateral vantage point is often at work in his studies of sculpture and painting. To some readers, it is Ruskin's most irritating habit. For example, in his discussion of a famous Botticelli *Virgin Enthroned with Saints* (fig. 65), Ruskin concentrates not on Mary or Jesus but on Saint Michael, the figure closest to the right edge of the painting. For Ruskin, Italian art, almost like nature itself, crowds the horizon with possibilities. The discerning viewer must make choices and those choices are not necessarily the obvious ones dictated by the artist or convention. Ruskin's

153

65 Sandro Botticelli, *Virgin Enthroned with Saints*, 1488, Galleria degli Uffizi, Florence.

discerning and dissenting eye moves about a painting until it finds its own way in. In this case he lingers on the edge: "The Saint Michael of Botticelli is a simple knight of Florence, standing before the Madonna . . . He is the Saint Michael of Peace, who stilleth the noise of the crowd and the tumult of the people" *(MF, Works,* XXIII, 273).

It is as though Ruskin wants to call attention to what the viewer is most likely to overlook: the highest, hardest to see fresco in the Bardi Chapel; the shortest, slightest saint in Botticelli's lineup, a figure on the margin of a colorful crowd, almost swallowed up by shadows and dark armor. Examples of this tendency abound. In analysing Pisano's sculpture of Jabal (fig. 66) on the bell tower next to the Duomo in Florence, Ruskin ignores Jabal and turns to Jabal's dog and Jabal's tent: "Note especially as a thing which would only have been enjoyed by a painter, and which all great painters do intensely enjoy – the *fringe* of the tent" *(MF, Works,* XXIII, 422). Nowhere is he more adamant about the importance of the periphery than in his encomium on Galileo's cap on a worn-down tomb carving in Santa Croce:

66 Pisano, *Jabal* (with dog at lower right), 1324,
Bell Tower, Duomo, Florence.

And now, here is a simple but most useful test of your capacity for understanding Flo-
rentine sculpture or painting. If you can see that the lines of that cap are both right,
and lovely; that the choice of the folds is exquisite . . . then you can understand
Giotto's drawing, and Botticelli's; – Donatello's carvings, and Luca's. But if you see
nothing in *this* sculpture, you will see nothing in theirs . . . What is Florentine, and
forever great – unless you can see also the beauty of this old man in his citizen's cap,
– you will never see. (*MF, Works*, XXIII, 308)

Once again Ruskin is doctrinaire. Once again he digresses. Once again he seizes on a
tangent. What may at first appear to be eccentricities or lapses become on wider reading
in his art criticism consistent enough to look like a methodology. He approaches each
work cautiously, maintaining a physical and emotional distance until he has grasped and
mastered the overall design. Then he enters through a side door, a fringe, a cap, a saint
at the end of the row and proceeds to "repaint" the picture, placing what had been his
peripheral entrance point at the center. By means of exaggerated claims and often gor-
geous meditative digressions, he transforms himself and the painting into a new creation,
a literary artifact which does not reproduce or obliterate the painting or the private life
but borrows from and transfigures both. Ruskin, though always ready with a new theory,
seems to have been more at home with contemplating the concrete in its ever varying
forms than in sustaining abstract reasoning. His own definition of "theory" goes back to

its ancient roots: "This dwelling upon and fond contemplation [of beauty] . . . is perhaps [what] was meant by the Greek theoria" (*MP*, ii, v, 246).[10] Further, for Ruskin, though contemplation begins with close and scrupulous attention to the surface of things, it does not remain there, but "believes the truth of the vision she has summoned, loses sight of actuality, and beholds the new and spiritual image faithfully" (*MP*, ii, v, 451).

A prime example of Ruskin's "wrong-headed," dissenting, and decentered yet powerfully empathetic and persuasive way of looking at painting occurs in a lecture on Fra Angelico delivered at Oxford in Michaelmas Term 1874, later published in *The Aesthetic and Mathematic Schools of Art in Florence*. Ruskin describes his reaction to one part of one painting with rapturous attention. The San Marco Altarpiece (fig. 67), now in the museum in the Dominican convent of San Marco in Florence, was originally in the church of that famous monastery built with Medici money. Like a tour guide, Ruskin ushers his reader toward the painting (at that time, in poor condition) and presents a first impression and a description of its subject matter: "A picture very sad and dingy at first glance, and in great part rubbed quite out. It is nevertheless the most precious Angelico in Florence and, as far as I know, in the world."[11] As is often the case, Ruskin peremptorily draws attention to what we as viewers might otherwise have missed. If the painting is unremarkable at first sight, the fault lies not with the original but with time and the ignorant restorers who have tampered with it. As for value, Ruskin does not appear interested in market price. Although he was a collector of Turners and medieval missals, the "preciousness" of the painting is other than monetary. Before evaluating the work further, he lists the cast of characters: "It represents Our Lady enthroned, with the infant Christ. St. Cosmo and Damian kneel before the throne. On the Madonna's left hand, St. Dominic, St. Francis, and St. Peter Martyr; on her right, St. Mark, St. John the Evangelist, and St. Lawrence" (*AMS*, *Works*, xxiii, 261–2).

At this point, one might expect Ruskin, like most art critics since, to make some general observations about the central figures of the painting and its peculiar staging of an otherwise familiar scene. In his 1974 essay on Fra Angelico, John Pope-Hennessy called the painting "a truly revolutionary work" whose innovations – "the orthogonals of the beautifully rendered Anatolian carpet," "the recession of the unprecedentedly extensive foreground," the "wall covered with woven fabric," the symmetrical arrangement of "palm trees . . . cedars and cypresses" – were imitated by generations of Italian painters.[12] Another critic observed that the saints surrounding Mary occupy the same space as the Madonna and Child rather than being separated from them in framed niches as in earlier paintings.[13] In his magisterial 1993 study, *Fra Angelico at San Marco*, William Hood notes the almost *trompe l'oeil* foregrounding of Cosmo and Damian, the two Medici patron saints, who seem to invite the viewer into the painting; the extraordinarily delicate arrangement of trees and shrubs in the background; the unusual authority in the upright pose of the infant Jesus who is holding an orb with an actual map of the world imprinted on it; and the striking originality and theological importance of the readable texts from

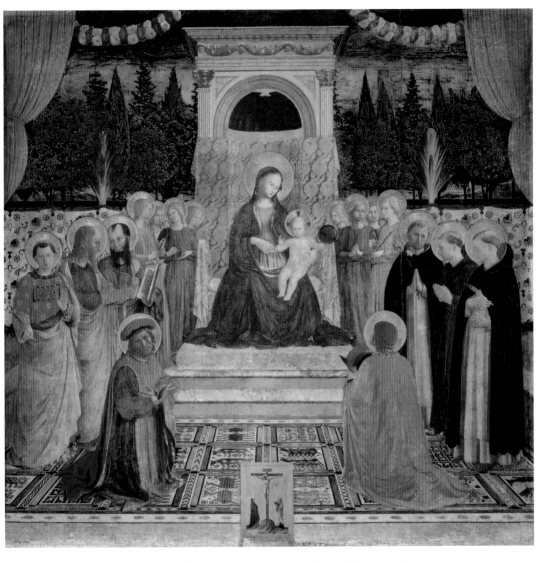

67 Fra Angelico, San Marco Altarpiece, 1438–40, Museo di San Marco, Florence.

Ecclesiastes embroidered on the Virgin's mantel and from Mark's Gospel on the book the saint holds open.[14] Given the poor condition of the painting in Ruskin's time and the fact that it has been painstakingly restored with the help of modern scholarship and technology, it might seem reasonable to assume that some of the detail noted by Pope-Hennessy and Hood was not fully visible in 1873. Yet from the evidence of copies and reproductions from Ruskin's time, everything that the modern critics mention, with the exception of the biblical texts, was in plain view.

What is fascinating, peculiar, and telling is where Ruskin's eye goes after his brief intro-duction. It is not to the central figures of the Madonna and Child, not to the boldly placed Cosmo and Damian, or to the brilliantly conceived perspective of the stage set but to the costume of Saint Lawrence (fig. 68):

> St. Lawrence is dressed in the following manner. He has a rose-colored tunic studded with golden stars, each star centered by a turquoise. On his breast is a large square scroll of gold, with an arabesque of pearls upon it, and his sleeves are embroidered with silver . . . Every turquoise and pearl is painted to a point beyond everything else in art. Chinese, Indian, American, old Spanish, Venetian, German, what you will — no gold and pearls were ever designed or done in the world like these. Van Eyck, Memling, Mantegna, even Botticelli are nowhere in comparison. (*AMS, Works*, XXIII, 262)

Suddenly, in a breathtaking indifference to the rest of the painting, Ruskin moves from calm description to the kind of hyperbole that has earned him the reputation of an insuf-ferably arrogant critic whose insights blind him to any way of seeing a picture other than his own. There is no doubt that he invites this reaction. After all, these remarks were delivered from a lecture platform. Still, there is another way to read them. Like the lit-erary critic, the art critic's most common, useful, and, at the same time, treacherous form of discourse is comparative. Yet every reader and viewer of works of art (and nature) knows that there are moments of encounter with objects of beauty that seem incompa-rable. What is the critic to do? Remain silent? Not if he is Ruskin who, like a lovesick sonneteer, would rather risk wild overstatement than refrain from giving utterance to his delight in the unique beauty of what he sees. Ruskin is not alone in his dilemma. Shake-speare often laments the failure of language to convey the true experience of beauty con-vincingly:

> If I could write the beauty of your eyes
> And in fresh numbers number all your graces,
> The age to come would say, "This poet lies." (Sonnet 17)

Shakespeare's ironic conditional, "If I could write the beauty," becomes in Ruskin an earnest, ecstatic determination to do just that, even if it means showing "not half [the] parts" of the painting or the saint's tunic. Notwithstanding his reputation for erudition, the professor could hardly have expected his Oxford audience or his readers to believe that he had seen more than a fraction of Chinese, Indian, or even European art. Yet he could certainly expect them and us to believe that he was captivated, stunned, at a loss for a proper comparison by what he saw in Fra Angelico's altarpiece. His claim for Saint Lawrence's pearls is as unprovable and impossible as a lyrical declaration of love. What is peculiar about it is not the utterance as an outpouring of delight in an object of beauty but the essayistic lecture format in which it is unfittingly framed, as if it were meant to be, as the title suggests, a lesson in mathematics.

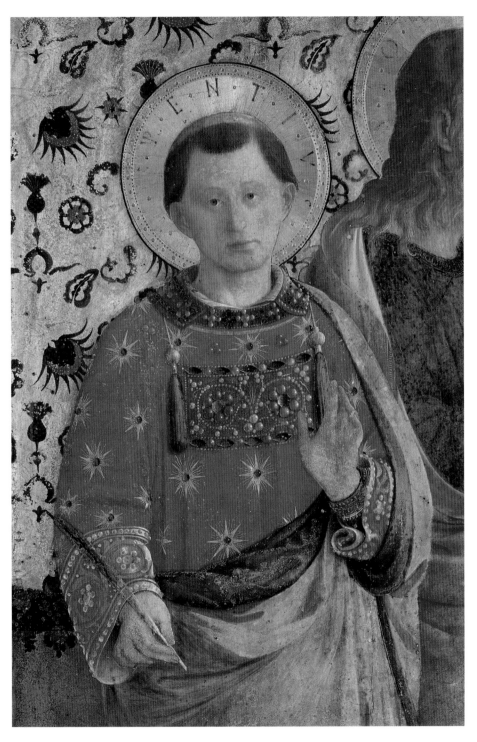

68 Fra Angelico, San Marco Altarpiece (detail of fig. 67, showing Saint Lawrence).

Instead of returning to an overview of Fra Angelico, Ruskin remains preoccupied with Lawrence's pearls and especially with the intensity of his own response to them: "Now what is the meaning of this?" "Every pearl is painted as if he had sold all that he had to buy it" (*AMS*, *Works*, xxiii, 262).The reference is to Matthew 13:46 in which the kingdom of God is compared to a merchant "who, when he had found one pearl of great price, went and sold all that he had, and bought it."[15] What is less clear is whether the "he" in Ruskin's sentence is Fra Angelico or Saint Lawrence or the critic who had recognized something uniquely "precious" in the "dingy" painting. The confusion or conflation of painter, subject and viewer is important. Ruskin accepted the tradition established by Vasari that Fra Angelico was a holy and modest friar whose piety informed his paintings with "purity," "innocence," and "simplicity," qualities with moral as well as painterly connotations. He must also have known that Saint Lawrence was martyred after giving away most of the Vatican treasury to the poor. Tormented throughout his life with personal and religious doubts and hesitations, Ruskin typically read signs of total devotion with an admiration triggered in part by envy and often converted into aesthetic transport.

Even more important than the conflation of artist, subject, and critic, however, is the identification of the magnificently painted pearls with the "pearl of great price" and, by a not very complicated indirection, the "kingdom of God" with the precious altarpiece. Everything in Ruskin's evangelical upbringing mitigated against the substitution of images for the transcendant and, most particularly, against the slightest gesture or word that would resemble what was considered popish idolatry. During his early sojourns, he often recorded the "severity" with which he judged the "idolatrous" attitude of Italians toward religious art. Yet with every trip to Italy, and certainly by the 1870s, his Calvinist convictions and inhibitions weakened, while his physical disposition before religious works of art became, often to his own astonishment, more passionate and demonstrative. Overwhelmed ("crushed" is his word) by Tintoretto's *Crucifixion* in the Scuola di San Rocco in Venice, he prostrated himself before it (in a diary entry of August 29, 1874, he wrote, "At Academy saw Sandro's [Botticelli's] *Madonna Enthroned* and *Madonna Crowned*, and was more crushed than ever by art since I lay down on the floor of the Scuola di San Rocco before the *Crucifixion*." *MF*, *Works*, xxiii, xlix); on trips to Fiesole and Assisi, he frequently mentions kneeling before frescos, not only to study but to pray before them (in his diary of September 9, 1874, he wrote from Fiesole, "I knelt in the road to the little lamp-lighted shrine as I returned to the Convent of San Domenico [where Fra Angelico had been a monk] in the twilight." *MF*, *Works*, xxiii, xlvii). In a striking literalization of an aesthetic communion, he writes that he would like not only to draw Saint Mark's and its mosaics but "eat it all up in my mind."

Another kind of appetite comes into play in his extended consideration of Saint Lawrence's pearls but only to distinguish their quality from a vulgar display of sensuous excess: "In his pearly affluence St. Lawrence would only have reminded you of the principal dish at the Princess Parizade's dinner – cucumbers stuffed with pearls" (*AMS*, *Works*,

xxiii, 262). In a passage of outlandish and impossible comparisons – or rhetorical demonstrations of the uselessness of comparison in the face of this unique work of beauty – this one takes the cake or the cucumber. Unless you had just put down the *Arabian Nights*, Princess Parizade's menu is probably the last thing to jump into your mind on seeing Fra Angelico's *Madonna and Child with Saints*. The effect of this odd and grossly inappropriate comparison is to return us yet again to the extraordinary and incomparable picture:

> With Fra Angelico it is the exact reverse. By the entirely passionate and perfect painting of them the jewels *become* divine; they *become* worthy of the saint in their own supreme perfectness; their beauty is so great that it *becomes* beauty of holiness [my emphasis]; and instead of feeling that they disguised St. Lawrence, you feel as if he could have been dressed no otherwise. (*AMS, Works*, xxiii, 263)

A union of "passion" and "perfection" may sound like a Victorian cliché, a Browningesque formula for a secular marriage of affect and craft, but, though Ruskin was capable of repeating such easy formulations, he usually was careful about his choice of loaded words when applying them to works whose religious subjects were bound to lend their own coloring to them. In the terms of his strict upbringing and early emotional makeup, "passion," defined as intensity of feeling, and "perfection," defined as right reason and right behavior, did not and, according to his mother and father, should not go together. In his forties he wrote to his parents that they had done him irrevocable harm by raising him correctly but without any demonstration of love or affection. Perfection and detachment were the natural counterparts for the senior Ruskins, and that puritanical combination had been deeply imprinted on the moral consciousness of their only child.

In praising "the entirely passionate and perfect painting" of a martyred saint by an artistic genius who had given up the pleasures of life for a religious vocation, Ruskin could hardly have thought of "passion" without including among its connotations of overpowering love a sense of redemptive sacrifice and suffering. Self-denial and pain, like his own, need not be meaningless. "Perfection" too, while encompassing the finesse of Fra Angelico's brush and the fidelity of his life, suggests a metaphysical dimension of the kind referred to by Jesus when he says, "Be ye perfect as my heavenly Father is perfect" (Matthew 5:48). This is not an exhortation to behave well but to be transformed. By uniting terms with such powerful religious as well as psychological and aesthetic resonance, Ruskin is not just describing a great painting but endowing it with an intrinsically sacred, healing power. In the course of his description, the painting becomes an icon, and the once detached narrator-critic momentarily becomes – or, at least, writes like – a worshipper.

"Becomes" is the key word in this extraordinary passage. "The jewels *become* divine"; "they *become* worthy of the saint"; "their beauty . . . *becomes* beauty of holiness." For this English Protestant viewer, the altarpiece is precisely not a "given" icon, not automatically and routinely iconic, not a familiar appeal to a cultural habit, but rather a challenge to

break a habit of seeing perfection dispassionately. Angelico's painting produces a transformation in the viewer, changing him from a critic to a worshipper, and is somehow in a continual process of enacting a transformation from the ordinary to the extraordinary, from the mundane to the divine, as though the artist's hand, like that of Jesus the High Priest at the Last Supper, sets in motion an endlessly repeatable transubstantiation. "Angelico pours out every earthly treasure around his St. Lawrence, and forces you to look only at the face still – the highest expression of religious life yet, as far as I know, achieved by man" (*AMS*, *Works*, XXIII, 268).

What a surprise! We thought we were looking at the pearls when, all the while, the pearls were merely – what? the prelude, the come-on, the biblical referent, the dodge, the ornamentation, the painter's indulgence, the aesthete's refuge, a Medici hand-me-down, the critic's excuse for analysis when what he really wants to do is point to a face about which he makes enormous claims and has nothing analytical to say. The saint's face is lovely, but it does not defy description. Some viewers might easily speak of its coloring, shape, angle, expression, features, but Ruskin will not or cannot bring himself to do this.

His procedure makes two leaps, from the descriptive to the lyrical and from the lyrical to the ecstatic, that cause one momentarily to forget that this is a lecture on painting and brings to mind instead the structure in miniature of the last cantos in the *Paradiso* where Dante leads the reader closer and closer to the beatific vision until he runs out of words. The longer and harder Dante gazes in the direction of the divine, the less he can find a satisfactory language or even remember what he wishes to say:

> *Qual e colui che sognando vede,*
> *che dopo 'l sogno la passione impressa*
> *rimane, e l'altro a la mente non riede,*
>
> *cotal son io, che quasi tutta cessa*
> *mia visione . . .*

> Like one seeing in a dream, and after the dream,
> the imprint of passion remains,
> but nothing else stays in the mind,
>
> such am I, since my vision almost disappears
> completely . . .
>
> *Paradiso*, XXX, 58–62

Dante cannot describe the source of his oblivion. What he can describe with astonishing economy and pointedness is the experience of contemplation, a sustained and concentrated looking even when, or especially when, the object of interest is beyond his powers of clear perception, description, or analysis:

162

Cosi la mente mia, tutta sospesa,
mirava fissa, immobile e attenta,
e sempre di mirar faceasi accesa.

Thus was my mind – completely suspended, my gaze fixed,
unmoving and intent; and it
grew increasingly inflamed as it watched.

<div align="right">

Paradiso, XXXIII, 97–9

</div>

Without blank verse or *terza rima*, Ruskin reaches for an expressivity, not merely an effect but a verbalized experience at once personal, intense, overwhelming, and finally so antithetical to his public persona and to the formalities of the lecture platform as to have nowhere to go except downhill into exhortations on taste or more frequently into awkward breaks in rhythm, silences that are gaps or gasps until the next new beginning. It is as though, without Dante's cosmic structure or Shakespeare's Petrarchan envelope, he is left high and dry in moments of ecstatic and contemplative transformation with no philosophical or social system with which to connect them.

While he was often intrigued by the inventiveness of his era, Ruskin saw the culture of scientific "progress" and positivism as literally eating away at the connections between knowledge and vision, skill and insight, curiosity and faith. In a letter written from Assisi to Dr John Brown in 1874, he described his preoccupation with a fresco, partially ruined by dampness, of Saint Francis being carried away like Elijah in a flaming chariot: "You scientific people . . . are, to my mind, merely damp in the wall, making one look with suspicion on all chariots of fire" (*Letters 1870–1889*, *Works*, XX, 119). In certain moods, Ruskin can go on for pages about the follies of his age or the virtues of a work of art; yet, in others, especially when overwhelmed by a beauty that seems to defy his own best efforts at analysis, he can also fall into abrupt and arresting silences.

The breaks in Ruskin's prose are often as telling as his rhetorical flights. Telling of what? His silences leave room – holes, really – in the middle of verbal excesses that never succeed in covering or closing them. Limits of logic, patience, energy, or time; exhaustion, despair, emotion too strong for words, haunt the empty spaces between paragraphs thick with analysis and description. We return finally to the face of Saint Lawrence undescribed except as "the highest expression of religious life yet achieved by man." With this extraordinary claim, Ruskin shuts up and leaves us, forces us, to return without him to the painting and the face. What do we see there? First, we see a face looking directly at us. Only one other figure, that of Cosmo in the foreground, looks out at us (fig. 69).

Ruskin has nothing whatever to say about this figure. The face, in contrast with Saint Lawrence's, has external experience, weather, even a kind of anguish written on it. (One wonders whether Ruskin had it in mind when sketching his own anguished self-portrait; fig. 70) Cosmo is gesturing toward the Madonna and Child, but there is an odd yearning,

LEFT 69 Fra Angelico, San Marco Altarpiece (detail of fig. 67, showing Saint Cosmo).
RIGHT 70 John Ruskin, *Self-portrait in Watercolor*, 1865–75, frontispiece from *Works*, XVII.

anxiety, and uncertainty in the expression as though along with inviting us to behold Mary, he, like Ruskin, is asking for our pity or understanding for himself.

Saint Lawrence looks innocent and, at the same time, knowing. His skin is smooth and softly colored like a new rose petal with a blush of red on the lips and cheeks. Yet the eyes are penetrating, a little sad, and sympathetic. If Cosmo wants something from the viewer, Lawrence, with his left hand raised in blessing, seems to be ready to give whatever we might ask without wanting anything for himself. He is poised. Complete. Serene. Lacking nothing. We have nothing that he could possibly want. He appears oblivious to his rich garment as though it had been put on him without his noticing. In his right hand he holds what should be a martyr's palm but looks more like a feather pen or paintbrush.

What, aside from the pearls, most attracted Ruskin to this face and figure? Was it the shock of recognition in the hand holding a pen or brush, a sign that Fra Angelico had transformed the martyr into a writer or painter? Was it that the suffering servant had been turned into a model of tranquil empathy? Was it that through this face the painting

164

71 Bronzino, *Martyrdom of Saint Lawrence*, 1545–50, San Lorenzo, Florence.

seemed to be looking out at the viewer and lending him some piece of its beauty? How much of the legend of Saint Lawrence was known to Ruskin when he first saw the San Marco Altarpiece is not clear. He surely knew that the saint had been martyred on a grill, as depicted in dramatic paintings of the episode by Bronzino in the Florentine Church of San Lorenzo (only a few streets away from San Marco) and by Titian in the Church of the Gesuiti in Venice (figs. 71 and 72).

Painted a century after the Fra Angelico altarpiece, the pictures are almost caricatures of the contrast between Florentine and Venetian art: line versus color; light versus shadow; clarity versus atmosphere; classical versus gothic. Neither shows much resemblance to the San Marco work. Both later paintings place emphasis on the body, not the face of Lawrence. Pearl-encrusted vestments are, of course, out of the question. Although the event is gruesome and would have been a horror to behold, the paintings are beautiful.

72 Titian, *Martyrdom of Saint Lawrence*, 1548–9, Gesuiti, Venice.

Bronzino's version is all brightness and curves. Seen from a slight distance and in relative dark (as it would have been by most viewers in San Lorenzo), it could be mistaken for a pagan revel. Titian's version is shadowy. Yet Lawrence's body glows with strength and hope as he reaches away from the red coals beneath him toward a finer light breaking through the gloom above. Perhaps both painters (surely Fra Angelico and possibly Ruskin) knew – but interpreted differently – Lawrence's legendary words to his persecutors: "My night has no darkness, but everything in it is resplendent with light."[16] Only Bronzino, with his reputed fondness for perverse humor, might have wanted to remind his viewers of another famous line of Lawrence's: "The meal is done; turn me over and eat" (*DO*, III, 1426).

Ruskin's and Fra Angelico's Lawrence is beyond joking, bravado, and the torments of the grill. He looks like what Ruskin often wanted to be. He looks at peace. He is the Lawrence described in *The Golden Legend* whose "sweetness broke down hardness of heart"; or as Saint Ambrose is quoted as saying in a sermon, "He possessed the coolness of paradise . . . and thus could not feel the torment of fire."[17] One can only imagine how Ruskin – increasingly tormented by prolonged fits of anger and anguish – longed for what he saw in the face of Fra Angelico's young saint. Of course, Ruskin does not say this and the saint's lips are sealed. Subject and object, critic and painted figure meet in contemplative silence until another picture is encountered, and a new beginning and a new digression get underway.

According to Ruskin's would-be mathematical rigor, his critical fits and starts hardly constituted an orderly theoretical process. Nevertheless, the madness in his method may be what saved it from dated sterility. In his prologue to *The Origin of German Tragic Drama*, Walter Benjamin introduced his own critical methodology by comparing it with "the canonic form of the treatise:"

> Its method is essentially representation. Method is a digression. Representation as digression – such is the methodological nature of the treatise. The absence of an uninterrupted purposeful structure is its primary characteristic. Tirelessly the process of thinking makes new beginnings, returning in a roundabout way to its original object. This continual pausing for breath is the mode most proper to the process of contemplation. For by pursuing different levels of meaning in its examination of one single object it receives both the incentive to begin again and the justification for its irregular rhythm.[18]

"Tirelessly the process of thinking makes new beginnings." How fitting this is for Ruskin! His emphatic pronouncements about this or that painter are now easy to dismiss but for him too the tireless process was indeed a matter of constant revision. He wrote in 1874:

> I discovered the fallacy under which I had been tormented for sixteen years – that religious artists were weaker than irreligious. I found that all Giotto's "weaknesses" (so called) were merely absences of material science . . . The things I had fancied easy in his work, because they were so unpretending and simple, were nevertheless entirely inimitable . . . the religion in him, instead of weakening, had solemnized and developed every faculty of his heart and hand. (*MF, Works*, XXIII, xlv)

The critic, especially one late in life, who can correct himself and still say, "I discovered" and "I found," is one prepared to "make new beginnings" and prompt even the most decisive reader to look one more time at a sentence or a picture.

Perhaps it was the foreshadowing of a Benjamin, an ideal and forgiving reader, a beloved and knowing counterpart never yet encountered, that Ruskin saw or thought he saw in the beautiful and intelligent face of a saint above the pearls.

167

VICTOR
CARPATHIVS
FINGEBAT

SAINT AUGUSTINE

6

Imagining Augustine Imagining

OR A THEOLOGIAN'S TOOTHACHE

"I am fully aware how many fancies the human heart can breed — what is my own heart, after all, but a human heart?"

Saint Augustine, *The Trinity*

Benozzo Gozzoli, the fifteenth-century Tuscan artist, did an odd thing when he imagined the scene in the Milanese garden where Saint Augustine experienced his final and most dramatic moment of conversion. According to Augustine's account in *The Confessions*, he was so troubled by doubts and hesitations that he could not stop sobbing. He left his friend Alypius and threw himself under a fig tree to weep in solitude when he heard a child's voice singing "Take it and read." Interpreting this as a sign from God, he rushed to the book of Paul's epistles which he had just been reading, opened randomly to a passage and found: "Not in reveling and drunkenness, not in lust and wantonness . . . Rather arm yourselves with the Lord Jesus Christ; spend no more thought on nature and nature's appetites."[1] The event is filled with such intense emotion and biblical overtones (the garden, the fig tree) that some commentators have wondered whether Augustine was trying to fashion a nervous breakdown into a religious revelation.[2] Augustine stresses his inner and outer turmoil: "My looks betrayed the commotion in my mind . . . The expression of my face and eyes, my flushed cheeks . . . told more of the state of my mind than the actual words that I spoke"; he recalls "the tumult in [his] breast," "I was beside myself with madness," "I was frantic," "I tore my hair and hammered my forehead with my fists; I locked my fingers and hugged my knees" (*Conf*, VIII, 8). Yet Benozzo does not picture

171

an alarmed, ecstatic, or overwrought man of the world faced with a stark choice between the rigors of celibacy and the comfortable, sexually active life to which he had been accustomed. He paints a quiet, calm, well-fed, scholarly figure reading in a garden as peacefully as if he had been there all his life (fig. 73).

It is true that Augustine claims that "in an instant . . . the light of confidence flooded into my heart and all the darkness of doubt was dispelled. . . . [and] my looks were quite calm as I told Alypius what had happened to me" (*Conf*, VIII, 12). Even so, Benozzo's Augustine, in the classic pose of contemplation, his right hand gracefully tracing the words of scripture, his left hand supporting his chin, gives no sign of wear and tear. His posture is not that of a lusty young man recovering from a crisis but of a sedate scholar, a judicious prince, a saintly cleric. On the right, his friend Alypius is gesturing toward the book but also toward the man as if presenting to the viewer, with the help of the angelic youth on the left, a composite icon of figure and text, an inseparable and monumental union of saint and scripture. Although the figure of Alypius is on the same plane as that of Augustine and the youth is only slightly to the rear, both appear to be not simply slighter than Augustine but on a smaller scale of being altogether. The Augustine in this painting has overcome not only turmoil and frenzy but also the realm of ordinary mortals and has become, in the moment of his conversion, larger than life, a figure so removed from his surroundings and companions that he seems oblivious to their decorative but marginal presence.

Benozzo was commissioned in 1464 by Fra Domenico Strambi, the reformist superior of the Augustinian monks in San Gimignano, to paint a fresco cycle of the saint's life emphasizing his role as scholar-teacher.[3] Augustine, the great defender of the faith, was surely that. Yet, as *The Confessions* keep relating, he was also a fallible and, even after his conversion, an anxious, conflicted, and often troubled man whose body and world, and their demands, did not disappear in a Milanese garden. Like all great painters of the Italian Renaissance, Benozzo was as interested in bodies as he was in monuments. He seems to have read Augustine closely enough (or heard enough from Fra Domenico) to have been intrigued by the flesh and blood man as well as by the icon. In what looks like a moment of whimsy, but also is a sign of the artist's capacity to look through the pious aura to the vulnerable mortal, while planning his fresco cycle, Benozzo sketched Augustine in an unedifying moment of no obvious relevance to his stature as a scholar-theologian (fig. 74). He shows the saint suffering from a toothache. What compounds the apparent irreverence is that the scene of irksome, humbling, commonplace discomfort looks much like the artist's depiction of the greatest moment in the saint's life, his conversion in the garden.

It has been pointed out that

the sketch conflates the conversion of Augustine with a later episode. As indicated by Benozzo's notation on the sheet, the saint, seated beneath a fig tree in a garden, suffers a toothache that is healed by prayer: "How Saint Augustine, at the foot of a fig tree in a garden experiences a toothache so terrible that he was unable to speak. He said to his companions, 'Pray to God for me.' A book comes from the sky." (*Come santo augh-*

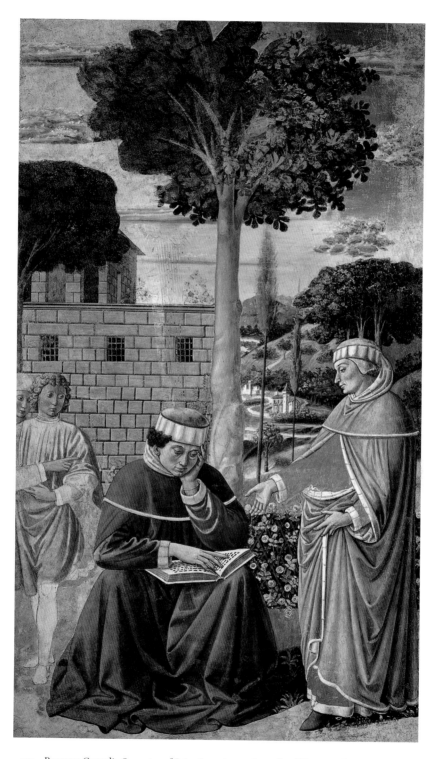

73 Benozzo Gozzoli, *Conversion of Saint Augustine*, 1464–5, Sant'Agostino, San Gimignano.

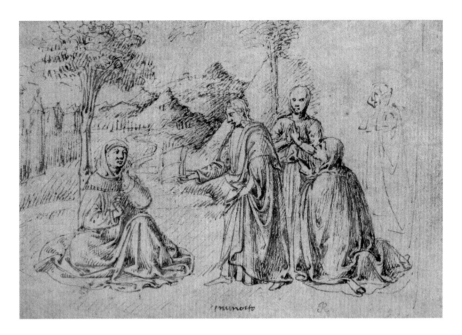

74 Benozzo Gozzoli, *Saint Augustine Suffers from a Toothache*, 1464–5, Fogg Art Museum,
Harvard University, Cambridge, Mass.

*ustino a pie di un fico in un orto gli venne un grande dolor di dente a modo che non poteva
parlarle, disse a suoi chompagni, preghate i dio per me. Venne un libro da cielo.)*[4]

In the sketch Augustine does indeed sit under a fig tree in a garden; he has been aroused
(presumably by pain) from his meditation and looks to his companions for comfort. They
stand a little apart from the saint as if out of respect and pity, but their distance also sug-
gests that they cannot do much to help him. One of the women, probably his mother
Monica, is praying and one of the young men is holding a book out to him. However, the
book that has fallen from the sky hangs open awkwardly and is too far from Augustine to
be read easily by him. In this sketch Augustine is not larger than the other figures. He is
separated from them not by size but by a background of beautiful mountains and perhaps
by the isolation of his pain. Like Benozzo's finished painting of the conversion, the sketch
is undramatic and understated, but, unlike the painting, it is a scene of unresolved tension,
discomfort, minor awkwardness; a great man in a decidedly unremarkable, unpicturesque
moment. In comparison with paintings of martyrs whose eyes were gouged out or heads
chopped off, Augustine's toothache seems trivial, even ridiculous. For the great saint who
had decided to give no further thought to "nature," this reminder of the flesh seems par-
ticularly humiliating.

What was Benozzo thinking? Was the sketch a private joke? A cartoon mocking what
had become a classic scene of conversion to bring the saint down a few pegs? Or did

Benozzo wonder, as he must have known Augustine did, how exactly one goes about "spending no more thought on nature" when nature spends so much time reminding everybody of its presence? How, in other words, does one distance oneself sufficiently from nature to be able to shape and manipulate it according to the will? This was a great and constantly pressing question of Augustine's life and work. It was also, for Benozzo and most painters of his time, the supreme question for the artist. What Benozzo knew was not simply that Augustine once had a toothache but that Augustine himself depicted it, tried to get hold of it and fix it in time and space as he recalled it in *The Soliloquies* and again in *The Confessions*. It is not surprising that Benozzo may have responded more sympathetically to Augustine the "scene designer" than to Augustine the theologian; to the Augustine who not only argued and preached but dreamed, remembered, and imagined; to the Augustine who, like the painter, could make a site of interest, order, and meaning out of a toothache.

If the most influential Christian theologian after Saint Paul could make an issue of stealing pears as a boy, it is perhaps to be expected that he would not have allowed a toothache to pass without comment, especially since the toothache occurred soon after his momentous conversion in a Milanese garden and was so severe that it temporarily prevented the famous professor of rhetoric from speaking. In 386 while in Cassiciacum on holiday with his mother and a few close friends and pupils, an emotionally drained and physically exhausted Augustine – transformed in heart but not yet baptized – "was tortured by a sharp toothache." In *The Soliloquies*, a dialogue with Reason written during this period, he complains that he has "never suffered anything worse" and is compelled to agree with the Roman physician who said "the supreme good is wisdom and the supreme evil bodily pain."[5] Without the benefits of painkillers and antibiotics, toothaches in the fourth century must often have been almost beyond enduring. Yet Augustine, the inquisitive scholar, does not merely want to complain; he wants to understand and frame his pain. The trouble is that the pain is so powerful that it makes thinking difficult. "I was completely prevented from learning anything new, which demands undivided attention."

What happened, one wonders, when the great thinker was unable to learn, reason, and argue in his customarily relentless fashion? Clearly, his mind did not stop working. When he was unable to speak, he wrote messages on wax tablets to his companions. When he was unable to think logically and deliberately, he did what most people do: he let his mind wander. Rather than constructing an argument about suffering or a definition of pain, he tried to avoid the ache by imagining that he pursued Wisdom as though she were "a beautiful woman" and he a "lover . . . desirous of seeing and embracing her, as it were, without any covering garment" (*Sol*, 37). The personification of Wisdom as female is a familiar convention and therefore it is possible that Augustine was simply being lazy as well as fanciful. Nonetheless, it seems odd to shun the senses in the search for truth, as Augustine claimed to be doing in the dialogue, and then to visualize the ideal object as a naked woman, replacing one disruptive physical sensation with another, a

painful "ache" with a pleasant one. The fantasy became both more vivid and more personal the next day when Augustine acknowledged that his efforts to separate mind from body, wisdom from pain, faltered. Reason chastises him for his inconsistency:

> "How sordid, how base, how execrable, how horrible the embrace of a woman seemed to you when we were discussing the desire for marriage! But as you lay awake last night and the same question arose, you found it was very different with you than you had supposed. Imagined fondlings and bitter sweetness tickled your fancy." [Augustine replies:] "Oh, be silent, be silent, I beseech you! Why do you torture me? Why do you cut so deep?" (*Sol*, 39)

Given Augustine's long struggle with sexual desire, it is not altogether surprising that he associates the overpowering symptoms of "lust" with a physical pain so strong as to be a reminder of what he regards as the body's undisciplined tendency to interfere with the pure pursuit of wisdom. Nonetheless, the association of a toothache with sexual arousal seems more of a poetic leap than the result of a logical progression. Does the actual toothache dissolve into a metaphor? If so, how far does the comparison go? Is sexual desire a localized sign of decay that can best be cured by means of extraction? Fortunately, Augustine does not carry the association that far (though some of his contemporaries did). In fact, the dialogue with Reason reveals, in the middle of attempts to separate mind and body, a tendency to create knots that are never untied and to raise questions that are never fully answered. "Imagined fondlings," "bitter sweetness," and a "tickled fancy" suggest not merely a lively libido but an active and often conflicted imagination, a mind resistant to neat distinctions and pure essences; on the contrary, a mind ready to combine opposites, mingle the disparate, fashion forbidden and impossible worlds, and ask unanswerable questions.

When he returns to the scene of the toothache in *The Confessions*, Augustine sees the pain as a sign of God's "lash" and the cure that followed as an indication of His "mercy" (*Conf*, IX, 189). Yet even this later attempt to find theological meaning in the event concludes with questions and a declaration that do not fit easily into rational discourse: "What was that pain? How did it vanish? . . . I confess that I was terrified." For many readers, it is precisely the Augustine who is human enough to admit that he does not have all the answers, yet gifted enough to express his uncertainties and irrational urges and fantasies with imaginative power, that remains most compelling: Augustine the artist, not Augustine the theologian. Of course, the two Augustines cannot be separated anymore than the mind can be separated from the body. Still it is worth attending to the poetic Augustine, not only through his lyrically beautiful prayers and theological apostrophes but also in his "toothaches," the odd interruptions, and bodily distractions that defy pure reason and threaten to derail (or re-route) the journey to absolute truth.

Augustine himself would not have liked being called an artist. Distrust of the imagination – of theater and spectacles, of fabricators, painters, sculptors, and story-tellers – runs throughout his writings:

Give me a single man who can see without being influenced by imaginations derived from things . . . Give me a man who can resist the carnal senses and the impressions which they impose on the mind . . . My imaginary Rome is not the real Rome, nor am I really there . . . The imaginary sun I place where and when I will . . . These imaginary things are false, and what is false cannot be known. When I contemplate them and believe in them, I do not have knowledge, because what I contemplate with the intelligence must be true.[6]

As always, Augustine wishes to make a clear distinction between "intelligence" and "the carnal senses," the true and the false, the real and the unreal. Products of the imagination, representations of things, persons or places, are by definition not those things, persons, or places. It seems logical and prudent, therefore, to avoid putting trust in images which are derived from and appeal to the physical senses rather than logic or "contemplation with the intelligence." Indeed, Augustine's position is consistent with all forms of religious iconoclasm. To allow the mind (*mens*) to be attracted by the works of the imagination (*imaginarium*) is to indulge in idolatry.[7] "Contemplation" and "belief" are to be reserved for truth alone. Entering into a serious relationship with the arts, either as a maker or spectator, is not only a threat to clear thinking but a danger to a piety that identifies God with truth. Augustine was enough of a realist to recognize, especially as he grew older, that it is impossible to detach oneself completely from the body, the earth, and material objects created by human artistry:

By every kind of art and the skill of their hands men make innumerable things – clothes, shoes, pottery . . . pictures and various works which are the fruits of their imagination. They make them on a far more lavish scale than is required . . . and all these things are additional temptations to the eye . . . Though I say this and see that it is true, my feet are still caught in the snares of this world's beauty. (*Conf*, X, 240–1)

The proto-puritan in Augustine is resigned to the necessity of constructed objects but wishes that they would be as simple and unostentatious as possible. At the same time, the confessional Augustine, whose fertile and restless imagination is never stilled by the strictures of his reason, beckons the reader away from the theorizing mind and redirects attention to a lower region of the body: *etiam istis pulchris gressum innecto*, literally, "my footsteps are still bound by beauty." It is a great and intriguing phrase, a rewording of his earlier citation of Psalm 25 when he hoped that he might resist the seductions "of the eye" by raising his mind to God so that He "may save [his] feet from the snare" (*ut tu evellas de laqueo pedes meos*). This is part prayer and part invitation. Where are we led if we follow the "footsteps" as well as the mind of this master? Why is it that feet are associated with beauty? In scripture the trap is set by the enemy or by the shepherd to catch a wolf; in either case, it is also a hazard for the innocent pedestrian whose mind may be in the heavens but whose feet are bound to the earth.

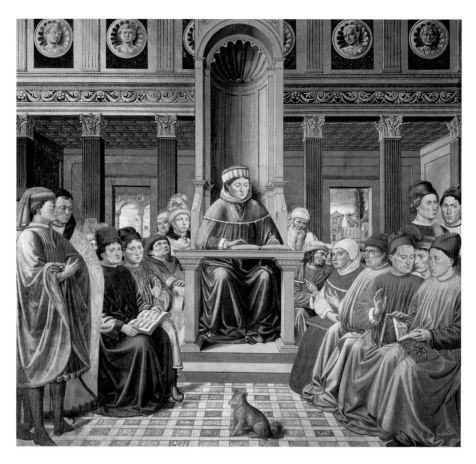

It makes sense that a Manichaean dualist would think in oppositional terms: light and darkness, head and toe, the Beauty of the eternal and transcendant in contrast with the beauty of the "pedestrian," that is, the physical and transitory. Most Augustine scholars would agree that "Manicheism was with him early and late;" given his complexity of mind and spirit, "nothing that aspires to be a picture of the man has a prayer of being anything like him."[8]

Renaissance painters, who regularly pictured Jesus, Mary, and God the Father, were less modest than a modern biographer in aspiring to picture a saint, even a complicated saint. However, when portraying Augustine, the artist had not only to choose episodes or moments in the saint's life but dimensions of his character. As has been noted, Benozzo Gozzoli "overlooked" the lusty, restless, and ambitious Augustine, choosing instead a placid, studious, monkish figure to suit his patrons. Benozzo's fresco of Augustine teaching in Rome (fig. 75) is, like the entire Sant' Agostino cycle, serene, undramatic, and

quietly composed – all of which is surprising given the unruly early life of the saint and the many theological controversies in which he was involved after his conversion.

Nothing about the scene is particularly Christian or religious. It appears to be a lecture on one of the liberal arts – rhetoric in Augustine's case – by a young, earnest, but not very inspiring master. Most of the mature scholarly men in the class seem to be paying little or no attention to the teacher. A few are chatting among themselves; others are looking off into space; a fat man with a blue cap on Augustine's left looks quite unhappy; only two, on the saint's far and near right, bother to look attentively at the speaker. This is strange. Even before his conversion, Augustine was known to have been a popular teacher and later, when he became a bishop, he drew large, enthusiastic crowds to his sermons. Yet neither the conversion fresco nor the teaching fresco shows a lively, energetic, or, in any visible sense, impulsive person. This may have more to do with the Augustinian monk who oversaw Benozzo's design than with Augustine himself. Fra Domenico was a distinguished scholar who had studied at the Sorbonne with the support of rich and powerful patrons. His efforts at reform repeatedly caused dissent, resistance, and even rebellion among the brethren of Sant' Agostino. In a period of relative calm, he must have preferred an artist who would emphasize Augustine's contemplative, scholarly nature rather than highlight the more dramatic (and interesting) aspects of his life and personality.[9] Perhaps Benozzo, wanting to please and pacify his patron, put more than a little of Fra Domenico into his placid Augustine.

By far the most common portrayals of Augustine show him as a Father of the Church, a bishop, bearded and stern, steady and staunch, well beyond the temptations of youth. Even Masaccio, skilled at imbedding character in the human form, clothes and

76 Masaccio, Pisa Polyptych (detail showing Saint Augustine), 1426, Staatliche Museen, Berlin.

subdues Augustine in the robes of authority (fig. 76). Masaccio's saint, his full beard untouched by gray, is broad in the shoulder and apparently in mature good health, but his entire form, like his eye, is fixed on scripture. This is a portrait of total and sober concentration. It leaves little or no room for "tickled fancies." A later, even more imposing version of the patriarchal (and older) Augustine was painted by Piero della Francesca for the Augustinians of San Sepolcro in 1469–70.[10] What is fascinating is that in Piero's original polyptych (parts of which have been separated and lost) the mature, stalwart cleric was paired with a limber, youthful Michael the Archangel (fig. 77). In pairing Augustine as a bearded elder clothed in full bishop's regalia with a youthful, beardless, athletic

179

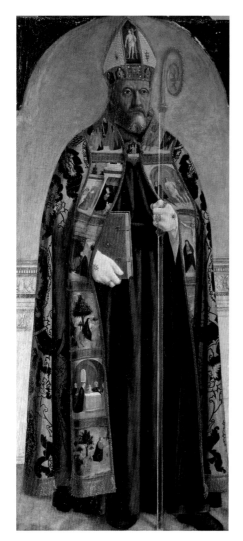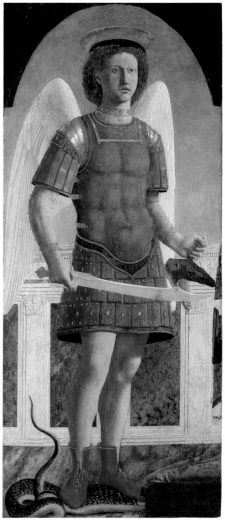

77a and b Piero della Francesca, *Saint Augustine*, 1469–70, Museu de Arte Antigua, Lisbon; and *Michael the Archangel*, 1469–70, National Gallery, London. (These two works were originally from the same polyptych in Sansepolcro.)

Michael, the artist could have been picturing two Augustines in one Manichaean frame much as Augustine often imagines and represents himself.

Whether or not Piero intended it, his two figures are beautifully evocative of the two Augustines who continually emerge in Augustine's writings: the stern, authoritative bishop grasping the crozier and Bible; the stunning and slightly stunned youth clutching a sword and serpent's head as if he has just cut off the head of lust but is unaware that the tale is still wagging. This is not simply the contrast of youth and age but of certainty

180

and uncertainty; the man clothed in the vestments of institution and the boy with the wings of an angel; the bishop's body shrouded in straight, heavy lines and the young man's body revealing the curves of belly and breast through scant armor. One is solemn, solid and dark; the other is bright and translucent. One is a rich, heavy, probably an authentic portrait of a prince of the Church; the other is a fanciful figure of a warrior who looks like a dancer in red booties with a halo that does not conceal his curly locks.

In showing that there is beauty and holiness in both the young Body and the old Cloth, Piero represents an Augustinian binary that may be oppositional or complementary. To the artist's eye, the authoritative patriarch, literally covered in scenes from scripture, is linked with the vulnerable, agile, youthful body of Michael. Piero, as it were, invites the viewer to a double (or, in the fully assembled polyptych, multiple) vision of sanctity or to choose between panels not on moral but on formal grounds. That is, he behaved like an artist. In the course of time and chance, Piero's joined panels were separated: the learned bishop went to Lisbon; the virile angel flew to London. Despite himself, Augustine too was an artist whose works can be viewed individually or as parts of a literary polyptych. Much of the internal drama of his life up to and beyond his conversion is performed in an extraordinary outpouring of prose as he struggled with his shifting need to integrate or separate complex elements of his identity and belief.

Even after his conversion to Christianity, Augustine never fully abandoned his dualistic habits of mind, but, in some of his greatest rhetorical and theological moments, he recognizes that in accepting the Incarnation, the taking on of flesh by the Divine, he throws all neat dualistic categories into question. A moving passage of *The Confessions* describes his long-delayed recognition of this central mystery of Christianity:

> I began to search for a means of gaining the strength I needed to enjoy you, [Lord,] but I could not find this means until I embraced the mediator between God and men, Jesus Christ, who is a man, like them, and also rules as God over all things . . . I was not humble enough to conceive of the humble Jesus Christ as my God, nor had I learned what lesson his human weakness was meant to teach . . . From the clay of which we are made he built for himself a lowly house in this world below so that by this means he might cause those who were made subject to him . . . to realize their own weakness when at their feet they saw God himself, enfeebled by sharing this garment of our mortality. And, at last, from weariness, they would cast themselves down upon his humanity, and when it rose they too would rise. (*Conf*, 152)

Framed within the spatial antithesis of "falling" and "rising" is the "means," the "mediator," the "house of clay," "the garment," the man of flesh who is discovered and embraced at our feet. The Savior is not an idea but a person who is found in an act of love that makes demands on the body and challenges the imagination as well as the reason. The very form and rhetoric of the passage reflect Augustine's attempt to submit his intellectual pride and customary dualistic formulations to the "humanity" of a mediator who confounds both

Manichaean and Platonic hierarchies. Since Latin is inflected, Augustine is able to unite terms that in the English translations are separated. "The mediator between God and men who is Jesus Christ, a man," syntactically divides "man" from "men," precisely those key terms that Augustine's Latin brings together: *mediatorum dei et hominum, hominem Christum Jesum.* "I was not humble enough to conceive of the humble Jesus Christ as my God" expands the Latin compression which literally joins subject and object, the humility of Augustine with the humility of Jesus: *Non enim tenebam deum meum Jesum humilis humilem.*

For all the intensity, beauty, and sincerity of this passage, it must be said that Augustine was only partially successful in putting aside his training in rhetoric and philosophy in his lifelong effort to "cast himself down upon the humanity" of Jesus. Much of his most influential writing – on grace, virtue, free will, Christian doctrine – is brilliantly abstract, theoretical, and distrustful of the body. Yet, not all of it: he tried to keep in mind that Jesus had a body and he never could forget that he had one of his own. The passionate, sensuous, physical, imaginative Augustine – the Augustine who could be earthy, playful, unreasonable, odd – continued to exist and find a means of expression. The professor who became a bishop still had toothaches and feet that were "caught in the snares of beauty." Sometimes when he went to bed, he, like other human beings, had disturbing and seductive fantasies. "We have grown so used to bodies" (*tanta facta est incorporibus consuetudo*), he wrote in his treatise on the Trinity, that "our interest slips back and throws itself out into them in such a strangely persistent manner."[11]

Three examples, of the many that are possible, of the "strangely persistent manner" of Augustine's "carnal senses" and imagination at work can provide the beginnings of a subversive sketch of the neo-Platonist as an earth-bound poet who finds beauty and, what is more, pleasure, in "low" places. When contemplating miracles, sex in Eden before the Fall, and the constitution of the resurrected body, the mature Augustine might be expected to skip lightly over the tricky physical details and rest his prose securely in generalized expressions of awe at the mysterious ways of the Creator. In fact, Augustine lets his imagination sink and dwell in places where his reason cannot comfortably go.

The young Augustine thought that the kinds of miracles reported in apostolic times were impossible in his day, but as he aged, he attempted "to persuade men reared on ancient physics, that the pure, uncontaminated Empyrian of their imagination might yet find room for the substance of their flesh."[12] Of course, he had to "contaminate" his own imagination before he could have an effect on others. For some scholars, wallowing in the often grimy and grotesque specifics of miraculous healings is a sign of the decline of Augustine's once powerful intellect.[13] Given his fondness for signs of "rising" and "falling," Augustine might well have agreed that he was lowering his mind to fleshly matters, but he would have added that it was a necessary and salvific lowering, and, indeed, not without its own beauty and pleasure.

The longest and most vivid account of a miracle cure in *The City of God* concerns a pious and prominent citizen of Carthage appropriately named Innocentius who suffered

from "fistulas intertwined in the rectum."[14] As Augustine describes the bishops, deacons, and elders who came to witness the surgery and the tantrums of the bad-tempered patient, it is difficult not to mistake the scene for one in Ben Jonson or Molière. It would be too much, perhaps, to say that Augustine is mocking the old man's suffering, but there is no doubt that he is drawing out the narrative and, as an "eye-witness," bringing the reader unnervingly close to the bare object of the surgeons' concern. He presents graphic little scenarios and snatches of dialogue as in a play. When one of the doctors suggests that a second operation may be necessary, "Innocentius angrily dismissed him from the house" and confronted his surgeons: " 'Are you going to operate again? . . . Am I to have him saying, "I told you so"?' They laughed at the other as a physician of no experience, and soothed the patient with fair words and promises" (CG, XXII, viii, 1035).

Days pass and Augustine builds suspense as one of the patient's boils fails to heal. (Given Innocentius's fear of the knife, it is a sign of one translator's recognition of Augustine's perverse humor when he turns *quid pluris?* into "to cut a long story short," especially since the author does nothing of the kind.) Augustine's compassion for the good citizen's suffering is mixed with a barely concealed disdain for his increasingly hysterical behavior. At the very thought of another operation, Innocentius "turns pale" (*expalluit*) and carries on until he is exhausted from crying. Later when the bishop and elders return to cheer him up, he cries so much that they tell him to trust God and behave more like a man (*viriliter ferret*). Indeed, Augustine's admiration is not directed to the patient but to his doctors and the "artistry" of their work thus far. When a new consultant is called in to assess the situation, the "artist in him" finds the scars so "supremely artistic in every detail" (*quorum artificiosissimam operam industriam diligentiam mirans in cicatribus eius videret*) that he is unwilling to take credit by adding his own touch.

Since this narrative is one of a series of miracle-healing stories, Innocentius is eventually cured. However, the final scene looks more like a page from a farce than a pious legend. The whimpering patient is laid out on a table and his backside is bared in the presence of doctors, a bishop, elders, and, of course, Augustine, who insists that he saw everything at close range. The chief surgeon searches for the open boil first with his eyes and then with his fingers (*scrutatur oculis digitisque contrectat*) and finds that it has been miraculously healed. At the end, the verbose, ever articulate Augustine is at an uncharacteristic loss for words, saying only that "the scene is better imagined than described." What more can we imagine than a group of dignitaries staring in amazement and admiration at the artfully scarred bottom of Innocentius?

It would be inaccurate to claim that Augustine was deliberately turning a miraculous cure into a burlesque, but the tale of Innocentius is not altogether innocent. There is a pleasure in the little drama, the tears of the petulant impatient patient, the skill of the doctors, and the presence of witnesses who have come to pray but also to watch, to be spectators, to be an audience at an exhibition of an encounter between art and the flesh.

183

Augustine might have stopped attending plays and gladiatorial combats, but he is able to craft his own show, one in which, as in much drama, the conclusion is foregone and the real pleasure and artistry lie in what leads up to it.

One of the many delights in reading Augustine is in watching his mind go blithely where others have feared to go or have gone and stumbled. Earlier theologians had speculated about the bliss of Eden before the Fall and concluded that since shame was a consequence of original sin there must have been no sex in prelapsarian paradise. Augustine thought this was nonsense since it amounted to saying that sin was necessary to produce the generations of the righteous saints needed to fill heaven's quota. In a surprisingly "modern" move, Augustine argues that sex is not a sin, but the way we think about it and employ it can be and that therefore there must have been "good" sex before the Fall. Being Augustine, he is not ready to stop there and insists on forging ahead, putting his imagination to work in speculating about what "good" sex might have been. At first Augustine's discussion assumes the form of a logical argument. If the original sin of Adam and Eve consisted of disobedience, it follows that one of the consequences was a replay of that disobedience in the division between the will and the flesh of humankind:

> Why should we not believe that the sexual organs could have been the obedient servants of mankind, at the bidding of the will . . . if there had been no lust, which came in as the retribution for the sin of disobedience? . . . Marriage in paradise would not have known this opposition, this resistance, this tussle between lust and will or at least this insatiability of lust and the self-sufficiency of the will. (*CG*, xiv, xxiii, 585–6)

Although the tone remains impersonal and the language abstract, the introduction of "resistance" between the "sufficiency" of the will and the "insatiability" of desire (*voluntas sufficientiam libidinis indigentiam*) suggests a tension in Augustine's discourse, a potential rift between the detached theologian and the lustful male, the debater and the dreamer, the man of reason and the weaver of fantasies. As Augustine lets his imagination play with the possibilities of happier sex before the happy Fall, he does three things. First, he pictures a man's paradise in which the male is not only the dominant and active partner but also the one with the freedom and ability to work his generative will whenever and wherever he wishes: "Then the instrument created for the task would have sown the seed on 'the field of generation' as the hand now sows seed on the earth" (*CG*, xiv, xxiii, 586–7). "Then, without feeling the allurement of passion goading him on, the husband would have relaxed on his wife's bosom in tranquility of mind and with no impairment of his body's integrity" (*CG*, xiv, xxvi, 591). The integrity of the female body is provided for later, almost as an afterthought, but the metaphor of a "field of generation" does not allow for the expression of a feminine will.

Second, Augustine imagines a language devoid of obscene expressions since the sexual act, like other physical functions in paradise, is understood to be both natural and controllable (always from a male point of view). In some ways, Augustine seems to be address-

ing women as well as fastidious male readers when he dreams of a language, really a society, without sexual inhibitions or taboos:

> And there would be no cause for modesty to object when I wish to discuss this subject in detail, no reason for decency to insist on my asking pardon, with an apology to pure ears. Discussion could then have free scope, without any fear of obscenity, to treat of any idea that might come to mind when thinking about bodily organs of this kind. Nor would there be any cause for calling the actual words obscene . . . Accordingly, if anyone has indecent thoughts in approaching what I am now writing, it is his own guilt that he should be aware of, not the facts of nature. (*CG*, xiv, xxiii, 587)

Thus far, Augustine seems to be mixing a surprisingly enlightened dream of sexual intercourse and language free from inhibiting shame with a strongly biased heterosexual masculine fantasy that leaves no room for a dissenting female voice. If his speculation had stopped here, it might have been classified along with Swift's chapter on the Houyhnhnms in *Gulliver's Travels* as a sterile fantasy of human nature controlled by a narrow conception of reason devoid of pleasure and passion. But Augustine does not stop there. His third tendency, like that seen in the narrative of Innocentius, is to play with his serious subject, to have fun with innuendo, to let the supposedly forbidden pleasures of the flesh thicken the atmosphere of his airy speculations. Sex in paradise begins to sound like erections on demand, as easy as falling off a log, and as often as you feel like stepping on the log in the first place:

> For we set in motion, at our command, not only those members which are fitted with bones and joints, like hands, feet, and fingers, but also those which are loosely con-structed of pliant tissues and muscles, which we can move, when we choose, by shaking, which we extend by stretching, which we twist and flex, contract and harden – such parts, I mean, as those of the mouth and face, which the will moves, as far as it can. (*CG*, xiv, xxiv, 587)

In this passage Augustine's Latin virtually sings: *movemus agitando et porrigendo producimus et torquendo flectimus et constringendo duramus*. The qualification of "mouth and face" (*ore et facie*) serves the nice double purpose of delivering a message that is at once innocent, earnest, and literal with one that is arch, playful, and analogical. In short, it succinctly performs what Augustine achieves throughout this discussion, a rich layering of reasoned speculation with imaginative invention.

As is well known, Augustine's artistry in *The Confessions* and in his sermons consists, in part, in his ability to alternate between cool, systematic reasoning and ecstatic flights of adoration and longing for the divine. I say "alternate," not "balance," because the thrill, sometimes verging on vertigo, of reading Augustine frequently comes from a strong impression of a precarious imbalance in which all his best arguments are in danger of being swept away by an overpowering religious passion. A comparable imbalance, less

often noted, is that between the hard-headed apologist and the digressive poet distracted by the aches, pains, pleasures, and sheer oddities of the body. In his attempt to imagine the "good" sex of paradise before the Fall, he argues that lust is the sinful body out of control but there is evidence that in ideal conditions the "fallen" body can still be made obedient to the will:

> Some people can even move their ears, either one at a time or both together. Others without moving the head can bring the whole scalp – all the part covered with hair – down towards the forehead and bring it back again at will. Some can swallow an incredible number of various articles and then with a slight contraction of the diaphragm, can produce, as if out of a bag, any article they please, in perfect condition. There are others who imitate the cries of birds and beasts and the voices of any other men, reproducing them so accurately as to be quite indistinguishable from the originals . . . A number of people produce at will such musical sounds from their behind (without any stink) that they seem to be singing from that region. (*CG*, xiv, xxiv, 588)

Aside from its being one of the most bizarre defenses of the freedom of the will in all theology, this passage on control is so nearly out of control as to come very close to defeating its own case. Augustine continues his list of remarkable bodily feats until he himself becomes embarrassed and admits that his attempt to imagine a post-Eden Edenic body submissive to the will founders on the eccentricity of the will and the unruliness of a fallen language:

> The activities I am discussing are bound to induce a feeling of shame, under present conditions. And although I am doing my best to imagine the state of affairs before these activities were shameful, nevertheless, in present circumstances, my discussion must be held in check by the restraining appeal of modesty instead of being furthered by such little eloquence as I command. The possibility that I am speaking of was not in fact experienced by those for whom it was available, because their sin happened first . . . The result is that the mention of this subject now suggests to the mind only the turbulent lust which we experience, not the calm act of will imagined in my speculation. (*CG*, xiv, xxvi, 591)

He checks his impulse to elaborate on his Edenic revery out of what he calls "modesty," a realization bordering on a confession that the words needed to depict his ideal are stirring up the very "turbulent lust" (*libidinis turbidae*), the uncontrolled desire, that he has been trying hard to put away. He may also have discovered that his Eden has begun to resemble a kingdom of freaks and calm but randy males. As usual, he has a solution to his own excesses of imagination: his fantasy Eden never existed. Adam and Eve never had the "good" sex of his dreams because they fell into sin right away. So the curious picture is framed but not erased. The prudent theologian returns to his reality, but the immoderate poet has had his say.

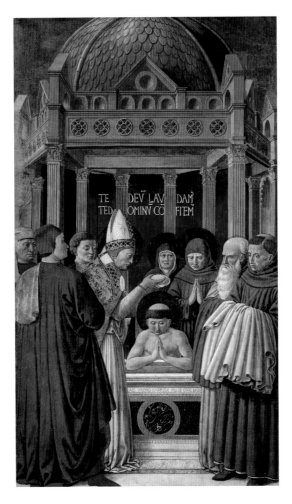

78 Benozzo Gozzoli, *Baptism of Saint Augustine*, 1464–5,
Sant'Agostino, San Gimignano.

Augustine's preoccupation with the flesh (especially when he most vigorously recoils from its unruly qualities and unreasonable demands) is a reminder to modern readers (and perhaps to readers of his own time) that he was a person of powerful appetites and, most likely, one with a distinctive physical presence. Yet, unlike Jesus, John the Baptist, Mary Magdalene, Lawrence, Sebastian, and a host of others, he is never (to my knowledge) represented nude or made to appear even vaguely erotic in artistic representations. The closest that Benozzo Gozzoli comes to showing Augustine's body in his famous fresco cycle is in the scene of the saint's baptism (fig. 78). This is aesthetically a far cry from the baptismal scenes of Jesus in which the Savior and the Baptist are often shown in full figure with little or nothing on. Benozzo's Augustine is a plump, tonsured, asexual monk –

resembling nothing so much as a big baby – modestly immersed up to his hairless chest, surrounded by his mother and clerics, all of whom, except the handsome youth behind Ambrose, the officiating bishop, avert their eyes from the display of flesh. What Augustine could never fully eliminate from his dreams, fantasies, and speculations – his lusty body – has been more thoroughly laundered by Benozzo, with the advice of Fra Domenico, than by Augustine himself in his own words.

A third example of Augustine imagining and giving rhetorical flesh to the seemingly unimaginable occurs in *The Enchiridion on Faith, Hope, and Love*, a basic handbook of Christian doctrine, in which he contemplates, among other things, the resurrection of the body. In keeping with the practical brevity of the genre, Augustine addresses a complex question with startling specificity and, at the same time, presents in highly compressed form a surprising theory of art, his most succinct "apology for poesy." Christians of the time wondered what their bodies would look like after the Resurrection, some going so far as to predict that all the parts that had been shriveled or lost through disease and age would be restored. Ever ready to put his imagination to work, Augustine saw this as a grotesque notion: "To suppose that the hair recovers all that our frequent clippings and shavings have taken away from it, and our nails all that we have so often pared off, presents to the imagination such a picture of ugliness and deformity [*immoderata et indecens cogitantibus*], as to make the resurrection of the body all but incredible."[15]

That the Resurrection must be physical and beautiful is an article of Augustine's faith in the benevolence, ingenuity, and power of God but also in the absolute value of embodied beauty. Indeed, in Augustine's Latin the line between the good and the beautiful, and, similarly, the line between the evil and the ugly, is often nonexistent. In his treatise on the Trinity, he wrote, "You certainly love only what is good, and the earth is good with its lofty mountains and folded hills . . . and a man's face is good when it has fine proportions and a fresh complexion . . . See good in itself if you can [and] you will see God" (*T*, 244). That which is "ugly" and "deformed" is also "immoderate" and "indecent." Having established this, he goes on to think through the properties of beauty and the process by means of which it is brought to life from the unpromising raw materials of decay. Anticipating Coleridge and Shelley by more than a thousand years, he imagines creative energy as a flame or pulverizing force that in appearing to destroy its material actually restores and reshapes it over and over into something new and ever more beautiful:

Just as if a statue of some soluble metal were either melted by fire, or broken into dust, or reduced to a shapeless mass, and a sculptor wished to restore it from the same quantity of metal, it would make no difference to the completeness of the work what part of the statue any given particle of the material was put into, as long as the restored statue contained all the material of the original one; so God, the Artificer of marvelous and unspeakable power [*mirabiliter atque ineffabiliter artifex*], shall with marvelous and unspeakable rapidity restore our body, using up the whole material of which it originally consisted. (*E*, 103–4)

The greatest of artists, for Augustine, is the one who loses nothing, wastes nothing, overlooks nothing – including, apparently, those old shavings and clippings – and is able through a flame-like intensity to remake the old into a new thing of beauty. Whether he intends it or not, Augustine is not only describing a divinely aesthetic process but also his own method as a rhetorician and theologian ever intent on reconfiguring the remnants of his neo-Platonic and Manichaean past into a new creation shaped by Hebrew scriptures, the Gospels, and the scorching memories of his own experience, trivial and grand.

It is significant that though Augustine looks for harmony in the resurrected bodies, in God's works of art (and presumably in his own), his idea of harmony is not a limiting symmetry or perfect balance. He says that "the great Artist takes careful heed that nothing shall be unbecoming or out of place" (*E*, 104). Individually and collectively, the results will be pleasing, but this does not mean that there will not be differences and "peculiarities of feature." Reassuring those of his readers who might wish to add or shed a few pounds in the after-life, he asserts that it is not certain that "the lean shall rise again in their former leanness, and the fat in their former fatness" (*E*, 104).

Summing up his position on resurrection as the supreme aesthetic act after Genesis, the model of all re-creation and therefore, of all the human arts, he avoids everything that suggests monotonous uniformity:

> There shall be a well-ordered inequality [*rationabilis inaequalitas*], such as there is in voices that make up a full harmony, then the material of each body shall be so dealt with that it shall form a person fit for the assemblies of the angels . . . Whatever shall be there shall be graceful and becoming: for if anything is not seemly, neither shall it be. (*E*, 105)

Despite his vigorous severities with himself and others after his conversion, it is clear that, in his imaginative digressions as well as in his theological leaps, Augustine stretched and occasionally crossed the limits of the "seemly" and "becoming." A "well-ordered inequality," a reasonable inconsistency, a proportional disproportion, leaves much room for speculation and play, which seems to have been exactly what Augustine had in mind.

While it is tempting to turn Augustine into a Romantic or Modern figure, just as theologians have sometimes tried to pigeon-hole him as the prototypical Catholic or Protestant, it must be remembered that a post-Romantic concept of the imagination would have been alien to him. For Augustine, the operative terms were "memory," "will," and "understanding," the human counterparts of the Holy Trinity. In all of these faculties is the original spark of God's grace and truth but, because of original sin, they are all subject to the shadows of falsehood and self-deception. It is one of Augustine's greatest innovations in *The Confessions* – indeed, in all of his writings – to test his philosophical and theological speculations not only against scripture and the teachings of the Church but also against his own experience. There is integrity if not perfect consistency in everything he wrote. His faith in the mind's ability to pursue pure truth led him to mistrust image-making and

the lure of the arts. Yet his experience of his own body and of himself as a rhetorician persuaded him that to be human was to be an embodied image-maker ever conscious of the need for mediation between that which is and that which is longed for.

Even when lecturing on the Nicene Creed to bishops and theologians, as in the Plenary Council of the African Church in 393, Augustine finds himself employing images while appearing to preach against them. Commenting on the creedal passage "he sitteth at the right hand of the Father," he cautions against picturing the scene too graphically:

> Of course, we are not to think that God the Father is limited as it were by a human form in such a way that thinking about him we should imagine a right side and a left side. When it is said that 'the Father sits' we are not to think of him doing so by bending his legs, lest we are to fall into the sacrilege which the apostle execrates in those who have changed the glory of the incorruptible God into the likeness of corruptible man. It is sinful to set up an image of God in a Christian temple. Much more nefarious is it to do so in the heart which is truly the temple of God.[16]

In the very process of picturing what he says should not be pictured, Augustine falls into a linguistic trap that he can identify but not avoid. A son sitting next to his father suggests a physical, spatial, and temporal relationship that must first be understood literally before it can be abstracted into meaning "supreme blessedness," as Augustine insists. Indeed, this passage, far from disposing of the imagistic nature of language, shows Augustine playing the part of both performer and interpreter, poet and critic. "Setting up an image of God in a temple" is idolatry insofar as the image remains an endpoint, a static and dead object of worship rather than an invitation to see possibilities beyond it that it suggests but does not contain. Augustine thus directs his listeners through the image not around it. By claiming that the heart is "the temple of God," he plunges right back into metaphor without hesitation or apology, illustrating by the rapidity of the move the dynamic and fluid nature of a theological discourse based on a persistent reliance on and dissatisfaction with the finite.

When addressing the creedal references to the Holy Spirit, hence to the Trinity, Augustine is, as always, at pains to discourage tendencies to idolatrous polytheism, the worship and picturing of three distinct gods. Yet even here he finds himself falling back on imagery to illustrate his argument:

> When we are asked about a fountain we cannot call it a river, and when we are asked about a river we cannot call it a fountain; and if we take a drink from a fountain or a river we cannot call it either a fountain or a river. But we describe all these three things, together or severally, as water. If I ask whether what is in the fountain or in the river or in the tumbler is water, in each case the reply must be that it is; and yet we do not say that there are three waters but only one. (*FC*, 362)

Although the language has a Beckett-like doggedness about it, Augustine seems to be pleased with his analogy. Yet within the next breath, he warns against an uncritical attach-

ment to his simile: "Certainly we must take care that no one imagines that the ineffable substance of the Divine Majesty is like a visible corporeal fountain or river or tumbler of water" (FC, 362). Both pleased and dissatisfied with his image, Augustine does not eliminate it from his discussion of the Trinity. He does what poets often do; he tries another comparison:

> In a tree the root is simply the root, the trunk the trunk, and the branches are nothing but branches. We do not use the word "root" of the trunk or the branches. Nor does the wood which belongs to the root pass in any way into the trunk or the branches, but remains only in the root. And yet the rule remains that the root is wood and the trunk and the branches are wood, but we cannot say there are three woods but only one. (FC, 362)

Augustine's understanding of botany may be faulty but the resourcefulness of his imagination is impressive, as always. Still, he no sooner proposes his second analogy than he warns the reader against taking it literally or even particularly seriously: "These corporeal examples have been given not because they bear any real resemblance to the divine nature, but because they show the unity of visible things, and to let you understand that it is possible for three things, not only severally but also together, to be designated by a singular noun" (FC, 362).

Perhaps Augustine's most appealing trait as an artist, in contrast with his theological dogmatism, is his irrepressibly inventive attraction to images he does not trust. Indeed, insofar as the artist cannot be detached from the theologian, it can be argued that a truly faithful reading of his doctrinal treatises should always take into account his fondness for narrative digressions and an extraordinarily varied imagery ever shifting and changing the shape of his discourse. Augustine's inability or refusal to remain for long with a single story, simile, or metaphor is a sign not only of a restless imagination but also of a genuine iconoclasm, a profound and determined resistance to idolatry, a habitual intolerance for an uncritical reliance on a solitary image or fixed set of images.

In his earliest writings on the Trinity, as in his later great treatise on that most intractable of subjects, Augustine repeatedly proposes and then rejects comparisons in favor of declarations of faith in the unimaginable, indescribable mystery of three persons in one God:

> We should understand God, if we can and as far as we can, to be good without quality, great without quantity, creative without need or necessity, presiding without position, holding all things together without possession, wholly everywhere without place, everlasting without time . . . Whoever thinks of God like that may not yet be able to discover what he is, but is at least piously on guard against thinking about him anything that he is not. (T, 190)

Since Augustine did not believe that images of God should be present in Christian churches, he probably would have been triply horrified to know that depictions of the

Trinity (usually in the form of an old man, a young man, and a bird) became common-place in the Christian Middle Ages and indeed that a variant on that image is prominently displayed in the same thirteenth-century Tuscan church, Sant' Agostino in San Gimignano, that contains the fresco cycle (including the conversion in the garden) of the saint's life by Benozzo Gozzoli. The painter arrived in town in 1464 following a devastating outbreak of the Black Death. While planning the design for the Augustine cycle, he was asked to paint a separate image of Saint Sebastian, protector against the plague, for a nearby side-altar (fig. 79). It has been noted that the painting "is unique in the iconographic tradition, while still partaking in their associations."[17] Sebastian, usually shown partially nude and pierced with arrows, is fully clothed and unscathed; his blue cloak, like that of the Madonna della Misericordia (Madonna of Mercy), billows out over a kneeling crowd, protecting him and them from the arrows.

What particularly would have surprised and disturbed Augustine, especially since the church was dedicated to him as a scholar and theologian, is Benozzo's representation of the Trinity. The arrows are not coming from Roman soldiers, as is ordinarily the case, but from an angry, white-bearded, God the Father shown cradling a white dove while aiming an arrow at the head of Jesus who is kneeling with Mary between the Father and Sebastian and the crowd below. Further complicating the Trinitarian iconography, Jesus and Sebastian look like the same person, with the same blonde braided locks, the same pink cheeks and benign youthful expression. Jesus points to the wound in his right side and gestures with his other hand protectively to the assembly below. In addition, as often in Italian iconography, Mary kneels in perfect symmetry – equal to Jesus in size and position – baring her breasts as if to offer her mother's milk to the praying townspeople. Mary is as young and beautiful as Jesus and Sebastian, and her cloak is of the same brilliant blue as that of the martyr saint.

While Benozzo undoubtedly included his own interpretations in his painting, his seem-ingly unusual iconography was also, notwithstanding Augustine's icon-wary theology, a reflection of popular conceptions of the Trinity at the time. The Father is seen as a wrath-ful patriarch, a figure as much like Zeus as Yahweh, ready to punish his sinful people with the arrows of plague. Jesus and Mary, pictured at one level below the Father, are imag-ined (heretically, according to orthodox Augustinian Trinitarian doctrine) as secondary but still powerful divinities capable of deflecting the Father's anger by baring and there-fore making vulnerable their own bodies. Sebastian and the townspeople below, with their hands clasped, can do nothing but hold tight and pray. Since there was no known cure for the plague in the fifteenth century, it makes sense that all the action is presumed to be taking place "above" while the painter sees his fellow human beings as potential victims, passive, and (for the duration) pious and humble.

Looking at the painting today and inspired as much by Augustine's restless imagination as by his theology, one can see another even more unorthodox Trinitarian concept emerg-ing from Benozzo's painting. The three most vividly and completely depicted figures are

192

79 Benozzo Gozzoli, *Saint Sebastian and the Trinity*, 1464,
Sant'Agostino, San Gimignano.

Jesus, Mary and Sebastian. God the old patriarch, though above them, is shown only from the waist up and his threatening gesture, deflected by the youthful Jesus, Mary and Sebastian, is one of impotence that ends in fragments of broken arrows caught by Sebastian's cloak. The balanced relationship of Jesus and Mary brings into harmony not only their beauty and benevolence but also their physicality, their bared breasts as signs of compassion, of their humanity, and, consequently, of their sexuality. The androgynous Sebastian, with the face of Jesus, but wearing a cloak of Madonna blue, suggests an everyman/everywoman counterpart to Jesus and Mary withstanding inexplicable suffering with serenity, strength, and, since handsomely clothed, with no sign of indignity or shame. In short, this Trinity is indeed godlike, in Augustinian terms, because it radiates beauty and compassion. Yet, because these qualities are represented in human form, the painting is also, in Augustinian terms, a theological failure or, worse, a false idol.

One might imagine Augustine writing a fierce condemnation of this impertinent, idolatrous, unscriptural rendering of the divine presence. But with Augustine things are rarely simple or predictable. Would the writer who turned adolescent growing pains into literature and a toothache into a theological meditation fail to recognize a formal and imaginative kinship with a painter who placed the mortal Augustine suffering from an ordinary pain and the serene newly converted saint in the same Edenic garden? Or would the theologian be blind to the stubborn faith and high spirits of the painter who fails to do justice to the Trinity but succeeds in celebrating the beauty of the human body in the face of the destructive ravages of plague? It is difficult to think that Augustine the artist would not have recognized the brilliance of color and invention, the daring juxtaposition of the voluptuous and the tender, the precarious balance between violence and benevolence, the repulsive and attractive, that is, the "reasonable inequality" in this painting. It is also difficult to imagine an Augustine who was unaware that his theologically abstract formulations left a door open to the particular and sensuous extrapolations of minds as human and fanciful as his own. When one reads in his great work on the Trinity that "the glimmerings" of a trinity appear in "the lover and what is loved and love" (*T*, 402), one can see that the physical and emotional relationships depicted in the Sebastian fresco are not altogether alien to an Augustinian tradition.

Doing justice to Augustine thinking and Augustine imagining has been a challenge to scholars and artists. Nevertheless, the challenge has been met at least twice with extraordinary intelligence and imagination. Two Renaissance depictions of Augustine, by Botticelli (fig. 80) and by Carpaccio (fig. 81), show him in his study gazing upward as if out of a window. He is surrounded by objects – books, pens, his miter, a clock, an astrolabe, an armillary sphere, figurines. Things. According to most scholars, the scene refers to a legendary moment when Augustine sees a celestial light and hears the voice of Saint Jerome to whom he is writing a letter. Jerome, who has just died, tells Augustine not to be so foolish or ambitious as to try to understand or explain the Trinity; indeed that it would be like trying to fill a vase with the sea. But, of course, Augustine does not stop trying.

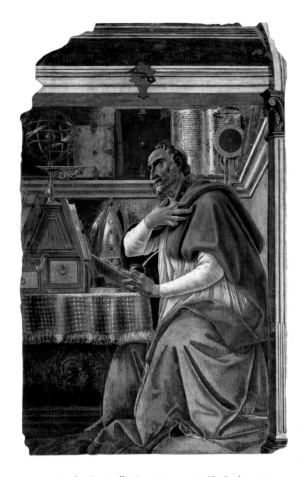

80 Sandro Botticelli, *Saint Augustine in His Study*, 1480,
Ognissanti, Florence.

He cannot keep from wondering and he cannot curb his ambition; he cannot avoid the imperfect, metaphorical nature of language or the imperfection of his own nature which, as both paintings show, is dependent on the material things that form a more or less orderly clutter around him. He has a "human heart" and body after all. He needs a chair, a desk, a room of his own. Yet he is not quite satisfied, so he looks away from it all – listening to a mysterious voice, thinking of his next sentence, or just daydreaming.

It seems perfectly appropriate that each of these paintings contains at least one image that has attracted the attention of scholars or, more accurately, distracted the attention of scholars away from the ostensible main subject. Ruskin thought that the Botticelli painting was of Saint Jerome, but, once that was cleared up and the painting itself was cleaned after the 1966 flood in Florence, restorers noticed that the text in the geometry book on the shelf was legible. It says, "Where is Fra Martino? He has vanished. Where has he gone?

195

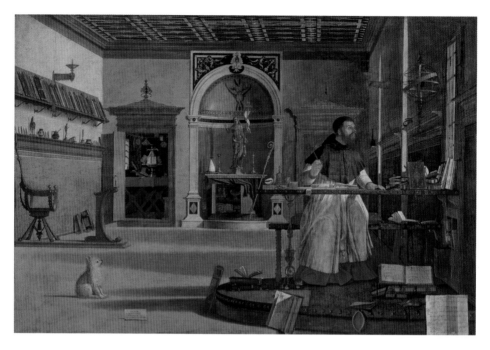

81 Vittore Carpaccio, *Vision of Saint Augustine*, 1502, Scuola di San Giorgio, Venice.

He is outside the Prato Gate." Naturally, critics have wondered what this means and what it has to do with Augustine. One of the more plausible guesses is that Botticelli, while painting, might have overheard this exchange between two of the notoriously lax Umiliati monks in Ognissanti.[18]

Then there is the little dog in the Carpaccio painting. It was noted that in the preparatory drawing, "the master's attention seems divided. He turns toward the window while glancing back in the direction of the animal, as if it has alerted him to a strange circumstance."[19] (Animals were thought to be especially sensitive to supernatural phenomena.) Also, dogs are a symbol of faith and this little dog appears with "rapt attention and pricked ears" as though he hears something, perhaps the voice of Jerome.[20] In the finished painting, Augustine pays no attention to the dog, but the dog is still there. Quite prominently there, as another little dog, ignored by Augustine and his pupils, is there in the very center of Benozzo Gozzoli's fresco of Augustine teaching in Rome (see fig. 75).

Whatever their significance to the artists or their relevance to particular circumstances in Florence or Venice of the period, it seems obvious that neither Fra Martino nor the little dog are of any significance to Augustine. Or are they? Like the old man with the boil or the question of sex before the Fall, they are distractions, seemingly random causes of digression from the main course, the path to wisdom and sanctity. In short, they are emblematic of the tendency of the best of human minds to wander. Augustine admits in

The Confessions, that, try as he might, he cannot eradicate from his mind's eye seductive images that have captivated him:

> The images of things imprinted [in my memory] by my former habits still linger on [*vivunt in memoria mea*]. When I am awake they obtrude themselves on me . . . When I dream they not only give me pleasure but are very much like acquiesence [*non solum usque ad delectationem sed etiam usque ad consensionem*]. The power which these illusory images have over my soul and body is so great that what is no more than a vision can influence me in sleep in a way that reality cannot do when I am awake. Surely, it cannot be that when I am asleep I am not myself [*numquid tunc ego non sum*]? (*Conf*, x, 30, 233)

Augustine is referring specifically to erotic "visions" here, not dogs or wandering friars, but the passage is part of a larger meditation on the ways in which all sensory perception can be a distraction from the pursuit of unadorned truth or, more likely, a necessary and inevitable path toward it. Fortunately, the great and exacting theologian never forgot his humanity, his dreaming self that not only enjoyed erotic images but gave his sleepy consent to them, and his rhetorician self who had a lifelong love affair with the adornments of language. In characterizing Augustine's image of Eden, Peter Brown has emphasized his attention to physical pleasure:

> The angelic state of Adam and Eve had lain in the future. They had been placed in Paradise for a probationary period, so that they should learn to experience and to accept, with unswerving obedience and with open-hearted gratitude, the full range of the joys of fully physical, fully social and, Augustine was quite prepared to conclude, of fully sexual beings. Compared with the notions of many of his most vocal contemporaries, it was a singularly sociable and full-blooded vision.[21]

It is true that Augustine had second, third, and probably fourth thoughts about all this, but, as noted, like many great artists, he tried more than once to paint a picture of bliss in Eden.

When Augustine worries that even the beauty of singing in church may be a distraction, he consoles himself with an indecisiveness that may not be characteristic of his theology but is a key to his power and integrity as an artist: "I waver [*Ita fluctuo*] between the danger in sensual gratification [*inter periculum voluptatis*] and the gratifying experience [*et experimentum salubritatis*] which can come from singing" (*Conf*, x, 33, 239).

Perhaps it is a coincidence that Carpaccio placed a sheet of music for voice on the floor in front of Augustine's desk. If so, it is a happy coincidence, not unlike the "Happy Fall." Melodies and metaphors, toothaches, erotic dreams, naked feet, fistulas, finger-nail clippings and hair shavings, faithful dogs, and disobedient monks have not yet been transformed in the Maker's caldron and resurrected into a new and better life. While waiting for that day, the artist-theologian *fluctuates* between image and abstraction, body and soul, and in so doing, imitates, perhaps not altogether unconsciously or perfectly, the Mediator whom he struggled throughout his life to understand and love.

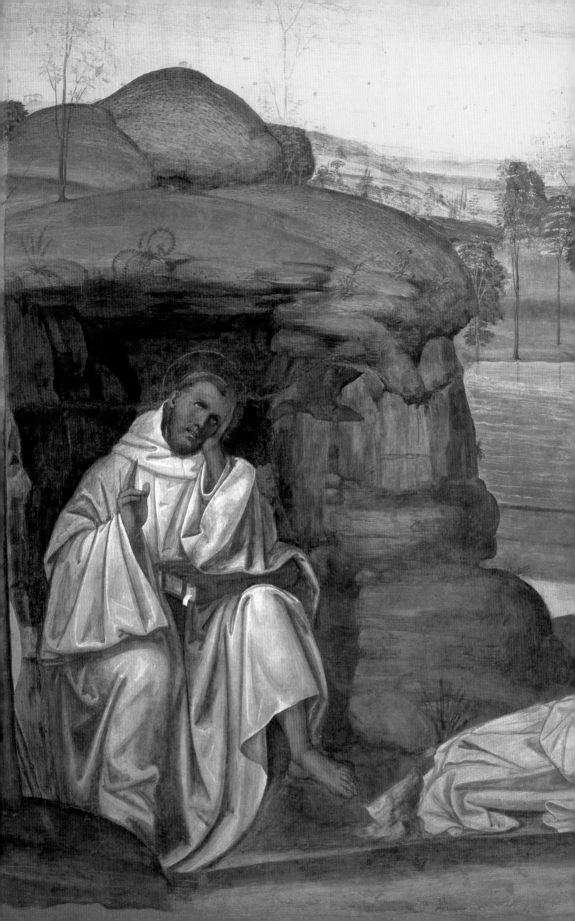

SAINT BENEDICT

7

SODOMA'S SAINT BENEDICT

OUT IN THE CLOISTER

"There was a man whose life was holy . . ."
Gregory's *Life of Benedict* from *The Dialogues*

"He was a happy, licentious man who used others shamefully for his pleasure . . ."
Vasari, *Life of Sodoma*

As saints' lives go, the story of Benedict of Nursia, the founder of Western monasticism, is impressive but not wildly dramatic. He did not receive the Stigmata, he was not shot full of arrows or beheaded. The miracles attributed to him are those of a practical problem solver, a resourceful organizer and foreman. He mended a broken tray, retrieved a hoe that had fallen into a lake, located a source of water on a hilltop, obtained flour in a period of shortage, and appeared in a dream to give building instructions to two disciples who were founding a new monastery. Benedict seems to have been a person of common sense and a good reader of character. He smelled a rat when some evil monks and later a jealous priest tried to poison him; and he saw through the disguise of one of Totila the Goth's henchmen who came to him dressed in his general's armor.

To paint the life of this sane, steady, determined, pragmatic patriarch, this icon of monastic regularity, stability, and discipline would have been a challenge for any painter. For the young Sienese Giovanni Antonio Bazzi, nicknamed Il Sodoma, it must have been a commission fraught with irony as well as promise. The monastery of Monte Oliveto Maggiore in the rugged hills of Le Crete near Buonconvento was a rich fortress-like estab-

lishment that had grown in wealth and size since its founding by three young noblemen from Siena in 1319.[1] A third "great" cloister had been completed in the mid-fifteenth century and it was in 1505 that the Abbot Domenico Airoldi invited Sodoma to complete a fresco cycle begun by the older, better-known Luca Signorelli who left the job unfinished in response to a more prestigious and lucrative commission to paint a Last Judgment in the cathedral of Orvieto.[2]

For reasons not fully understood, Signorelli painted eight episodes from the mature Benedict's life after the saint's move to Monte Cassino, leaving the early years, the founding of houses at Subiaco, and several of the later miracles to be composed by his successor. Signorelli's frescos show traces of strong figuration and bold color but they have not weathered the centuries as well as those of the younger painter. In number but also in freshness of design, delicacy of color, elegance, vitality, and wit, Sodoma dominates the great space. It is to him and his work that I turn my attention.

Indeed, there is no way of ignoring the painter while studying these paintings. Sodoma's "signatures" are everywhere in the narrative of a life that could hardly have been more different from his own. Whereas the young Benedict withdrew from the "world" to seek a life of silence and solitude, Sodoma loved company and laughter; whereas Benedict devoted his life to establishing quiet places of prayer, study, and labor ordered according to every hour of the day, Sodoma's house in Siena was an unruly zoo filled with his pet squirrels, badgers, dwarf hens, turtles, a miniature donkey, and a raven who could answer the door. Benedict's name means "one who is blessed" (and blesses others); Sodoma's nickname refers to a sexual disposition and behavior in flagrant defiance of the public morality of his day. According to Vasari, "He was a happy, licentious man who used others shamefully for his pleasure and amusement. He was always surrounded by boys and beardless young men whom he loved unconventionally, which is how he acquired the nickname of Sodoma, a label that didn't bother him at all but rather that he glorified in and sang out while playing the lute."[3]

Not all scholars have accepted this account (or others) by Vasari as accurate. An early biographer of Sodoma protested that "the evil overshadowing Bazzi's life and name is mainly due to the animus shown towards him by Vasari" – perhaps, but it seems a stretch to suggest that the pseudonym "may only be a place name . . . or a *nom de guerre* given him without special evil meaning by some club or society of which he was a member."[4] No one disputes the fact that Sodoma was married or that he loved fancy clothes and traveled and worked without his wife in the company of young men and a menagerie of favorite pets. To some critics, it seems extraordinary that he was invited to the monastery at all.[5] Yet it is important to remember that he did not force himself on the place. He was an invited guest who, along with some of his young friends and pets, lived with the monks on and off for a period of two years. According to the Rule of Saint Benedict, "all guests are to be received as if they were Christ."[6] There is no evidence to suggest that the artist was an exception. The monks gave him a new friendlier nickname, *Il Mattaccio*, the

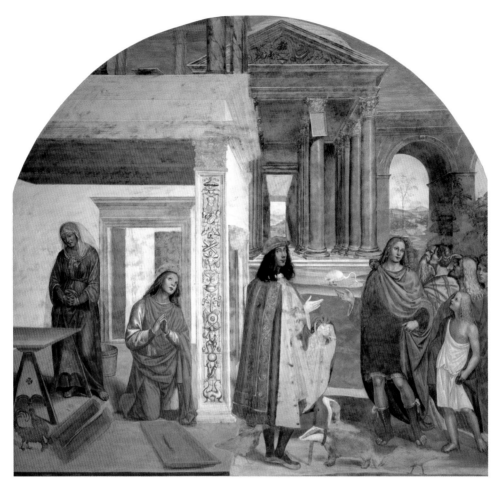

82 Sodoma, *Miracle of the Tray*, 1507–9, Monte Oliveto Maggiore, Asciano.

Jokester; and the abbot general, evidently aware of the painter's love of fancy outfits, lent him the yellow cape of a Milanese nobleman who had recently joined the order and taken the monk's habit.

Perhaps in gratitude, but more likely out of pure vanity, Sodoma proceeded to include his self-portrait decked out in the nobleman's cape in the narrative of the life of Benedict. He placed himself prominently at the center of the scene of Benedict's first miracle in which the young saint, still a boy, prays for the repair of a broken tray (or sieve) that his nurse had borrowed from a neighbor and let slip from the table (fig. 82): Sodoma seems to be winking at the viewer as if to say, "How do you like my outfit? And don't overlook the sword and my pet badgers." Benedict is off to the left on his knees with eyes not on Sodoma but lifted up to heaven. To the right, a young man, perhaps

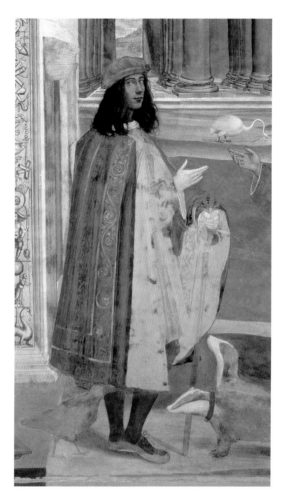

83 Sodoma, *Miracle of the Tray* (detail of fig. 82, showing
self-portrait of the artist)

another Benedict or just a pretty onlooker, gestures toward the scene of the miracle
in a way that makes him appear to be saluting the artist. At first glance, one thinks
that surely this picture belongs to Sodoma, the central figure, but does it? Like any actor
who upstages another, he makes himself noticed, but there is a knowing, half-naughty,
half-apologetic expression on his face, suggesting that he realizes that he is being outra-
geous (fig. 83). "Oh, what a bore this first miracle is!" he seems to be thinking. "The
goody-two-shoes cries and prays over his nurse's little (very little) accident. Couldn't
the neighbors just buy another tray? What an unpromising beginning of a great career!
It was a small thing. It was not even the boy's tray and not his fault that it was broken.
Wasn't he taught that you shouldn't cry over spilt milk? Wouldn't you rather look at me
in my yellow cape?"

As the fresco cycle and narrative continues, these seemingly rhetorical, caustic questions are, in fact, answered. Benedict did pay attention to small things. (So, as will be seen, did the painter.) Benedict, the ascetic, could be emotional and sentimental. (So could the capricious dandy.) Benedict, the sober patriarch, was a determined optimist who built houses of prayer against the tide of barbarian invasions and in defiance of Roman corruption. (Sodoma, the Jokester, held on just as stubbornly to his sense of humor and admiration for the beauty of the body while depicting the life of one of the most solemn spiritual figures of Christendom.) Sodoma must have realized that in Benedict he was meeting his match in unconventionality if not in virtue. In painting Benedict's first recorded miracle, he "makes a scene" not simply of an artist trying to upstage a saint but of an artist who is acutely conscious of the strange, surprising, funny, and beautiful possibilities in the meeting of opposites, of Immodesty with Modesty, of Vice with Virtue, of Whimsy with Vision. The two-year encounter between the exhibitionist artist and the reclusive saint provided the painter with the vitality, wit, pathos, and drama he must have found lacking in the pious legends and commentaries that had turned Benedict into a revered but, to him, lackluster icon.

The primary source for the life of Saint Benedict is the second volume of the *Dialogues* of Gregory the Great written in 593–4, nearly a half century after the death of the saint in 547. While the narrative is not without psychological and theological interest, especially in some of the exchanges between Gregory and his young disciple, it is almost totally lacking in the kind of picturesque detail that would have appealed to Sodoma. From the very beginning, Benedict is treated more as a monument of sanctity than a fallible human being:

> *Fuit vir vitae venerabilis, gratia Benedictus et nomine, ab ipso pueritiae suae tempore cor gerens senile. Aetatem quippe moribus transiens, nulli animum voluptati dedit, sed dum in hac terra adhuc esset, quo temporaliter libere uti potuisset, despexit iam quasi aridum mundum cum flore.*

> There was a man whose life was holy, Blessed by grace and by name. From his earliest youth he had the heart of an old man. Precocious beyond his years, he did not give himself up to sensual pleasure . . . He could have had a good time, but disdained to do so as if he already saw the aridity of the world in flower.[7]

Since Benedict's maturity and perfection are established from the outset, his triumphs over adversity are so predictable, so inevitable, as to be in constant danger of becoming a monotonous litany rather than dramatic chapters in an evolving story. What was a "happy, licentious" young painter, hardly old before his time, to do? He had to invent details and create surprises while at the same time following the main outline of the story, pleasing the abbot, and conforming to the allotted cloistral space. No simple challenge.

Structurally, Gregory's narrative is straightforward and simple. His "audience" is a young novice named Peter who occasionally asks a question but mostly listens with reverence and awe to the story being told. Gregory explains that his sources were four dis-

ciples of Benedict, but he hardly needs to remind Peter or the reader that he himself had been a monk and is the pope and therefore is free to offer his own "authoritative" glosses when the spirit moves him. Although Gregory begins with the birth and early years of Benedict, his form of hagiography is not a *Bildungsroman* since his hero, unlike Augustine or Francis, does not pass through stages of development culminating in conversion. He is holy and old before his time and seems destined to move steadily and philosophically through life's trials and tribulations. At least, that is the way the story starts.

By comparison with the wrenching separations from home of David Copperfield or, for that matter, of Teresa of Avila, Benedict's leave-taking of his parents at a tender age to go away to school in the big city is described without emotional or physical detail of any kind. "He was born into a free-man's family in the district of Nursia and was sent to Rome to study the liberal arts" (*LSB*, 3). That is all there is to the "Once upon a time" where Sodoma had to begin a chronological depiction of the saint's life.[8] No tears, no wicked stepfather, not even a clear indication of the child's age, though it is said later that he was accompanied by his nurse and so must have been quite young.

In one of his boldest and brightest paintings, Sodoma, undeterred by the brevity and blandness of Gregory's opening lines, turns the moment into an episode charged with heroic grandeur, poignancy, natural beauty, and whimsy (fig. 84). He shows the boy Benedict, an androgynous figure of twelve or thirteen in flowing ringlets, looking sadly back at his mother while saddled on a leaping white stallion who could be carrying a young emperor off to battle. His nurse, on a mule, gestures to her breast while glancing down reassuringly. Benedict's father, whose idea this trip must have been, looks on with a cool severity that suggests his unwillingness to change his mind about education or anything else. Meanwhile, a little girl, perhaps Benedict's sister, Scolastica, is in the foreground being nipped at by a puppy – in this moment of heroic leave-taking, no one notices this except the artist who has placed the child so prominently that the viewer cannot help but take note of her. It is perhaps Sodoma's way of lending the scene some cheer, some ordinary humanity, some direct expression of feeling (since the girl does not hide her alarm). It is also a sign to the observer to pay attention to seemingly irrelevant details.

Behind Benedict, in the background, is another of Sodoma's "signature" touches, a tranquil body of azure water reflecting a pale, translucent sky. There is also a city, Rome or, more likely, a town on the way, in any case, the "world" to which the young Benedict is sent and from which he will soon flee to a hermit's cave. Inside the city wall is a tiny gruesome reminder of the "world's" dangers, a gallows and a hanged man. Closer to Benedict, leading his horse to the city of learning and corruption, is a servant or squire fashionably dressed in fifteenth-, not fifth-, century livery and showing, as Sodoma was fond of doing, a well-turned leg and rear-end. So much for a slow start!

Sodoma, like Gregory, has no doubt that Benedict will be the "hero of his own life." There could hardly be a clearer sign of greatness and authority than a powerful white horse evocative of Revelation 19:11–13: "And I saw heaven standing open. And behold,

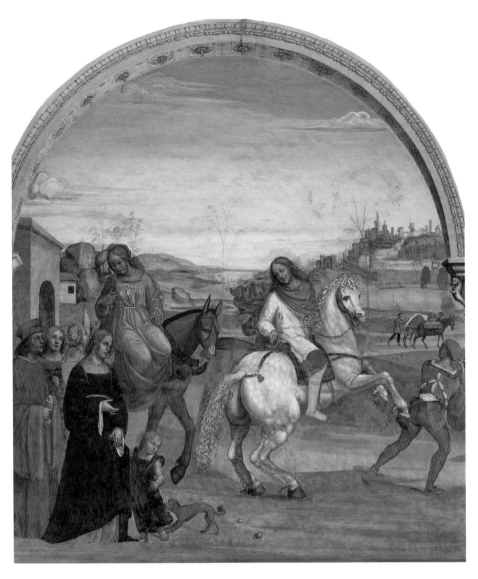

84 Sodoma, *Benedict Takes Leave of His Family*, 1507–9, Monte Oliveto Maggiore, Asciano.

a white horse and he who sat upon it is called Faithful and True, and with justice he judges and wages war . . . and his name is called the Word of God." If Gregory's opening claims about Benedict (that he was holy and mature before his time) seem exaggerated, Sodoma's implicit claim (that he is like the triumphant Christ of Revelation) is greater still. Yet Sodoma does something even more daring. His "warrior" does not have "eyes like flames of fire" but the eyes and face of a delicate, sad, almost effeminate child. Furthermore, the "world" of nature and of the distant city are enchantingly beautiful, especially if one does

207

not notice the tiny silhouette of the hanged man in the far distance. What about the unnamed, faceless squire who is leading the horse? Does his presence mean that Benedict is being taken away against his will? Or is Sodoma giving the boy another friend and protector beside the nurse mentioned by Gregory to keep him company on the road and in Rome? The details added by Sodoma to Gregory's narrative – the horse, the dog, the squire, the ringlets, the landscape – pose questions prompted by the picture but not answered by it, thus giving the episode a physical and psychological dynamic, an aesthetic allure and complexity absent from the first chapter of the *Dialogue*.

Gregory the Great was not a simpleton and neither was Benedict. Both were well acquainted with the world of their time. Rome of the fifth and sixth centuries was a city of extremes, of luxury and poverty, elegance and filth, piety and depravity. A typical liberal arts school of the period would have been a cold, dull place of long hours, dry recitations of grammar and rhetoric, and harsh discipline for those who had not learned their lessons. Benedict was probably in his mid-teens when he decided that he had had enough. Like all good rebels and drop-outs, he went "west," at first still accompanied by his nurse, but somewhere on the road he got away from her too and went to live by himself in a cave in the rocky hills of Subiaco. All this has the makings of a romantic and lively story. However, Gregory, like his hero Benedict, was less interested in romance than in the didactic example of willed holiness.

When Gregory adds detail and complexity to the plain narrative, he does so in an effort to understand the inner life and motivations of his hero and to show their conformity to scripture and orthodox theology. For example, when Benedict has lived alone for a period of time, his sanctity becomes so well known in the region around Subiaco that he is invited by a group of monks to be their superior. Although he is reluctant to leave his retreat, he agrees, but his first monastic experience is not a success. His efforts to enforce discipline on an unruly and corrupt community prompt the monks to shorten his tenure by poisoning his wine. As soon as Benedict realizes this, he rebukes the monks and, according to Gregory, "he returned to the place of his beloved solitude, and alone, under the eye of the Onlooker from above, he dwelt with himself" (*LSB*, 30; *Tunc ad locum dilectae solitudinis rediit, et solus in superni spectatoris oculis habitavit secum, D,* 144).

The *Dialogue* does not say much about the evil monks. In fact, Gregory does not say what form their corruption took. He does not describe them, their behavior, or their house with any particularity. However, since he and Peter, like the young Benedict, were trained in rhetoric, he is prepared to respond at length when Peter questions the peculiarity of the phrase *habitavit secum*, since to live "with yourself" is not the same thing as living "by yourself." At first, Gregory offers a practical explanation saying that if he had stayed longer with the unruly monks, Benedict "could have exceeded his strength and lost his peace" (*LSB*, 31; *fortasse sui vigoris usum et modum tranquillitatis excederit," D,* 144). This makes good common sense, but it also seems to imply that Benedict is not perfect after all, that his energy, patience, and serenity had their limits. Perhaps there is also a hint that

Benedict preferred to live not only "with himself" but "for himself" rather than "for others" in imitation of Christ.

Not wishing to carry the argument too far in that direction, Gregory turns to scripture and a comparison between psychological and moral equilibrium. Referring to the parable in Luke 15, he notes that the Prodigal Son "returns to himself" before he decides to return to his father. The "self" here means the grateful and repentant one, the inner and outer person who literally runs back to the father once he has returned to his "senses" and his heart has led him there. In Gregory's reading of the parable, sin is a straying from God, a loss of self-knowledge and self-control that separates the person from the Creator. Even among the corrupt monks, Gregory thinks that Benedict never lost himself, his awareness of the presence of God. Yet, Benedict's hasty exit suggests that his genius lay not only in rare equilibrium but also in an awareness of the need to nourish and preserve that equilibrium in prayer and solitude.

Making something of a nuisance of himself, Peter recalls another passage in scripture (Acts 12) in which the Apostle Peter is released from prison by an angel and is said to "have come back to himself, saying, 'Now I know truly that the Lord has sent an angel to deliver me'" (LSB, 31). This plays right into Gregory's hands since he obviously wishes to develop the idea that the true "self" to which Benedict (and presumably all good people) aspire is a midpoint, a prototype of what Freud called a healthy ego balanced between the extremes of the id and the superego. For Gregory, the good extreme is contemplation, rapture in God, from which the Apostle Peter and Benedict had, now and then, to descend into a less ecstatic but more reliable self. The bad extreme is any form of sin, a lowering to a lesser self, which, according to Gregory's narrative, Benedict avoided with remarkable determination and skill.

After all this, Peter still wonders whether it was right for Benedict to leave the evil monks rather than staying and trying to save their souls, a perfectly reasonable question. Gregory once again asserts Benedict's "perfection" by reminding his pupil that "it often happens with perfect souls [animo perfectorum] that, finding their work ineffectual, they go elsewhere in order to work fruitfully" (LSB, 32). Gregory cites the case of Paul (Acts 9: 25) escaping from a city hostile to him so that he could go on preaching to more hospitable crowds. Oddly enough, Gregory does not mention Matthew 10: 13–14 in which Jesus says to his apostles: "If the house be worthy, your peace will come upon it. But if it be not worthy, let your peace return to you. And whoever does not receive you or listen to your words, go forth outside that house or town, and shake off the dust from your feet." Perhaps Gregory assumed that any literate Christian of his time would know this passage so well that it would serve as the background of his exegesis without needing to be mentioned.

Gregory's analytical digression prompted by Peter's questions is a sophisticated and subtle commentary, but it is not helpful to a painter. Sodoma evidently enjoyed putting wicked faces on monks, but otherwise his paintings of this episode are workmanlike rather

than inspired. By contrast, the artist was so intrigued by Gregory's description of and commentary on Benedict's sexual temptation that he composed one of the more startling, beautiful, and subversive scenes in the cycle. According to Gregory, Benedict was minding his business one day when "the tempter" in the form of a blackbird fluttered around him until he made the sign of the cross and it flew away:

> But, then, when the bird had gone, a carnal temptation came upon him so strongly that this holy man had never before felt anything like it. Some time before this, he had seen a woman that the evil spirit brought before the eyes of his soul. Such a fire was enkindled in the spirit of God's servant at the memory of this beauty that he could no longer contain the flame of love in his heart. He was on the point of deciding to quit the desert, overcome by sensuality. (*LSB*, 21)

Sodoma surely knew that temptations of this kind were often part of the regular fare in saints' lives and recalled, in more lurid form, the temptation of Christ in the desert before he began his public ministry. Still, Benedict was not Jesus. There had been a slight crack in the armor of the young hermit's perfection. This was a sign of Benedict's humanity that Sodoma could understand and feel for (though, if Vasari was right, Sodoma's tempter would have been a handsome young man rather than a beautiful woman and he might well have taken it as a blessing in disguise).

Gregory continues the narrative, in keeping with the legends of Saint Anthony and other desert hermits, by telling how Benedict

> touched by grace, came back to himself and, noticing close at hand some thick bushes of nettles and brambles, he took off his clothes and threw himself naked among the sharp thorns and fierce nettles. These flesh wounds served as a bodily outlet for the wound in his soul, pleasure being changed into pain . . . As he himself told his disciples, from then on the temptation to sensuality was so controlled that he never felt it again. (*LSB*, 21)

How would Sodoma have reacted to this part of the story? We as viewers now can guess without straining too hard that he would have liked the thought of Benedict getting naked, that he would have had mixed feelings about the neat opposition of pleasure and pain, and that he would have had trouble believing that a roll in the thorns would put an end to sexual desire once and for all. But we do not have to guess; we have the painting (fig. 85). It is a study in balances and imbalances, hard verticals and soft horizontals, solids and transparencies, discomfort and ease. On the left in front of his tomb-like cave sits Benedict clothed in the white Olivetan habit. The rocks are stacked heavy and thick; the dark rectangle of the entrance frames the saint who seems at sixes and sevens, his head and shoulders bent awkwardly and his arms and legs at odd, uncomfortable angles. For once, his expression, usually serene, is almost deranged. His eyes are unfocused, his mouth slightly agape, baring a row of teeth. On the right, against a gorgeous background of a

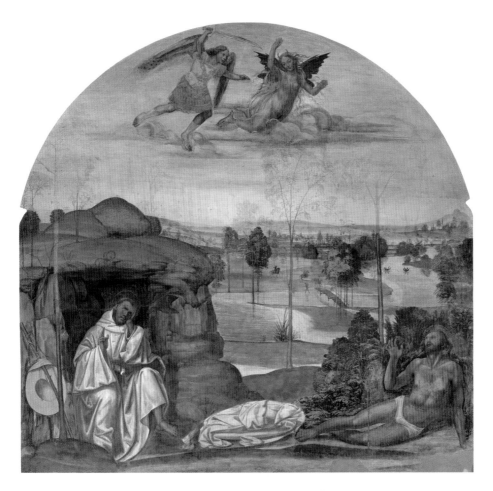

85 Sodoma, *Temptation of Saint Benedict*, 1507–9, Monte Oliveto Maggiore, Asciano.

gently flowing river, feathery green trees, and smooth translucent hills, lies an equally smooth, perfectly proportioned almost nude Benedict, like Adonis or Adam before the Fall, with only the tiniest scratches on his chest. Unlike his other self on the left, he looks quite comfortable and his expression is one of ease rather than agony. Above the whole scene, in a cheery chase, a miniature Michael the Archangel flies after a horned, red-winged woman in a filmy dress.

How did Sodoma get away with this idiosyncratic, whimsical, sensuous version of an episode that was no joke to Gregory and would hardly seem to have been an occasion of beauty and humor to Benedict and the generations of monks after him who tried to live lives of celibacy? In the current introduction to the frescos published by L'Abbazia di Monte Oliveto (and therefore written by the abbot or with his approval), a certain discomfort with Sodoma's rendering of the story is evident: "Though Benedict's body shows

anatomical perfection, the spiritual effect called for a nudity less marked and less human [*meno forte e meno humana*], a position more modest and composed, a facial expression that told of the intimate joy of his triumph over the rebellious flesh." Indeed! Today's monastery text would have the viewer "reflect before Benedict among the thorns on the value of holy purity."[9]

Actually, reflecting on both Gregory's and Sodoma's versions of the episode is bound to lead to more questions than answers. Gregory concludes his portion of the narrative with a reference to Numbers 8 : 24–6 in which it is said that the law of Moses sent Levites between twenty-five and fifty years old into active service while those over fifty were "committed to the guardianship of holy things" (*LSB*, 21). Peter, who is under twenty-five, is more confused than ever and asks for clarification. "It is quite evident," explains Gregory, "that when a person is young, temptations of the flesh are at their highest intensity; after the age of fifty, the temperature lowers" (*LSB*, 21). Young Peter has no way of proving or disproving this thesis and so, as usual, he bows to the greater wisdom and age of his teacher. There is no doubt that Gregory succeeds in tidying up a potentially disturbing event, but Benedict's momentary wavering and Peter's probing question are more sharply concrete, direct, and memorable than Gregory's shaky biology and strained reference to an obscure passage from scripture. In any case, at the time of the temptation, Benedict and, soon after, most of his followers were still far from reaching the safe zone of fifty.

For his part, Sodoma obviously saw a rare opportunity, in portraying the life of one who donned the monk's habit at an early age, to paint a nearly nude figure. It is thought that for the very first fresco he attempted at Monte Oliveto, the story of seven "depraved women" sent by an envious priest to tempt Benedict's young monks, Sodoma painted the women nude. However, the abbot was so scandalized when he saw this that he had the artist put clothes on the women so that his own monks would not be seduced by the picture. The introductory text of the present Abbazia still acknowledges the provocative nature of the painting, clothing and all: "Anyone can understand how this spectacle of seductive women can shake some young heart and rekindle in it those natural desires [*naturali desideri*] which withdrawal from the world and mortification have bridled and caused to subside."[10]

Evidently, the abbot of Sodoma's time did not consider that "anyone" with "natural desires" would be shaken by the sight of their patron, young, handsome, almost nude, and supine. As both Sodoma and the abbot would have known, Italian Renaissance convention allowed for and, in some places, reveled in depictions of nearly nude saints like John the Baptist, Lawrence, Sebastian, and even of a virtually nude Jesus in scenes from the Baptism and Passion.[11] A nude male, especially a holy nude male, seemed to be outside the realm of temptation though, presumably, some portion of the population (congregation or monastic community) would not have been immune to the attractions of such representations of the male body.

86 Sodoma, *Temptation of Saint Benedict* (detail), 1507–9,
Monte Oliveto Maggiore, Asciano.

Taking full advantage of convention, Sodoma remained faithful to most of the main outline of Gregory's narrative except the part about the nettles and thorns. Whereas Gregory's thorns were sharp enough to cause painful "wounds" (*cutis vulnera*) and an "exterior burning" (*arderet foris*), Sodoma's little bushes provide a pleasant background for an almost unscathed Benedict. If one separates the right side of the fresco from the left (where Benedict sits in awkward discomfort), the impression is one of sheer beauty and tranquility. True, Benedict's gesture could be one of distress but it could just as well be of praise or pleasure. In any case, it is a graceful gesture that adds harmony to the scene. Behind, the "world" is a place of airy welcome, of soft light and restful color. There is no sign of ugliness or depravity here. Any monk passing by this fresco, even one of "natural desires," might also have noticed that Benedict did not look at all bad out of his habit and also might have felt a slight twinge of longing at the sight of a bridge that leads the eye back out into the spacious world beyond the enclosure (fig. 86).

Are we to suppose, then, that Sodoma went craftily about following the letter of Gregory's narrative while repeatedly undermining its spirit with images of sensual attractions, often of a homoerotic nature? There is no doubt that certain of his "signature" additions to the story support this view. For example, more than once, he includes among the onlookers in a scene from Benedict's life a well-dressed youth in cocky *contrapposto*

213

87 Sodoma, *Benedict Receives Marus and Placidus* (detail), 1507–9, Monte Oliveto Maggiore, Asciano.

pose (fig. 87). While there is no reason that such a figure should not be included in a crowd scene, some of these spectators seem to have more prominence, more "leg" and swagger, than absolutely necessary. Granted, they may be seen as an innocent and fairly commonplace quotation from Pinturicchio or Perugino who often included similar types in their paintings.[12] Nonetheless, the discrepancy in perspective from that assumed by Gregory and the physical contrast with the white-clad followers of Benedict do more than add decorative detail and color to the basic narrative. None of Sodoma's colors or details is neutral. As has been seen, he is not a mere copyist, but a critical reader eager to introduce his own views to the representation of a life story already heavily loaded (by Gregory and tradition) with "attitude."

Despite Gregory's and Benedict's insistence that temptation had been conquered once and for all in the thorn-bush episode, Sodoma seemed determined to keep sex alive in his frescos. Maybe he simply could not do otherwise. Yet, to notice that Sodoma liked to paint well-formed male bodies is only the beginning of what can be said about the many ingenious ways in which he reminds the viewer of the varieties of desire, attraction, relationship, and pleasure associated with the human body. The white horse notwithstanding, Sodoma's bodies, unlike Michelangelo's, are not the massive, muscular, godlike figures of epic. They may be shapely or not so shapely, but they are always vulnerable, even soft and delicate, and always human. They look as though they can be hurt, but they also look as though they can have fun, as in the background scene in the episode in which Benedict fetches a hoe that has fallen into the water (fig. 88).

The bodies in this lively scene are full of movement and childlike play, though they do not look like children but rather like monks on holiday. This may be the point of this "impertinent" addition to Gregory's tale. Apparently, for Sodoma, the pleasures of the flesh are not all evil, selfish, and corrupting. These distant figures are naked, plump, and happy. Individually they are not remarkable, but together they compose an appealing scene of refreshing and harmless ease. No blood, no battle, no fornication, just bathing on a hot day. Perhaps some of the monks in Sodoma's time actually did this (there is a lake nearby), or maybe it was his wish for them, his picture postcard to his hosts from beyond the rigors of the Rule and the legend.

His reputation, according to Vasari, encompassed careless capriciousness yet Sodoma's reading of Gregory's *Life of Benedict* – faintly, or not always faintly, homoerotic and playful – is also gentle and affectionate. The frescos tease but do not mock the monks. Sodoma

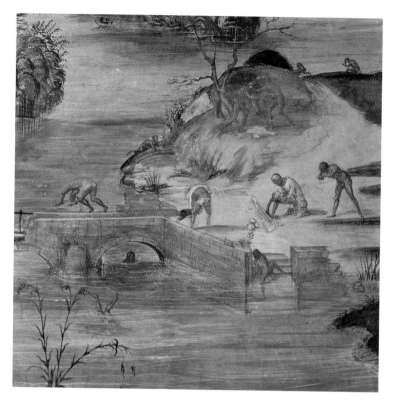

88 Sodoma, *Benedict Fetches a Hoe from the Water* (detail), 1507–9,
Monte Oliveto Maggiore, Asciano.

sees balance and beauty in their lives, perhaps not always as Benedict or Gregory or Abbot Airoldi would have seen them, but with a sense of order and equilibrium that complements the monastic life and delights in its humanity. Two examples illustrate this point.

After Benedict had moved to Monte Cassino, Gregory reports that at one time there was a great famine in the region and the monks feared that they would have nothing to eat. Benedict rebukes and reassures his followers: " 'Why are your minds so upset by fear of the lack of food? It is low today, but tomorrow you will have food in abundance.' The following day they found two hundred measures of flour in bags outside the monastery door" (*LSB*, 100). Once again, Benedict is shown to be a fearless leader with absolute faith in God's providence (and perhaps in his own ability to provide for his congregation through bartering or other practical means unspecified by Gregory, who simply says, "God himself sent" the flour). Rather than focusing on the "miraculous" bags of flour, Sodoma foregrounds the hungry young monks at table with enough food though by no means a feast (fig. 89). The faces of the monks are alive with quiet relief. One sly brother, trying to look innocent, is helping himself to the roll of his neighbor who is not pleased and

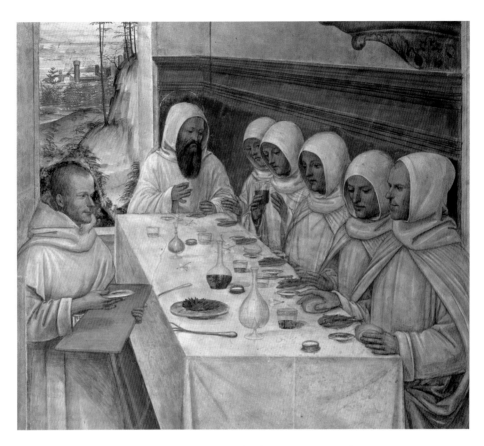

89 Sodoma, *Benedict Provides Flour for His Monks* (detail), 1507–9, Monte Oliveto Maggiore, Asciano.

probably is about to snatch it back. The server is amused by this little scene within a scene. At the head of the table is a benign and benevolent Benedict, the provider, head bowed in modesty and enjoying the repast with his brothers. Sodoma manages to display a minor but natural scene of petty greed without judging it harshly or allowing it to disrupt the overall serenity and order of the moment. As a recollection of the miracle of the loaves and fishes, the picture retains a decorous modesty not claiming more miraculous power for Benedict than for Jesus. In fact, the pose of a peaceful Benedict at the head of the table may show that Sodoma appreciated the memory of the saint as good provider and father as much as founder and miracle-worker.

While this painting is not overtly sensual, it reminds the viewer of the physical intimacy of the brothers, of the daily opportunities for minor (or major) acts of trespass, of breaches of the Rule, and of the stirrings of hunger even among pious men who have withdrawn from the "world." Perhaps Sodoma thought that the real miracle of Benedict was that he inspired many disciples of entirely ordinary appetites and desires to attempt

216

a life of self-denial and communal sharing. Except for those few who once tried to poison Benedict before he established his own monasteries, Gregory's and Sodoma's monks are not the depraved, vicious maniacs of Gothic fiction. Most of their foibles, fears, and departures from the Rule are made appealing by Sodoma precisely because they are commonplace and recognizable. Furthermore, what must have been equally important to this impetuous young painter is that they are forgivable, as is demonstrated again and again by the fact that Benedict, the "man of God," always forgives them.

The second example of a scene in which Sodoma tweaks one of Gregory's episodes with his own wry but gentle touch refers to the time when Benedict sent two of his monks to build their own monastery. He tells them that he will come later and give them instructions about how to proceed with the building. "On the night before the dawn of the appointed day, the man of the Lord appeared in a dream to the servant of God whom he had appointed abbot, and to his prior, and indicated precisely all the sites on which they should build" (*LSB*, 101). Not trusting their dream, the two monks return to Benedict to ask why he did not come to instruct them as he had promised. He tells them that he had indeed come as promised, though in a dream, and that they should go back and do exactly what he had already told them in the night. Like most of Gregory's anecdotes, the story – whether taken literally or not – is yet another instance of Benedict's practicality and the widening sphere of his influence among his followers.

What Gregory does not mention is the sleeping arrangement of the two monks. However, Benedict, who overlooks nothing, notes in careful detail in his Rule how monks should sleep: "Let each one sleep in a separate bed. Let them receive bedding suitable to their manner of life . . . A candle shall be kept burning in the room until morning. Let the monks sleep clothed and girded with belt or cords . . . The younger brothers shall not have beds next to one another, but among those of the older ones." With his usual prudence and wisdom, Benedict realized that monks, especially young ones, might be tempted to misbehave in some unspecified ways if permitted to spend their nights literally "out of habit" and too close to one another (*Rule*, chapter 22, 42–3).

Sodoma may not have been aware of this chapter or he may have thought that travelling monks who had not yet built a monastery could be forgiven for bending the Rule a little or he may have just liked the idea of two monks in one bed. In any case, his version of the episode shows two not old monks, in habit, comfortably and cozily together in bed (fig. 90). There is a candle on the bedhead but it has long since burned out. There is no excessive or indecent exposure of flesh, only the innocent and peaceful faces of the hooded monks and one relaxed hand drooping limply over the side of the bed. A holy picture of the Madonna looks down on the sleeping monks and Benedict hovers nearby holding a model of the proposed monastery and wagging an instructive index finger. In almost all ways, the fresco is a pleasant, unexceptional depiction of quiet and naivety, of the easiest of tutorials during which the pupils can sleep and learn at the same time, and the tutor need not leave the comfort of his own room. Yet, surely, whatever Sodoma might have

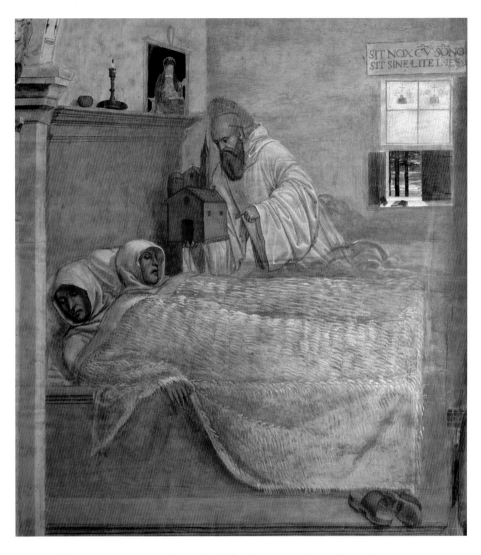

90 Sodoma, *Benedict Instructs Sleeping Monks* (detail), 1507–9, Monte Oliveto Maggiore, Asciano.

guessed about the minds of future secular viewers, he and the abbot must have known that his primary audience, the monks of his time, could hardly have passed by the painting without noticing the one bed.

This painting, like all of Sodoma's frescos based on Benedict's life, is wonderful precisely because it is suggestive without being salacious or sentimentally pious. Of course, Sodoma would not have been permitted to paint a salacious picture in the monastery, but there is no indication that he would have wished to in the first place. His talent was for the delicate and elegant, for fair figures and faces, for light and airy spaces even within

the confines of the bedroom or cloister. In fact, the grand cloister of Monte Oliveto is truly a grand, lovely, open place undoubtedly decorated with flowers and shrubs and a fountain in Sodoma's day. Although confined like the monks to four walls, Sodoma's pictures open beyond themselves to soft, velvety landscapes or through windows, arches, and doorways to glimpses of an inviting, half-hidden world. In the same way, his gestures toward the whimsical and erotic are just that, gestures. They do not overshadow Benedict or Gregory but bring them to life by showing how they engage a sensibility so obviously different from their own. Sodoma's beautiful bodies and naughty asides do not displace the Benedictine ideals but refresh and illuminate them, like open windows and doors, with questions and possibilities from outside the monastic frame.

Sodoma can be funny and sexy, but it would be a mistake and a misjudgment of him as an artist to think of him only in terms of his jokes and pretty boys. Among the other achievements of his Monte Oliveto frescos is his superb accommodation to the architectural space of the cloister and his obvious aesthetic pleasure in architectural form in itself. Sodoma knew that Benedict was a builder. He probably also knew that the monastic houses of Benedict's time were small and plain. The founder believed that no monastery should hold more than the apostolic number of twelve brothers. When it became crowded, some monks should leave and build another house. Yet, by Sodoma's time, Benedictine (and Olivetan) abbeys had grown rich and elaborate. By the fifteenth century, Monte Oliveto had been expanded into an impressive aggregate of church, chapels, cloisters, guest houses, and farms. For Italian painters of the fifteenth and sixteenth centuries, buildings were canvases. Walls, roofs, columns, pedestals and capitals, angles and curves, bricks and plaster, were elements of surfaces to be filled, as well as objects of interest in their own right.

Perhaps Sodoma's greatest point of identification with Benedict was in his role as architect and artist. The Benedict who could provide flour during famine and appear to give building instructions in a dream must have been resourceful and creative, to say the least. Yet any artist knows that creativity, in order to be fruitful, requires structure. Sodoma need not have wanted to become a monk in order to recognize and admire Benedict's gift for innovation and organization. The way a painter could best understand and show this was through what he did every day, structuring space, as Benedict in the hours of his Rule had structured time. No one knows how much Benedict actually had to do with laying stones on stones or bricks on bricks, but his Rule reveals a mind so down to earth and involved in the day-to-day details of eating, sleeping, and working (as well as praying) that it does not seem too much of a stretch to imagine him standing among the masons and carpenters like a knowledgeable foreman. That is exactly what Sodoma does in one of the most stately and balanced paintings in the cycle (fig. 91).

In Subiaco one can still see the ruins of the humble foundations of Benedict's first houses. They would have looked nothing like the richly marbled and columned palace that Sodoma has imagined in this painting. However, his arches in fact echo the arches of the

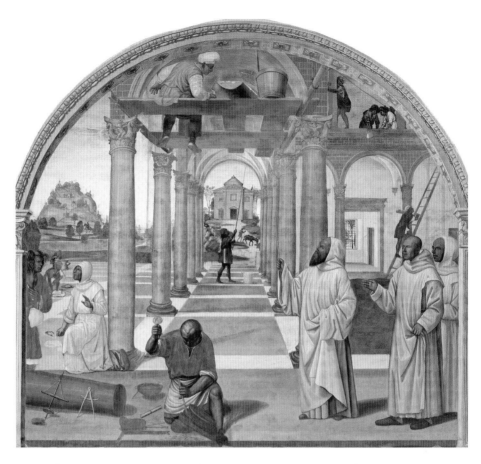

91 Sodoma, *Benedict Completes Building of Twelve Monasteries*, 1507–9, Monte Oliveto Maggiore, Asciano.

grand cloister of Monte Oliveto and his pink floors match the pink floors which the monks walked over (and still walk over) on their way to and from the church. Other than the little man hanging on to a column for dear life in the upper right, this picture is more about work than fun. In Italian the word for "building" in the script below the fresco is *edificazione*. It is a word that Sodoma seems to have understood. Benedict's work, like that of a good artist, was edifying in that it sought to build up, "edify" people as well as places. True, Sodoma's idea of edification was not always in conformity with Benedict's, but while living at Monte Oliveto he had ample opportunity to observe and absorb certain elements of the Benedictine aesthetic. Like virtually all Benedictine monasteries, Monte Oliveto is in a remote and beautiful place surrounded by hills and looking out on a richly forested valley. All parts of the building – cloister, church, refectory, library, chapter room, dormitory – are segments of an overall harmonious design arranged for the easy and practical needs and movements of large numbers of monks and guests. At the same time, each

220

space is a physical sign of the balance, order, and moderation of Benedict's Rule, and each contains some reminder of the charity preached by Jesus in the Gospels.

Although Benedict says relatively little about buildings in the *Rule for Monasteries*, his assignment of tasks to individual monks – prior, guest master, novice master, and others – provides some idea of how he envisioned the use of space, whether in a large or small house. For example, in describing the cellarer, the monk in charge of food and wine, Benedict says that he should be "wise, of mature character, sober, not a great eater, not haughty, not excitable, not offensive, not slow, not wasteful, but a God-fearing man who may be like a father to the whole community . . . Let him take the greatest care of the sick, of children, of guests and of the poor" (*Rule*, chapter 31, 48). Benedict is constantly seeking an equilibrium between practicality and charity, benevolence and self-discipline. One of the refrains throughout the Rule is "Let all things be done with moderation" (chapter 48, 68).

Moderation and Sodoma do not seem to go together, yet, as a guest of the monastery, he must have benefited from the care of the monks and seen them at work in the fields tending crops, in the cloister cleaning and maintaining the building, in the kitchen cooking, in the refectory serving. Activities that could be noisy and chaotic were, according to Benedict's Rule, to be carried out with a constant concern for the peace, quiet, and dignity of the monastic calling. In showing Benedict building his monasteries, Sodoma in fact maintains moderation and achieves a harmony with the building in which he was working. The painting is in harmony both with the forms of the grand cloister and with the symmetry and serenity of the Olivetan Benedictine communal ideal. Everyone in the fresco is working, yet there is no sign of haste or commotion. Each figure has ample space for his chore though the painting occupies no larger area than any of the others. Benedict supervises the work with a thin stick that looks like a cross between a wand and a long paintbrush. Like the monks, each artisan has his own skill and assigned task. Tools – trowels, mallet, chisel, right-angle rule, compass – are in evidence. As always in Sodoma's paintings, the structures do not weigh down or obscure nature but frame, complement, and point to it. Without removing life from the labor, Sodoma combines a variety of perspectives, of symmetries and asymmetries, of action and stillness, of individual and shared enterprise that reflects the serenity and balance sought by Benedict in his life and spelled out in his Rule.

What is extraordinary in Sodoma's Monte Oliveto frescos is the number of ways in which the artist was able to insert himself into Gregory's narrative without neglecting Benedict or his disciples. Only once, in the miracle of the broken tray, does he go so far as to place his self-portrait in the center of the action. But, one way or another, he is often there in the paintings, not only through his perspective but also in the image of one who does not quite belong – an overdressed onlooker, a recalcitrant monk, an odd "bird" or badger. Yet Benedict is always there also and, oddly enough, the two figures are not locked in mortal combat but engaged in a curious, sometimes witty, often charming dia-

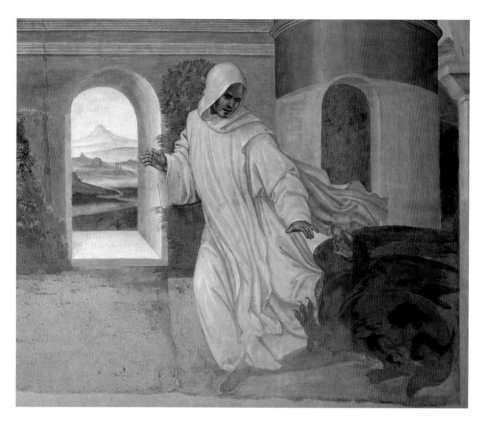

92 Sodoma, *A Monk Met by a Dragon* (detail), 1507–9, Monte Oliveto Maggiore, Asciano.

logue that often resembles a dance. Whenever it appears as though some element in Gregory's narrative is going to dampen the artist's gusto, Sodoma finds a meeting of his mind with Benedict's in their shared preoccupation with form. Unspectacular miracles and monastic enclosures might have seemed dull subjects for a lusty young painter, yet Sodoma clearly discovered lively and beautiful potential in both.

Even the monk's habit had possibilities for a man with an eye for style. Although no one can say exactly what color and shape the clothing of Benedict and his followers was, the monks of Monte Oliveto wore (and still wear) white. It is likely that Abbot Airoldi asked his painter to depict Benedict and his disciples in the shapeless white robe of an Olivetan. Sodoma, being Sodoma, saw bodies beneath habits and must have wondered how it would have felt and what he would have looked like in a flowing white gown. One of his elegant, graceful, physically supple figures is that of a young monk who is said to have had "such a restless mind that he did not wish to stay in the monastery" (*Quidam autem eius monachus mobilitati mentem dederat et permanere in monasterio nolebat*; D, II, xxv, 212). The monk left the enclosure without permission but was stopped on the road by a

dragon. Much of the fresco is lost, but what remains is perhaps the most representative signature of Sodoma's Benedict or Sodoma-cum-Benedict, a combination of fright and fancy, of grace and action, of stilled restlessness, in short, a surprisingly successful marriage between artist and saint (fig. 92).

In the story the monk, having been chased by the dragon, returns to the monastery and asks forgiveness of Benedict who, of course, grants it. The most vivid detail of the remains of the fresco is that of the young monk in flight like a dancer, his graceful motion causing his habit to billow out like a sail and reveal the curves of a lithe and spirited body. True, the dragon is at his heels, but there is also an arched window with a view of soft blue and lavender hills in the distance. In Sodoma's frescos there are always views. There is always a way out, an alternative world, an opening. For Benedict and Gregory, the ideal "way" out of the world's conflicts, disappointments, and snares was prayer, faith, doing the Lord's work. Sodoma's paintings show that he understood and even appreciated that but never underestimated the restless urges and energy of the body beneath the habit, of beauty beyond the frame, and therefore the importance of keeping an eye on the moment when the procession becomes a dance and the disciple looks like a dancer heading for the nearest exit. The dashing young figure is neither Benedict nor Sodoma but an image of restless movement between the two. He could be running back to the monastery, as Gregory says in his narrative, or he could forever be on the move between the dragon and paradise, which is how Sodoma and the deletions of time have made it appear.

SAINT FRANCIS

8

FURTHER CONSIDERATIONS OF THE HOLY STIGMATA OF SAINT FRANCIS

WHERE WAS BROTHER LEO?

"Why did you come here, Little Brother Lamb? Did I not tell you many times not to go around watching me?"

Saint Francis to Brother Leo, quoted in
The Little Flowers of Saint Francis

On the walls of the corridor leading to the tiny chapel on Mount La Verna (or Alvernia), the damp and thickly wooded outcropping of rock where in the autumn of 1222 Saint Francis of Assisi received the Stigmata – the wounds of the crucified Christ on his own body – there are frescos of the saint's life scarred with graffiti. The frescos are amateurish, twentieth-century imitations of a great medieval and Renaissance art form; the graffiti are scratchings of initials and dates left by visitors in the dry paint and plaster. Similar markings can be seen throughout Italy on frescos painted low enough for a hand to reach. What is remarkable in La Verna is the juxtaposition of the hall of graffiti and the place of the Stigmata, a scarred wall next to a shrine commemorating a wounded body. On the wall, the imprints appear random and without meaning; in the chapel, the imprints on the saint are recalled by Franciscans and millions of Christians as Godsent and endowed with an ultimate significance. In both cases, a border has been crossed, an apparently finished surface has been opened and violated.

Despite its negative connotations in English as a form of defacement, the term *graffiti* in Italian originally means "writings" or "markings" scratched by a stylus into a tablet or plaster wall. Historically, implications of "writing over" an earlier text or image are not

necessarily indicative of deliberate damaging since later inscriptions on ancient tablets or scrolls often displayed pride of discovery or ownership, or a desire to label, explain, and expand on a previous message.

Even the seemingly barbarous markings on religious paintings are not as easy to read as they first appear. Undoubtedly, some were carved by people intent on discrediting what they saw as religious superstition; others may have been done by children with no sense of the difference between a painted wall and a school-desk; others may have been left by pious pilgrims who thought that they were participating in the saint's life by imprinting their names on its pictured narrative. Whatever the intentions, the frescos are materially transformed by the addition of the scratching. We as viewers now see the paintings differently from those who first saw them, not only because the motives and meanings of the graffiti are opaque but also because the jumble of signatures alters the perspective of the viewer. Like it or not, one can only see the paintings (and whatever illusory forms of perspective they contain) through or beyond the scars on their surface.

The word *stigmata* also means "markings," though its negative connotations of "wounding" or "branding" have an earlier and more consistent history than those associated with graffiti. To be stigmatized is to be marked as a criminal, a sinner, a slave, an outsider. The mark of Cain was a stigma, as was the Scarlet Letter (as intended by Hester Prynn's Puritan judges) and the Star of David (as intended by the Nazis against Jews). As each of these cases makes clear, the stigma proposes a reading and, at the same time, opens itself to other, even opposing interpretations. For Christians, the wounds of the crucified Christ are the paradigm of transformative stigmata, marks of punishment and pain reread as signs of healing and salvation. To the Romans, public execution was a sign of humiliation and a warning to would-be insurrectionists. Either way, the wounds of Christ in particular and punitive wounds in general are not random marks in the flesh but intentional "texts" asking to be interpreted.

A preoccupation with textuality may be a postmodern, poststructuralist phenomenon but it is hardly unique to this era. The tendency to see signatures everywhere binds us to our medieval ancestors. What most distinguishes us from them is the way we tend to address language as an evolved complex of systems of communication and locate authorship on various natural rather than supernatural planes. In his *Life of Saint Francis*, Saint Bonaventura, the thirteenth-century Franciscan theologian, sees Francis as a new Moses bearing God's message, like Jesus, on his own flesh: "The angelic man Francis came down from the mountain, bearing with him the image of the Crucified, which was depicted not on tablets of stone or on panels of wood by the hands of a craftsman, but engraved in the members of his body by the finger of the living God."[1]

For the medieval mind the Bible was an encoded text. By means of the right keys to scripture, even the most abstruse signs in nature and art could be deciphered. Yet in Francis's own day, the strange and gruesome form of God's "engraving" and its meaning were subjects of bewilderment and disbelief. In an otherwise pious rendering of the

miracle, a fourteenth-century author (certainly a Franciscan) shows admirable candor: "Now why these holy Stigmata were imprinted on Saint Francis is not yet entirely clear."[2] Such candor is one of the attributes of Francis himself that made him distinctive among religious people of his own time and has made him a beloved, almost mythical figure, even among non-Christians, to this day. Francis, the darling of environmentalists, is remembered for preaching to the birds, taming the wolf of Gubbio, conserving the earth's bounty by living simply. Today most Christians, even Catholics, would probably prefer to leave the saint in the garden by the birdbath than reopen the wounds of a strange and disturbing miracle story as "shockingly novel" today as it was in the thirteenth century.[3]

Yet in all the early accounts (in words and paintings) of Francis's life, the episode of the Stigmata is the culminating, climactic event. To forget about it is like forgetting about the Crucifixion in the life of Christ, which in some versions of Christianity is more or less what happens. Like the Crucifixion, the episode of the Stigmata is a problem as well as a sign and, for some, an unsavory, unsolvable problem best avoided. First of all, did it really happen? If so, why? Why Francis? Was he a masochist? Was he being rewarded by a gracious God or punished by an internal demon? Did his followers invent the whole thing? Why did they and Christians for centuries love to repeat and depict the story? Why do we today prefer not to think about it, especially in relation to such a nice and friendly saint? In short, how to read the wounds of Francis?

Since we cannot place our own hands on the body of the saint or see the event firsthand, we must rely on a form of graffiti – later writings over the original embodied text. This is where Brother Leo comes in. According to tradition, he alone of Francis's companions came closest to witnessing the miracle, it was to him that Francis related his own account and interpretation of it, and it was to him in his old age that later authors went to hear the story retold.[4] I too need to approach the text through Brother Leo, but first I have to find him.

Most of the paintings and frescos of Francis receiving the Stigmata show another friar somewhere in the picture, observing Francis and the six-winged seraph or dozing over his prayerbook – but not always. In two of the earliest (around 1230–50) depictions of the miracle, by the Master of the Bardi Saint Francis Dossal (fig. 93) and Bonaventura Berlinghieri on an altarpiece in San Francesco, Pescia, Francis is alone with the seraph. The Bardi dossal frames Francis in a three-tiered narrow mountain-top that encloses the saint and his tidy classical chapel in a somewhat airless architectural space. Francis's vertical posture and triple-knotted cord repeat and reflect the symmetry of the seraphic figure to whom he shows his punctured hands in a moment of private communion. No space for a witness is provided and, indeed, the only signs of the wilderness of La Verna are the stones in the neat path beneath Francis's knees and a dainty three-branched tree behind the chapel roof.

In the last decade of the thirteenth century, a standard was set for portraying the Stigmata by Giotto and his workshops in Florence, Assisi, and Pisa. Only in the Assisi cycle in the Upper Church of the Basilica of San Francesco is a companion shown with Francis,

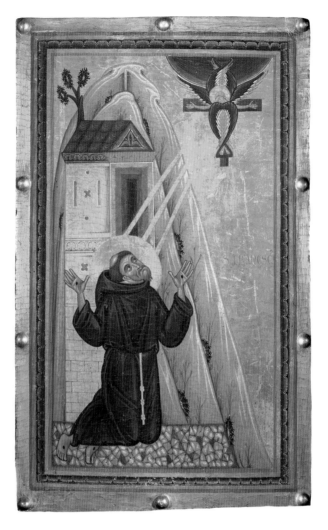

93 Master of the Bardi Saint Francis Dossal, *Stigmatization of
Saint Francis, c.* 1 2 3 o–5 o, Galleria degli Uffizi, Florence.

and he is sitting unobtrusively off to the lower right with his head bent over a book, obliv-
ious to the miracle (fig. 94). Trees, deep blue sky, and sculpted yellow crags suggest
wilderness; Francis's body, tilting back and clothed in a rough-textured brown habit,
seems a natural part of the landscape. Two booth-like chapels introduce a formality to the
scene and accentuate by their placement that the two friars are on different planes and
levels. Leo is lower down and closer to the viewer than Francis; his golden chapel, with
a prominent cross and decorated eaves, is slightly fancier and more church-like than the
plain brick-colored booth of Francis. The structure of the painting is triangular because

94 Workshop of Giotto, *Saint Francis Receiving the Stigmata*, *c.*1290, Upper Church,
San Francesco, Assisi.

of Brother Leo; his open book repeats on a modest scale the outspread wings of the envi-
sioned figure. This composition seems to suggest that Leo (and perhaps the Church)
guards and bears witness to the miracle of the Stigmata. But it also suggests that they are
separated from it by Leo's inattention and the crevice that cuts him off from the platform
of rock on which the saint experiences his unfathomable ecstasy. Leo is present and absent,
there and not there.

In the *Pisa Stigmatization* (fig. 95) and in the great fresco on the entrance wall of the
Bardi Chapel in Santa Croce, Florence (the only one of the three that most art historians

95 Workshop of Giotto, *Pisa Stigmatization, c.* 1295, Louvre, Paris.

96 Giotto, *Stigmatization of Saint Francis*, c. 1 3 2 0, Bardi Chapel, Santa Croce, Florence.

believe to be the work of Giotto himself; fig. 96), Francis is alone with his vision. He, not the seraph and not the stark and simple landscape, is the center of attention. He kneels on one knee; his torso is half-turned in a gesture of surprise; his arms are raised as if in prayer and awe; his face is lifted to the heavens; the wounds in his side, hands, and feet are not bloody openings but tiny focal points for the linear rays that connect him to the wounds of the crucified apparition. The seraph, perhaps half the size of the saint, is a bearded, haloed Jesus, floating with arms spread more like a bird in flight than a man pinned to a cross. In the Assisi and Pisa versions, the Crucifixion is implied, not through the presence of the cross but in its absence, as though the rigidity and weight of the wood have been left behind.[5] Francis himself is "grounded" in both paintings. Yet the scalloped and gentle curve of pale rock beneath his robe gives the impression that he is floating, if not on a cloud, then on a weightless platform between heaven and earth.

Although two chapels are shown in the Pisa version, they are both empty and so reduced in size in comparison with the figure of Francis that they appear more as tokens or disembodied traces of Leo or other brothers than an actual representation of a witnessing presence. In the Santa Croce version, there is sufficient physical space for a witness within the framework of the painting, but the emotional space is so completely dominated by Francis and Jesus that another figure would have seemed an aesthetic intrusion. This is a picture of Francis alone with his vision. His position between cave and church suggests his role as mediator between solitude and community, independence and institution. Giotto places Francis somewhat awkwardly on his left knee so that his torso and hands, showing their wounds, are turned toward the spectator. His witness is the viewer, not Brother Leo.

In all the early depictions of the Stigmatization, Francis raises his arms and hands in awe and in imitation of Christ's position on the Cross as recalled by the seraphic vision. References to Francis as *alter Christus*, "another Christ," became popular but also controversial after his canonization in 1228. The question – as with the wounds in his hands, feet, and side – was how literally to take the comparison with the original.[6] In an early fifteenth-century, non-narrative painting of Francis among other saints, Taddeo di Bartolo depicts Francis, posed like the iconic Jesus after the Crucifixion, displaying his Stigmata apart from the legendary context of La Verna and Brother Leo, as though the mere sight of the scars bore its own sacred significance (fig. 97).

By the fifteenth century, the Order of Friars Minor, along with the Dominicans, was the major preaching branch of the Church, well established within the institution. Yet, as the Franciscans became more numerous and prosperous, they also became more and more divided in their views of how best to follow Francis and to interpret certain events in his extraordinary life. Disputes arose not only about the authenticity of the Stigmata and the claims that Francis was "another Christ" but also about the unruly potential of the Spirituals, those brothers who wished to imitate the freedom and radical poverty of Francis more literally than seemed prudent to an increasing number of leaders in the Order and the Church. As always, pictures tell the story (or, more precisely, reflect the atmosphere) in their own way.

Since in paintings of the Stigmata by Italian artists of the mid-fifteenth century Brother Leo is usually present, awake, and alert to the miracle, it seems logical at first to assume that this suggests an authentication of the event by a humble and trustworthy witness approved of by Church leaders. But the case is not so simple. Leo, like most of the first companions of Francis, identified with the Spirituals and was strongly opposed to Franciscans building elaborate convents and churches, including the Basilica in Assisi to house the tomb of the saint.

It is not surprising, then, that some paintings from this period reveal a combination of institutional conservatism and a recognition of the extent to which Francis (and Leo) challenged and disrupted religious and social complacency. The Dominican Fra Angelico (or

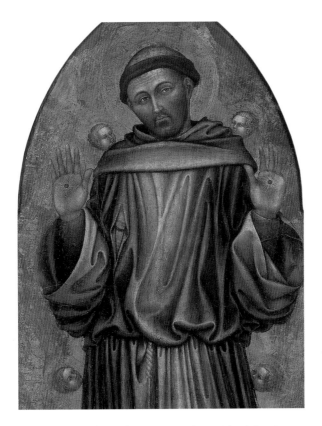

97 Taddeo di Bartolo, *Madonna and Saints* (detail showing
Saint Francis), 1403, Galleria Nazionale, Perugia.

a member of his workshop), painted in tempera on wood a startling, almost surrealistic
scene in which a flash of light from the seraph appears to break open the earth so that
the rocks part like the Red Sea before the outstretched arms of Francis and the diminu-
tive seraphic Jesus (fig. 98). Brother Leo is close to Francis – habited like him in brown,
tonsured like him – clearly startled by and shading his eyes from the brilliant light. He
and Francis are obviously brothers, almost twins, yet the overall effect of the picture is
one of fracture. The earth has been torn asunder by the seraphic vision. Leo is a witness
to a miraculous and disquieting event that lets in a new light through a rupture in the
rock that, in the logic of the painting if not the intention of the artist, is the rock on which
the Church (or at least that architectural bit of it shown top left) is built.

In 1450 one of Fra Angelico's pupils, Benozzo Gozzoli, painted scenes from the life of
Saint Francis in the Franciscan church in Montefalco, Umbria (fig. 99).[7] In the upper left
panel of the south wall of the choir, Saint Francis is depicted receiving the Stigmata in
much the same position, kneeling with arms raised, established by Giotto. However, to

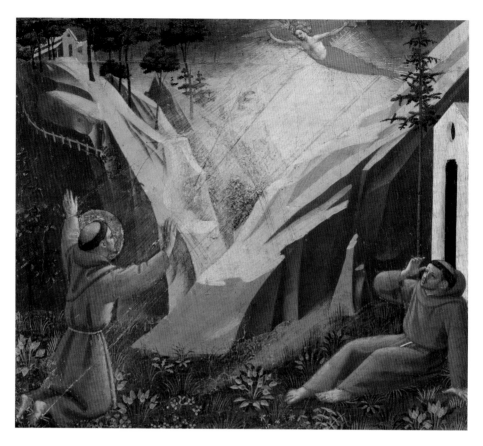

the saint's right and only slightly behind him is a cowled figure of a young beardless friar with a book in his lap, looking up in the same direction as Francis and shading his eyes from the divine light. The winged seraph itself, though in a place of honor higher up on the east wall, occupies a separate, smaller panel. "In no other extant cycle is the stigmatization represented in separate panels."[8] Thus, the larger framed panel of Francis and his young companion makes a structurally complete and compelling composition "connected" to the seraph by thin lines to the wounds that are interrupted and rerouted by the curve and angle of the walls, broken by painted half-columns, and virtually invisible to a viewer examining the frescos from the middle of the church.

There is a fissure in the rock but it does not separate Francis from his companion. It joins them in their separation from the church or monastic buildings on the other side of the cleft behind them. According to the legends, Francis indeed went off across a cleft in the rocks by himself to pray while at La Verna. However, Francis's insistence that his brothers should own no property and have no fixed abode was a matter of dispute in his

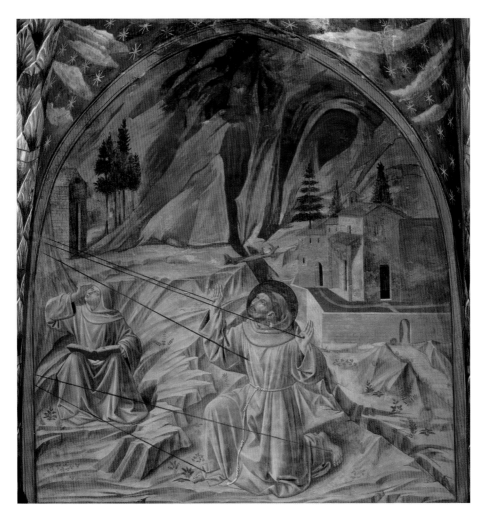

99 Benozzo Gozzoli, *Stigmatization of Saint Francis*, 1450, San Francesco, Montefalco.

lifetime and a source of conflict in the Order for many years after his death. In the fif-
teenth century Montefalco had become a center of Franciscan reform. The fiery, charis-
matic Franciscan Bernardino da Siena had preached reform there in 1425; in 1442 Fra
Antonio da Montefalco became Provincial General of the Osservanza, the branch of the
Franciscans dedicated to the original simplicity and poverty of Francis's Rule. It could
hardly have escaped an artist of sensibility working in Montefalco in 1450 that there was
a deep irony in decorating richly furnished churches with scenes from the stripped-down
life of the beggar saint whose favorite hermitages were caves and favorite bed the ground.

One must be careful not to over-read the signs of fracture. Benozzo Gozzoli was famous
for his smooth surfaces, bright and cheerful colors, innocent faces. The overall effect of

the fresco cycle in Montefalco is by no means grim. Much of the church decoration was done "with a desire for reconciliation rather than division."[9] Yet the Stigmata story itself, not to mention the controversies that came after it, is riddled with gaps and dark corners. It is remarkable that Fra Angelico and Benozzo Gozzoli – two masters of light and harmony – did not (or could not) prevent the crevices from showing.

In the sixteenth century, during the Reformation and Counter-Reformation, the veneration of saints was ridiculed by Protestant Reformers as superstitious idolatry. Within the Roman Church, the more fanciful of miracle stories gave precedence to a greater emphasis on the interior life, including the inner struggles, of holy persons. Throughout the sixteenth century, Francis continued to be revered, though much of the narrative charm and joy of the early legends and paintings was replaced by a brooding mysticism. Dim scenes of Francis alone, meditating on a death's head, were favored. The clean lines and glowing hues of enchanting old stories and pictures were often swallowed up by introspective shadows. It seems that there was no place for simple, pure-hearted Brother Leo in the dark night of the soul.

As the old stories show, however, Brother Leo had a way of insinuating himself into the picture. Between 1594 and 1595, Federico Barocci painted him into a version of the Stigmata on a large canvas (fig. 100).[10] In Mannerist style, the painting is a dramatic contrast of darks and lights. Despite the apparent stillness of the scene, the garments and gestures of the figures are full of curving movements that complement the undulating shapes of the rocks and cave that encompass them. What is most striking is the position of a friar – it must be Brother Leo – whose large full-bearded Michelangelesque figure, torso twisting away from his lower body, right arm sweeping above his head to shade his eyes, left hand gently clasping a rosary on his generous lap, frames the lower left-hand corner and seems to introduce the viewer to the entire scene. A few "feet" to the right, deeper into the composition, his face bathed in golden light, his arms outstretched more in welcome than in fear, is Francis (smaller than his companion), kneeling and looking up to a tiny birdlike figure bursting radiantly through the black clouds of night. Two soft beams of light seem to be touching the saint and the only marks visible on his clothed body are small unbloody spots on his open palms. Softening the rock beneath Francis's knees is the skirt of his habit – almost like an altar-cloth draped hastily but elegantly beneath the image of a revered icon.

The barely perceptible figures in the dark background – "a shepherd sleeping with his flock, while lighted by a fire another shepherd kills one of his companions" – reminds the viewer of the sin of fratricide which Francis "wishes to expiate for humanity."[11] Even if one's eyes fail to penetrate into the recesses of the painting, it is clear that Barocci's La Verna is a darker, more complex place than that of most earlier pictures, many of which show the miracle of the Stigmata occurring in broad daylight. Yet there, well-lit and in full view, is Brother Leo – alert and powerful – ready, it seems, to defend as well as observe his beloved Francis. He might also be a figure of the artist as hero, a stalwart and

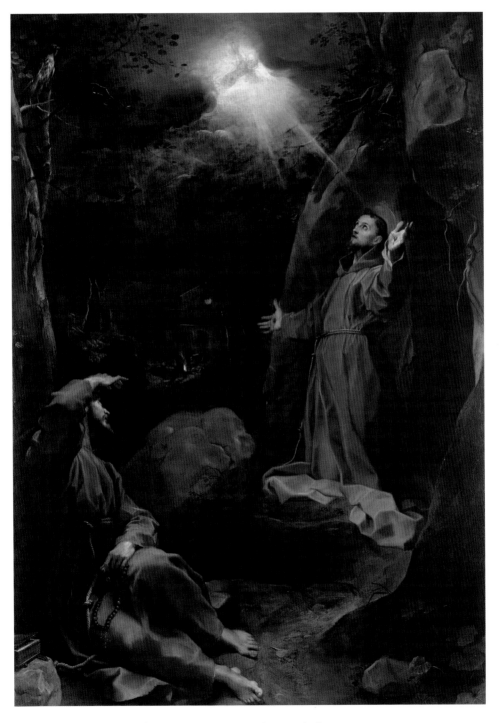

100 Federico Barocci, *Saint Francis Receiving the Stigmata*, c. 1594–5,
Galleria Nazionale delle Marche, Urbino.

stubborn observer shading his eyes in order to frame the mysterious and sacred moment for himself and "save" the holy man for posterity.

More pictures would have to be examined before an authoritative conclusion could be reached about widespread changes in the depiction of the Stigmata by Italian painters from the Trecento to the Cinquecento. Still, these examples are representative of their times. What is more important, they show differing readings of the Stigmata, not merely slightly varied angles on the same scene but interpretive approaches so distinctive as to produce significant changes in the scene itself.[12] It would be tempting and easy to observe that as the companion witness (Brother Leo) became more prominent, Saint Francis and the seraph receded, "proving" an increasing skepticism about the miracle. Yet this reading says too much and too little too quickly. It does not take into account the mood of each picture and, crucially, it assumes that the role of an intermediary is necessarily one that distances and dilutes.

In continuing the search for Brother Leo, one must look behind the paintings to the major written texts (and the oral tradition that informed them), especially the *Vita di San Francesco (Prima e Seconda)* by Fra Tomaso da Celano (1245–7), the *Legenda Maior (The Life of Saint Francis)* by Bonaventura (1263), and *The Considerations of the Holy Stigmata*, an addition to *I Fioretti di San Francesco (The Little Flowers of Saint Francis*; 1370–85), anecdotes from the saint's life selected and translated anonymously into Italian from the Latin *Actus* written by Fra Ugolino di Monte Santa Maria around 1325. Bonaventura and Ugolino depended heavily on Celano's earlier text for much of their information, but, like him, they collected and included stories gathered from interviews with people who had known Francis or knew someone who had known him. Giotto's frescos in Santa Croce appear to have been based on Celano whereas the Assisi cycle is explicitly tied to Bonaventura (and includes citations from the text). Although in 1266 Bonaventura's version was declared by the Order and Rome to supersede all others, the earlier and later manuscripts continued to circulate. By the time of Angelico, Benozzo, and Barocci, Ugolino's collection of stories and the additional chapters on the Stigmata were widely circulated and would have been as familiar to painters and patrons as the Celano and Bonaventura.[13]

Celano never once mentions Brother Leo. He narrates the episode of the Stigmata with a brisk economy reminiscent of the spare, hurried recounting of certain miraculous events in the Hebrew Bible (such as Jacob wrestling with the angel in Genesis 32) and the Gospels (such as the Transfiguration in Luke 9). Since the narration is in the third person, it could be read as a witnessed account, yet no witness is mentioned and the feelings of awe, fear, and joy seem to belong exclusively to Francis:

> While at his hermitage at La Verna, he saw above him in a vision a man with six wings in the form of a seraph, with his hands outstretched and his feet together nailed to a cross . . . At this sight the blessed servant of the Most High was in awe, but he did not understand the significance of the vision. He was filled with joy from the loving sweetness with which he was looked on by the seraph . . . a gaze of inestimable beauty, but

he was terrified by the thought of the one nailed to the cross and the bitterness of his suffering. He got up, sad and happy at once, joy and sorrow alternating in him. He tried to understand this vision, but his spirit was agitated . . . As he was contemplating the strangeness of the apparition, signs of nails began to appear on his hands and feet.[14]

Then follows a detailed description of the size, shape, and color of the nails, of their exact location, and of the wound in the saint's side. Given the peculiarity of the scene, the narrative is surprisingly clear and straightforward. Francis's holiness, not his understanding, is assumed throughout. His feelings are mixed and alternating; he is "agitated" and "terrified," "joyful" and "happy." Twice this short account relates that he did not understand what he saw. The overall impression is one of awe and mystery. No witness is mentioned.

Here and there in Celano there are references to an unnamed favored companion, a brother particularly close to Francis, privy to some of his deepest secrets. In the chapter preceding the description of the vision, Celano anticipates it as a "mystery known only to God and to the Saint who revealed it in part to one person only" (*Vita Prima*, 99). According to the oral tradition, Francis had close and affectionate ties to more than one of his friars but one in particular is mentioned most frequently during the period of the Stigmata and the following two years of Francis's life. Francis gives this friar his tunic and asks him, along with one other (according to Celano), to sing psalms with him at his deathbed.

The most moving and revealing episode, seemingly involving the same unnamed friar (repeated and embellished by Bonaventura and Ugolino), appears in chapter 20 of Celano's *Vita Seconda* in which "a brother who is tempted wishes for a piece of writing in the saint's hand." According to the story, Francis and a few of his companions have remained on Mount La Verna after the apparition of the seraph. Anticipating his approaching death, the saint has removed himself from his friars to pray in solitude. Meanwhile, one of his friars suffers "a grave temptation, not carnal, but spiritual," and is convinced that the only thing that will free him is something written for him by Francis. Although the friar does not want to disturb the saint, Francis perceives his anguish and writes a blessing for him, saying, "Take this little parchment and keep it carefully with you until the day of your death" (*Vita Seconda*, 219).

One of the few surviving samples of Saint Francis's handwriting, the parchment described in the text, now on display in Assisi, was written, according to tradition, after the episode of the Stigmata in September of 1224. On one side are Francis's praises of God; on the other is his version of the blessing in Numbers 6 : 24–6: "May the Lord Bless you and keep you; May He show His face to you and be merciful to you. May He turn His countenance to you and give you peace. May the Lord bless you, Brother Leo." The recipient later added his own graffito in red ink: "Blessed Francis wrote with his own hand this blessing for me, Brother Leo." Leo later added, again in red ink, in the upper margin, the date and occasion of the gift.[15]

241

Given the mysterious (and undoubtedly terrifying) circumstances of the Stigmata, the appearance after the event (if not during it) of Francis's suffering mixed with ecstasy, and the text's insistence that the friar's temptation was spiritual not carnal, it seems more than possible that Leo was tormented by doubts about the miracle's meaning for him and its power to alleviate the fear of his own future suffering and death. Whether he was on the scene of the Stigmata or only near it, Leo witnessed in Francis, in a peculiarly heightened and intense form, a paradoxical embrace of pain and death in a spirit of absolute faith and joy. Doubting Thomas notwithstanding, the greatest test of faith for many who find themselves close to extraordinary sanctity is less about the saint than about the self. Leo, like others who have come after him, must have wondered not whether Francis (or Jesus) successfully passed the test but whether he could. His wish for a kind of promissory note is touchingly *not* superhuman. Having seen, close-up or at a little distance, what Francis has gone through, he would rather have God's graffiti on paper than on his flesh. Who can blame him? Who can fault his imperfect faith? Not Francis, evidently.

During the writing of his *Life of Saint Francis*, Bonaventura, educated at the University of Paris and appointed Vicar General of the Order during a divisive time between the Spirituals and Conventuals, went to La Verna in 1261 and secluded himself in a cave-cell next to the one in which Francis had lived during his retreat on the mountain. Although Francis had been dead for only a few decades, his followers were deep in conflict about how literally to follow in his steps. Bonaventura wished to find a middle way that would establish harmony in the Order. In addition to using the Celano text, Bonaventura interviewed a number of friars, possibly including an elderly Brother Leo, who had known Francis and his earliest followers. Bonaventura adds an elegant style and a sophisticated theology to the basic data provided by Celano but he omits many of the incidents that show Francis's humor, oddity, and radicality.

In contrast to Celano, Bonaventura frames the episode with repeated references to scripture, explains that Francis understood the meaning of the vision, and insists that the existence of the wounds was verified by the testimony of numerous reliable witnesses. Bonaventura introduces his account by comparing Francis to "the heavenly spirits on Jacob's ladder [Genesis 28 : 12], either ascending to God or descending to his neighbor" (*Bon*, 303). His Francis consults the Gospels three times while praying alone at La Verna and each time comes upon the narrative of Christ's Passion. He compares Francis's devotion with "the very great love of God" referred to by Saint Paul in Ephesians 2 : 4. Bonaventura then describes the vision in much the same terms as Celano, concluding with his own emphasis on the spiritual transformation of Francis.

When Bonaventura went to La Verna to pray and write in 1261, Francis was already a canonized saint, memorialized, revered, raised into heaven, absorbed into God, transformed by love into "another Christ." Bonaventura could say what many believed, in words that Francis would not have been likely to use or want to hear applied to himself in pious adulation. According to Bonaventura, Francis had reservations about revealing the episode

of the Stigmata to anyone for fear that people would misread his wounds, that they would not believe him and think he was crazy or, perhaps worse, that they would believe him and treat him like a saint.

By Bonaventura's time there had been many discussions and opinions about what had actually happened, who saw and said what, and whether the original testimony came from Francis himself or an eyewitness. Francis could not hide his suffering or his blood-soaked garments from his friends. What to tell them? Bonaventura answers the question through an appropriately named Brother Illuminato, who seems to appear out of nowhere. When Francis tells his circle of brothers that something extraordinary has happened to him, but that he is uncertain about disclosing it, Illuminato urges him to share the story or else risk being "blamed for hiding his talent" (as in the parable in Matthew 25:25; *Bon*, 306–7). When Francis does tell some, not all, of what he experienced at La Verna, his worst fears come true. Not only is he in great pain for the final two years of his life, but everywhere he goes, people want to see him, touch him, tear pieces off his habit until it is in shreds, and, most terrible of all, probe his wounds to see if they really exist and to benefit from miraculous healing if they do.

The account of the Stigmata is concluded in a prayer (and a kind of apology) to Francis as a heavenly hero at last freed from the prying eyes and probing hands of skeptics and believers. Bonaventura also provides his own testimony before the court of public opinion. For this latter-day faithful Franciscan and loyal churchman, the unique sanctity of Francis must be authenticated by "proof," that is, by the intrusive, unwittingly abusive, but inevitable attention that the reports from La Verna inspired and Francis feared:

> Come now, Knight of Christ . . . carry the seal of Christ, the High Priest. For now, because of the brand-mark of the Lord Jesus which you carry on your body, no one should trouble you . . . Now through these most certain signs (corroborated not by sufficient testimony of two or three witnesses, but by a superabundant testimony of a whole multitude) God's testimony about you and through you has been made over-whelmingly credible. (*Bon*, 311–12)

Whereas Celano says that only those who have experienced a miracle can really under-stand it and that "silence" must "speak" where "ordinary words" fail, Bonaventura offers an extensive and passionate theological gloss on Francis's life and especially the mystery of the Stigmata: "Divine providence had shown him this vision so that, as Christ's lover, he might learn in advance that he was to be totally transformed into the likeness of Christ crucified, not by the martyrdom of his flesh, but by [*incendium mentis*] the fire of his love consuming his soul . . . " (*Bon*, 305–6).

Perhaps because of his reference to "superabundant testimony" in authenticating the wounds of Francis, some critics have argued that Bonaventura "changed [the original story] completely," moving "the accent from a spiritual, mental suffering to a physical one."[16] A careful reading of the text shows the opposite to be the case. With the phrase *incendium*

mentis, Bonaventura shifts the emphasis from the physical to the spiritual; for him, the outward sign, as in a sacrament, is of importance only as an indicator of an inner condition. Bonaventura locates the extraordinary and, for many, even in the thirteenth century, bizarre story of the Stigmata in an orthodox tradition that acknowledges the potential power of penance and physical suffering but refuses to equate grace with pain. For the modern reader, Bonaventura's phrase provides a way to understand Francis's experience in psychological terms ("a mind on fire") without rejecting its spiritual authenticity ("a soul on fire").

Since chronology, like identity, is often a fluid and unstable element in medieval narrative, it is not completely surprising that Bonaventura alters Celano's sequence in positioning certain events. He places Leo's request for a sample of the saint's writing before, not after, the event of the Stigmata and in juxtaposition with another anecdote of "a certain friar" who was "obsessed" with a desire for "intimate friendship" with Francis. Although, as in the case of the wish for written words, the friar is too shy to disturb the saint with his petition, Francis intuits his longing and grants it without hesitation: "Let no thought trouble you, my son . . . I hold you most dear, and I gladly lavish on you my friendship and love" (*Bon*, 286). Since neither friar is named, the narrative allows the reader to take them as one and the same or two different persons. What is significant in Bonaventura's sequencing is the repeated example of Francis's unconditional and instinctive generosity toward his companions in giving them their heart's desire without pause or qualification.

As preparation for the retelling of the Stigmata episode, Bonaventura places these stories at the threshold of his theology of union with God and, consequently, his interpretation of the miracle of the wounds that appeared in the flesh of Francis. According to Bonaventura's theology, an all-loving God grants to those of a passionate and sincere (not necessarily perfect) heart their deepest longings. As everyone who knew or wrote about Francis says repeatedly, Francis's strongest and most sustained desire from his conversion as a young man was to be like Jesus. In his radical piety, poverty, and loving generosity to the poor and to his friends, he was already like him before reaching La Verna. But Francis's desire carried him even further. For Bonaventura, he was not wounded like Christ because God arbitrarily decided it would be a good idea but because Francis wanted it so badly: "By the seraphic ardor of his desires, he was being borne aloft into God; and by his sweet compassion he was being transformed into him who chose to be crucified because of the excess of his love" (*Bon*, 305).

In using "seraphic" as a modifier of Francis's desire, Bonaventura interiorizes the vision without devaluing or desacralizing it. With a verbal gesture that imitates the event it is describing, subject and object – "seraphic ardor" and "seraph" – become one. The key to the miraculous vision and the wounds imprinted in Francis's body is desire driven by love. Is there such a thing as too much love? Bonaventura does not say so. Yet the element of "excess" is introduced into his analysis. Writing and praying in a cell next to that in which

Francis lived on La Verna, Bonaventura must have had a humbling realization, not unlike that of Brother Leo and the other companions of Francis, that, as much as he loved and admired Jesus and Francis, he did not have the courage (*incendium mentis*, "seraphic ardor," "excess of love") to want to be exactly like them. Despite Francis's order that none of the friars minor should ever take a position in the Church hierarchy, Bonaventura allowed himself to be ordained a bishop and eventually a cardinal. In doing so, he furthered the cause of the Franciscan Order, but, as he must have remembered every day, he was not a true copy of Francis who loved and served priests but never presumed to become one. Seeking institutional pacification, this intelligent and influential interpreter of Francis may have sacrificed some portion of his own zeal and peace of mind. Once again, as with the Stigmata, the degree of literal fidelity to the original is problematic.

A century after Bonaventura's *Legenda* was proclaimed to be the authorized biography of Francis, Celano's *Vita* had not disappeared and yet another text, *I Fioretti* (*The Little Flowers*, including "The Considerations of the Holy Stigmata"), became the popular favorite after its appearance between 1370 and 1385. The various "lives" of the saint were not neutral compilations but distinct reflections of the divisions within the Franciscan Order. Whereas Celano had been sympathetic toward the Spirituals and incorporated in his *Vita Seconda* material contributed by Leo, Rufino, and Angelo, Bonaventura was intent on smoothing over differences and showing Francis as a revered founder, not a disruptive extremist.

It was *I Fioretti* that captured the everyday, down-to-earth charm, eccentricity, and humanity of Francis and those companions who referred to themselves in their writings as *nos qui cum ipso fuimis* ("we who were with him") and prefaced their recollections with *nos vidimus et audivimus* ("we saw and heard").[17] More anecdotal and entertaining than abstractly theological, the collection provides vignettes of the saint and his companions that mix the miraculous and the often comically mundane. In the five chapters that deal with the Stigmata, Brother Leo is virtually everywhere, including the first sentence in which Saint Francis leaves the Valley of Spoleto "with his companion Brother Leo." When choosing the group that will accompany him to La Verna, Francis includes Leo, "who was a man of the greatest simplicity and purity, because of which Saint Francis loved him very much and used to reveal nearly all his secrets to him" (*LF*, 171, 174).

As the events on the mountain unfold, it becomes clear that the "simplicity" of Brother Leo is not simple-mindedness or a lack of psychological complexity. Given the fact that he outlived Francis by forty-five years, Leo must have been young during the last years of the saint's life. He must also have been inexperienced and unsophisticated, innocent, but by no means dull. In *The Little Flowers*, as in Bonaventura's *Legenda*, the episode of the written blessing precedes the reception of the Stigmata. However, instead of being jux-taposed with a separate story about a friar who desired Francis's friendship, it is com-bined with it. Perceiving Leo's anxiety and "spiritual temptation," Francis gives him a written blessing and, in doing so, declares his particular love for him: "Do not be trou-

bled because you have temptations. For I consider you more of a servant and friend of God and I love you more, the more you are attacked by temptations" (*LF*, 181).

According to the text, "all temptations" left Leo as soon as he received the blessing, yet the narrator, not without some irony, shows the young friar succumbing to still another temptation (and perhaps hoping thereby for more love from Francis). Despite Francis's strict orders that he be left alone except when Leo (chosen above the others) takes him food, Leo begins trying to observe "with great innocence and good intention . . . what the saint was doing" (*LF*, 181). Francis was living apart from the other friars in a cell or cave that could only be reached by crossing a log thrown across a fissure in the rocks. To a modern reader, Leo's "innocence" notwithstanding, his behavior begins to sound like spying: "He watched the hidden doings of Saint Francis by night and day with holy ingenuity."

Not only does Brother Leo watch Francis, he also comes as close to the saint's "solitary" moments of contemplation as is physically possible; and apparently recounted these experiences in minute detail:

He found [Francis] outside the cell raised up into the air sometimes as high as three feet, sometimes four, at other times halfway up or at the top of the beech trees – and some of those trees were very high. At other times he found him raised so high in the air and surrounded by such radiance that he could hardly see him. Then Brother Leo would kneel down and prostrate himself completely on the ground on the spot from which the Holy Father had been lifted . . . When Saint Francis was raised so little above the ground that he could reach him and touch his feet, what did the simple friar do? He would go to him quietly and embrace and kiss his feet and say with tears, "God, have mercy on this sinner. And through the merits of this holy man, let me find Your grace and mercy." (*LF*, 181)

Like the episode of the Stigmata, which this passage precedes, the narrative invites contradictory readings. The references to "three" or "four" feet, the height of the beech trees, and the picture of the "simple" friar hanging onto Francis (without disturbing him) could be dismissed as just another outrageous miracle story, too exaggerated and silly to repeat. (To my knowledge, there are no paintings of Leo kissing Francis's feet while the saint is in midair.) Yet, as in the parables of Jesus and many of the "absurd" anecdotes in *The Little Flowers*, the scene is filled with an unembarrassed physical demonstration of passionate faith and the incurable human desire to touch the divine, if only through the agency of another. Before receiving the wounds of the Cross, Francis, like Jesus, is lifted up and transfigured. Leo, the immature friend, the simple friar, the one who watches and waits and worries, stays on the ground and reaches up in a gesture of love tainted (only a little) by impertinence and self-interest.

When Francis, having established himself in his cave across the chasm, asks not to be disturbed even by Leo unless he answers his call, one night after hearing no response,

246

"Brother Leo did not go back, as Saint Francis had instructed him, but with a good and holy intention he went across the bridge and entered the saint's cell" (*LF*, 186). Leo observes Francis outside his cell in ecstatic prayer, not yet the moment of the Stigmata, and, suddenly afraid of being caught, he tries quietly to escape. Francis hears him step on some twigs and confronts him with surprise but not anger: "Why did you come here, Little Brother Lamb? Did I not tell you many times not to go around watching me?" When Leo confesses to having observed Francis, the saint concludes that God must have wanted Leo to know at least some of his secrets and, therefore, he reveals to him the contents of his ecstatic dialogue with the Lord. In concluding, Francis once again admonishes Leo, "But be careful, Little Brother Lamb, not to go watching me any more" (*LF*, 189).

Within the space of another page of text and another day, the narrative of the vision of the Stigmata occurs in the third person without reference to Brother Leo or any other witness. There is no textual proof, therefore, that Brother Leo was present. However, given all the preceding evidence of his "holy ingenuity," his persistent tendency to succumb to the temptation of disobedience, his curiosity about and devotion to Francis, it is difficult to read the account without imagining Leo peering from behind a bush. When, in this account, Francis decides, without interference from a Brother Illuminato, to reveal what had happened and show his wounds, it is Brother Leo who is chosen as his confidant and caretaker: "He chose Brother Leo, who was simpler and purer than the others. He revealed everything to him, and let him see and touch the holy wounds" (*LF*, 194).

Whether Leo was on the spot or only nearby, it is to him that the text goes for its source: "Brother Leo told this account to Brother James of Massa, and Brother James of Massa told it to Brother Ugolino di Monte Santa Maria, and Brother Ugolino, a good and trustworthy man, told it to me who am writing" (*LF*, 192). After Francis's death, Leo became the person to go to for firsthand information about the saint, especially in his last years. *Leo qui omnia videret*, "Leo who had seen it all," recalls in chapter thirty-six of *The Little Flowers* a vision of friars carrying a load across a river and drowning; and then others with no load who crossed into safety. Francis explains to Leo that those who sank are the ones who do not wish to "keep voluntary poverty," while those who cross easily are those who follow Christ and are obedient to the Rule of poverty. In short, Leo willingly gave testimony and it was not always testimony that the Franciscan Conventuals – those who lived by a relaxed Rule – and Church authorities wished to hear (*LF*, 125).[18]

❧

Over the years, in the written texts as in the paintings, a companion witness of Saint Francis comes into clearer and clearer focus in the representation of the miracle of the Stigmata. Even in those early paintings in which no companion is depicted and in the early narratives in which Leo is not named, the presence of a witness (almost but not quite transparent) is implied: in the paintings, by perspective; in the written texts, by a third-person narrative voice. The effect, in both cases, is to seem to let the event "speak for

itself" without interference, theological or otherwise, from a bystander. As Celano puts it, miracles can really only be understood by those who experience them; the rest of us can do little but remain silent. Impartial as this may sound, the settings of the frescos (churches dedicated to the sanctity of Francis) and of the writings (hagiographies by Franciscans) make it plain that the "transparency" and the "silence" are informed by awe and reverence in a spirit of religious faith.

Nevertheless, the story of the Stigmata and indeed the example of Francis's entire life left open wounds and open questions that troubled Christians and the Church for centuries, and trouble some still. For many, Francis was not simply a model of pious humility but a dangerously independent radical whose direct communion with God and God's creatures seemed to render the Church and its hierarchy superfluous. In receiving the wounds of Christ into his own flesh, he transgressed the boundaries of reason and nature. As the *alter Christus*, he went where even his closest companions could not follow him. For years, the Franciscan Order and the Church of Rome struggled to understand and sustain (some would say censor and rewrite) the legacy of Francis.

As "silence" and "transparency," the appearance of impartiality, gave way to disputation and a prolonged process of interpretation and reinterpretation, the presence of a witness interpreter takes on greater importance in the representations of the saint's life. The "Leo" figure recalls to a modern reader and viewer not only a historical companion of the saint but also the active, intrusive role of all – including Giotto, Angelico, Benozzo, Barocci, Celano, Bonaventura, Ugolino (not to mention the scholar and critic) – who turn their gaze on the hidden Francis and try to make others "see" this great religious figure and the extraordinary event that marked the last years of his life. As Julian Gardner has observed, even the most honorable and sincere witnesses "may have imposed received conceptual and visual patterns on their experiences . . . The more unprecedented an event is, the greater need perhaps to temper and domesticate its strangeness."[19]

Among the most troubling and, to a modern observer, strange aspects of the Stigmata narratives are the many accounts of witnesses who tried to satisfy their curiosity about Francis's wounds and prove to themselves (or others who doubted the truth of the story) that they were real. Jesus had his "doubting" Thomas; Francis seems to have had dozens. The most frequently mentioned in various accounts is Brother Rufino who, while massaging the saint's back, "accidentally" put his hand into the wound on Francis's side and, on another occasion, asked Francis to exchange habits with him so that he could see the saint's unclothed body (*LF*, 202). Other friars schemed to inspect his wounds; bishops and cardinals came up from Rome before and after Francis's death to authenticate the wounds by putting their hands into them. A respected knight, "educated and prudent" (in other words, skeptical), asks to place his fingers in the wounds and move his fingers around inside them until, according to Bonaventura, his doubting heart was "healed" (*Bon*, 323).

Running through all references to a witness of the secrets and miracles of any saint's life is an implied or explicit claim to authenticity. As the Evangelists offer testimony to

the truth of their reports about the life of Jesus, the followers of Francis repeatedly swear that they have seen him in ecstasy and touched his wounds. Yet, like stigma, testimony is a paradoxical signal. It may be false or true. In either case, it calls attention to the one who provides it as well as to the deeds he narrates.

As well as looking for Brother Leo in paintings and texts, I am prompted to ask what kind of person he was and how he presents himself as an intermediary between us and Saint Francis. In both the Celano and Bonaventura narratives, the unnamed companion of the saint is virtually interchangeable with the other three friars who accompanied Francis to La Verna. He is representative of those who loved the saint with a particular devotion, who were closest to him in his last years, and who lived to relate the events connected with the Stigmata.

It is in the fourteenth-century "Considerations" that Leo is named and given a distinctive character – "simple and pure" but also inquisitive, skeptical, disobedient, and afraid. He is not an impartial witness. He expresses a love for Francis so great that he does not wish to live without him (although, in fact, he lived many years after the saint's death). He is a witness that cannot be totally trusted since even his promises to leave his beloved teacher undisturbed are repeatedly broken. After the retreat at La Verna when Leo had touched and nursed Francis's wounds and accompanied him back to Santa Maria degli Angeli and the saint lay sick and blind, Leo was once again "troubled" by questions, doubts, and a seemingly insatiable curiosity. He said to himself: "Look, this man calls himself a very great sinner in public . . . yet in secret he never confesses any carnal sin – can he be a virgin?" (*LF*, 200). It seems late in the day to ask such a question. Once again, one has to wonder what kind of obtuse, faithless friend Leo, who supposedly "saw it all," really was.

Brother Leo could be seen as a foil for the holy man: a wavering, inconstant follower, an utterly unreliable witness or the one true and faithful friend and witness – to Francis what Francis was to Christ. However, what is important in the story is not only how a bystander sees Brother Leo, but also how Francis sees him. Francis calls him "Little Lamb," gives him his written blessing, and repeatedly chooses to have him near him, to hear his secrets, and to wash his wounds. He gives Leo his tunic before he dies and he summons Leo to sing with him at his death.

The desire to put hands on "greatness," to touch celebrities – the pope, the Dalai Lama, Elvis Presley – takes its own form in modern times. Depending on the aggressive intrusiveness of the seeker, the efforts, like the scratching into frescos, can be disturbingly invasive and destructive. In all the attempts to "touch" Francis, none was as obsessive or insistent as the various investigations into the true nature of the Stigmata. Piety, innocence, love, devotion mingle with doubt, voyeurism, morbid curiosity, and an erotic desire to enter the saint's experience through his body. Artists, as often is the case, brought them all together in deathbed scenes of Francis in which he is surrounded by weeping, adoring brothers and probed, once more, by a kneeling figure – a doctor – testing the authenticity of his miraculously wounded body (figs. 101 and 102).

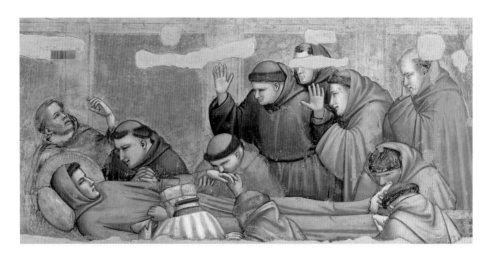

Although Francis is said to have died on the ground, Both Giotto and Benozzo paint the scene as they must have heard it described later. Yet there are important differences. Giotto's Francis is smooth-faced and beardless; Benozzo's is haggard and bearded; Giotto's friars appear, by their wild gestures and expressions, to be in the first throes of grief; Benozzo's solemn assembly of clergy and friars are gathered in a liturgical ritual led by a priest holding a prayerbook. The witnesses vary in position, attention, and expression. Even at the very end, the story is not simple and *Il Poverello*, the Little Poor Man – who tried hard to lead a simple life – is not left in peace. In both paintings, while the friars are praying and lamenting, a kneeling figure, in the garb of a physician, disturbs the scene and the body of the saint, searching for evidence of the Stigmata. He appears to see no indignity or shame in poking his fingers into the dead man's wounded side. Did Giotto and Benozzo see this as Church "business as usual," willingly adding their "witness" to the authenticity of the saint's miraculous Stigmata? Or were they horrified by such morbid and literal-minded meddling with holiness? Does faith triumph over doubt or does doubt have the last word? And where is Brother Leo?

Artists do not have to answer the questions of curious viewers. However, they regularly "answer" one another by means of their imitations of and departures from the works of their predecessors. Perhaps the most radical, generous, and therefore most "Franciscan" insight into the perspective and character of Brother Leo and his relationship with Francis is depicted by the notoriously unsaintly Caravaggio in his *Saint Francis in Ecstasy* (fig. 103) in which the saint is shown fainting in the arms of an angel. It has been pointed out that Caravaggio's painting was "unprecedented" in that the artist "made visually lucid the mystical rather than the literal meaning of the seraphic miracle."[20]

102 Benozzo Gozzoli, *Death and Inspection of the Stigmata of Saint Francis* (detail), 1452,
San Francesco, Montefalco.

For Caravaggio, the seraphic presence is neither a source of wounds nor an idle spectator, certainly not a cardinal or knight, but a comforter, the one who catches the saint as he falls and lets us see him through his loving eyes. It may seem that Caravaggio has drastically altered the story to suit his own artistic purposes. Perhaps, but in doing so he has made a powerful and moving argument for how Francis might have retold the story himself. This angel is grounded; he has wings, but they are shrouded in shadow whereas his bare, beautiful arm and leg – his vividly human limbs – support the fainting man. He could be the "angel" who played the viola for Francis and appeared to him at La Verna; or who wrestled with Jacob at Peniel or, better, the Good Samaritan on the road to Jericho. The stranger, the victim, the companion, the witness, the seraph, and the Christ-figure are brought together in one image. A faint form barely visible in the dark background may be Leo. If so, he is too far away to see clearly what is happening to Francis. Yet there is another possibility. Caravaggio, like Leo, was not shy about getting close to his subject. He may have transformed the would-be but not-quite angelic Leo – the incorrigible friar whose greatest weakness was his longing to touch his friend – into himself: a winged messenger, artist; witness and comforter.

As Leo, with his innocence and imperfections, comes into clearer focus, he becomes a peculiarly effective bridge across the chasm of time and unbelief not only to the mystery

103 Caravaggio, *Saint Francis in Ecstasy*, c.1596, Wadsworth Atheneum, Hartford, Conn.

of the Stigmata but to the mystery of the extraordinary attraction Francis had for everyone who came into contact with him in his lifetime. In choosing Leo as his witness, Francis seems to be offering a way to interpret the Stigmata miracle and the "Francis problem" in general. In taking Jesus' invitation to "take up your cross and follow me" literally, Francis does not appear to expect or even want others to do it in exactly the same way. In admonishing Leo to come close to him, but not too close, he leaves room not merely for skepticism and fear but, perhaps most importantly, for individuality. Francis's "cross" may have been, among others, an extreme literal-mindedness (some would call it zeal, others fanaticism) that led him to the agony of becoming an *alter Christus*. Leo's cross, more familiar to most of us – his nosiness, his need for proof, his restless conscience, his ambivalence, his spiritual timidity – apparently seemed to Francis heavy enough for one person.

While attempting to read Francis with the help of Leo, the possibility of reading Leo with the help of Francis may be overlooked. Of all the written words the saint might have chosen to give his friend and witness, the blessing that the Lord gave Moses for Aaron and his priestly descendents is particularly reassuring and comforting, asking that the Lord "keep you," "be merciful," and "give you peace." It is a blessing not to be kept exclusively

252

by Moses or Aaron but a message to be passed on and on through time. Since Moses, like Francis, came close to seeing God at his own peril, his wish that the Lord may "show His face to you" in juxtaposition with "mercy" and "peace" suggests a belief that agony need not accompany theophany.

Like Moses, Francis seems to have understood that the heaviest cross – humiliating burden – for anyone who wants to believe is not having the trust, courage, occasion, or will to see God face to face. Although in Christianity, as in all theistic traditions, God is constantly sending messages and messengers, the trouble is that messages need to be interpreted and messengers to be scrutinized and judged. Central to the riddle of Saint Francis and the Stigmata is the inseparable interplay between faith and doubt. If the closest friends and companions of the saint needed to touch his wounds in order to believe, what hope is there for those who have only stories and pictures, retold and repainted, written and scratched over until they obscure as much as they reveal?

Modern readers and viewers can blame Brother Leo, Bonaventura, Giotto, the Church, the Conventuals, and hundreds of others who, in representing Francis, seem to have meddled so much with the original that we can no longer see or even imagine the real person through their graffiti. Yet we can also take our place with Leo, a historical and symbolic figure of the flawed witness, as a necessary companion for Francis. Like all interpreters, he crosses forbidden bridges, reveals secrets he does not fully understand, and asks questions that are none of his business.

However painters or writers have imagined him, the intermediary is almost always believable as a character even when the object of his testimony remains hazy or partially obscured. A story that tells as much about Brother Leo as it does about Francis is yet another message from Francis, another variant on the Stigmata for those who can only tolerate wounds and blessings secondhand:

> Sometimes it happened that when Brother Leo was changing the bandage of the wound in the side, Saint Francis, because of the pain which he felt . . . would put his hand on Brother Leo's chest over his heart. And from the contact of those holy hands on which were printed the venerable Stigmata, Brother Leo would feel such sweetness of devotion in his heart that he nearly fainted and fell to the ground. (*LF*, 194)

It may be impossible to get into perfectly clear focus the original picture of God's imprint on Francis, but one cannot fail to see and perhaps feel the imprint of Francis on those whose importance, like Brother Leo's, is not only that they saw and touched him but that he saw and touched them. The paradox of the writings and paintings that deface (or obscure) their apparent subject while, at the same time, revealing something about it cannot be completely overcome. To "decorate" the walls of a great church with images of the "Little Poor Man" in rags or to "entertain" readers with tales of his miracles and visions seems a violation of the poverty, humility, and simplicity that Francis cherished. Yet without these imperfect and impertinent Leo-like intrusions, we might never have known him at all.

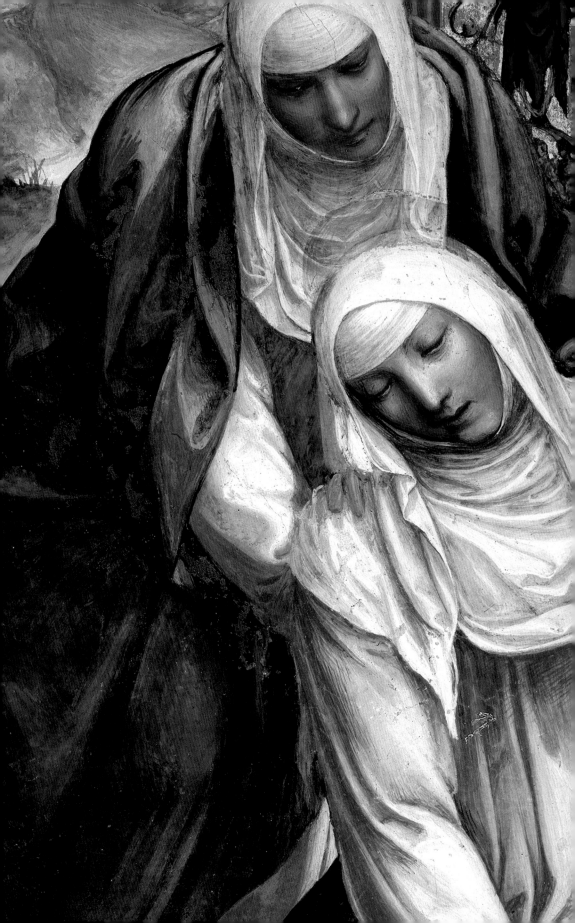

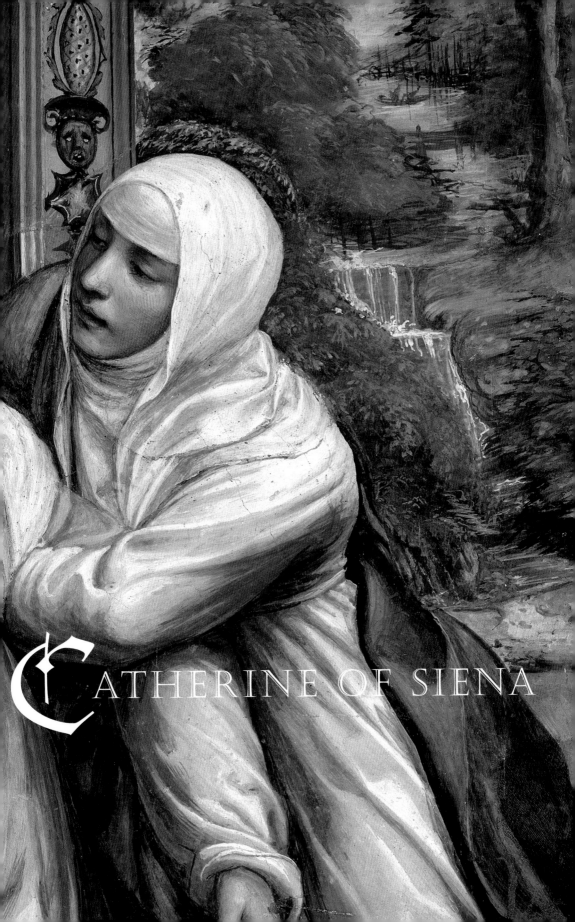

CATHERINE OF SIENA

9

The saint who lost her head

OR WHO'S AFRAID OF CATHERINE OF SIENA?

*"I am filled with admiration for myself and the goodness of God . . . who gave
me the disposition of a writer so that I could vent my heart and not explode."*
 Catherine of Siena

It made perfect sense in the fourteenth century but it comes as a shock today to find the
head of Catherine of Siena enshrined in a reliquary in the Church of San Domenico in
Siena (fig. 104) while the rest of her reposes beneath the altar in the beautiful gothic Santa
Maria Sopra Minerva in Rome. Since Catherine Benincasa died in Rome in 1380 when
holy relics were revered (and scattered) throughout the Christian world, it seemed appro-
priate to her admirers that some part of the great woman be returned to the city of her
birth. Nonetheless, granting the obvious historical explanation, the bodily bifurcation of
the saint has symbolic associations that are more intriguing and disturbing than the inno-
cent piety of the devotion to relics might suggest.

Catherine was not an ordinary woman of her time or any time. She was a mystic
"married" to Christ and a social activist who ministered to the most miserable outcasts
of her city. She was an "uneducated" laywoman who wrote hundreds of letters of advice
to popes, bishops, abbots, and princes. She was sent on diplomatic missions as a peace-
maker between Rome and the Italian city-states and she argued pragmatically that the
Crusades could be a way of stopping Christians from fighting one another if they united
against a common enemy. While she was still in her twenties her followers called her
mama but one of her favorite terms of encouragement to herself and her female and male

104 Head of Catherine of Siena in a reliquary, San Domenico, Siena.

disciples was the admonition to behave *virilmente*, "like a man." It would be an understatement to say that Catherine was a complicated character. Yet, after reading her own writing (letters, *The Dialogue*, and prayers), most of the writings about her (biographies, commentaries, and papal pronouncements), and the "holy" paintings that attempt to picture her as frail and feeble (figs. 105 and 106), one comes away with the impression that between Catherine's self-representations and the many idealized representations of her by others, there is not mere complexity but a disconnection, a mutilation almost as radical as that which was done to her corpse.

In both the paintings by Andrea Vanni and Giovanni di Paolo, Catherine holds a lily, symbol of virginity and moral purity. When relating one of her life-changing visions of Jesus, Catherine does not say that she was given a lily but an olive branch and a cross, which she understood to be signs that she was to be an active peacemaker prepared to suffer for her diplomatic efforts.[1] In these characteristic "portraits" of Catherine, she wears the black and white habit of a Dominican, the religious order with which she was associated as a laywoman. She is thin, pale, and stooped; her eyes are cast down and her expression sad. It is the portrait of a fragile, humble, quiet woman seemingly resigned to the narrow niche assigned to her by fate and the admiration of the pious. In fact, though Catherine was probably thin and perhaps pale, she was not fragile or humble and she was definitely not quiet.

It is true that Catherine was called in two seemingly opposite directions in her lifetime. The geographic and spiritual distance between Siena and Rome is a good place to start. Catherine's life in Siena was profoundly influenced by the interior spirituality of her Dominican friends and confessors and by her persistent care of the outcast poor and those with sicknesses so hopeless and disgusting that few others would go near them. However, as her reputation for wisdom and holiness increased, she was urged to come to the aid of the pope whose authority was being challenged on all sides. There is no doubt that Catherine was a loyal defender of the papacy, that she persuaded Gregory XI to leave Avignon and reestablish his Curia in Rome, and that late in her life she herself traveled to Rome at the request of Urban VI.

What Catherine found in Avignon and Rome did not please her. She made, and still seems to make, popes nervous. Her language in the letters to Pope Gregory, urging him to return the papacy to Rome, often verge on the insulting: "Don't be afraid! Do something about it"; "I'm begging you, I am telling you . . . Be a courageous man for me, not

258

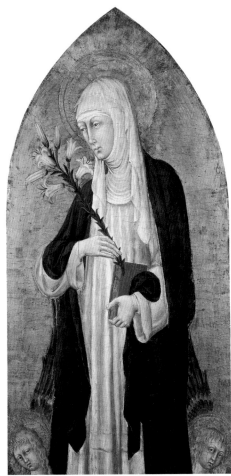

a coward"; "Well, I assume as much poison can be found on the countertops of Avignon or any other city as those of Rome!"; "Don't be a timid child but a courageous man."[2] Catherine told the pope through her interpreter and confessor Raimondo da Capua that she "smelled a greater stench from the sins committed by the Roman Curia every day" than she had in a whole lifetime in Siena.[3]

Catherine was relentless and fearless in calling for reform of the clergy and hierarchy from top to bottom. Her criticisms in *The Dialogue* are as fierce and rude as anything written by Martin Luther: "These wretches, unworthy of being called ministers, are devils incarnate"; "They sell and buy and have made the grace of the Holy Spirit a piece of mer-

chandise"; "Like a shameless whore you boast about your exalted position in the world
. . . but you are a thieving bandit, because you know very well that your heirs are sup-
posed to be none other than the poor and holy Church."[4] True, Catherine puts these words
in the mouth of the Lord and she prefaces the criticism with praise for the "good" clergy.
Nonetheless, her tone and the very idea that a laywoman had a right to communicate
these views was (and is) startling.

This saint never claimed to be a theologian, but her doctrinal declarations also can
sound "dangerously" close to those of later reformers. She "hears" God say that "not one
of you, for all your righteousness, could reach eternal life" without the grace of Christ
(*Dialogue*, 58). This position is balanced by an insistence elsewhere on the necessity of
good works and an active will. But Catherine's rhetoric, whether ecstatic or angry, often
challenged the complacency of accepted practices and the manner if not the matter of
orthodox thinking.

Manner and matter have a way, especially in Catherine's case, of becoming conflated.
Despite Catherine's extraordinary, sometimes operatic, efforts to unify body and soul,
mind and emotion, word and thing, commentators have frequently tried to organize her
into disparate parts, as it were, separating her from herself. When Pope Paul VI declared
her a Doctor of the Church in 1970, he alternated lavish praise of Catherine's piety with
reserve about her ideas: "We shall certainly not find the apologetic vigor and the theo-
logical boldness which mark the works of the great lights of the ancient Church"; "What
did she mean by the renewal and reform of the Church? Certainly not the overthrow of
the basic structures, rebellion against its pastors, a free reign for personal charisms." Ten
years later in a homily in Siena, John Paul II reassured his listeners that Catherine was
"bold but absolutely orthodox," a person "submissive and obedient . . . to the Holy Spirit."[5]

Why would popes six hundred years after Catherine's death still have to reassure them-
selves and their listeners that she was "orthodox," "obedient," "submissive," and without
"apologetic vigor," not learned enough to be a "great light?" Since Catherine had no trouble
speaking up to popes and other authorities in her own time and voice, it is still possible
to imagine some of her reactions to these characterizations. Along with being a Doctor
of the Church, and a patron of Italy, Catherine is one of the major authors in the Chris-
tian and Italian literary canon. Her *Dialogue*, a conversation between God and the soul,
originally in Italian, was quickly translated into Latin and was published in Bologna in
1472/5, becoming one of the early books after the Bible to be printed after the inven-
tion of the printing press. The first translation into a modern language was in English,
printed in 1519 by Wynken de Worde as the *Orchard of Syon*. Thirty-one of Catherine's
letters were printed in Bologna in 1492 and 353 were collected and published in Venice
in 1500.[6] In short, Catherine was a producer of words as well as a performer of good
deeds. From the beginning, in striking contrast with the iconography that often depicts
her as mute and senseless, she insisted on speaking and writing with deliberation and a
clear mind.

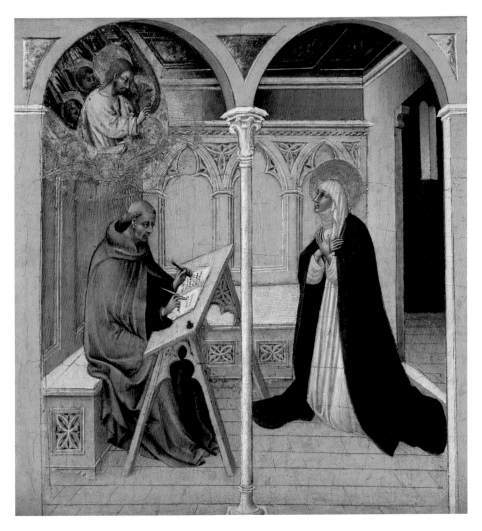

107 Giovanni di Paolo, *Saint Catherine Dictating to Raimondo da Capua*, 1460–1, Institute of Arts, Detroit.

In a rare painting of Catherine the author on a wood panel from a cycle depicting scenes from the saint's life, Giovanni di Paolo shows her dictating to her friend and confessor, the learned Dominican priest Raimondo da Capua (fig. 107). According to legend and her own word, Catherine learned to write miraculously, but because her correspondence became so voluminous, she regularly dictated to several scribes at a time. The painting makes it clear that Jesus is telling her what to say. Indeed, since she is on her knees, her words are apparently not really her words but answers to her prayers. She is "taking" dictation as well as giving it. There is no doubt that this is the way Catherine understood, or at least explained to others, the nature of her inspiration. It might seem, then, that, as

in the painting, two men, Jesus and Raimondo, are doing the important work and Catherine is merely a transmitter without brain or agency, a modest go-between, a humble servant appropriately on her knees while the true authorities, the males, stand giving instructions or sit writing them down.

There is, however, another way to look at the painting and at Catherine. Above the priest, Jesus is literally speaking to Catherine over the head of the man of the Church. Jesus and Catherine are linked in a mutual gaze that excludes their surroundings. Catherine is on her knees and further away from the viewer than Raimondo but, in an odd distortion of perspective, the artist has made her figure appear taller than that of the scribe. On reflection, this pious scene manages to be conventionally reverent while including hints of a potentially radical challenge to institutional authority. Although some scholars have suggested that medieval male scribes used religious women as vehicles for their own voices, Caroline Walker Bynum thinks otherwise: "There is no reason to hold that all texts by, for, and about women are a kind of ventriloquism of male concepts, concerns, and stereotypes." In the case of Catherine of Siena, for example, "where we can compare the woman's own writings with accounts of confessor or hagiographer, we can find important differences."[7]

Whether dictating or actually writing, Catherine never leaves any doubt that the thoughts and feelings expressed are her own. In 1377, without the aid of a scribe, she wrote to Raimondo, "I have written this in my own hand . . . In fact, I am filled with admiration for myself [*piena d'ammirazione di me medesima*] and the goodness of God . . . who gave me the disposition of a writer [*l'attitudine dello scrivere*] so that I could vent my heart and not explode [*non scoppiasse*]" (Morra, 113).

As to orthodoxy, there is no reason to question Catherine's devotion to scripture, which she knew almost by heart, to the sacraments, to Jesus, to the Church (in its mystical ideal if not in its corrupt reality), and to the papacy (as a divinely graced institution even when occupied by weak and incompetent men). Still, she regularly trumped the authority of the Church and the hierarchy by claiming that everything she knew and believed came directly from Jesus with absolutely no help from men. Raimondo, who under ordinary circumstances might have expected some gratitude, quotes her:

> *Padre mio, tenete come verita certissima che nulla, di quanto riguarda la via della salute, mi e stato insegnato o da un uomo o da una donna, ma precisamente dallo stesso Signore e Maestro . . . il Signore Jesu Cristo.* ("My Father, take it as the absolute truth that nothing having to do with the way to salvation was taught to me by a man or a woman, but precisely by the same Lord and Master . . . the Lord Jesus Christ;" *Legenda Maior*, 90)

With regard to orthodox practice, two examples, of the many that are possible, illustrate Catherine's resistance to (defiance of?) Christian custom of the day: her frequent reception of the sacrament and her preaching, privileges normally reserved to male clergy. Catherine did both, with permission, of course, but also because she seems to have seen

no reason not to. Not only did the pope authorize daily communion for Catherine but he allowed her confessor to travel with a portable altar so that mass could be said on the road during her frequent diplomatic travels. When a disapproving bishop quoted Augustine to her, Catherine snapped back, "If Saint Augustine doesn't cast blame, why do you?" (*Legenda Maior*, 276).

Still in her twenties, Catherine's eloquence and wisdom were so widely known that she was invited to preach throughout Tuscany — in Siena, Pisa, Florence, in the great Church of Sant' Antimo and the powerful and influential monastery of Monte Oliveto Maggiore. Although none has been preserved, the quality and content of Catherine's sermons can be inferred from her existing writings. Like them, they were evidently not politely pious or forgettable performances. A rich young Florentine, Giovanni Dominici, heard the famous woman preach twice and was so moved by her persuasive call for a return to apostolic purity in the Church that he entered the Dominican order and became one of its great reformers and preachers himself. A touching and telling story — given the many images of Catherine fainting and speechless — is that Dominici lost his stammer and gained his eloquence as a preacher while praying to Catherine after her death.[8] Now in Rome Catherine's body is without a head, but she definitely had one in life and a voice that went with it, a voice that was heard and gave voice and courage to others.

In reference to the reformist role played by Raimondo da Capua after the saint's death, William Hood has summed up the extraordinary (though, for Catherine, typical) nature of one of her achievements: "Raimondo drew his determined energy to reform the Order from Catherine's example, and it was in this way that the elements of the Dominican reform, generated in the mind of an ecclesially liminal person (a fundamentally uneducated laywoman who knew no Latin), entered the heart of an institution entirely dominated by a male hierarchy."[9] Is this the description of a person lacking in "apologetic vigor?" "Absolutely orthodox?" "Obedient?"

If so, Catherine's actions and words at least make one rethink what these terms mean or what they meant to her. She devotes the last section of *The Dialogue* to her "favorite virtue," obedience, an extended meditation on the word and its application to her life, public and private. Putting most of the words in the mouth of the Lord, as usual, Catherine makes it clear at the outset that obedience is not a passive virtue. "I created you without your help," says the Lord, "but I will not save you without your help" (*Dialogue*, 330). This indeed is a statement of orthodox Roman Catholic doctrine showing that, despite her reformist zeal, Catherine was not a pre-Luther Lutheran. Yet she follows it with a surprising choice of symbol: "You must, then, carry the key in your hand; you must walk, not sit." Obedience to the Word is the "key" here, but Catherine's knowledge of scripture and her habit of borrowing scriptural images for her own rhetorical purposes brings to mind Matthew 16:19 in which Jesus gives "the keys of the kingdom of heaven" to Peter. Could this have slipped Catherine's mind? Hardly. What could she have meant? Did she believe that she, and perhaps others like her, were also given the "keys" of salva-

tion by Jesus? This is exactly what she meant. She did not wish to take the keys away from Peter, but she felt authorized to help him carry them even if it meant acting and speaking in ways not considered "appropriate" for a woman.

Written when she was already famous throughout Italy not only for her piety but for her highly visible works of healing in Siena, diplomacy in Florence, Pisa, and Avignon, her letters to princes and popes, and her many appearances accompanied by an entourage of followers, *The Dialogue* is, among other things, an apology, a justification really, for Catherine's "unmaidenly," busy public existence. The Lord had told her not to "sit." After three years of relative solitude (if it is possible to have solitude in a household with twenty-three children) in her parents' home, Catherine hears Jesus tell her to get up and get out:

> *Lo sai che due sono i precetti dell'amore: cioe l'amore di me e del prossimo . . . Voglio che tu adempia questi due commandamenti. Devi infatti camminare non con uno, ma con due piedi, e con due ali volare su al cielo.* ("You know that there are two precepts of love: love of me and love of your neighbor . . . I want you to fulfill both of these commandments. You should walk with two feet not one, and fly with two wings to heaven;" *Legenda Maior*, 1 2 3)

Obedience, for Catherine, was first and always obedience to the words of Jesus but as she heard and interpreted them. From the point of view of her parents, especially her mother, she was not an obedient daughter when she refused the only two options seemingly available to a young woman, marriage or the convent. When her mother asked her to make herself beautiful to attract men, she cut off her hair; when she took her to Bagni Vignoni, the curative baths, for a vacation, she deliberately scalded herself in the hottest water. As is well known, she would not eat much other than bread, water, and raw vegetables. Whatever else was going on, Catherine did not start out life as a "submissive" daughter to her parents or, despite her fidelity to prayer and the sacraments, as a conventionally dutiful daughter of the Church. As Bynum noted, "Women manipulated far more than their own bodies through fasting. They manipulated their families, their religious superiors, and God himself."[10]

Obedience to God, for Catherine, meant liberation from many of the familial and ecclesial expectations about how women, especially young women, should behave and speak. With absolutely no chips for bargaining other than her clearly formidable will and intelligence, she learned at an early age how to get her way. She agreed to do kitchen work in exchange for a room of her own in the crowded household; she wanted to wear the Dominican habit but not as a cloistered nun and persuaded the local superiors to allow her to be one of the Mantellate, usually widowed women who lived at home and moved freely about the streets; she wanted to overcome her repugnance to the stench of illness so that she could minister to victims of plague and leprosy, so she put her face close to wounds and once drank the washings from a patient's sore to steel herself; when things got too hectic at home, she ignored gossip and moved in with her best friend

Alessia, a young widow; despite lack of formal education, she wanted to learn to read and write, telling God that since she was a slow learner, he would have to perform a miracle which, of course, he then did. Even in her own day, some people thought Catherine was crazy. Many more thought she was a saint. Either way, her idea of obedience was not run of the mill.

In the last section of *The Dialogue* obedience is praised as a royal woman: "She is a queen, and whoever espouses her will never know evil but only peace and calm. No matter how the sea's stormy waves may pound her, they cannot hurt the marrow of her soul" (*Dialogue*, 332). It is tempting to read through this part of the text as a fairly predictable echo of Proverbs in which wisdom and other virtues are personified as female. Catherine undoubtedly had this in mind, but her writings – however familiar some of the images and symbols may be – are never mere echoes. They are nothing if not reflections of lived and felt experiences. Catherine never leaves herself out of her representations of divine discourse. Despite her reputation as "uneducated," she knew her Augustine and Aquinas equally well, but it is Augustine whom she most resembles in her intellectual passion and in the concreteness of her imagination. She knew what analogy and allegory were but she was too much of an "incarnationalist" to keep her rhetorical categories consistently separate and parallel. Like most great poets, she moves with agility between the comparative and literal.

When saying that Queen Obedience is not hurt by the "stormy waves," Catherine must have had in mind Matthew 8:23–7 in which Jesus calms the sea, but she almost as surely had in mind an episode recalled by Raimondo in his biography. While they were at sea en route to one of Catherine's missions, a storm came up that, by his own admission, terrified the Dominican priest, who was ten years Catherine's senior and was meant to be her protector. Running to Catherine, he called out, *O mamma . . . non vedi in che pericolo siamo* ("O mamma, don't you see what danger we're in!"). To which Catherine replied, *Che avete da farci voi?* ("What do you have to do with it?" or, more colloquially, "What's it to you?" *Legenda Maior*, 102). Catherine does not calm the sea but she calms the nerves of her confessor in the same way that she does most things, by demonstrating her faith, willpower, and absolute refusal to give in to fear. Perhaps, too, her sharp tongue shocked Raimondo into bravery. Her self-possession seems to have been so extraordinary, so transparent, so dominant that it empowered her to devote much of her public life to telling men – especially priests and popes – to "get hold of themselves."

By conflating scripture and an episode from her own life into the picture of Queen Obedience untroubled by rough seas Catherine performs a characteristic stylistic move. She identifies herself with a virtue that draws its narrative meaning, its majesty and authority from the example of Jesus. Indeed, since it is Catherine or, more precisely, Catherine's soul whom the Lord is addressing throughout *The Dialogue*, it is difficult not to read her into the personified virtue when Obedience suddenly becomes the direct (no longer the indirect) object of God's address:

O Obedience! You sail on without weariness . . . You pattern yourself after the Word, my only begotten Son . . . You are straight, not winding . . . You are a dawn bearing the light of divine grace. You are a warming sun, never without charity's heat. You make earth blossom . . . You are wholly joyous, for you have not marred your face with impatience . . . Your authority is so great that no one can have authority over you because you have left behind the deadly servitude of selfish sensuality . . . Once this enemy was slain . . . you regained your freedom. (*Dialogue*, 332)

The passage lyrically describes much of what Catherine admired but it also describes much of what she seems to have been: tireless, straightforward, bright, compassionate, patient, authoritative, and free. Great qualities, but not usually associated with obedience unless one recalls that the authoritative, free, and compassionate Jesus, as well as the suffering Jesus, is the model on which the copy is patterned. Indeed, except for her devotion to Mary Magdalene, Catherine goes straight to Jesus (and sometimes Saint Paul) – not to women or the contemporary Church – for her models: "There were no religious institutions for lay people, especially women, who wanted to be apostles. There were no acceptable theological or spiritual theories to rely on to justify her apostolate in the Church. Catherine had no contemporary role models to imitate; significantly, the saints she identified with lived in the very early Church, not her own day."[11]

One of the things everyone seemed to know in Catherine's lifetime and that has continued to interest scholars and others today is that she imitated the suffering of Jesus by eating almost nothing for years. Raimondo da Capua thought it was a miracle; others thought she was showing off; her mother thought she was crazy. Catherine herself said that she could not stand the smell of meat and would have eaten more if food did not seem so repulsive to her. Several modern scholars have thought that she suffered from anorexia. The most thoughtful analysis from a theological and historical perspective has been that undertaken by Caroline Walker Bynum in *Holy Feast and Holy Fast* in which it is argued that the consumption of food, with its sacramental as well as biological significance, was one of the few areas in which medieval women could take control of their lives.[12]

However Catherine's motives may be explained, she makes it plain throughout her writings that she never thought that in God's eyes suffering was an end in itself. Early on the Lord tells her in *The Dialogue*: "The value is not in the suffering but in the soul's desire" (*Dialogue*, 29). Perhaps Catherine was occasionally (or frequently) tempted by the "pleasures" of pain. Raimondo reports that she once told him that she got rid of a taunting devil by telling him, *Per mia gioia ho scelto i dolori . . . anzi, ci godo!* ("For my happiness I have chosen pain. . .Besides, I enjoy it!"; *Legenda Maior*, 111). What is important and completely characteristic of Catherine is that she saw and consistently noted the difference between bravado and theology, temperament and religion.

She may have "enjoyed" taking control of her body through fasting but it is impossible to read her writings without recognizing that her definition of "joy," while it may have

included command of her physical sensations, extended in practical charity and reformist idealism well beyond sensory gratification. If Catherine's treatment (mistreatment) of her body seems difficult to understand in the twenty-first century, it might help to think of the contemporary athletes and dancers, among others, who "sculpt" their bodies by means of diet, weights, and steroids in order to achieve what they regard as an end worthy of discipline and sacrifice and even the risk of death. An article in the *New York Times* of August 24, 2003, with the headline "Rest the Tummy, Restore the Soul," told of the latest fad among busy professional women who fast in order to slim their bodies and renew their spirits: "While millions of high-fat, low-carb devotees are gorging themselves on steak and butter, a small group of the body-conscious have opted to eat nothing at all."

Perhaps Catherine, in her own way, was "body-conscious" but she never lost sight of her objective – a union with Jesus as nearly complete as she could manage – or the rationale for undertaking, experiencing, and expressing it in terms that never left the desires and sensations of the flesh out of the equation. Barring a few early qualms, Catherine seems not to have been squeamish about nursing sick bodies running with sores or prudish in imagining the body of Christ as that of a mature man with all the usual parts. Catherine was fully "orthodox" in taking the Incarnation literally, but she seems, especially by post-Freudian standards, naively "unorthodox" in the passionate physicality with which she expresses her love of Christ. Yet, the more one reads Catherine, the harder it becomes to think of her as naive. Of course, she knew the Song of Songs and the biblical tradition of erotic language associated with the relationship between God and his people. A favorite hymn of praise was Psalm 83: "My heart and flesh exult in the living God!"

She also knew that to suffer with Jesus was to assume a particular intimacy with him – "for better or for worse" – as in a marriage, which is exactly what Catherine imagined occurring, not with the infant Jesus, as in some paintings (fig. 108), but with the fully grown man. To recognize that "marriage to Christ" was (and, in some Orders, still is) a common convention for women in religious life does not mitigate the interesting complications that follow if the analogy is carried too far. One way to avoid the sexual implications of such a "union" is to imagine Jesus as a baby. Nothing takes the romance out of a wedding scene more emphatically than featuring the groom as an infant clinging to his mother's knee.

Fra Bartolomeo may have known what he was doing by not showing Catherine's face in this sweetly chaste painting because he could not "face her" knowing that his picture of Catherine receiving a ring from a smiling baby Jesus had no relation whatsoever to Catherine's way of "seeing" her marriage to Jesus as an adult male. Unlike the painter, Catherine does not shrink from physical detail. To seal the bond, she does not see "a silver band but a ring of his flesh," Christ's foreskin (*anello della carne sua*).[13] As in all things, Catherine's idea of marriage was anything but sweet and sentimental. Yes, she loved Jesus with a passion, but, despite the painting that shows her as a demure bride, she did lose something like her virginity in the match. During the "ceremony," Jesus tells her that from

108 Fra Bartolomeo, *Mystic Marriage of Saint Catherine of Siena*, 1511, Louvre, Paris.

this time on, strengthened by their bond, she should *agisci virilmente* ("act manly"), indeed, *fingerti uomo* ("pretend to be a man"), since to him, according to Catherine's variant on Galatians 3:28, *non c'e maschio ne femmina, ne rico ne povero, ma tutti sono uguali* ("there is neither male nor female, rich nor poor, but all are equal;" *Legenda Maior*, 117, 123, 124).

This is the beginning of Catherine's public life. The bride is obviously not weakened by the "Suffering Servant" but strengthened by her union with the God-man to leave the kitchen and go like a man – like Him – into the world, healing, preaching, and exercis-

ing authority over those who think they are in charge. Far from being an embrace of the infantile, the convention of "marriage to Christ," for religious women of the Middle Ages, was a form of rebellion, "obverse to the orthodox idea of family, male sexuality, and authority sanctioned by the *civitas hominis*."[14]

If one sees Catherine's understanding of her relationship with Jesus as one of docile submission in which she abandons her will and personality, her letters and indeed the last ten years of her life make no sense. On the contrary, her profoundly emotional, physical, and intellectual identification with Jesus, the Word and Miracle Worker, gave her a voice in a world where women were usually not heard and what Paul VI nervously called a "personal charism" that comforted the suffering and moved popes. Furthermore, Catherine does not drop the physical imagery once the honeymoon is over. When she finds the sight and smell of sick bodies almost more than she can bear, Jesus "invites her" to strengthen her resolve by drinking from the open wound in his side (*Legenda Maior*, 157). However one imagines the scene, it is an unsettling picture. Most artists tended to avoid it. Despite Catherine's own analogy with a mother nursing her child, one of the few graphic depictions of the event brings to mind a disturbing conflation of vampirism and fellatio (fig. 109).

In the background of Giovanni de Vecchi's fresco in Santa Maria Sopra Minerva, a young Catherine receives the Dominican habit along with a lily to remind her and the viewer of her vow of chastity. Yet the scene in the foreground is filled with sexual tension. Christ appears to be lunging forward with pleasure; his right hand and arm and his naked right leg are enlarged out of proportion with the rest of his body as though they might be indicators of genital inflation under his red cloak. Catherine grasps above the Savior's thigh with her left hand; her right hand cannot be seen. Her Dominican black outer garment falls loosely away from her waist. A priest, presumably poor Raimondo, looks on from the side with fascination or horror. His face is hidden, but the dramatic curve of his body indicates nothing less than astonishment at what he sees. Perhaps Raimondo was not as adept as Catherine or Jesus in ignoring gender. De Vecchi, though not a great painter, shows how shocking and visceral Catherine's behavior must have seemed to those who knew her. Undoubtedly, Catherine would have said that whether the fluid in question is mother's milk, blood, or semen, the nurturing, strengthening, life-giving quality is what matters. What the two parties may be feeling is probably none of our business. One thing is clear. Catherine did not understand the act to be a sign that she was meant to keep quiet and stay on her knees.

With one of her distinctive symbols in *The Dialogue*, Catherine, "transcribing" the words of God, compares the crucified Christ to a "bridge" between heaven and earth which must be crossed in order to attain salvation. Once again, scriptural images – Jacob's ladder and crossing the Jordan – resonate through the text, but Catherine, as always, shows her preference for anatomical rather than architectural or geographical imagery. The bridge becomes Christ's body which must be "climbed" as in an eroticized progress from "the

109 Giovanni de Vecchi, *Saint Catherine of Siena Drinking from Christ's Wound* (detail), 1585,
Santa Maria sopra Minerva, Rome.

feet which symbolize the affections" to "the heart [where] she begins to feel the love of
her own heart in his consummate and unspeakable love," and finally to "his mouth, where
she finds peace." As if wanting to justify the physicality of the imagery and to give it a
weight greater than the merely metaphorical, she throws the picture into focus with a
lucid and compressed declaration worthy of Saint Paul (whom Catherine liked to refer
to as *Paoluccio*, Little Paulie): "Though the bridge has been raised so high, it is still joined
to the earth" (*Dialogue*, 65). Tricky engineering, but solid Christian theology![15]

As readers now attempt to understand the sexual as well as the rhetorical and theo-
logical implications of Catherine's prose, it is useful to remember that her prayers and

The Dialogue were understood by her and intended by her disciples to be for general consumption and guidance. Even her letters, though addressed to particular persons, were dictated in the presence of several scribes and friends and were ordinarily read aloud in courts, families, and chapter rooms. Catherine's passion for Jesus may have been looked on by some as a wonder or aberration, but it was also looked on by her and her admirers as a model to be emulated. Although she does not put it in quite these words, it seems that Catherine took it for granted that if Jesus could turn water into wine and a reclusive young girl into a "manly" apostle, he could, by means of his radiant beauty united to the perfection of his spirit, turn men as well as women into his lovers.

What is perhaps the best-known and most powerfully dramatic of Catherine's letters describes just such a process. The occasion, narrated in detail by Catherine in a letter to Raimondo, was the execution for treason of a young Sienese nobleman who refused the consolation of religion as he waited in prison for his fate. When Catherine arrived on the scene, everything changed. In her narration of the events, she compares the execution to a wedding in which she is the Christlike groom and the young man is the frail, frightened bride dependent on the strength and courage of "his" or "her" partner:

> He was so comforted and consoled that he confessed his sins and prepared himself very well. He made me promise for love of God that when the time came for the execution I would be with him. This I promised and did.
>
> In the morning, before the bell, I went to him and he was greatly consoled. I took him to hear Mass and he received holy communion . . . His only fear was of not being strong at the final moment . . . He said, "Stay with me; don't leave me alone. That way I can't help but be all right, and I'll die happy!" His head was resting on my breast. I sensed an intense joy, a fragrance of his blood – and it wasn't separate from the fragrance of my own. (*Letters*, I, 109)[16]

Here, Catherine not only sees herself taking charge but also, more importantly, transforming a scene of horror into a site of rapture for both victim and consoler in which the two are so close that she sensed, literally smelled, the life essence – probably the sweat – of her companion. As always in Catherine, all bodily fluids are associated with blood. "Blood" is the word and the substance that connects even the most frightened and defeated lovers to one another and to Christ, the man and Redeemer who poured out his blood for the sake of others. Catherine's intimate physical embrace of the young nobleman is a perfect crystallization of her way of dealing with Jesus and with people. Her encounters do not always end in a hug, but they often begin that way, even verbally, as when she addresses the Avignon pope whom she has not yet met as *O babbo mio*, "O my daddy" (*Letters*, 168). Whether dealing with suffering or power, Catherine usually went straight to the heart, but her instinctive compassion and Italian gestures did not mean that her brain was not working.

She waits for the young man at the place of execution and, like Sister Helen Prejean in *Dead Man Walking*, she takes him to the threshold between life and death, refusing to

leave his side. Catherine also refuses to drop her marriage analogy until it turns submission into consent, death into a secondary reality, and decapitation into a virgin's yielding her maidenhead to a lover:

> Then he arrived like a meek lamb, and when he saw me he began to laugh and wanted me to make the sign of the cross on him. When he had received the sign I said, "Down for the wedding, my dear brother, for soon you will be in everlasting life." He knelt down very meekly; I placed his neck [on the block] and bent down and reminded him of the blood of the Lamb. His mouth said nothing but "Gesù" and "Caterina!" and, as he said this, I received his head into my hands, saying, "I will!" with my eyes fixed on divine Goodness. (*Letters*, 1, 110)

The young man's version of how it felt to lose his head might have been quite different from that of Catherine, who could not have imagined that she would eventually lose her own head under widely different circumstances. Yet there are so many accounts of Catherine's extraordinary effect on people that one can at the very least entertain the possibility that things happened as she describes them. In any event, what is of most interest here is not what others saw or said but what Catherine wrote. She offers no apology to her confessor for assuming the masculine role in the "wedding" ritual or in feeling "joy" in the close and fragrant embrace of the young prisoner. She does not even seem surprised that her name is interchangeable with that of Jesus in the victim's last breath. However, if she is ready and willing to take on the Christlike roles of groom, comforter, lover, she is equally ready to let those roles go. When she imagines the soul of the dead nobleman joining Jesus, she steps back as if with the "bridesmaids": "As for him, he made a gesture sweet enough to charm a thousand hearts . . . He turned as does a bride when, having reached her husband's threshold, she turns her head and looks back, nods to those who have attended her, and so expresses her thanks" (*Letters*, 1, 111).

There is poignancy as well as drama in this story of Catherine and the beheading of the Sienese nobleman. Although her decapitation occurred after her death and was intended as an expression of devotion to her memory, it symbolizes a ghastly separation of the woman from the icon, the person from the saint, the author from her texts, which appears increasingly ironic the more one reads her own words. However else her narration of the execution may be interpreted, it is clear that she wanted the young man to die with dignity, not to "lose his head" as he was about to lose his head. It is also clear that throughout her life – facing her mother, the pope, the stench of sick patients, the turbulence of the sea, the corruption of the clergy – to everyone's astonishment, she did not "lose her head." She did not lose her presence of mind, her faith, or her determination to live, act, and speak, in her own way.

The separation of her head from her body is not the only indignity visited on the saint since her death. This eloquent, energetic, stubborn, intelligent, fearless, independent, influential woman was most frequently portrayed by artists in the two centuries after her

110 Domenico Beccafumi, *Saint Catherine in Ecstasy*, 1515,
Pinacoteca Nazionale, Siena.

death in 1380 as an insipid wraith fainting and swooning in an ecstatic trance. Indeed, when three well-known paintings (figs. 110–12) are looked at in sequence, Catherine seems to be falling through vast stretches of time and space. In each of these paintings, Catherine is shown as acted on rather than acting. Beccafumi places her kneeling before the Cross, perhaps receiving the Stigmata, framed by two austere, unbending, and unbowed patriarchal saints, Jerome and Benedict. Sodoma turns her not into another "virile" Christ (as she often saw herself) but as another Virgin Mary sinking into the arms of two women as if beneath the Cross. Despite the pope's restriction, the painter shows the mark of the Stigmata on her hand. Her book and lily have fallen to the ground. Two centuries later, Batoni shows Catherine fainting into the arms of attentive, energetic angels. Francesco Vanni's paintings of Catherine after 1600 did depict Catherine as an active healer, but, by then, a vivid impression of swooning frailty had already been made and repeatedly reinforced.[17]

Catherine might have experienced trance-like states while praying, but where are the great portraits of her preaching or standing up to princes, priests, and popes? With only

273

111 Sodoma, *Saint Catherine in Ecstasy*, 1526,
San Domenico, Siena.

a few exceptions, painters tended to depict Catherine mute and passive clutching a lily or having a fit on the floor. Although she does not dwell on her mystical experiences in her letters and does not mention the Stigmata at all, these became preoccupations of those who contributed to and argued over her saintly reputation after her death. Franciscans – often at odds with the Dominicans – insisted that her Stigmata wounds were invisible and therefore less painful and significant than those of Saint Francis (Francis would have been appalled by such a dispute). Sixtus IV, a Franciscan pope, issued two bulls in 1472 and 1478 prohibiting "anyone, under pain of excommunication, from preaching or publicly maintaining that Catherine had received stigmata like those of Saint Francis. Representations of Catherine with visible stigmata were, therefore, forbidden."[18] Artists tended to ignore the papal threats yet they often painted a different Catherine from the one who emerges from her own writing. Catherine on the road, in the pulpit, aboard ship, with a

112 Pompeo Batoni, *Ecstasy of Saint Catherine*, 1743,
Museo di Villa Guinigi, Lucca.

pen not a flower in hand – the Catherine of quick wit and sharp tongue – is hard to find
except, of course, in her own words and in the testimonies of a few who really knew her.

Many of Catherine's admirers seem to have taken her apart, albeit reverently, and
handed her down to posterity in fragile incongruous pieces. This is a shame for many
reasons not the least of which is that she devoted much of her life and writing to seeking
integrity and helping others to attain it. Inclined early in her life to solitude and con-
templation, she came to understand that the Gospel injunction to love God and neigh-
bor overrides the apparent tension between prayer and charity. While God encourages
prayer in *The Dialogue*, He also anticipates and resolves a problem that plagued Christians
for centuries, the relative merit of good works: "Whatever you do in word or deed for
the good of your neighbor is a real prayer" (*Dialogue*, 127).

In a century rife with categorical oppositions – Avignon/Rome, church/state, spirit/
flesh, female/male, heaven/earth – Catherine chose the "bridge" as one of her central
metaphors, a sign of Christ's power to rejoin what had been separated by sin and death
and a sign of his followers' inherited power to imitate him by making bridges of them-

275

selves. Catherine seems to have understood quite early that in order to be a healer of wounds, a broker of peace, a reformer of the Church, she would first have to know herself and remain undivided in her desire to love and serve God. With help from Augustine and Aquinas, she identifies self-knowledge as the first necessary stage in the soul's progress to full maturity (*Dialogue*, 25). She also demonstrates that she has been well tutored by her Dominican friends when she identifies memory, understanding, and will as the three components of the soul. Yet, as the transcriber of God's message, she places her own characteristic scripture-based emphasis on what she calls the "gathering" of these powers into an integrated soul that sounds much like Matthew 18:20 ("Where two or three are gathered together in my name, there am I"). The source of integrity for the individual soul is the same for the harmonious Christian community: "When these three powers of the soul are gathered together, I am in their midst by grace" (*Dialogue*, 108).

Catherine repeatedly reminds herself (or understands God to be reminding her) to keep the past (through memory), the present (through understanding), and the future (through will) in mind. Although she is an "uneducated" woman, she is expected to know what has happened to the persons and Church she wishes to serve and to pay sufficient attention to what is happening so that with the grace of God and the determination of an informed intelligence, she can influence what will happen. The soul, for Catherine, is not an empty inert vessel but a "gathering" of power available to all women and men if only they would take the trouble to know themselves. Or, as Catherine would put it, to know the God within themselves. The Lord tells her more than once, "I am one thing with you" (*Dialogue*, 46). In one of her memorable similes, God says, "As the fish is in the sea and the sea in the fish, so am I in the soul and the soul in me, a sea of peace" (*Dialogue*, 211).

The discrepancy between Catherine's thoughts and actions as revealed in her strong and passionate words and the insipid images of her as a saint makes it clear that whatever it may mean in heaven, canonization is a mixed blessing on earth. Catherine was canonized in 1460 by the Sienese Piccolomini pope, Pius II, whose colorful life as an ambassador and churchman is recorded in vivid scenes painted by Pinturicchio for the library in the Duomo of Siena. The least original and lively picture in the series shows another ambassador and extremely colorful (though unofficial) churchperson, Catherine, but she is lifeless, out flat, speechless, and unmoving. She is a corpse laid out before the pope and his richly outfitted, mostly male court (fig. 113).

The scene is a sobering reminder of the double-edged sword of institutional approbation. As in the process of literary canonization, ecclesiastical canonization tends to wash over the most awkward, embarrassing, and troubling characteristics of the icon or to turn eccentricities into miracles and highlight only selected virtues. Once Catherine is encountered through her own words, her "miraculous" ecstasies and eating habits, fascinating though they may be, seem much less interesting than the refreshing clarity and arresting earthiness with which she was able to call to the attention of the learned and mighty of her day the magnetism of Jesus and the teachings of the Gospel. In an era of corruption

113 Pinturicchio, *Canonization of Catherine of Siena*, 1490, Duomo, Siena.

and disarray in the Church, she demanded reform with prophetic wrath and authority. In a century when women had little voice and virtually no official power, she influenced the behavior of popes, princes, and clergy. And, very simply in conformity with scripture, though not at all simple for a young unmarried woman of her time, she tended the sick and dying in Siena.

Perhaps Catherine's greatest legacy – and one more reason to send her head home to her body – is her fundamental refusal to separate intellect from passion, willpower from reverence, self-respect from love of God. As usual, she puts it clearly, echoing scripture but in her own way. In the conclusion of *The Dialogue*, the soul thanks God and addresses him as a "deep sea" and a "mirror:" "When I look into this mirror, holding it in the hand of love, it shows me myself, as your creation, in you, and you in me through the union you have brought about of the Godhead with our humanity" (*Dialogue*, 366).

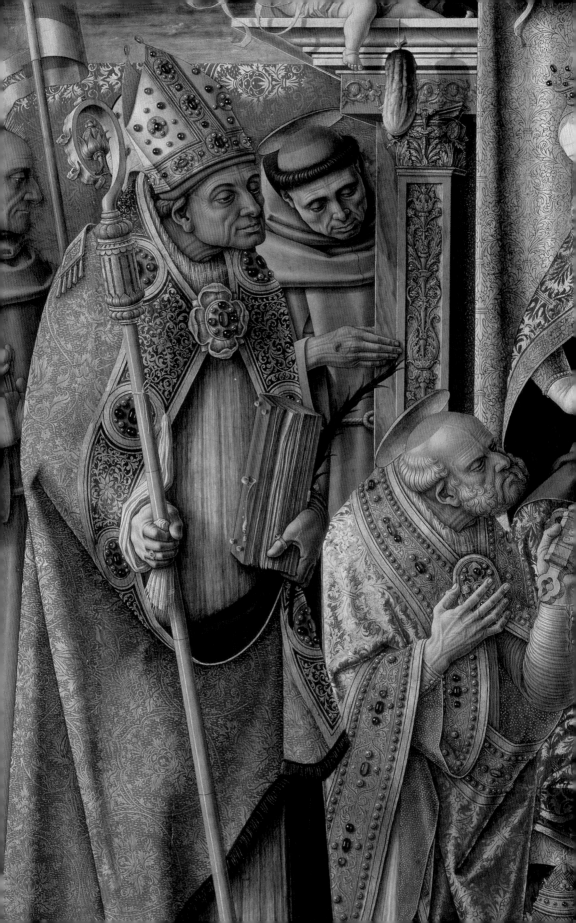

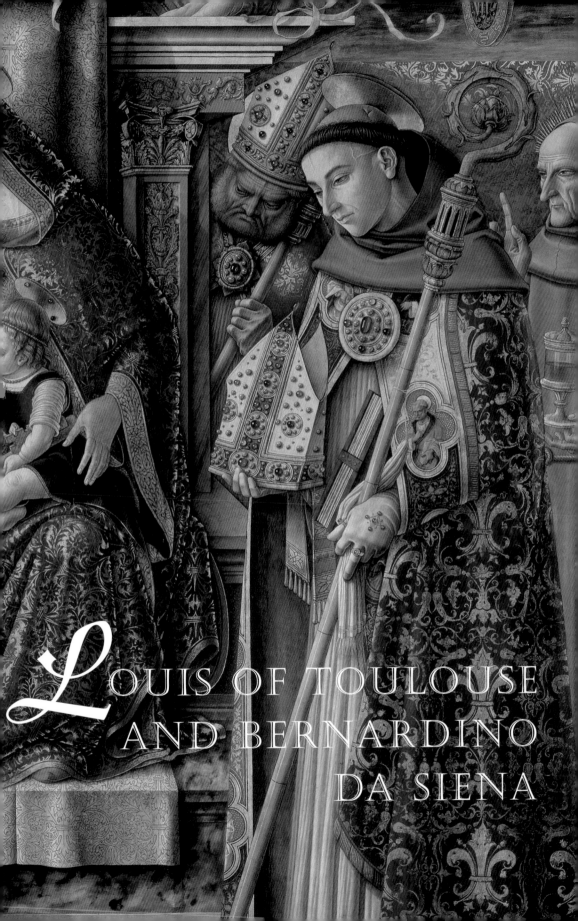

LOUIS OF TOULOUSE
AND BERNARDINO
DA SIENA

10

Saints Fair and Fearsome

LOUIS OF TOULOUSE AND BERNARDINO DA SIENA

"All good things you see in your neighbor, all wisdom, all beauty, every gift of nature . . . be glad of it."

Bernardino da Siena

What, after all, is a saint? Most people think they know. A saint is a really good person. All religions recall, honor, and sometimes invoke the aid of virtuous figures, living and dead. For Christians, a saint is one who imitates or follows Jesus in such a way as to stand out among fellow mortals. A saint is a "friend of God" but our friend too, a human being like us, only better, whose legends, shrines, relics, and images are reminders of the coming together of heaven and earth.[1] In the earliest centuries of Christianity this usually meant martyrdom for the faith. The graves and relics of martyrs were venerated by Christians not because of papal decree but because incidents of bravery in the face of persecution gave courage, dignity, and pride to scattered congregations of the faithful. Saints were local heroes and heroines whose status within the larger Church increased or decreased according to the strength of the *vox populi* rather than through a central authority.

By the fourth century, local bishops were taking a greater interest in and control of the claims to sainthood by members of their communities. Witnesses were called, hearings were held, and traditions about qualifications were gradually established. Unusual signs of asceticism, charity, prayerfulness and, increasingly, miraculous powers, were investigated. As efforts to centralize Church government intensified and papal authority was asserted, Rome's approval became required by decree of Pope John xv (985–95).

281

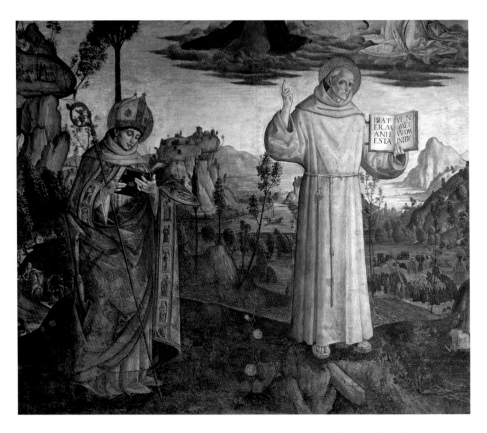

114 Pinturicchio, *Saint Bernardino da Siena in Glory with Saint Louis of Toulouse* (detail), *c.* 1480,
Ara Coeli, Rome.

The need for witnesses to miracles and other holy deeds was made a requirement by
Urban II (1088–99.) In 1173 Pope Alexander III gathered the basic elements of the tra-
dition and established in his Decretals the procedures and standards that remained largely
unchanged until the present day.

 For those who do not know the "rules" – the requisite number of miracles, the accept-
able waiting period, the sufficient number of testimonies, the precise definitions of heroic
virtue – where is there to look for clues? In Italy, the most obvious and beautiful places
to look are the walls of churches and museums filled with portraits of sanctity. For
example, in Rome in the ancient Franciscan Church of Ara Coeli high up on the Capito-
line Hill, there is a painting, *Saint Bernardino da Siena in Glory* with Saint Louis of Toulouse
and Saint Anthony of Padua on either side of him (fig. 114). Of the three, Saint Anthony
is now the best known, a favorite of Italians in America, patron saint of people who lose
things and need help finding them. Who are the other two? What do their portraits tell
the viewer about the nature of sainthood?

Both figures are standing; both hold books; both are detached from the magnificent landscape behind them; and both, if one looks closely, are wearing the Franciscan habit. Otherwise, the two seem physically to have nothing in common. Louis is young; his face is smooth and his expression mild; his eyes are cast down in prayerful reading. Over his habit, he wears the richly embroidered robes of a bishop; he wears shoes on his feet, white gloves on his hands, and rings on his fingers. He appears not only unaware of his surroundings but also oblivious to these gorgeous trappings. His crozier looks less like a symbol of authority than a half-forgotten walking stick. As a portrait of saintliness, this youthful figure seems a crystallization of innocence and contemplation purely and perfectly unaware of its own beauty and power. At first glance, Louis, thus elegantly packaged, bears little resemblance to a homeless, tattered Galilean Jew or the Little Poor Man, *Il Poverello*, from Assisi. On closer inspection, however, his gentle and meek expression seems worthy of a spiritual brother of Jesus and Francis, burdened by unwanted – though undeniably eye-catching – luxury. Indeed, the well-dressed, little-known young saint comes close to stealing the show from the figure elevated above him on his left.

Bernardino is old, skinny, and bald; his tight, thin mouth suggests that he has lost both his patience and his teeth. He holds the book open to PATER MANIFESTAVI NOMEN TUUM OMNIBUS ("Father, your name is manifest in everything") while pointing with his right hand to heaven in a gesture that combines menace with authority. His expression is severe; his habit plain; his feet bare. He looks out of the picture with a sharp and accusing eye. If the figure of Louis is an idealized image of over-dressed but simple virtue, the picture of Bernardino looks like a real-life portrait of a complex, not particularly attractive person whose virtue is concentrated in his raised finger and plain dress rather than in the radiance of his visage.

Can two such disparate figures both be saints within a common definition and tradition? Both wear haloes, though Louis's is less noticeable hidden behind his bishop's mitre. Both show facets of Jesus: Louis, the meek and mild man of prayer; Bernardino, the angry prophet reviling the Pharisees and moneychangers. The viewer's eye moves back and forth between the two but, like Pinturicchio, he or she may find it difficult to reconcile them. Piously detached from the sumptuous landscape, they are also – perhaps not so piously – detached from one another. One critic noted with disappointment that Pinturicchio's saints are only "passive witnesses" to the glory of God (represented high above them in the painting) and that "the final impression remains one of hierarchical isolation of man from deity."[2]

Louis of Toulouse and Bernardino da Siena were not acquainted. They lived a century apart: Louis died young and lived most of his life in relative isolation and obscurity; Bernardino's life spanned many years of fame and notoriety. Louis was born in 1274 in Provence, the son of Charles II, King of Naples, and Princess Mary of Hungary. On both parents' sides, he was the descendant of heavenly and worldly royalty. Saint Louis, King of France, was his father's brother; Saint Elizabeth, Queen of Hungary, was his mother's

aunt. When his father was defeated by Spain in the war of the Sicilian Vespers in 1288, Louis and his brothers were taken to Spain as hostages. There he lived in a castle under guard from the age of twelve to nineteen accompanied by servants and Franciscan friars, including Francesco Bruni, his tutor, confessor, and perhaps his closest friend.

While imprisoned, Louis studied, prayed, fasted, and increased in piety to the point of wishing to devote his life to the celibate priesthood as a Franciscan. When his older brother died, his father expected him to marry and inherit the throne. But, despite Charles's opposition, Louis took the first step toward ordination secretly while still in Spain, receiving the tonsure and the first minor orders from Fra Bruni in the presence of two witnesses who later reported that "he received his vows with many tears."[3] Released from captivity at the age of nineteen, accompanied by Bruni and his Franciscan circle, Louis stopped in Provence on his way to Naples, preached at his sister's wedding, but refused marriage for himself. Later he stopped in Rome to pay his respects to Pope Boniface VIII and, withstanding the outrage of his father, he was ordained to the sub-diaconate on Christmas Day 1295 in Saint Peter's. Although Charles still hoped to dissuade his son from taking the final step to priesthood, he permitted Louis to live apart from the royal court in Naples with his small community of friends, friars, and scholars.

While only twenty-one and reputed to be of a mild and gentle temper, Louis held to his own course, renouncing his right of primogeniture to his younger brother Robert in 1296. On Trinity Sunday that same year, surrounded by friends and tutors, he was quietly, though not secretly, ordained to the priesthood in Naples, refusing the invitation of the pope to come to Rome for a more public, formal ceremony fitting a prince. So far, Louis had resisted his father's wishes at every turn, but he was still not a Franciscan. For Charles, the idea of a royal prince identifying himself with the poor friars seemed to be carrying humility to the point of disgraceful degradation. Boniface, the king's friend and political ally, then did Charles a favor and tried to help him save face. The pope commanded the newly ordained Louis to come to Rome and offered him the see of Toulouse. Charles liked the idea of his son becoming a prince of the Church, if not King of Naples. Reclusive, pious, studious, and utterly inexperienced in administration, Louis at twenty-two would have preferred living with his religious brothers and serving the poor, but he had one last card to play. He agreed to be ordained a bishop if the pope would allow him to become a Franciscan.

In a pact with the pope, after his ordination as bishop, Louis was secretly received into the order of Franciscan Friars Minor on Christmas Eve 1296, concealing his rough habit under rich episcopal robes. Evidently unable to keep his secret or his joy hidden much longer, after celebrating mass at Ara Coeli on February 5, 1297, Louis cast off his bishop's regalia and publicly put on the Franciscan tunic. When his father heard this, he was furious. He became even more furious the next day when Louis insisted on "flaunting his beggardom" by walking barefoot through the muddy streets of Rome to pay his respects to the pope.[4]

115 Piero della Francesca, *Saint Louis of Toulouse*, 1460,
Pinacoteca Comunale, Sansepolcro.

Even without a heroine in distress, the story bears many resemblances to medieval
romance: the captivity in a remote castle; the defiance of the father; the loyal band of
friends; the secret vows; the sudden revelations and transformations of identity; and, espe-
cially, the total devotion of the hero to an ideal. It is this heroic, stalwart, sturdy, deter-
mined, and fearless Louis that Piero della Francesca portrays a century and a half later in
1460 (fig. 115). Piero's Louis is not a delicate youth barely past adolescence, weighed
down by unwanted authority, but a mature young man who wears his bishop's regalia and
Franciscan habit with equal ease and assurance. His grip on his crozier, his Bible, and on
himself looks firm. He looks a little worried but Piero's Louis stands up straight and strong
like a knight for whom the bishop's garb and the Franciscan habit are not in conflict but
constitute harmonious elements of a uniform worn with pride.

285

116 Antonio Vivarini da Murano, *Saint Louis of Toulouse*, 1450,
Gallerie dell'Accademia, Venice.

Louis occupies the roles of both hero and heroine in his own story. True, he was brave,
determined, wily, unstoppable, reckless, and he knew when and how to make a display
of his strength. At the same time, he was a passive victim of wars, pacts, and political
intrigues over which he had no control. He was held in relative seclusion during the form-
ative years of his life, protected and befriended by a small group of friends of his own
sex. (It is thought that no woman was allowed into his presence during his imprisonment
in Spain.) He would not allow his younger brother to use bad language at table; he was
regularly described as "pure" and "innocent."

In a 1450 portrait of Louis, Antonio Vivarini da Murano depicts the youthful saint,
smooth-skinned and wistful, not, as Piero's Louis, facing up to a challenge like a soldier
but, more like many portraits of the Virgin Mary, mild, modest, and resigned (fig. 116).
Although supposedly tonsured, Vivarini's Louis appears to have so much hair that his mitre

does not fit tightly over his head. Furthermore, unlike Piero's Louis who wears his habit and his mitre trimly like a uniform, Vivarini's Louis appears as if he is draped in a borrowed bishop's costume, parts of which are too big for him; the neckline of his simple Franciscan habit dips slightly down from his white neck. The hands of Piero's saint are strong and bare; the hands of Vivarini's Louis are gloved, delicate, and slack.

It is commonly accepted by biographers that early paintings of Bernardino were taken from life, by people who had actually seen him or had heard detailed descriptions of his physiognomy.[5] While accounts of Louis's youth and goodness abound, there are no precise descriptions of his features. Louis is Cinderella and the Prince and the Pauper all in one: under his rich garment is the dress of a poor man; under the garb of a poor man is the flesh of a prince. Perhaps most extraordinary in the life of a saint, many early accounts report fairly generally on his good looks and more particularly on what he was wearing. According to witnesses in the canonization process, when Louis was released from prison, his father was angry with him for riding a mule

> and not wishing to eat off silver, and ordered his son to wear costly furs suitable for a layman of his rank . . . To this last demand, Louis unwillingly consented, but near Viterbo "he altogether laid aside his furs and costly garments and dedicated himself to God; wearing garments of white cloth . . . a tunic . . . and a hood . . . and from this he had a cloak fastened to his breast, and he used to eat in this cloak."

In his life of Louis, John of Orta reports that on a visit to Tarascon, Louis "was in habit and cloak with a beautiful and joyful face." When he returned to Barcelona, the crowd is said to have "pushed and jostled in order to obtain sight of the young bishop . . . with the face of an angel. Who could see such a one and not marvel?"[6]

A bishop so young, so innocent, so angelic, so lacking in pride, political ambition, and greed, so unlike the stereotype of the higher clergy of the day, he seemed to look good whether dressed up or dressed down. Who, indeed, among the faithful or among artists, could resist such a figure? Some critics have thought that the "bland, adolescent faces of youthful saints caused difficulty" for artists,[7] but many rose creatively to the challenge. Although his cult did not last for much more than a century and a half after his death, Italian painters, like the crowds in Barcelona, rushed to "see" him.

It is true that in what is probably the earliest painting of Louis, commissioned in 1318 by the family, the saint's face is not the most remarkable element. Simone Martini shows Louis renouncing his right to the Kingdom of Naples to his brother Robert (fig. 117). Louis's posture and features are so wooden, flat, and generic as to give little idea of a real, living person. Sainthood here seems to have little or nothing to do with individual identity and everything to do with royal status. In what has been called "among the most splendid images" Martini painted,[8] Louis is enthroned like a king against a gold background. The border of his cape and the frame of the altarpiece are decorated with *fleurs-de-lys*, emblems of the Angevin dynasty, signs of the legitimacy of the transfer of power from one brother

to the other. Robert may be small in the painting, but the political message is that he has been given, with due ceremony and legality, the authority of his royal and blessed brother.

Since Louis had not yet been ordained a bishop when he gave up his inheritance, the picture is historically inaccurate. However, painted within a year of Louis's canonization in 1317 for a family chapel in the Church of San Lorenzo, the image condenses several attributes that contributed to Louis's iconic stature. Although the bishop's crozier, mitre, and cloak are plainly visible, so too are the simple brown Franciscan habit and knotted cord. Louis's halo is huge; over his head two angels hold a crown that makes the one that the saint hands over to his "little" brother appear to be an insignificant plaything. What appears at first sight to be a richly textured but otherwise straightforward tribute to a young saint is, in fact, a complex statement. "With its disturbing conjunction of regal and mendicant iconography, its overtones of *imperium*, extreme richness in honor of a saint who struggled toward the ideal of abject, apostolic poverty, it accurately mirrors the tensions of Robert's court."[9]

Louis's rigid posture and steady gaze may have been Martini's idea of sanctity. Or they might well have been suggested to the painter by a family who wanted Louis to be presented to posterity with the bearing of a "real" king and who had experienced more than once Louis's stubborn refusal to be moved by the pressures of the world. Torn from his home and cast into prison as a child by war and struggles for power, he is shown by Martini to be "sitting tight," holding himself, his peace, and his crozier as symbols of a higher power fixed like a rock in time and space.

Bernardino, born of wealthy parents in Massa Marittima in 1380, was only slightly luckier than Louis in his childhood. His mother died when he was three; his father when he was six; and the maternal aunt who had cared for him, when he was eleven. At almost the same age as Louis when he was sent to Spain, Bernardino was taken to Siena to be raised by relatives of his father. He was not imprisoned or mistreated; rather, he was sent to the best schools and was reputed to be an excellent scholar of rhetoric, grammar, and philosophy. Like Louis, he was befriended and taught by Franciscans. He spent three years studying for a doctorate in canon law but gave up the academic life at the age of twenty-two when he joined the Observant Franciscans, the strictest, most faithful followers of the original Rule of Saint Francis. He worked with lepers and plague victims in the hospital of Santa Maria della Scala in Siena and for several months attempted living as a hermit on the forested slopes of Monte Amiata.

Whereas Louis's calling was to solitude, scholarship, and service, Bernardino's true vocation was preaching. At first he restricted himself to Tuscany and Umbria but by his thirties he was traveling throughout Italy and eventually into other parts of Europe. It is sometimes said that his fame as a preacher began at the age of thirty-seven when he gave a particularly rousing sermon to a huge, enthusiastic crowd in a neighborhood known as La Scala in Milan. Where and when his "career" actually blossomed may be difficult to say, but Milan (eventually the home of another La Scala) seems symbolically the right place.

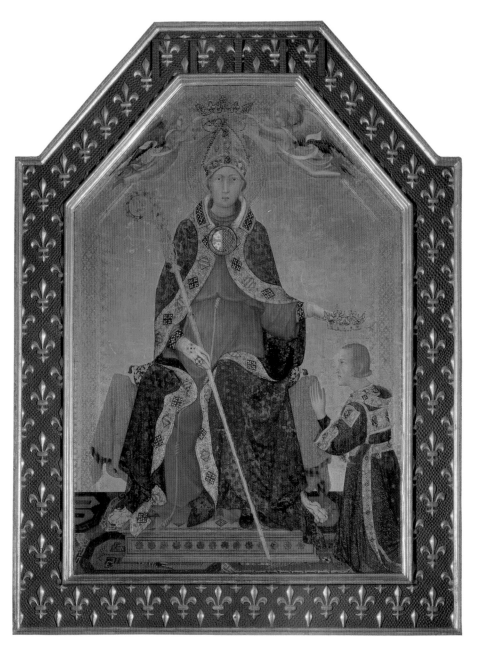

117 Simone Martini, *Saint Louis of Toulouse Renounces His Right to the Kingdom of Naples*, 1318, Museo Nazionale, Naples.

Bernardino was a performer whose audiences packed churches and city squares, sometimes waiting for hours, to hear him. If Martini's painting of Louis renouncing an earthly throne while occupying a heavenly one brings together key elements in Louis's narrative, the counterpart for Bernardino would be an early depiction of him preaching (fig. 118). Though Louis's act of renunciation was a public and legal affair, Martini chose, in keeping with the life and character of the young prince, to depict it as a private matter between the saint and his brother. In Sano di Pietro's painting, the pink tower of the Palazzo Pubblico and the attentive crowd of listeners occupy more space than the preacher; they demand as much attention from the viewer as does Bernardino in his pulpit. It is a neat and orderly picture of a devout, modestly attired congregation, divided by gender, on their knees in the heart of a great city listening to a sermon by a friar with, behind him, what appear to be civic or Church leaders.[10] The technique in each picture is sharp and clear, but the message is more complicated than at first meets the eye. Louis had attained holiness by embracing a private piety incompatible with his public positions as prince and bishop. He is shown giving up his titles, but he nonetheless looks the prince and bishop. Bernardino's sanctity was inseparable from his public persona which, according to the painting, displayed itself sedately and serenely in a scene of perfect harmony. Yet, why is Bernardino preaching in front of a civic building, not a church? And why is this memorial of a lively preacher so still and static?

Both Martini and Sano di Pietro tell a vivid and partially true story about their subjects, but both also leave out significant and messy details. Louis's angry father, his various acts of subterfuge, his illnesses are wiped away, as it were, by angels and a golden backdrop. Bernardino's crowds were large and mostly admiring, but they were also human and Italian. Nothing in the records of his sermons suggest that people sat or kneeled quietly lined up like little ducks for hours on end. He repeatedly chastises his listeners for whispering and gossiping while he speaks; coming late, leaving early, flirting, and falling asleep. "You woman over there who is sleeping . . . I come here to bring you the word of God and you settle yourselves down to sleep so that I have to interrupt my sermon to wake you!"[11] At more than one point, he shouts out to young men near the fountain to stop playing ball and making so much noise. Bernardino was not a sedate or calm speaker. He gesticulated and pointed; he made oinking, clucking, and baaing sounds in imitation of beasts and members of the congregation. He frequently expressed outrage and shock with "Uuh, uuh, uuh" or "Oime, oime, oime."

Bernardino refused to become bishop of Siena (and two other cities) not because he was too modest but because he felt he could act and speak more freely as an itinerant friar than as a church official. "If I had come here as your bishop, half my mouth would have been closed up. Like this! [He must have closed his mouth tightly.] I would not have been able to speak except with a closed mouth . . . But I want to say what I want to say and to speak of everything in my own way" (Orlandi, 69). He attracted attention wherever he went, but the attention was not always positive. Bishops could not have liked being

118 Sano de Pietro, *Saint Bernardino da Siena Preaching in the Campo in 1427*, 1445,
Museo dell'Opera del Duomo, Siena.

made fun of as tight-lipped hypocrites and cowards. Parish priests could not have liked it when he told the crowd that "If you have time either to hear mass or the preaching, skip mass and hear the sermon."[12] Women could not have liked being told that they spoiled their sons and disgusted their husbands, "making themselves hateful to men" with so much "reeking makeup" that they drove them to sodomy. Italians (and especially the Sienese) could not have liked hearing that they were the most corrupt, carnal, and sinful people in the world, and that if he had a son he would send him out of the country at the age of three and not bring him back until he was fifty (Bianchi, II, 166).

Whether they thought what he said actually applied to them or their neighbors, people still flocked to hear Bernardino. He told funny stories, moral tales, gave out advice about marriage, housekeeping, reported the news from other cities he had visited, alternately entertaining, threatening, encouraging, and terrifying his audience. His favorite theme was the wrath and vengeance of God, *la vendetta di Dio*; he could work himself up to a frenzy of apocalyptic prophecy: "You will lose everything, children, possessions, land and your houses will be destroyed . . . *Guarda! Guarda!* [Beware! Beware!] You think you lack nothing, but you lack one thing: *l'ira di Dio* [the wrath of God]!" (Bianchi, II, 127).

Part of Bernardino's appeal was his fearless conviction that he spoke with the voice of God. He accuses hypocrites of speaking with a voice that is *una tromba di simulazione*, "a trumpet of pretense" (Bianchi, II, 169), but this is not a bad description of what his own voice must have sounded like to many: a resounding trumpet imitating the voice of God. After a fashion, Bernardino realized that this is what some people thought of him: "Uh, uh, uh . . . I think you wish me well, and you would kill me willingly" (Bianchi, II, 168). He says that, according to civil law, slanderers should have their heads cut off; and, according to Church law, they should be excommunicated. Bernardino compares "backbiters" to frogs, "*qua, qua, qua.*" Then, not altogether surprisingly, he adds: "I'd like to speak a little about myself. Oh, such things have been said about the doctrine I teach . . . that I teach contrary to the gospel. I never said such things" (Orlandi, 23–4). "I have heard what has been said of me . . . Oh, oh, Friar Bernardino is coming! One says well of it and one says evil . . . Of every one who says good, one hundred say evil" (Orlandi, 27–8). The fact is that they all knew who he was, that he was coming, and that, whether to laugh or cry, you had better go hear him or risk losing your soul, not to mention your chance to hear the latest news. Little wonder that Bernardino is the patron saint of people who work in public relations and advertising (also boxers).

The crowds, his loose tongue, and his enormous success in promoting himself (or, as he would have put it, the Gospel) made Bernardino a source of great interest and some uneasiness in Rome. Many Dominicans and Augustinians thought him a heretic; one accused him, among other things, of being the anti-Christ, a Hussite, a Jew.[13] His arriving in every town with a huge banner or board with the symbol of a flaming sun and the letters IHS (an abbreviation of the name of Jesus) attracted attention. It also appeared to some as shameless self-promotion and, worse, as a heretical concentration on the name

of Jesus at the expense of the Father and Holy Spirit, encouraging superstitious attachment to a magic sign (fig. 119). Twice he was brought before the Inquisition and twice he was acquitted. As with most celebrities, controversy only increased the interest of the people.

Clearly, the crowds who pushed and shoved to see Louis, the handsome young bishop, and those who jammed the city squares to hear the furious and funny old preacher were looking for a different kind of saintliness. "What did you go out in the wilderness to see?" asks Jesus in Matthew 11: 7–10. "A reed shaken in the wind? . . . A man clothed in soft raiment? Behold, those who wear soft raiment are in king's houses. Why then did you go out?" In this passage, Jesus is referring to John the Baptist but, by indirection, to himself and, by implication, to those who would follow him. As an early clue to a description of holiness from the mouth of the Messiah, the words are striking. Jesus assumes that the crowds who "go out" to see a holy man expect to find a delicate, well-dressed, weak character easily bent by turbulence. Obviously, this description does not tally at all with Isaiah, Jeremiah, Ezekiel or any of the prophets of the Hebrew Bible. Jesus' sarcasm is a rebuke to those who do not know scripture or who know it but would prefer a prophet with a softer, milder, less demanding approach to salvation.

119 Vecchietta, *Saint Bernardino da Siena with Monogram* (detail), *c.*1450, Pinacoteca, Siena.

The attention to dress in Jesus' rhetorical question would have resonated with Louis. Even after he was consecrated bishop, he went out of his way to appear whenever possible in his simple Franciscan habit. En route from Rome to take up his post in Toulouse, he stopped in Paris, choosing not to stay with the archbishop but with his fellow Franciscans. He insisted on wearing the rough Franciscan habit, working in the kitchen, washing dishes, serving meals, feeding beggars, and washing their feet on Holy Thursday. Biographers note that "clad in the habit of a simple Franciscan without mantle or cope, in spite of his being a bishop, he preached to an assembly of clergy in the convent cloister." Again, escorted to the university by King Philip IV, "he discoursed on the beauty of humility in the presence of the King and an assemblage of masters and scholars . . . habited simply as a friar."[14]

In an era when dress reflected not only status, profession, and wealth but also, in church circles, presumed holiness, a preoccupation with clothing seems understandable. (Bishops identified by crozier and mitre were called "Excellence"; cardinals in red, "Eminence"; only

120 Simone Martini, *Saints Francis and Louis of Toulouse,* 1318, San Francesco, Assisi.

the pope, in white and gold, was "Holiness.") Louis, like Francis, and Francis, like Jesus, turned the conventional expectations about appearance, as well as behavior, upside down. From the beginning, Jesus rejected ostentatious displays. He speaks scornfully of hypocrites who take the most prominent places in the synagogue, making a show of their religious dress. "They make broad their phylacteries, and enlarge the borders of their garments" (Matthew 23 : 5). In one of his most frequently quoted sermons, Jesus asks, "Why take thought for raiment? Consider the lilies of the field, how they grow. They toil not, neither do they spin. And yet I say to you, even Solomon in all his glory was not arrayed like one of these" (Matthew 6 : 28–9). Over the first centuries, Christians were often identified by and mocked for their plain habits and plain dress. Yet, as time went on, they, like everyone else, varied in their interpretations of ostentation and display. Looking rich could be showing off but so could looking pious or poor. What was a good Christian to do?

Louis of Toulouse made a choice that created problems as well as opportunities for himself and, of course, for artists attempting to represent his particular kind of saintliness. Consider another early portrait of the saint by Simone Martini (fig. 120) and one painted by Carlo Crivelli more than a century later (fig. 121). True, one painting is from early in the fourteenth century; the other from late in the fifteenth century. True, Martini tended toward a spare sobriety of form and color whereas the Venetian Crivelli stood out,

121 Carlo Crivelli, *Madonna Enthroned with Saints*, 1488, Gemäldegalerie, Berlin.

even in his own time, for his love of rich ornamentation, golden tapestries, and decorated spaces crammed with detail.[15] Nevertheless, the portraits of Louis (facing Saint Francis in the Martini; standing with head bowed and mitre in hand on the right side of the Crivelli) reflect the complex nature of the young saint's life and an iconography that sought to do it justice.

In the Martini painting, Louis is virtually a mirror reflection of Francis. His mitre and cope are nearly as plain and simple as his Franciscan habit. Louis turns toward Francis, but, according to one critic, it is unclear whether Francis's "interest focuses on, or bypasses, the young bishop saint," whose reluctant acceptance of episcopal title might have disappointed Francis.[16] Even if this is the case, the two solemn elongated figures shown against a plain background stand as types of an unadorned piety that calls atten-

tion to itself, if noticed at all, by way of contrast with the glitter of the world around it. Indeed, the fresco-crowded and colorful walls of the great basilica of San Francesco in Assisi (which would have displeased Francis and did displease his most faithful followers) bear unintended and ironical witness to Francis's (and Louis's) protestations against material excess. If one thinks of the interior of the church as a contextual frame for the two portraits, it is not hard to see that the frame risks obscuring what it pretends to show.

In Crivelli's painting, everyone is dressed to the teeth in richly woven golden fabrics. The Virgin, clothed in embroidered robes and wearing a crown, is seated like a Queen on a throne covered with soft fabric. Her halo is a glittering disk. Saint Peter, on his knees holding a large golden key with the papal crown before him, seems to make it plain that the painting is a tribute to, really a flaunting of, the power and material wealth of the Church Triumphant. What is Louis of Toulouse doing in this gleaming, glowing, sumptuously adorned company? One answer is that, like all the saints acknowledged by the Church, he has been absorbed by the institution, made to conform to its historic moment, and deprived of any traces of his individuality. Insofar as this is so, he is in good company, since Mary and Peter are similarly impressed into institutional service.

Like all painters of his time, Crivelli had to please his patrons. But he was an artist still. On closer inspection, the picture is not only a fashion show. The infant Jesus, in a little dark smock, is the most simply dressed of all the figures. He is not handing the keys of the kingdom to Peter, as the mature Jesus did metaphorically in Matthew 16 : 19, but he is looking rather quizzically and sweetly at the scowling Peter who brandishes the huge, heavy key like a blunt instrument under the chin of the Holy Infant. The Virgin touches the key daintily with two fingers as though it were too hot to handle. Their gestures and expressions are odd and difficult to read. Is Peter angry and trying to give back the key? Is Mary frightened? Is Jesus too little to hold such a cumbersome toy? Then there is Louis. His crozier is so long and his cope so beautifully embroidered that he seems at last to have succumbed to the gilded pressures of his high clerical office. But look again (fig. 122).

This is a rare depiction of Louis with his head uncovered revealing his tonsure as a friar. The brown of his Franciscan hood shows plainly against all the surrounding glitter. He holds his mitre like a dead weight. His head is slightly bowed as if in prayer or in contemplation that takes him out of the picture. He looks burdened but not defeated by gilt, surrounded but somehow unmoved by all the gold. It is the kind of marginal masterpiece that Ruskin would have loved. Crivelli's Louis carries the eye of the viewer away from the gorgeous but perplexing center of the painting, away from surly Peter, to a different "key" that opens the possibility of a purer, simpler, more innocent sanctity.

Evidently, artists, like designers of fashion and saints, knew that the way in which a costume is worn is as important as the costume itself. Everyone seemed to agree that clothing signifies. In this regard, Bernardino da Siena was no exception. He liked to say, *Come tu vedi vestiti un uomo di fuore, cosi il puoi giudicare dentro* ("As you see a man dressed on the outside, you can judge what is within"; Bianchi, II, 189). Bernardino often calls attention to his plain Franciscan habit and cautions people to follow the example of friars and soldiers by dressing in keeping with their station in life, not above or below it. He berates women for wearing gowns with flowing trains and long sleeves, sweeping grandly through the narrow lanes and wide piazzas of Siena like queens or prosti-

123 Perugino, *The Miracles of San Bernardino: The Healing of a Young Girl* (detail showing fifteenth-century male dress), 1473, Galleria Nazionale del Umbria.

tutes. He notices how they attempt to increase their stature by wearing platform shoes and piling their hair high "like donkeys carrying a load of hay" (Bianchi, II, 188).

When ridiculing vice, Bernardino describes it with relish and an eye for detail that must have alternately entertained and chilled his audience. His colorful diatribes also make it clear that his congregations usually bore little resemblance to the sober crowd in Sano di Pietro's painting. Bernardino's Italian, always colloquial and vivid, virtually strums and twangs as he calls attention to the outfits of the stylish young men in the crowd: *gamba tirata, stringato in torno, gamba rotta, e calze sparlata e fessa*, "legs laced up in close-fitting tights with little slits, and stockings torn to show what's underneath." Bernardino cannot help noticing that these outfits are sexually provocative: *O giovanezzo*, "O young man . . . your tunic is so short that it almost shows your . . . etc" (Bianchi, II, 189; fig. 123). Is this a joke? A menace? A leer?

In a painting more after the artist's heart than the Ara Coeli *Saint Bernardino in Glory*, Pinturicchio painted the spirit of Bernardino miraculously releasing a prisoner while a crowd of young men, dressed exactly in the way the saint deplored, stands around dis-

124 Pinturicchio, *Saint Bernardino da Siena Releasing a Prisoner,* 1473,
Galleria Nazionale dell'Umbria, Perugia.

playing their colors and curves (fig. 124). It is a good thing that the spirit of San Bernardino has its back turned to the fashionably dressed *giovanezzi* who steal the foreground and limelight from the tiny figure floating behind them on its errand of mercy. If Pinturicchio had included a few pious elders, one imagines some of them looking around to see which of the young men best fit the preacher's furious and detailed descriptions of scandalous dress. Some must have been ready to mock and abuse their neighbors, others to laugh at

or defend them, but all had to be wary since no one was exempt from the scorn or gaze of the beady-eyed fashion policeman. Even though most of his criticism seemed to be aimed at fashionable young men and women, some of the higher clergy and wealthy merchants on stage or in the audience must have felt more than slightly uncomfortable when he shouted, "Christ was dressed in purple to be mocked . . . Every time you dress in purple or vermilion, you mock Christ" (Bianchi, II, 195).

Bernardino, the keen observer, liked to remind his audiences that God saw everything down to the tiniest detail and that every little act was "weighed" on the Day of Judgment. As God's representative, he does some of the preliminary watching and weighing himself. He wanted people to listen to him but also to look at him so that they might get a preview of God's disposition toward them. He was most familiar and most severe with his hometown of Siena: "Here I am, home again. Have you seen how an angry man looks? He shows it by a grim face – see?" (Orlandi, 46). Many artists seem to have heard this message, if only second hand, and imagined the face that went with it (fig. 125).

Certainly, no two grumpier saints can be found in the Christian pantheon than Bellini's odd couple, the hermit Anthony and Bernardino, the preacher. Bellini need not have seen Bernardino in person in order to capture this familiar form and expression. As Iris Origo pointed out, portraits of the saint were painted "by men who had known him by sight or, soon after, by artists who scrupulously followed their models."[17]

125 Jacopo Bellini, *Saints Anthony Abbot and Bernardino da Siena*, 1456–60, National Gallery of Art, Washington, D.C.

What made Bernardino so angry? He was not shy about explaining himself. Most of his sermons consist of elaborate lists and anecdotes about the categories of sins and the almost infinite number of ways in which they can be committed. References to the Ten Commandments and the seven deadly sins abound, but what really inspires his imagination and loquacious wrath, aside from fancy dress, are the sins of witches, Jews, and sodomites.[18] Bernardino did not invent the targeting of these groups. They had long been singled out as scapegoats responsible, among other things, for causing plague, loss of property, crop failure, and a decline in the population. Bernardino was unusual, if not unique, in his ability (and seeming pleasure) in whipping himself and his crowd into a frenzy of loathing against these targets.

Although he described local fashions with obvious glee, he was even more graphic in regaling his audience with stories of incantations and witch burnings in Rome. He reports that witches, mostly old women, were accused – rightly, in his opinion – of killing babies, sucking their blood, and then turning themselves into cats. They had magic mirrors that could turn big things small and small things big so that noses, mouths, and eyes could suddenly become monstrous. They were burned at the stake by the dozens, the only "cure" that made sense to him: *Non vi so' meglio dire: Al fuoco! Al fuoco!* ("I don't know how to say it better: To the fire! To the fire!"; Bianchi II, 1 2 1–4). That is not all. "Nothing was left of them but dust [*polvere*]! . . . cinders [*cendere*]!" He sounds as if he is cheering at a football rally. Then he turns with a warning to his listeners: "I advise you to turn in to the Inquisition every enchanter, every suspicious old woman or old man . . . and don't help them or pray for them because they have denied God!" (Bianchi, II, 1 2 5).

Bernardino's denunciation of the lending practices of the Jews was slightly more moderate and conventional; occasionally he even urged his listeners to be tolerant of their Jewish neighbors. Usury was wicked, but sodomy was far worse (and apparently more interesting to denounce). According to Franco Mormando, "The number of sermons among the preacher's extant works devoted to the topic of what he calls '*l'abominabile peccato della maladetta sodomia*' ('the abominable sin of accursed sodomy') causes it to be ranked among the friar's most frequently addressed themes of his entire repertoire."[19] "Sodomy," in Bernardino's time and usage, refers to behavior, not an identity or condition to be confused with homosexuality, a term unknown until the nineteenth century. For Bernardino, sodomites have "strayed from the womb;" they are "insane," "corrupt," "raging," "false," and "proud;" "there is no sin on earth that so seizes the soul" (Bianchi, II, 2 5 5–6).

Many preachers and theologians of Bernardino's time thought that describing a sin in too much detail could give ideas to members of the congregation, but Bernardino seems to have gotten too carried away to let this stop him. He tells a story about "a famous sodomite in bed with a young man" who thought it not right for preachers to use "filthy words" that might arouse bad thoughts in susceptible listeners (Bianchi, II, 2 7 1). Yet Bernardino goes right ahead, letting those in the crowd who may still be innocent know what he is talking about: "The love of the form of a beautiful young man [*bel garzone*] is a forgetting of reason . . . They go behind a boy as a dog goes behind a bitch" (Bianchi, II, 2 5 7). He works himself into a torrent of fury: "You are all – young and old – involved. Whatever touches pitch is soiled . . . Even the devil hates this sin, but God hates it more!" (Bianchi, II, 2 6 2). "First they flatter, then they pay, then they make promises, then they threaten, then they force! They smell of sulphur!" The only cure of this vice is fire and smoke, *Fuoco e fumo!* The cry of their unborn children is *Vendetta! Vendetta! Vendetta!* (Bianchi, II, 2 6 6–8).

Saints are supposed to be like Jesus but where is Jesus in the grimacing, tormented face of Il Vecchietta's unflatteringly life-like statue (fig. 1 2 6) and in the sermons filled with prurient loathing? It is true that Jesus expelled the moneychangers from the Temple

126 Vecchietta, *Saint Bernardino da Siena* (detail), wood, 1455,
Pinacoteca, Siena.

and railed against the Pharisees and Sadducees, but he has nothing to say about sodomites.
It is true that according to Luke, Jesus said, "I came to bring fire to the earth" (Luke
12 : 49) but nothing in the context of these words or in his actions suggests that Jesus
meant them literally rather than as metaphorical expressions of the radical power of his
message. When he encounters "demoniacs," he does not send them to be burned to ashes
as witches; he exorcises and heals them. Jesus is repeatedly criticized by the religious
authorities of his time for consorting with "sinners," for befriending, consoling, and bless-
ing prostitutes, tax-collectors, and others on the margins of society. He can be stern, but
he is never hysterical or vindictive. And where is Francis, the little poor man, who tamed
the wolf, charmed the birds, begged for his food, and was profligate with love and mercy
for all creatures? Finally, where is that other Franciscan, Louis of Toulouse, gentle,
innocent, and mild?

Perhaps Bernardino was an exception to the "rule" of sainthood. Perhaps he was a
fanatic or simply a man of his time, terrified by threats of plague, war, and famine, assum-

ing the cause to be the wrath of God. Perhaps, as some have suggested, he was accosted by a sodomite as an adolescent and scarred for ever by the experience.[20] Certainly, some of his own comments on sainthood give pause today and must have given pause even to those Christians accustomed to the penitential practices of the fifteenth century. In one sermon, he speaks of having seen in Milan "beatings of the discipline by about five hundred, for all beat themselves with chains of iron, and the blood flowed, and it was a pious thing to see . . . But not here [in Siena] . . . and I once thought you were all saints" (Orlandi, 75–6).

It is tempting to write off Bernardino as a disturbing curiosity of his era, a talented entertainer, a troublemaker, a false prophet who took perverse pleasure in terrifying his audiences, and verbally reveling in the vices he condemned. In short, a mistake in the roster of saints. Then one reads another sermon. The voice sounds surprisingly genial: "Let it never be out of your mind that we are all from one seed begotten by one father. We are all brothers . . . All good things you see in your neighbor, all wisdom, all beauty, every gift of nature . . . Be glad of it" (Orlandi, 68). When he speaks of Francis, it is with longing, a barely concealed self-criticism, and, perhaps, envy for the one who "walked in Christ's footsteps," and possessed "an innocence like that of Adam before the Fall." His most telling praises of Francis paint a picture in sharp contrast with the self-portrait provided by his own sermons: "He knew how to find the sweetest words in the world" (Orlandi, 151–5). "He was naturally magnanimous" (fu naturalmente magnanimo; Orlandi, 439). "His voice was like running water . . . his face shone like the sun. My face gives notice of me; and his gave notice of him" (Orlandi, 462–6).

In the relatively few paintings in which Bernardino is shown with Francis, the comparison that he himself "drew" to his own disadvantage is unmistakable. As Benozzo Gozzoli's fresco of *The Virgin and Child with Francis and Bernardino* (fig. 127) shows, Bernardino, except in habit and gesture, bears little resemblance to his ideal saint. Yet Bernardino was an ardent Franciscan. In 1439 he became Vicar General of the Observant Franciscans, and was known as one of the great reformers of the Order. He often preached at Montefalco, a center of the reform movement where the fresco was painted, urging his brother friars to follow the simple life of poverty and charity exemplified by their founder. In Benozzo's painting, Mary looks fondly at Jesus; Jesus looks sweetly at Francis; Francis, tender, tanned, and handsome, looks beyond the frame in prayer; Bernardino, pale and pinched, a shrunken, imperfect copy of the original Franciscan, looks humbly and a bit sadly toward the founder.

Bernardino obviously thought he was doing the right thing in roaming throughout Italy denouncing sin and sinners. Yet, so did Louis when he followed the example of Francis by disobeying his father and renouncing worldly wealth and power. After reading the explosive and troubling words of Bernardino, one turns from so much sordid reality with relief, as artists must have done, to the beautiful possibilities in the life of a young prince whose early death left behind no volumes of sermons, but a brief last will and

127 Benozzo Gozzoli, *Virgin and Child with Saints Francis and Bernardino da Siena*, 1450,
San Fortunato, Montefalco.

memories of a lifetime of troubles endured with quiet courage in a small circle of beloved friends. When Louis arrived in Toulouse, he found a corrupt system of benefices, a dissolute clergy, and a bishop's palace filled with treasures. With the aid of a seasoned administrator, he sought, with mixed results, to change the system and to reform the clergy. He gave away three quarters of the bishop's wealth, invited beggars to take their meals with him, supported young students with scholarships at the university, and, as one always conscious of symbolism, was strict about clerical tonsures.[21]

Not surprisingly, the people loved him and the clergy resented this young zealot. After eight months of what must have been a daily trial for him, he visited his sister in Spain and then determined to go to Rome to ask the pope to release him from his bishopric so that he could live the life of a true Franciscan serving the poor. In Brignoles, where his father held court, he fell ill with a fever and within two weeks he was dead. His Franciscan friends, including Francesco Bruni, were with him, consoling him, praying with him, and, as it is recorded – and seems fitting for this boy saint – one was holding his hand at the end.[22]

Aside from occasional pious remarks recalled by friends, the only words recorded directly from Louis are found in the Latin of his last will and testament. For a thirteenth-century prince and bishop, it is a remarkably straightforward and telling document. After the formal preliminaries, he gets right to the point:

128 Sebastiano del Piombo, *Saint Louis of Toulouse*, 1510,
Gallerie dell'Accademia, Venice.

In primis in domo Fratrum Minorum Massiliae meam eligo sepulturam. Deinde de bonis meis . . . ordino in hunc modum . . . De libris nostris lego Religioso viro Fratri Guilhelmo de Corneliano, socio & familiari meo, Bibliam in uno volumine, quam praefatus dominus rex, dominus et genitor meus, dedit mihi, & etiam Summam Thomae . . . Omnes autem alios libros meos lego Fratribus Petro Scarrerii, & Francesco Bruni, sociis & familiaribus meis, inter ipsos aequaliter dividendos, propter plura grata servitia, quae ab ipsis longo tempore recolo suscepisse.

First I choose to be buried in the house of the Friars Minor of Marseilles. As to my belongings . . . I wish them to be distributed in the following manner: From my books, I leave to Friar William of Corneliano, my friend and companion, my Bible in one volume, which was given to me by the lord king my father, and also *The Summa* of Thomas [Aquinas] . . . All my other books I leave to Friars Petro Scarrerii and Francesco Bruni, my friends and companions . . . in gratitude for their service to me over a long period of time.[23]

That a Franciscan had any possessions to leave behind was rare, but for a prince to have so few possessions to leave was rarer still. All were books. Louis was clearly not an idle or ignorant solitary. His repeated references to "friends and companions" are touching reminders of his close ties to and reliance on his Franciscan brothers and teachers, many of whom became witnesses at the canonization process after Louis's death. If the persona and reputation of Bernardino is largely defined (and tainted) by his extraordinary and well-recorded loquacity, part of Louis's appeal derives from the mystery of a barely heard voice. Virtually everything that is known about him is based on what he did (or refused to do) and what was said about him rather than what he said about himself or others.

Whereas artists were aided and limited by lifelike sources (pictures and sermons) of Bernardino's physiognomy and personality, they were free to picture Louis as they wished – as long as he was a young bishop, innocent and charming. Sebastiano del Piombo depicts not only a figure but a phenomenon, an enchanting form emerging from the shadows about to say something, a male Mona Lisa, whose half-smile seems to contain words of potential significance (fig. 128). The artist chose not to accentuate the Franciscan Louis. He does not show a brown habit. His Louis is all bishop and all youth about to step out of the picture, tilting his head as if ready to speak. The viewer is free to put words into his mouth. Louis could be about to say, "I'm willing to do this job if that is what God and the Church want of me." Or, more likely, "I can't wait to get out of this outfit. I'm on my way to Rome to resign." Yet, the beauty of painting in general and this painting in particular depends to a great extent on the silence that surrounds it. What is memorable about Sebastiano and Louis has nothing to do with the sound of the spoken word. Even the traditional halo is missing or is displaced into the golden glow in the curved vault above. Sebastiano's Louis, like Piero della Francesca's *Madonna del Parto*, is on the verge of something, not there yet.

Louis's early death, like his relative silence, is an essential ingredient of his iconography. He never grew old or ugly or sardonic like Bernardino who, in one famous sermon,

compared life to a bowl of macaroni with a fly in it, asking, "Who in this audience is really content with life and has never had a fly fall into his macaroni?" (Orlandi, 26–7). For one born a prince and imprisoned at twelve, a bug in the pasta seems a far from adequate metaphor for life's tribulations. The power of Louis's story – a story told by others – is the power of a romance which leaves much to the imagination. Traces of it can be found as far from Brignoles as Ireland in the poem of a fourteenth-century Irish poet, Tadhg Camshosach O'Daly, who, like Louis, distressed his parents by becoming a Franciscan:

> Were I a young lad, sole heir of a great lord yonder in my father's land . . . then were it right to grieve for my sake. A child there was, whose action was no child's, a king's son and his only heir – I never heard of one so young – Louis, the comely, the slender. Into this order of poverty that I have joined he came in his young years – a sorrowful story, of another age – the heir of the folk of Sicily . . . Why should anyone grieve for me, a poor man, son of poor folk? It is not that I measure myself with that fresh, youthful countenance, but it is a holy tale that I have told of that bright-haired, sweet-voiced noble."[24]

O'Daly does what poets (especially Irish poets) and painters (especially Italian painters) always do. He alters the story for his own purposes, making Louis the "sole heir" and endowing him with attributes particularly admired in Ireland, "bright hair" and a "sweet voice." In doing so, he imagines Louis as Bernardino had imagined Francis, as one whose goodness could be seen on his face and heard in his voice. However, since he could not "hear" Louis's voice through sermons (as in the case of Bernardino) or in the colorful dialogues of the folk legends widely circulated about Francis, the Irish poet seems to suggest, like Keats in *Ode on a Grecian Urn*, that, "Heard melodies are sweet; those unheard sweeter." Indeed, it is astonishing that, without the support of recorded sermons, teachings, or writings, Louis's humility, youth, and reputed good looks continued for more than a century to carry weight in the retelling of his story, giving his embrace of the Franciscans and his early death a heroic and glamorous quality.

While for the modern viewer, the inclusion of Bernardino in pictures of saintly company can seem incongruous, like sour grapes amid the ripe harvest, a joke in poor taste, a mistake in paradise, the presence of Louis, the long-forgotten boy-bishop, comes as an unexpected treat, a pleasant surprise, a consolation. When Tintoretto was commissioned to paint Louis in a panel with Saint George and the dragon, even he might have been at a loss as to how to put such an unlikely pair together. He could have done what Pinturicchio, Crivelli, and others had done before him, shown Louis as isolated and alone in the presence of other saints. Tintoretto had his own ideas (fig. 129).

Louis clutches his robe and looks down with some astonishment at George's broken spearhead while trying not to notice the provocative way in which the princess straddles the limp dragon. One critic thinks that Louis is "looking over his shoulder with disdain,"[25] but mild shock at finding himself present at such a strange and famous scene seems more

129 Tintoretto, *Saint Louis of Toulouse with Saint George, the Princess,*
and the Dragon, 1553, Gallerie dell'Accademia, Venice.

like it. Louis may not have played a role in the legend of George and the dragon yet he
is a slightly stunned and stunning witness in Tintoretto's picture. Unlike Pinturicchio's
Louis who is oblivious to Bernardino in Glory, he is shown to be physically and emo-
tionally present in Tintoretto's imaginary scene. His red stole overlaps the armor of Saint
George and touches the knee of the princess whose dress it matches. He holds his crozier
like a lance, standing guard as George raises his arms in victory over evil. Louis may not
want to touch the dragon or the woman; his bare foot and the hem of his brown

307

Franciscan habit show him avoiding harm. He is fastidious, but he is also curious enough not to step completely out of the frame. He participates, perhaps to his own surprise, in the heroic scene. For Tintoretto, there is obviously more than one way to defeat the devil, more than one way to be a "knight," in or out of shining armor.

The relative paucity of detail about Louis's life and words makes it all but impossible to be disappointed by him or scandalized, as readers now are bound to be by the more outrageous of Bernardino's sermons. Bernardino, free with judgments and condemnations, left himself open to judgments and condemnations in his own day and, since his words have been carefully reported, he leaves himself vulnerable to criticism still. Despite his frequent and booming outbursts of prophetic self-assurance, Bernardino did not see himself as perfect. He probably would have been as surprised as Louis to find himself among the saints. Doubtless, he was speaking from experience when he said, "It often happens that devout souls suddenly feel themselves oppressed by sadness and tedium; they no longer find delight in solitude; reading becomes tedious to them and prayer a weariness".[26] While this is a conventional description of *acedia*, the dryness of spirit that was thought to be a particular scourge of those in the religious life, Bernardino's words have their characteristic ring of personal witness.

Although Bernardino often sounds misanthropic and suspicious of human affection, he, like Louis, depended on the company and support of a few close friends. John of Capistrano, a learned Franciscan, advised him on matters of theology and canon law; he acted as his defense before the Inquisition in Rome and was largely responsible for his acquittal by Pope Martin v. When Vincenzo da Siena, a Franciscan companion who traveled with him for twenty years, died, Bernardino put his grief, as he had often put his anger, into words: "He encouraged and sustained me. I was afraid and he comforted me; lazy and negligent and he inspired me."[27] "How is it that you were torn from me, my Vincent? How is it that you were seized from my hands, O man of one mind with me, man according to my heart? We have loved each other in life, how is it that we have been separated in death?"[28]

To realize that these words too have a familiar ring, that they belong to a rhetorical convention among religious writers of the period, does not lessen their sincerity. Language is convention. Even Bernardino's strikingly "original" sermons are a pastiche of the scriptural and colloquial, of Jeremiah and the street vendor, of Augustine and the gossip nodding off in the back row. Bernardino himself was such a mixture of appealing and obnoxious traits – imagination and paranoia, learning and superstition, good humor and spleen – that he is easier to recognize than to love. His fondness for the earthy, proverbial wisdom of his time, that "whoever touches pitch is soiled," seems to implicate everybody. If so, his own intimate acquaintance (some might say, obsession) with sin – even if only in his imagination – does not leave him completely clean.

Over the centuries, Louis of Toulouse has faded from memory with his purity intact. Having suffered and made his grand gestures of repudiation of war, politics, and power,

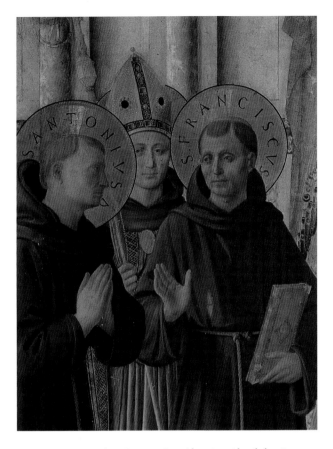

130 Fra Angelico, Bosco ai Frati Altarpiece (detail showing
Saint Louis of Toulouse between Saints Francis and Anthony of Padua),
1450, Museo di San Marco, Florence.

he died young and innocent. He is a saint whom few remember but everyone might like for a friend or son (unless you were a king). Bernardino often seems a caricature of everything that went wrong with Christianity – the Inquisition, antisemitism, homophobia, misogyny. He is rendered beyond his own time, entertaining and alive but also appalling, by his own well-recorded words.

The more one probes into the lives of Louis and Bernardino, the more the former recedes into the shadows of pious legend while the latter becomes increasingly vivid, human, and imperfect. Like two photographic prints in fixative, one seems on the verge of melting away as the other takes on sharper, darker contrasts. Two paintings, by Fra Angelico and by El Greco, make the point as clearly as any biography. Fra Angelico graphically puts young Louis "in his place," almost hiding him between Saints Francis and Anthony of Padua (fig. 130). It is as if the viewer is permitted (invited) not to notice the

young bishop peering from behind the two famous saints. But what company! What proximity! The prominent haloes of Francis and Anthony nearly cut Louis out of the picture, but they also frame, envelope, and embrace him. Mitre and crozier notwithstanding and partially obscured, he is one of them – what he always wanted to be, a brother Franciscan. Born with the distinct mark of royalty, what Louis struggled for throughout his short life was not distinction but resemblance. He wanted to be another Francis who wanted to be another Christ. The Dominican Angelico "got the picture" and painted it.

Bernardino, in his own way, also tried to imitate Francis by living ascetically as an itinerant preacher. Like Francis, he drew large crowds who came to hear him speak, but, unlike Francis, he often stirred up trouble and dissent. Francis was renowned for bringing a miraculous calm wherever he went. His salutation and blessing was *Pace e bene*, "Peace and goodness." Like Francis, Bernardino could not help but call attention to himself, but Francis offered himself as a transparency, a magnifier of the Lord, whereas Bernardino was an opaque and egocentric conveyor of the "good news," which, in his version, often sounded instead like very bad news. Bernardino had friends, but he was never one to blend in, to recede into the background. He stood out in the crowds of his own time and he stands out still. El Greco worked in Rome and Venice where he assisted in the workshop of Titian and studied the art of Tintoretto. He must have known of Bernardino's reputation and the Italian iconography that showed him as elderly and severe. His Bernardino, decisively and surprisingly, is something else (fig. 131).

Is this Bernardino? If so, he is shockingly unfamiliar. He is young, tall, and strong; he has thick dark hair and a moustache. He looks every inch a sincere Franciscan: his feet are bare and he is clothed in a rough brown habit. His head is tilted modestly; his eyes are soulful and inviting; his expression gentle. His sunburst IHS monogram is not a banner or board but a pilgrim's staff. At his feet are gold-embroidered mitres symbolizing the bishoprics that he refused in order to retain his freedom and poverty as an itinerant friar. This is a late portrait by an artist who never saw Bernardino and who always put his own dramatic and spiritual signature on everything he painted. In El Greco's time, the Franciscans were a large and powerful presence in Spain; their missions were spreading throughout the New World. The Spanish version of their spirituality emphasized asceticism and introspection.

El Greco may have used Bernardino as an excuse to portray a peculiarly mystical Spanish version of Franciscan piety, but, in doing so, he reminds one that Bernardino was young once. Before too many flies had fallen into his macaroni, he too must have been idealistic and even dreamy (not completely unlike the young Francis or Louis). Just as Sebastiano's Louis, with head tilted (which El Greco could have seen in Venice), looks out of the picture as if about to speak, El Greco's Bernardino also seems to have something to say. In time, Bernardino had plenty to say. But El Greco has shown him as he might have looked before he opened his mouth. He has painted an extraordinary phenomenon, a quiet Bernardino, a benign preface to the prophet.

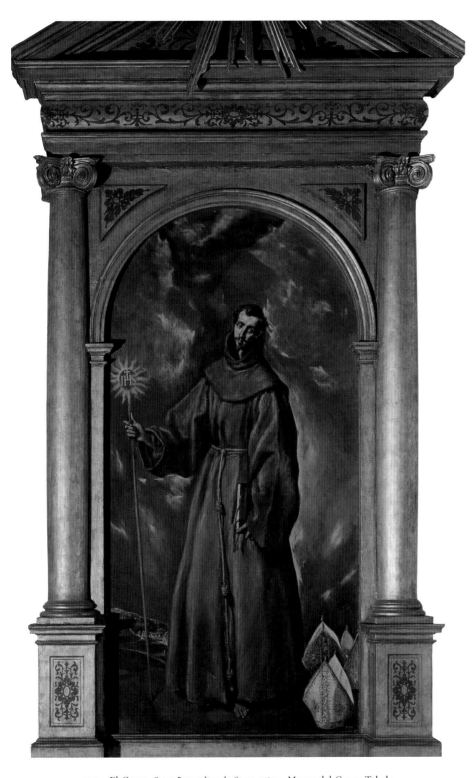

131 El Greco, *Saint Bernardino da Siena*, 1603, Museo del Greco, Toledo.

It may take a stretch of the imagination – like El Greco's – to conceive of Bernardino in the same spiritual "league" with Louis, not to mention Francis. Yet God's house, it is said, has "many rooms" (John 14:2). There is no question that the Church has admitted to its honor roll many figures who seemed to conform or, in hagiographic retrospect, were made to conform to the theological and political exigencies of the time of their canonization, and were usually supported by powerful patrons and religious orders. Seen in this light, the community of saints may look like a miscellaneous cast of characters gathered together for practical and propagandistic reasons. Even the reputations of reformers, those who, like Francis and Catherine, challenged the conduct of Church leaders, were smoothed over and absorbed into institutional coherence.

Something essential is missing, though, if the narrative stops there. Some would call it the Holy Spirit blowing where it will; others would call it the recalcitrance of heroic virtue. There is also the testimony of the living "relics" of the individual saints themselves: their often surprisingly independent words and acts; the words written about them by those who knew them (or wished they did); and the unforgettable faces and (mostly) beautiful bodies invented for them by artists who imagined, recreated, and "canonized" them in their own way. Celebrating their diversity and keeping the saints "in line" has often been a challenging balancing act for the Church. The conservative, coercive, conformist weight of large old institutions – including government and the academy – is powerful. Saints – like kings, queens, mythical heroes, popes, and revolutionaries – can be represented as bland, forgettable, indistinguishable minor players in a vast gray scene or as the stunningly vivid originals that most of them seem to have been. Even Louis and Bernardino – different in almost every respect – have occasionally been placed in niches that all but erase their individuality (fig. 132).

Without the colorful inventiveness of Pinturicchio and Crivelli or the soul of Fra Angelico, Sebastiano del Piombo, and El Greco, Vincenzo Foppa renders two solemn, lifeless figures who reflect no tension with one another, with the flesh, or with their architectural space. These two unique characters, each of whom went his own radical way, have been swallowed up by static gesture and symmetrical form. Yet, definitions of symmetry, like definitions of sanctity, can be stretched. Louis and Bernardino can be shown to belong and not to belong, to conform and not to conform, to deserve veneration and to be unworthy models, just mortals like everyone else. Real and unreal. Ordinary and fantastic. Neither separated himself or wanted to separate himself from the Church as a mystical body, yet each separated himself from some of the most powerful political and ecclesiastical structures of the time. Canon lawyers may have difficulty putting the contradictions together, but many of the great artists of the Italian Renaissance clearly saw them as an opportunity. Once the viewer has met Louis and Bernardino in a few great paintings and in the story of their lives, it becomes almost impossible – Foppa notwithstanding – to miss their individuality, whatever their company may be (figs. 133 and 134).

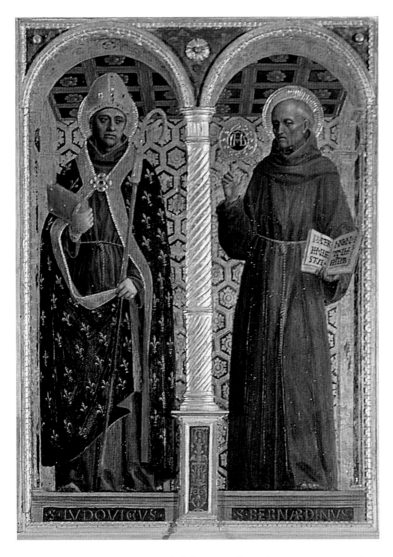

132 Vincenzo Foppa, Polyptych delle Grazie (detail showing Saints Louis of
Toulouse and Bernardino da Siena), c.1460, Pinacoteca di Brera, Milan.

As soon as one thinks that they have been put in their niches, absorbed by an institu-
tional anxiety for order, there they are again: odd, interesting, slightly uncomfortable,
almost alive and ready to speak. Bellini's Louis looks tired of posing as a bishop, but he
does not seem to mind sharing the stage with Christopher, a saint who probably never
existed, and standing watch before what appears to be a painting within a painting of
Jerome translating scripture in the desert. Layers of reality and artifice, like layers of
clothing and experience, bishop's cope and friar's habit, seem familiar elements in the life

313

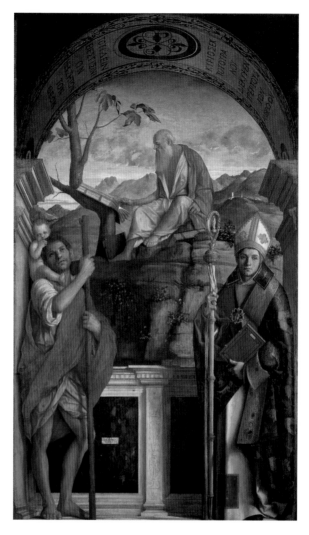

133 Giovanni Bellini, *Saints Louis of Toulouse, Christopher,*
and Jerome, 1513, San Giovanni Crisostomo, Venice.

of the young saint. Piero's Bernardino looks as though he is about to reveal a secret. He does not appear intimidated or particularly impressed by the proximity of John the Evangelist. As in life, he is all business, no nonsense. Both Louis and Bernardino gaze out of the picture toward an unknown spectator just passing by or pausing like the over-dressed men and women in the Campo in Siena or jostling for room, like the crowds in Toulouse and Barcelona, to catch a glimpse of something wonderful.

The stories and paintings of Louis of Toulouse and Bernardino da Siena leave plenty of room for people who think of themselves and their heroes and heroines as fitting some-

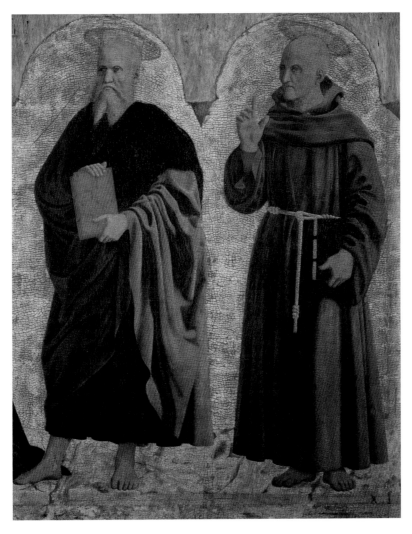

134 Piero della Francesca, *Madonna della Misericordia* Altarpiece (detail showing
Saints Bernardino da Siena and John the Evangelist), 1460–62, Museo Civico, Sansepolcro.

where between extremes of innocence and experience. The institutional Church of the
Renaissance was powerful and often corrupt. But it was not impenetrable, oblivious to
all virtue, or blind to variety. As long as it left the doors open, even a crack, for imagi-
nation – for painters, poets, storytellers, and preachers – it left its doors open to flesh
and blood, to dissent, to the survival of idiosyncrasy, reserving a place in heaven – along
with the meek, the innocent, and angelic – for those whom history has found far from
perfect, saints and would-be saints, the spotless few, but also the many "touched by pitch,"
worthy only of the forgiveness of an all-merciful God.

315

Epilogue

PACE E BENE

In a book about saints, there ought to be a blessing over the company. The question is which one to choose to do the honors. It may seem improper to choose a favorite, but in the long history of Christian devotion, people have always had favorite saints, a patron, a namesake, a local hero or heroine, or simply someone whose company is preferred. Jesus "so loved the world that he gave his life" for the salvation of all, but he seems to have "liked" Mary Magdalene and the disciple John in a particular way. It is only human. Although Christians do not believe that Jesus was "only" human, they do believe that he was also human.

Therefore, with scriptural justification and an easy conscience, I choose Francis.

With the exception of Jesus himself and perhaps Mary and John the Baptist, no sacred figure in the Christian pantheon has been painted and sculpted so frequently, so lovingly, and so carelessly. From Assisi to Beijing, one finds painted tiles, figurines, holy cards, and garden statues with blurred and crazed features that make the "little poor man" look like a poor little clown or alien or a survivor of a disfiguring accident. Yet there is the tonsure, the cord around the waist, the bare feet, and a bird on the shoulder. So it must be Francis.

Francis never thought of himself as handsome. He probably would have been amused and even pleased by the fact that some of the world's worst artists have made it their business to picture him. In a typical story in *I Fioretti*, one of his friars, Masseo, asks Francis why the whole world seems to want to see, hear, and follow him since he is not good-looking, educated, or of noble birth. Francis answers cheerfully that God could not find anyone "more vile and imperfect" than he; paraphrasing Saint Paul, he explains that

135 Anon., *Saint Francis*, 13th century,
Sacro Speco, Subiaco.

he has been chosen "to confound the noble, the great, and the powerful" (*I Fioretti*, x). As with many stories about Francis, the reader (and Fra Masseo) can take this as a lesson in humility.

One of the great things about Francis, however, is that he is never just solemn. In this case, he seems to be laying the self-effacement on pretty thickly. Does he really think he is that bad? Is he teasing Fra Masseo? Is this yet another saint's story that is so exaggerated that it tells us nothing more than that the saint is superhumanly humble? Or is this a reassurance to Masseo (and anyone else listening) that God's love does not depend on physical beauty, moral perfection, or privileged birth? That seems much more like it and much more like the amiable Francis, the man with a sense of humor and a beautiful soul, that keeps reappearing through (and sometimes despite) the awful art, the fanciful legends, and cartoon-like images.

An early portrait of Francis is a kind of cartoon, a simply colored line drawing in a cave, the Sacro Speco, where Saint Benedict is believed to have lived in the sixth century, probably done in Francis's lifetime because there are no signs of the Stigmata. Francis looks young, bright-eyed, alert, and readier to break into a smile than a sermon (fig. 135).

The figure of Francis is elongated, though he is said to have been quite short. His entire pose has a rigid Byzantine formality until one comes to the face. Out of the shadows of the cave and the hood appears an expression of startling intensity and freshness. No doubt, the figure has been touched up; much of it is mottled and faded. But the eyes are unblinking and engaging. He looks both incredibly determined and, at the same time, ready to be amused. His big ears give him away. He is not Adonis. He is almost like a big kid caught up in a role and a pose he still finds surprising. Of course, this painting is a caricature. Francis may not have looked like this at all, but the artist has captured something of the radical simplicity, humanity, and magnetism of a man who, by becoming poor, caused a revolution.

Francis did not use weapons in his revolution. After his disastrous experience of battle in a war between Assisi and Perugia, he became a pacifist who behaved like an artist not

a soldier. He was a wandering troubadour who liked to sing and tell stories, he composed a canticle in praise of Brother Sun and Sister Moon, and he created an aesthetic that was inseparable from his moral vision. Throughout Umbria, parts of Tuscany and the Marches, one finds his imprint in "Franciscan places," a rough stone marker between Cannara and Bevagna where he preached to the birds, a rugged path winding through a valley where he walked to Gubbio, a plain chapel in Rivatorto where he prayed, a quiet island in Lake Trasimeno where he fasted, a dramatically remote and creviced cave in La Verna where he slept. It is the Francis who possessed an exceptional eye and ear who heard Christ speak to him through a painted wooden cross in San Damiano. The place names themselves are like poems.

His aesthetic is easy to understand, hard to follow. It stays close to the earth – the closer to earth the closer to heaven – and takes away from it only what is necessary. It rejoices in the hard parts as well as the soft spots in nature. It finds expression in solitude, in the company of friends, and even in the presence of large and unruly crowds.

All saints, presumably all Christians, try to imitate the compassion, courage, integrity and determination, active intelligence, and grace of Jesus. The role of the saint is to interpret and embody those traits – or some of them – to the highest degree possible within the limits of his or her character and time. The role of the patron saint or "favorite" is to translate Christ's virtues into a language of particular clarity and resonance for a given individual. Not everyone wants a translator. Some think an intermediary, whether artist or saint, distorts and confuses the message. Others think that the person of Jesus and his teaching become more personal and immediate with the help of an exceptionally gifted friend, living or dead. Peter Brown quotes a fourth-century hymn that conveys the idea beautifully:

> Give me a companion, O King, a partner, a sacred messenger of sacred power . . . illumined by the divine light, a friend, a dispenser of noble gifts, a guard of my soul, a guard of my life, a guard over prayers, a guard over deeds.[1]

My first encounter with Francis happened when I was a graduate student traveling with friends in Italy. In Assisi we were in awe of the Giotto frescos in the Upper Church of San Francesco and moved by the rough stone tomb of Francis in the crypt. But the true Franciscan moment was the next day. It was extremely hot when we decided to hike up to the Carcere, the wooded grove on the slopes of Mount Subasio where Francis and his companions regularly retreated to pray and sleep in the caves away from the noise of the city. We were all sweating when we arrived at the gate of the small chapel at the edge of the place now sacred to Franciscans. We looked like a motley crew. I had not shaved in weeks and I was wearing shorts, which I suddenly remembered was not permitted in the holy places of Italy. As we hesitated at the bell, a young Franciscan with a tonsure, sandals, a trim brown beard, and a beautiful smile appeared at the gate and beckoned to us to enter. He spoke no English and our Italian was rudimentary, but he accompanied us

136 Sassetta, *The Ecstasy of Saint Francis*, 1437–44,
Villa I Tatti, Settignano

through the woods happily pointing out where Masseo, Bernardo, Leo, and Brother
Francis had slept in caves with rocks for their pillows. He seemed in no hurry to be rid
of us, but when we finally thanked him and left, he stood at the gate as we headed down
the hill. Each time we looked back he was waving with a particularly Italian wave – both
arms spread out, palms facing in – laughing and shouting, *Auguri! Auguri!* At the time, I
did not know what the word meant. I have since found out, and have never forgotten the
sight of him – another Francis who was another Christ – and the sound of that blessing
echoing like a canticle through the hills (fig. 136).

Notes

INTRODUCTION

1 Walter Pater, "The School of Giorgione," *The Renaissance*, Chicago: Academy Press, 1978, p. 138.

2 Martin Kemp, *Behind the Picture: Art and Evidence in the Italian Renaissance*, New Haven and London: Yale University Press, 1997, p. 83.

3 Michelangelo Buonarotti, "Veggio nel tuo bel viso," *Michelangelo: Life, Letters, and Poetry*, ed. George Bull, trans. George Bull and Peter Porter, Oxford: Oxford University Press, 1999, p. 144.

4 Peter Brown, *The Cult of the Saints: Its Rise and Function in Latin Christianity*, Chicago: University of Chicago Press, 1981, pp. 50–1.

5 Gregory the Great, "Letter 13: To Serenus," *Fathers of the Church, Registrum Epistolarum*, Book XI. All translations are mine unless otherwise specified.

6 Joseph F. Chorpenning, "Another Look at Caravaggio's Religion," *Artibus et Historiae*, vol. 8, no. 16 (1987), p. 156.

7 Margaret R. Miles, *Image as Insight: Visual Understanding in Western Christianity and Secular Culture*, Eugene, Or.: Wipf and Stock, 1985, p. 72. See also Kemp, *Behind the Picture*, p. 30.

8 *The Notebooks of Leonardo da Vinci*, trans. and ed. Edward McCurdy, New York: George Braziller, 1958, pp. 852–3.

9 Leon Battista Alberti, *On Painting*, trans. John R. Spencer, New Haven and London: Yale University Press, 1966, p. 64.

10 Paul Ricoeur, *Figuring the Sacred: Religion, Narrative, and Imagination*, trans. David Pellamer, ed. Mark Wallace, Minn.: Fortress Press, 1995, p. 222.

11 Leo Steinberg, *The Sexuality of Christ in Renaissance Art and Modern Oblivion*, Chicago: University of Chicago Press, 1983, p. 12.

12 Thomas Aquinas, *Summa Theologiae*, ed. Timothy McDermott, Allen, Tex.: Christian Classics, 1989, p. 355.

13 Jacobus de Voragine, *The Golden Legend: Readings on the Saints*, trans. William Granger Ryan, Princeton, N.J.: Princeton University Press, 1993, vol. I, pp. 13, 43–5, 55, 250, 368.

14 Marilyn Aronberg Lavin, *The Place of Narrative: Mural Decoration in Italian Churches: 431–1600*, Chicago: University of Chicago Press, 1990, p. 121. Lavin's book is a detailed and illuminating study of sequential patterns of narrative paintings within the architectural and liturgical contexts of the church buildings in which they appear.

15 Gerard Manley Hopkins, "As Kingfishers Catch Fire," *The Poems of Gerard Manley Hopkins*, ed. W. H. Gardner and N. H. MacKenzie, Oxford: Oxford University Press, 1970, p. 90.

16 John Shearman, *Only Connect: Art and the Spectator in the Italian Renaissance*, Princeton, N.J.: Princeton University Press, 1992, pp. 4–5.

17 Jules Lubbock, *Storytelling in Christian Art from Giotto to Donatello*, New Haven and London: Yale University Press, 2006, p. 290.

1 STANDING OF MARY

1 *The Hours of the Divine Office in English and Latin*, 3 vols., Collegeville, Minn.: Liturgical Press, 1963, vol. 1, p. 989 (hereafter, *DO*).

2 Jaroslav Pelikan, *Mary Through the Centuries: Her Place in the History of Culture*, New Haven and London: Yale University Press, 1990, p. 2.

3 Marina Warner, *Alone of All Her Sex: The Myth and the Cult of the Virgin Mary*, New York: Alfred A. Knopf, 1976, p. 338.

4 *Decrees of the Ecumenical Councils*, 2 vols., ed. N. P. Tanner, Washington, D.C.: Georgetown University Press, 1990.

5 Pelikan, *Mary*, p. 57.

6 Albertus Magnus, *Opera Omnia*, 38 vols, ed. Auguste and Emil Borgnet, Paris, 1880–99, xx.

7 Thomas Aquinas, *Summa Theolgiae*, ed. Timothy McDermott, Allen, Tex.: Christian Classics, 1989, ch. xiv, p. 514. See also Sarah Jane Boss, "The Development of the Doctrine of the Immaculate Conception," in *Mary: The Complete Resource*, ed. Sarah Jane Boss, Oxford University Press, 2007, pp. 210–24.

8 Robert Orsi, "The Many Names of the Mother of God," *Divine Mirrors: The Virgin Mary in the Visual Arts*, ed. Melissa Katz, New York: Oxford University Press, 2001, pp. 3–4. See also Margaret R. Miles, *Image as Insight: Visual Understanding in Western Christianity and Secular Culture*, Eugene, Or.: Wipf and Stock, 1985, pp. 75–81.

9 Warner, *Alone of All Her Sex*, p. 330.

10 *Ecumenical Councils*, Trent, Canon xxiii, Justification Canons, Sixth Session.

11 Heinrich Denzinger, *The Church Teaches: Documents of the Church in English*, St. Louis, Mo.: B. Herder Book Co., 1955, p. 1073.

12 *L'Osservatore Romano*, Eng. edn, January 23, 2002, p. 5.

13 Gerard Manley Hopkins, "The Blessed Virgin Compared to the Air We Breathe," *The Poems of Gerard Manley Hopkins*, ed. W. H. Gardner and N. H. MacKenzie, New York: Oxford University Press, 1967, p. 93.

14 James Joyce, *A Portrait of the Artist as a Young Man*, New York: Penguin, 1992, p. 43.

15 For a discussion of images of Mary elevated into the heavens, see Rosemary Muir Wright, *Sacred Distance: Representing the Virgin*, Manchester University Press, 2006.

16 Jacobus de Voragine, *The Golden Legend: Readings on the Saints*, trans. William Granger Ryan, Princeton: N.J.: Princeton University Press, 1993, vol. ii, p. 149 (hereafter *GL*).

17 David Rosand, "Titian's Presentation of the Virgin in the Temple and the Scuola della Carità," *The Art Bulletin*, vol. 58, no. 1 (March 1976), pp. 63–7.

18 This hymn, well known by the end of the fourteenth century, was based on Luke 2 : 35 in which Simeon predicts that Mary's heart will be pierced with a sword. It is traditionally attributed to Jacopone da Todi (1230–1306), though it has also been ascribed to Saint Bonaventure and Pope Innocent iii, among others. It became extremely popular in Franciscan houses and churches but was not introduced into the Roman breviary until 1727.

19 For a discussion of this controversy, see Harvey E. Hemburgh, "The Problem of Lo Spasimo of the Virgin in Cinquecento Paintings of the Descent from the Cross," *Sixteenth Century Journal*, vol. 2, no. 4 (Winter 1981), pp. 45–75. See also Amy Neff, "The Pain of Compassio: Mary's Labor at the Foot of the Cross," *The Art Bulletin*, vol. 80, no. 2 (June 1998), pp. 254–73, in which Mary's collapse is compared to that of a woman giving birth.

20 See Elisabetta Marchetti Letta, *Pontormo / Rosso Fiorentino*, Milan: Scala, 1994, pp. 46–8.

21 Salvatore S. Nigro, *Pontormo*, Milan: Fabbri Editori, 1994, pp. 42–3. See also Luciano Berti, *Pontormo e il suo tempo*, Florence: Banca Toscana, 1993.

22 The *Salve Regina* has been traced back to the tenth century; some versions of it may have existed earlier. Authorship is uncertain but claims have been made for Hermann Contractus and Petrus of Monsoro, Bishop of Compostella. It was introduced into the monastic liturgy at Citeaux in the twelfth century and included in the singing of Compline by the Dominicans in the thirteenth century. It is still sung in monasteries at Compline from Trinity Sunday until the Saturday before Advent. (This is the standard English translation.)

23 Warner, *Alone of All Her Sex*, p. xxi.

24 The *Akathistos* takes its inspiration from scripture

and from the Councils of Nicea, Ephesus, and Chalcedon. It is sung in the Eastern liturgy on the Fifth Saturday of Lent and has recently been sung in some Latin Rite congregations. See "Veneration of the Holy Mother of God," *Directory on Popular Piety and Liturgy: Principles and Guidelines*, Vatican City, Rome, 2001, ch. 5.

25 Louise Marshall, "Manipulating the Sacred: Image and Plague in Renaissance Italy," *Renaissance Quarterly*, vol. 47, no. 3 (Autumn 1994), pp. 506–10.

26 Dante Alighieri, *Paradiso, La Comedia Divina*, 3 vols., trans. Allen Mandlebaum, Berkeley: University of California Press, 1982, vol. 1. (Citations in the text indicate canto and line numbers.)

27 Timothy Verdon, *Mary in Western Art*, New York: Hudson Hills Press, 2005, p. 49.

28 Maurizio Calvesi, *Piero della Francesca*, New York: Rizzoli, 1998, p. 32.

29 Melissa Katz, "Regarding Mary: Women's Lives Reflected in the Virgin's Image," in *Divine Mirrors*, p. 51.

30 Jorie Graham, "San Sepolcro," *The Dream of the Unified Field: Selected Poems 1974–1994*, Hopewell, N.J.: Ecco Press, 1995, pp. 21–2.

31 Verdon, *Mary*, p. 115.

32 Michael Baxandall, *Painting and Experience in Fifteenth Century Italy*, Oxford and New York: Oxford University Press, 1972, p. 87.

33 Calvesi, *Piero*, pp. 162–3.

34 Simone de Beauvoir, *The Second Sex*, trans. H. M. Parshley, New York: Alfred A. Knopf, 1971, p. 71.

35 Warner, *Alone of All Her Sex*, p. 35.

36 See Eberhard König, *Michelangelo Merisi da Caravaggio, 1571–1610*, Cologne: Koneman, 1997, pp. 118–19. See also Giorgio Bonsanti, *Caravaggio*, Florence: Scala, 1984.

37 Joseph F. Chorpenning, "Another Look at Caravaggio and Religion," *Artibus et Historiae*, vol. 8, no. 16 (1987), p. 150.

38 Nathaniel Hawthorne, *The Marble Faun*, New York: Viking Penguin, 1990, p. 348.

39 Maurice Vloberg, "The Iconographic Types of the Virgin in Western Art," in *Mary: The Complete Resource*, ed. Sarah Jane Boss, Oxford: Oxford University Press, 2007, p. 562.

40 For a discussion of Jerome's *Against Helvidius*, see J. N. D. Kelly, *Jerome: His Life, Writings, and Controversies*, London: Duckworth, 1975, pp. 105–6.

2 SAINT FOR ALL SEASONS

1 Oscar Wilde, *Salome: A Tragedy in One Act*, trans. from the French by Lord Alfred Douglas, New York: Dover Publications, 1967, p. 6 (hereafter, *S*).

2 W. Barnes Tatum, *John the Baptist and Jesus: A Report of the Jesus Seminar*, Sonoma, Cal.: Polebridge Press, 1994, p. 19.

3 Joan E. Taylor, *The Immerser: John the Baptist within Second Temple Judaism*, Grand Rapids, Mich.: William B. Eerdmans Press, 1997, p. 317.

4 Rona Goffen, *Renaissance Rivals: Michelangelo, Raphael, Leonardo, Titian*, New Haven and London: Yale University Press, 2002, p. 325.

5 For an analysis of the symbolism of Piero's *Baptism*, see Martin Kemp, *Behind the Picture: Art and Evidence in the Italian Renaissance*, New Haven and London: Yale University Press, 1997, pp. 168–77.

6 Albert Camus, *The Fall*, trans. Justin O'Brien, New York: Alfred A. Knopf, 1956, p. 147 (hereafter, *F*).

7 Taylor, *Immerser*, p. 7.

8 Saint Ambrose, "A Homily on the Birth of John the Baptist," *The Hours of the Divine Office in English and Latin*, Collegeville, Minn.: The Order of St. Benedict, 1964, vol. II, pp. 1891–3.

9 M. A. Lavin, "Giovanni Battista: A Study in Renaissance Religious Symbolism," *The Art Bulletin*, vol. 37, no. 2 (January 1955), pp. 85–101.

10 For an analysis of this painting, see Joanne Snow-Smith, "Leonardo's 'Virgin of the Rocks' (Musée du Louvre): A Franciscan Interpretation," *Studies in Iconography*, vol. 11 (1987), pp. 35–94; Pietro C. Marani, *Leonardo: Una Carriere di Pittore*, Milan: Federico Motta Editore, 1999, pp. 120–55; and Serge Bramly, *Leonardo: The Artist and the Man*, trans. Sian Reynolds, London: Harper Collins, 1991, pp. 184–90. See also *Leonardo da Vinci, Michelangelo, and the Renaissance in Florence*, ed. David Franklin, National Gallery of Canada, Ottawa, in association with Yale University Press, New Haven and London: 2005, esp. the essay by Louis Waldman, "'Ingenious and Subtle Spirits:' Florentine Painting in the First Half of the Sixteenth Century," pp. 30–45.

11 See M. A. Lavin, "Giovanni Battista: A Supplement," *The Art Bulletin*, vol. 43, no. 4 (December 1961), pp. 319–26.

12 For extended discussions of possible meanings of and models for this painting, see Avigdon W. G. Poseq, "Caravaggio and the Antique," *Artibus et Historiae*, vol. 11, no. 21

(1990), pp. 147–67, and Creighton E. Gilbert, *Caravaggio and His Two Cardinals*, University Park: Pennsylvania State University Press, 1995, pp. 1–23. See also Eberhard König, *Michelangelo Merisi da Caravaggio, 1571–1610*, Cologne: Konemann, 1997, pp. 41–9.

13 Taylor, *Immerser*, p. 7.

14 Jacobus de Voragine, *The Golden Legend: Readings on the Saints*, trans. William Granger Ryan, Princeton, N.J.: Princeton University Press, 1993, vol. 1, p. 336.

15 Tatum, *John the Baptist*, p. 102.

16 See John Shearman, *Mannerism*, Harmondsworth: Penguin, 1967, pp. 162–9.

17 See Michael Douglas Scott, "Pordenone's Altarpiece of the Beato Giustiniani for the Madonna del'Orto," *The Burlington Magazine*, vol. 130, no. 1026 (September 1988), pp. 672–9. Scott points out that Pordenone had been to Rome and must have seen Michelangelo's "titanic" Jesus in Santa Maria sopra Minerva. See also Caterina Furlan, *Il Pordenone*, Milan: Electa, 1988.

18 Goffen, *Renaissance Rivals*, pp. 168–70.

19 Shearman, *Mannerism*, p. 226; Paul Barolsky, "The Mysterious Meaning of Leonardo's Saint John the Baptist," *Source: Notes on the History of Art*, vol. 8, no. 3 (Spring 1989), pp. 11–15.

20 Walter Pater, "Leonardo da Vinci," *The Renaissance*, Chicago: Academy, 1977, p. 118.

21 Bramly, *Leonardo*, p. 396.

22 See *Botticelli: From Lorenzo the Magnificent to Savonarola*, exh. cat., Milan: Skira, 2003, esp. the discussion by Daniel Aresse, pp. 204–6.

23 See Catherine M. Murphy, *John the Baptist: Prophet of Purity for a New Age*, Collegeville, Minn.: Liturgical Press, 2003, pp. 57 and 84.

24 Taylor, *Immerser*, p. 322.

25 Julian Kliemann and Michael Rohlmann, *Italian Frescoes: High Renaissance and Mannerism*, New York: Abbeville Press, 2004, p. 78.

3 RECOVERING MARY MAGDALENE

1 Henry James, "Venice," *Italian Hours*, ed. John Auchard, University Park: Pennsylvania State University Press, 1992, p. 7.

2 Sarah Wilk, "The Cult of Mary Magdalene in Fifteenth Century Florence and Its Iconography," *Studi Medievali*, serie terza, vol. 2, 1955, p. 685.

3 See Esther de Boer, *The Gospel of Mary: Beyond a Gnostic and a Biblical Mary Magdalene*, London: Continuum, 2004, pp. 172–3.

4 *Esposizione del Vangelo Seconda Luca*, in *Opera Omnia di San Ambrogio*, vol. 2, ed. Giovanni Copa, Rome: Biblioteca Ambrosiana, Citta Nuova Editrice, 1978, pp. 510–13 (hereafter, *San Ambrogio*).

5 St. Leo the Great, "Sermon 71," *Sermons: The Fathers of the Church*, trans. J. P. Freeland csjb and A. J. Conway ssj, Washington, D.C.: Catholic University of America Press, 1996, pp. 312–13.

6 Thomas Aquinas, *Summa Theologiae*, ed. Timothy McDermott, Allen, Tex.: Christian Classics, 1991, p. 450.

7 See references in Katherine Ludwig Jensen, *The Making of the Magdalene: Preaching and Popular Devotion in the Later Middle Ages*, Princeton, N.J.: Princeton University Press, 2000, pp. 54–60.

8 Gregory the Great, "Homily 33," *Patrologiae cursus completes*, ed. J. P. Migne, Series Latina, lxxvi, col. 1180.

9 Susan Haskins, *Mary Magdalen: Myth and Metaphor*, New York: Riverhead Press, 1993, p. 227.

10 "Mary Magdalene," *The Digby Plays, with an Incomplete Morality of Wisdom, Who is Christ*, ed. F. J. Furnivall, London: Elibron Classics, 2006, pp. 95 and 96.

11 Jacques Lefèvre d'Etaples, *De Maria Magdalena*, 2nd edn, Paris: Ex officina Henrici Stephani, 1518, p. 8: "Ex tribus una Maria: intelligere debeamus."

12 *Luther on Women*, ed. S. C. Karant-Nunn and M. E. Wiesner-Hanks, Cambridge: Cambridge University Press, 2003, p. 84 (hereafter, *LW*).

13 Ignatius of Loyola, *Spiritual Exercises*, trans. Louis J. Puhl, s.j., Chicago: Loyola University Press, 1951, p. 132.

14 John Calvin, *Commentaries*, ed. and trans. Joseph Haroutunian, London: Library of Christian Classics, Westminster Press, 1958, pp. 168–9.

15 Christine de Pisan, *The Book of the City of Ladies*, trans. Earl J. Richards, New York: Persea Books, 1982, p. 27 (hereafter, *Pisan*).

16 William Hood, *Fra Angelico at San Marco*, New Haven and London: Yale University Press, 1993, pp. 240–5.

17 Leo Steinberg, *The Sexuality of Christ in Renaissance Art and Modern Oblivion*, Chicago: University of Chicago Press, 1983. For excellent analyses of this painting, see Charles Hope, *Titian*, London: Chaucer Press, 2003, pp. 20–2, and David Alan Brown and Sylvia Ferino-Pagder, *Bellini, Giorgione, Titian and the Renaissance of Italian Painting*, National Gallery of Art, Washington D.C., Kunsthistorisches

Museum, Vienna, in association with Yale University Press, New Haven and London: 2006, pp. 128–31.

18 I first heard this story from my colleague Elaine Scarry. It is also recalled in the introduction to *Mariam, the Magdalen, and the Mother*, ed. Deirdre Good, Bloomington: Indiana University Press, 2005, p. vii.

19 See Maurice Block, *Bronzino*, trans. D. P. Poole and C. Schultz-Touge, Paris: Flammarion, 2002, pp. 294–302.

20 Elizabeth Pilliod, "Le Noli me tangere du Bronzino (1503–1572) et la Décoration de la Chapelle Cavalcanti de l'Eglise Santo Spirito, Florence," *Revue du Louvre*, vol. 5, no. 6 (1991), p. 58.

21 See Deborah Parker, *Bronzino: Renaissance Painter as Poet*, Cambridge: Cambridge University Press, 2000, esp. pp. 166–7.

22 Caroline Murphy, *Lavinia Fontana*, New Haven and London: Yale University Press, 2003, p. 34.

23 John Ruskin, *Modern Painters*, vol. 2, in *The Works of John Ruskin*, ed. E. T. Cook and Alexander Wedderburn, London: G. Allen, 1903–12, v, pp. 195, 295–6.

24 Bernard Aikema, "Titian's Mary Magdalene in the Pitti Palace: An Ambiguous Painting and its Critics," *Journal of the Warburg and Courtauld Institutes*, vol. 57 (1994), pp. 53–4.

25 Rona Goffen, *Titian's Women*, New Haven and London: Yale University Press, 1997, p. 186.

26 Marilina Mosco, *La Maddelena tra Sacro e Profano*, Florence: La Casa Usher, 1986, pp. 192–4.

27 I owe this wonderful quote to Susan Haskins (p. 256), who discusses the Titian painting at length and with balance in her *Mary Magdalen*, pp. 234–41.

28 M. L. Dunkelman, "Donatello's Mary Magdalene: A Model of Courage and Survival," *Woman's Art Journal*, vol. 26, no. 2 (Autumn 2005/Winter 2006), pp. 10–13.

29 *San Ambrogio*, pp. 505–9.

30 Marvin Meyer, with Esther de Boer, *The Gospels of Mary: The Secret Traditions of Magdalene, the Companion of Jesus*, San Francisco: Harper Collins, 2004, p. 20.

31 "Magdalene," *Digby Plays*, pp. 105–6.

32 *Calendarium Romanum Generale*, 1969, 97, 98, p. 131, quoted in de Boer, *Gospel of Mary: Beyond a Gnostic*, p. 4.

33 Philippe de Grève, *De Sancta Maria Magdalena: Ad Laudes, Analecta Hymnica, Medii Aevi*, ed. Clemens Blume and Guido Dreves, Leipzig: 1907, p. 534.

34 Maurizio Calvesi, *Piero della Francesca*, New York: Rizzoli, 1998, pp. 160–1.

35 Mosco, *La Maddalena*, p. 67.

36 Haskins, *Mary Magdalen*, pp. 41 and 247.

37 *The Poems of John Donne*, vol. 1, ed. E. K. Chambers, London: Lawrence and Bullen, 1896, p. 156.

38 Henry James, "Venice," *Italian Hours*, p. 28. See also *Sebastiano del Piombo*, Rome: Federico Motta Editore, 2008, pp. 106–9.

39 D. H. Lawrence, *The Man Who Died*, New York: Random House, 1953, p. 176.

4 MANLINESS AND SAINTLINESS

1 Friedrich Nietzsche, *The Will to Power*, trans. Walter Kaufmann and R. J. Hollingdale, New York: Random House, 1967, p. 123 (hereafter, *WP*).

2 Algernon Charles Swinburne, "Hymn to Proserpine," *Poetry of the Victorian Period*, ed. George Benjamin Wood and Jerome Hamilton Buckley, New York: Scott, Foresman, 1955, p. 677.

3 Harvey Mansfield, *Manliness*, New Haven and London: Yale University Press, 2006, pp. x, 230, 235.

4 Margaret Walters, *The Nude Male: A New Perspective*, New York: Penguin, 1978, p. 10.

5 Jacobus de Voragine, *The Golden Legend*, vol. 1, trans. William Granger Ryan, Princeton, N.J.: Princeton University Press, 1993, p. 243.

6 Hippolyte Taine, *Italy: Florence and Venice*, New York: Holt and Williams, 1873, p. 314 (hereafter, Taine).

7 See Tom Nichols, *Tintoretto: Tradition and Identity*, London: Reaktion Books, 1999, pp. 58–9 and 29, 37, 67, 84. See also Teresio Pignatti and Francesco Valcanover, *Tintoretto*, Milan: Garzanti, 1985.

8 See C. Clifton Black, *Mark: Images of an Apostolic Interpreter*, Columbia, S.C.: University of South Carolina Press, 1994, and Thomas E. A. Dale, "Inventing a Sacred Past: Pictorial Narratives of St. Mark the Evangelist in Aquilea and Venice, circa 1000–1300," *Dumbarton Oaks Papers*, vol. 48 (1994), pp. 53–104.

9 Peter Brown, *The Cult of Saints: Its Rise and Function in Latin Christianity*, Chicago: University of Chicago Press, 1981, p. 11.

10 Giuseppe Pavanello, *San Marco: Nella Legenda e Nella Storia*, extract from *Revista della Città di Venezia*, Venice: Agoston, 1928 (A.VI), p. 306.

11 Roberto Cessi, *Venezia Ducale: Le Origini*, 2 vols, Padua: Draghi, 1928, vol. 1, p. 158.

12 Pavanello, *San Marco*, p. 318.

13 Roland Krischel, *Tintoretto, 1519–1594*, Cologne: Koneman, 2000, p. 70.

14 Nichols, *Tintoretto*, pp. 95–6.

15 Krischel, *Tintoretto*, p. 90.

16 Richard Kaye, "Losing His Religion: St. Sebastian as Contemporary Gay Martyr," *Outlooks: Lesbian and Gay Sexualities in Visual Cultures*, ed. Peter Horne and Reina Lewis, New York: Routledge, 1996, pp. 86–7.

17 Donald L. Boisvert, *Sanctity and Male Desire: A Gay Reading of Saints*, Cleveland, OH: Pilgrim Press, 2004, p. 43.

18 See Sheila Barker, "The Making of a Plague Saint: St. Sebastian's Imagery and Cult Before the Counter-Reformation," in *Of Piety and Plague: From Byzantium to the Baroque*, ed. Franco Mormando and Thomas Worcester, *Sixteenth Century Essays and Studies*, 78, Kirksville, Mo.: Truman State Press, 2007, pp. 90–131. For an analysis of early images of Sebastian, see also Diana Norman, "Art and Religion after the Black Death," *Siena, Florence and Padua*, vol. 1, ed. Diana Norman, New Haven and London: Yale University Press, 1995, pp. 187–95.

19 Louise Marshall, "Reading the Body of a Plague Saint: Narrative Altarpieces and Devotional Images of St. Sebastian in Renaissance Art," *Reading Texts and Images: Essays in Medieval and Renaissance Art and Patronage in Honor of Margaret M. Manion*, Exeter: University of Exeter Press, 2002, p. 240.

20 Giorgio Vasari, *Artists of the Renaissance*, trans. George Bull, New York: Viking, 1978, pp. 68–72, 233, 238.

21 Pico della Mirandola, *On the Dignity of Man*, trans. C. G. Wallis, P. J. W. Miller, and D. Carmichael, Indianapolis: Hackett Doubleday Co., 1965.

22 Leo Steinberg, *The Sexuality of Christ in Renaissance Art and Modern Oblivion*, Chicago: University of Chicago Press, 1983, pp. 6 and 12.

23 See Carlo Ginzburg, *The Enigma of Piero: Piero della Francesca*, trans. Martin Ryle and Kate Soper, London: Verso, 1985, and Maurizio Calvesi, *Piero della Francesca*, New York: Rizzoli, 1998, pp. 152–5.

24 It has been suggested that Antonello da Messina may have seen Piero's *Flagellation* when passing through Urbino on his way back to Sicily in 1476; see Gioacchino Barbera, *Antonello da Messina: Sicily's Renaissance Master*, New York: Metropolitian Museum of Art, and New Haven and London: Yale University Press, 2005, pp. 25–8.

25 Marshall, "Reading the Body," p. 260.

26 See Louise Marshall, "Manipulating the Sacred: Image and Plague in Renaissance Italy," *Renaissance Quarterly*, vol. 47, no. 3, Autumn 1994, pp. 485–532.

27 Bernard Berenson, *Italian Painters of the Renaissance*, Garden City, N.J.: Phaidon Publishers, 1954, p. 8.

28 John O. Malley, s.j., "Postscript," in Steinberg, *Sexuality of Christ*, pp. 213–14.

29 Ibid., p. 24.

30 Barker, "Making of a Plague Saint," p. 115. See also Charles Hope, *Titian*, London: Chaucer Press, 2003, pp. 56–8.

31 Robert E. Goss, *Queering Christ: Beyond Jesus Acted Up*, Cleveland, OH: Pilgrim Press, 2002, p. 10.

32 Benvenuto Cellini, *Autobiography*, trans. George Bull, New York: Penguin, 1956, p. 223.

33 William Caxton, *The Golden Legend*, vol. v, London: Temple Classics and F. S. Ellis, 1922, p. 6. The Caxton translation is quoted here because of the earthiness of the phrasing.

34 See Paolo Goi, "Di Rocco (e di Compagno Sebastiano): Una Lettura Iconografica dal Friule," *San Rocco: Genesi Prima e Espansione di un Culto*, curated by Antonio Rigon and André Vauchez, Brussels: Société Bollandistes, 2006, pp. 269–83. See also Caterina Furlan, *Il Pordenone*, Milan: Electa, 1988.

35 Rona Goffen, "*Nostra Conversatio in Caelis Est*: Observations on the *Sacra Conversazione* in the Trecento," *The Art Bulletin*, vol. 61, no. 2 (June 1979), p. 199.

36 Eve Kosofsky Sedgwick, *Between Men: English Literature and Male Homosocial Desire*, New York: Columbia University Press, 1985.

37 Baldassare Castiglione, *The Courtier*, trans. Thomas Hoby, London: J. M. Dent, pp. 98, 33, 38–9.

38 For an excellent analysis of this painting, see Hope, *Titian*, pp. 30–2.

5 PEARLS OF SAINT LAWRENCE

1 Edith Wharton, *False Dawn, Old New York*, New York: Simon and Schuster, 1995, p. 43.

2 Ibid., p. 56.

3 "All the great arts have for their object either the support or exaltation of human life – usually both," John Ruskin, *Lectures on Art: 1870*, New York: Allworth Press, 1996, p. 81. Among the many studies of Ruskin's life in relation to his work, see esp. Joan Apse, *John Ruskin: The Passionate Moralist*, New York: Alfred Knopf, 1980; John Batchelor, *John Ruskin: No Wealth But Life*, London: Sinclair-Stevenson, 2000; Wolfgang Kemp, *The Desire of My Eyes: The*

Life and Work of John Ruskin, New York: Farrar, Straus and Giroux, 1990; and the most detailed and balanced 2-vol. biography by Tim Hilton, *John Ruskin: The Early Years* (1985) and *John Ruskin: The Later Years* (2000), New Haven and London: Yale University Press.

4 John Ruskin, *Modern Painters*, Boston: Dana Estes and Company, 1873, II, iv, 256 (henceforth, *MP*).

5 Peter Quennell, *John Ruskin: The Portrait of a Prophet*, New York: Viking Press, 1949, pp. 29–30.

6 John Ruskin, *The Eagle's Nest: Ten Lectures on the Relation of Natural Science to Art* (1872), in *The Works of John Ruskin*, ed. E. T. Cook and Alexander Wedderburn, London: G. Allen, 1903–1912, XXII, 237 (henceforth, *Works*).

7 John Ruskin, *The Stones of Venice*, in *Works*, X, p. 129. (hereafter, *SV*).

8 For details on Ruskin's affection for Saint Francis, see correspondence from June 1874 in *The Letters of John Ruskin, 1870–1889*, in *Works*, XXXVII. Sleeping and working in a sacristan's cell in the monastery attached to San Francesco in Assisi, Ruskin developed an interest in the saint beyond the aesthetic. In a letter of June 19, 1874, he refers affectionately to the saint's tomb as "St. Francis lying within thirty yards of me" (p. 112). According to a note in vol. XXIII, p. xlvii of *Works*, Ruskin is reported to have said that if he ever became a Roman Catholic, he would like to be a Third Order Franciscan. For further commentary on this subject see also *Fors Clavigera*, 1878, in *Works*, XXIX, letters 41 and 46.

9 *Mornings in Florence*, in *Works*, XXIII, p. 341 (henceforth, *MF*).

10 For further discussion of Ruskin's aesthetic theories, see Roger B. Stein, *John Ruskin and Aesthetic Thought in America, 1840–1900*, Cambridge, Mass.: Harvard University Press, 1967; Robert Hewison, *John Ruskin: The Argument of the Eye*, Princeton, N.J.: Princeton University Press, 1976; Susan P. Casteras, *John Ruskin and the Victorian Eye*, New York: Harry N. Abrams, 1993.

11 John Ruskin, *Aesthetic and Mathematic Schools of Art in Florence*, in *Works*, XXIII, p. 261 (henceforth, *AMS*).

12 John Pope-Hennessy, *Angelico*, Florence: Scala, 1974, p. 47. Pope-Hennessy's only mention of Saint Lawrence is of a figure "on the left . . . with hand raised in wonder."

13 Creighton Gilbert, "Peintres et Menusiers au debut de la Renaissance en Italie," *Revue de l'Art*, vol. 37 (1977), p. 25. See also Rona Goffen, "*Nostra Conversatio in Caelis Est*: Observations on the *Sacra Conversazione* in the Trecento," *The Art Bulletin*, vol. 61, no. 2 (June 1979), p. 219.

14 William Hood, *Fra Angelico at San Marco*, New Haven and London: Yale University Press, 1993, pp. 112–21. Like Ruskin, Hood reflects on the extraordinary effect of the painting on the viewer, especially the viewer of the fifteenth century: "Looking at the painting in 1443 must have been rather like seeing a vision. Consider, for example, the figure of St. Lawrence . . . The decorations of [his] jewel-laden vestment bewitch the eye." Furthermore, despite age and poor restorations, Hood finds a "still-moving pathos" in Saint Lawrence's face.

15 The Gospel text shown in the painting in the Bible held by the bearded figure of Saint Mark is Mark 6 : 2–8: "Where did this wisdom come from? Isn't he the carpenter, son of Mary?" See Stefano Orlandi, O.P., *Beato Angelico*, Florence: Leo S. Olschki, 1964, p. 73.

16 *DO*, III, "Feast of Saint Lawrence, August 10," 1426.

17 Jacobus de Voragine, *The Golden Legend: Readings on the Saints*, trans. William Granger Ryan, Princeton, N.J.: Princeton University Press, 1993, vol. II, p. 73.

18 Walter Benjamin, *The Origin of German Tragic Drama*, trans. John Osborne, London: Verso, 1977, pp. 28–9.

6 IMAGINING AUGUSTINE IMAGINING

1 Saint Augustine, *Confessions*, ed. R. S. Pine-Coffin, New York: Penguin, 1961, VIII, 12 (hereafter, *Conf*).

2 See James J. O'Donnell, *Augustine: A New Biography*, New York: Harper Collins, 2005, pp. 73–7. For a more balanced view of the episode, see Peter Brown, *Augustine of Hippo*, Berkeley: University of California Press, 1967, pp. 106–9.

3 For extensive discussions of Benozzo's work in San Gimignano, see Diane Cole Ahl, *Benozzo Gozzoli*, New Haven and London: Yale University Press, 1996, pp. 121–55, and Steffi Roetgen, *Italian Frescoes: The Early Renaissance, 1400–1470*, New York: Abbeville Press, 1996, pp. 374–95.

4 Cole Ahl, *Benozzo Gozzoli*, p. 138.

5 Augustine, "The Soliloquies," *Augustine: Earlier Writings*, ed. and trans. J. H. S. Burleigh, Philadelphia: Westminster Press, 1953, p. 36 (hereafter, *Sol*).

6 Augustine, "Of True Religion," *Earlier Writings*, pp. 257–8.

7 Augustine employs a variety of words to indicate the sources and functions of human thought, emotion, and belief. Although none has a precise modern equivalent, the most commonly accepted translations are as follows: *mens*,

mind; *animus*, consciousness; *anima*, soul; *imaginarium*, imagination. For a helpful analysis of Augustine's vocabulary of mental function and structure, see the foreword to Books IX–XIV of *The Trinity* by Edmund Hill, O.P., *The Works of Saint Augustine*, vol. 5, trans. Edmund Hill, O.P., ed. John E. Rotelle OSA, Brooklyn, N.Y.: New City Press, 1991, pp. 258–69.

8 O'Donnell, *Augustine*, pp. 47 and 5.

9 Diane Cole Ahl, "Benozzo Gozzoli's Frescoes of the Life of Saint Augustine in San Gimignano: Their Meaning in Context," *Artibus et Historiae*, vol. 7, no. 13 (1986), pp. 35–53.

10 O'Donnell, *Augustine*, pp. 5 and 47.

11 Saint Augustine, *The Trinity*, in *Works of Saint Augustine*, vol. 5, p. 303.

12 Brown, *Augustine*, pp. 415–18.

13 See e.g. the argument in Charles Freeman, *The Closing of the Western Mind: The Rise of Faith and the Fall of Reason*, New York: Alfred A. Knopf, 2004.

14 Saint Augustine, *Concerning The City of God Against the Pagans*, trans. Henry Bettenson, intro. John O'Meara, London: Penguin, 1972, Book XXII, viii, p. 1035. (I have chosen this edition for the particular excellence of the translation; hereafter, *CG*).

15 Saint Augustine, *The Enchiridion on Faith, Hope, and Love*, trans. J. B. Shaw, intro. Thomas Hibbs, Washington, D.C.: Regnery Publishing, 1961, p. 103 (hereafter, *E*).

16 Saint Augustine, "Faith and Creed," *Earlier Writings*, p. 360 (hereafter, *FC*).

17 Cole Ahl, *Benozzo Gozzoli*, pp. 144–5.

18 Millard Meiss notes this dialogue in *The Great Age of Fresco: Discoveries, Recoveries, and Survivals*, New York: George Braziller in association with the Metropolitan Museum of Art, 1970, p. 170. Martin Kemp thinks Martino might refer to a church that had been destroyed outside the Prato Gate, in "The Taking and Use of Evidence: With a Botticellian Case Study," *Art Journal*, vol. 44, no. 3 (Autumn 1984), pp. 207–15. Ronald Lightbown suggests the monkish dialogue in *Sandro Botticelli: Life and Work*, New York: Abbeville Press, 1989, pp. 73–80.

19 Helen I. Roberts, "Saint Augustine in 'Saint Jerome's Study': Carpaccio's Painting and Its Legendary Source," *The Art Bulletin*, vol. 41, no. 4 (December 1959), p. 293.

20 Richard Stemp, *The Secret Language of the Renaissance: Decoding the Hidden Symbolism of Italian Art*, London: Duncan Baird, 2006, pp. 172–3.

21 Peter Brown, *The Body and Society: Men, Women, and Sexual Renunciation in Early Christianity*, New York: Columbia University Press, 1988, pp. 400–1.

7 SODOMA'S SAINT BENEDICT

1 Bernardo Tolomei and his two companions left Siena for Le Crete in 1313. At first they lived in caves as hermits, but they were eventually joined by others and were asked by the local bishop to conform to the Rule of Saint Benedict. The first charter establishing the Olivetan branch of the order was signed on March 26, 1319. See *Monte Oliveto Maggiore*, L'Abbazia di Monte Oliveto Maggiore, Florence: Scala, 1991, pp. 2–3.

2 See Antonio Paolucci, *Lucca Signorelli*, Florence, Scala, 1990, pp. 34–43.

3 Giorgio Vasari, *LeVite de' Piu Eccellenti Pittori et Architettori*, vol. 3, ed. Pio Pecchiai, Milan: Casa Editrice Sonzogno, 1930, p. 50.

4 Robert H. Hobart Cust, *Giovanni Antonio Bazzi: Hitherto Usually Styled as 'Sodoma,' 1477–1549*, New York: E. P. Dutton and Co., 1906, pp. 12 and 21.

5 See e.g. Enzo Carli, *Le Storie di San Benedetto a Monte Oliveto Maggiore*, Milan: Silvano, 1980.

6 *Saint Benedict's Rule for Monasteries*, trans. Leonard J. Doyle, Collegeville, Minn.: Liturgical Press, Saint John's Abbey, 1948, ch. 53, p. 72 (hereafter, *Rule*).

7 See Latin and French texts, Grégoire le Grand, *Dialogues*, vol. 2, trans. Paul Antin, ed. Adalbert de Vogue, Paris: Les Editions du Cerf, 1979, p. 139 (hereafter, *D*); English text, Gregory the Great, *The Life of Saint Benedict*, trans. Hilary Costello and Eoin Bhaldraithe, Petersham, Mass.: Saint Bede's Publications, 1993, pp. 1–2 (hereafter, *LSB*); Italian text, S. Gregorio Magno, *S. Benedetto da Norcia*, ed. PP. Benedettini di Subiaco, Rome: Edizione Tipografia Editrice S. Scolastica, De Cristofaro Editore, 1964.

8 Sodoma actually began painting the cycle with a later episode in which Benedict's young monks are tempted by *male femine*, "depraved women." See Steffi Roettgen, *Italian Frescoes: The Flowering of the Renaissance: 1470–1510*, Abbeville, New York: Abbeville Press, 1997, pp. 350–83.

9 *Monte Oliveto Maggiore*, p. 24.

10 Ibid. p. 38.

11 See Roberto Bartalini, *Le Occasioni del Sodoma: Della Milano di Leonardo alla Roma di Raffaelo*, Rome: Donizelli, 1996.

12 For a discussion of the possible influences of Pinturicchio, Perugino, and Leonardo da Vinci on Sodoma, see Andrée Hayum, *Giovanni Antonio Bazzi: 'Il Sodoma,'* New York: Garland Publishing, 1976, pp. 12–16.

8 HOLY STIGMATA OF SAINT FRANCIS

1 Bonaventure: The Soul's Journey into God; The Tree of Life; The Life of Saint Francis, trans. Ewert Cousins, Mahwah, N.J.: Paulist Press, 1978, p. 307 (hereafter, *Bon*).

2 *The Little Flowers of Saint Francis*, trans. Raphael Brown, New York: Doubleday Image, 1958, p. 192 (hereafter, *LF*).

3 See Julian Gardner, "The Louvre Stigmatization and the Problem of the Narrative Altarpiece," *Zeitschrift für Kunstgeschichte*, vol. 45, no. 3 (1982), p. 221. Gardner notes that Christ's Stigmata are mentioned once in Galatians and that when an English peasant inflicted the wounds on himself, he was condemned and imprisoned for life.

4 In addition to Brother Leo's testimony as reported by Celano, Bonaventura, and Ugolino, Leo's reminiscences were collected in an early Franciscan document entitled *Speculum perfectionis*. It was first published in 1898 by Paul Sabatier as *Legenda Antiquissima San Francisci*, claiming that Brother Leo wrote the original in 1227. Many scholars think it is of a later date and written by several Franciscans.

5 Discussions of Franciscan frescos by Giotto and his workshop and followers include Gardner, "Louvre Stigmatization;" Rona Goffen, *Spirituality in Conflict: St. Francis and Giotto's Bardi Chapel*, University Park: Pennsylvania State Press, 1988; Elvio Lunghi, *The Basilica of St. Francis of Assisi*, London: Thames and Hudson, 1996; and Alistair Smart, *The Assisi Problem: The Art of Giotto*, Oxford: Clarendon Press, 1971.

6 See H. W. Van Os, "St. Francis of Assisi as a Second Christ in Early Italian Painting," *Simiolus*, vol. 7, no. 3 (1974), pp. 115–32.

7 See Diane Cole Ahl, *Benozzo Gozzoli*, New Haven and London: Yale University Press, 1996, pp. 41–79, and Steffi Roettgen, *Italian Frescoes: The Early Renaissance 1400–1470*, New York: Abbeville Press, 1996, pp. 286–301.

8 Diane Cole Ahl, "Benozzo Gozzoli's Cycle of the Life of St. Francis in Montefalco: Hagiography and Homily," in *Saints: Studies in Hagiography*, ed. Sandro Sticco, Bingham ton, N.Y.: Medieval and Renaissance Texts and Studies, vol. 14 (1996), p. 199.

9 Ibid., p. 204.

10 *Urbino: A Historical-Artistic Guide*, Milan: Kina Italia, 1998, pp. 113–17.

11 Andrea Emiliani, *Federico Barocci (Urbino 1535–1612)*, Bologna: Nuova Alfa Editoriale, 1985, p. 297.

12 Representations of the Stigmata are a major exception to Rona Goffen's assertion that "depictions of St. Francis . . . remained essentially consistent" for centuries, *Spirituality in Conflict*, p. 22. See, e.g., Cole-Ahl's analysis of the Montefalco Francis cycle, *Benozzo Gozzoli*, p. 58.

13 In 1266 the Franciscan Minister General, with the support of Rome, suppressed all versions of the life of Francis except Bonaventura's. Fortunately, the suppression did not work. Celano's *Vita* and various uncollected, unofficial documents were preserved by the Spirituals. By the fifteenth century, all these texts, as well as *I Fioretti*, were in circulation and available to artists. See Roettgen, *Italian Frescoes*, pp. 288–9.

14 Fra Tomaso da Celano, *Vita di San Francesco (Prima e Seconda)*, trans. Fausta Casolini, Assisi: Santa Maria degli Angeli, 1997, pp. 103–4 (hereafter, *Vita*).

15 *Francis and Clare: The Complete Works*, trans. Regis J. Armstrong OFM CAP and Ignatius Brady OFM, New York: Paulist Press, 1982, pp. 99–100.

16 See Chiara Frugoni, "St. Francis of Assisi: A Saint in Progress," in Sticco, *Saints*, pp. 166–9. See also Goffen, *Spirituality in Conflict*, p. 62.

17 John Moorman, *The History of the Franciscan Order From Its Origin to the Year 1517*, Oxford: Clarendon Press, 1968, pp. 181–9.

18 Ibid., pp. 108–9.

19 Gardner, "Louvre Stigmatization," p. 242.

20 Pamela Askew, "The Angelic Consolation of St. Francis of Assisi in Post-Tridentine Italian Painting," *Journal of the Warburg and Courtauld Institutes*, vol. 32 (1969), pp. 285–7. See also Eberhard König, *Caravaggio, 1571–1610*, Cologne: Koneman, 1997, pp. 41–9.

9 SAINT WHO LOST HER HEAD

1 See an excellent discussion of Catherine as an "apostle of peace" by Karen Scott, "Saint Catherine of Siena, 'Apostola,' " *Church History*, vol. 61, no. 1 (March 1992), pp. 34–46.

2 *The Letters of St. Catherine of Siena*, vol. 1, trans. and intro. by Suzanne Noffke, O.P., Binghamton, N.Y.: Medieval and Renaissance Texts and Studies, 1988, pp. 169, 202, 246, 248 (hereafter, *Letters*). See also collections of Catherine's letters and other writings in Italian: *Caterina da Siena: Passione per la Chiesa, Scritti Scelti*, ed. Giuseppe di Ciaccia, O.P., Rome: Citta Nuova Editrice, 1989; and *Caterina da Siena: La*

Citta Prestata: Consigli ai Politici, ed. Gianfranco Morra, Rome: Citta Nuova Editrice, 1990 (hereafter, Morra).

3 Beato Raimondo da Capua, *Santa Caterina da Siena: Legenda Maior*, Latin trans. into Italian by Giuseppe Tinagli, O.P., Siena: Edizione Cantagalli, 1969, p. 149 (hereafter, *Legenda Maior*).

4 Catherine of Siena, *The Dialogue*, trans. Suzanne Noffke, O.P., New York: Paulist Press, 1980, pp. 233, 248, 262 (hereafter, *Dialogue*).

5 Quoted in Anne Baldwin, *Catherine of Siena: A Biography*, Huntington, Ind.: Our Sunday Visitor, 1987, pp. 153 and 158. See also Giulio Cesare Santucci, *Caterina da Siena*, Padua: Edizione Messaggero, 1987.

6 For a history of Catherine's publications, see Giuliana Cavallini, O.P., *Catherine of Siena*, London: Geoffrey Chapman, 1998, pp. 1–21.

7 Caroline Walker Bynum, "Patterns of Female Piety in the Later Middle Ages," in *Crown and Veil: Female Monasticism from the Fifth to the Fifteenth Centuries*, ed. Jeffrey F. Hamburger and Susan Marti, New York: Columbia University Press, 2008, pp. 176–7.

8 See William Hood, *Fra Angelico at San Marco*, New Haven and London: Yale University Press, 1993, p. 22.

9 Ibid., p. 23.

10 Caroline Walker Bynum, *Holy Feast and Holy Fast: The Religious Significance of Food to Medieval Women*, Berkeley, California: University of California Press, 1987, p. 207.

11 Scott, "Saint Catherine," p. 44.

12 For extensive discussions of Catherine's fasting, see Rudolph M. Bell, *Holy Anorexia*, Chicago: University of Chicago Press, 1985, and Bynum, *Holy Feast*, pp. 171–9, 206–7, 223–4.

13 I owe the discovery of this quote to Caroline Bynum in *Holy Feast*, pp. 175 and 376–7.

14 Thomas J. Heffernan, *Sacred Biography: Saints and Their Biographies in the Middle Ages*, New York: Oxford University Press, 1988, p. 192.

15 For a discussion of bridge imagery in Catherine's writing, see Barbara Pike Gordley, "A Dominican Saint for the Benedictines: Beccafumi's Stigmatization of Saint Catherine," *Zeitschrift für Kunstgeschichte*, vol. 55, no. 3 (1992), pp. 394–412.

16 The reliability of Catherine's account was questioned by Robert Fawtier, *Sainte Catherine de Sienne: Essaie de critiques des sources*, vols 121 and 135, *Bibliothèque des Ecoles françaises d'Athènes et de Rome*, Paris: De Boccard, 1921 and 1930. However, accounts of this and similar executions in

Siena at the time have persuaded most scholars of the accuracy of Catherine's report.

17 See Susan E. Wegner, "Heroizing Saint Catherine: Francesco Vanni's 'Saint Catherine of Siena Liberating a Possessed Woman,' " *Woman's Art Journal*, vol. 19, no. 1 (Spring–Summer 1998), pp. 31–7.

18 Gordley, "Dominican Saint," p. 397.

10 SAINTS FAIR AND FEARSOME

1 See Peter Brown, *The Cult of the Saints: Its Rise and Function in Latin Christianity*, Chicago: University of Chicago Press, 1981, pp. 4–6.

2 Robert L. Mode, "San Bernardino in Glory," *The Art Bulletin*, vol. 55, no. 1 (March 1973), p. 74. For a perceptive and more recent analysis of this painting, see Marilyn Aronberg Lavin, *The Place of Narrative: Mural Decoration in Italian Churches, 431–1600*, Chicago: University of Chicago Press, 1990, pp. 215–22.

3 Quoted in Margaret Toynbee, *Saint Louis of Toulouse and the Process of Canonization in the Fourteenth Century*, Manchester: Manchester University Press, 1929, p. 84. The three major sources of information about Louis are John of Orta, *Vita Sancti Ludovici Episcopi Tholosani*, 1319–34; Louis's *Last Will and Testament*, 1297; and the *Bull of Canonization* by Pope John XXII, 1317.

4 Toynbee, *Saint Louis*, p. 117.

5 See Julian Gardner, "The Cult of a Fourteenth-Century Saint: The Iconography of Louis of Toulouse," *Patrons, Painters, and Saints*, Aldershot: Variorum, 1993, p. 172.

6 Toynbee, *Saint Louis*, pp. 95, 15, 13.

7 Gardner, "Cult," p. 178.

8 Adrian S. Hoch, "The Franciscan Provenance of Simone Martini's Angevin Saint Louis in Naples," *Zeitschrift für Kunstgeschichte*, vol. 58, no. 1 (1995), p. 22.

9 Julian Gardner, "Saint Louis of Toulouse, Robert of Anjou, and Simone Martini," *Zeitschrift für Kunstgeschichte*, vol. 39, no. 1 (1976), p. 33.

10 For a discussion of Sano di Pietro in the context of fifteenth-century Sienese art, see Enzo Carli, *Sienese Painting*, Florence: Scala, 1982.

11 *Sainte Bernardine of Siena: Sermons*, ed. Don Nazareno Orlandi, trans. Helen J. Robins, Siena: Tipografia Sociale, 1920, p. 9 (hereafter, Orlandi).

12 *Le Prediche Volgari di San Bernardino da Siena detta nella*

Piazza del Campo 1427, 3 vols., ed. Luciano Bianchi, Siena: Tipografia Arciv. S. Bernardino Edit., 1888, vol. 1, p. 6 (hereafter, Bianchi).

13 Iris Origo, *The World of San Bernardino*, New York: Harcourt, Brace and World, 1962, p. 128.

14 Toynbee, *Saint Louis*, pp. 119 and 120.

15 See Pietro Zampetti, *Crivelli*, Florence: Giunti, 1995.

16 Joseph Polzor, "Simone Martini's Two Frescoes in the Lower Right Transept of the Church of San Francesco in Assisi," *Arte Christiana*, vol. 72 (November–December 1984), p. 355.

17 Origo, *World of San Bernardino*, p. 3.

18 For the most compelling analysis of Bernardino's scapegoats, see Franco Mormando, *The Preacher's Demons: Bernardino of Siena and the Social Underworld of Early Renaissance Italy*, Chicago: University of Chicago Press, 1999.

19 Ibid., p. 110.

20 Ibid., pp. 139–40.

21 Toynbee, *Saint Louis*, pp. 123–5.

22 Ibid., p. 132.

23 Ibid., p. 236.

24 Ibid., p. 245.

25 Richard Stemp, *The Secret Language of the Renaissance: Decoding the Hidden Symbolism of Italian Art*, London: Duncan Baird, 2006, p. 65.

26 Origo, *World of San Bernardino*, p. 120.

26 Ibid., p. 230.

27 Mormando, *Preacher's Demons*, p. 144.

EPILOGUE

1 Peter Brown, *The Cult of the Saints: Its Rise and Function in Latin Christianity*, Chicago: University of Chicago Press, 1981, p. 53.

Photograph Credits

© 2009 Photo Scala, Florence – courtesy of the Ministero Beni e Attività Culturali: 1, 4, 11, 30, 38, 42, 43, 48, 52, 53, 59, 65, 67, 73, 75, 78, 84, 85, 86, 91, 101, 110, 112, 117, 120, 128, 129; © Duomo, Prato / The Bridgeman Art Library: 2; © Gallerie dell'Accademia, Venice – courtesy of the Ministero per Beni e le Attività Culturali: 3; © 2009 Photo Scala, Florence: 5, 6, 12, 13, 14, 21, 23, 24, 31, 33, 39, 40, 41, 44, 46, 47, 51, 54, 58, 61, 71, 72, 77a, 81, 98, 99, 115, 134, 136; © RMN / Jean-Gilles Berizzi: 7, 95; © Akg-images / Rabatti-Domingie: 8, 9, 123; © Regione Autonoma Valle d'Aosta: 10; © 2010 Photo Scala, Florence / Fondo Edifici di Culto – Ministero dell'Interno: 15; © Akg-images / Erich Lessing: 16, 18, 34, 116, 131; © 2009 Copyright The National Gallery, London / Scala, Florence: 19, 26, 29, 77b; © Akg-images: 20, 28, 133; © National Gallery of Art, Washington: 22, 125; © Akg-images / Cameraphoto: 25; © Akg-images / Electa: 32; © 2010 Photo Scala, Florence – courtesy of the Ministero Beni e Attività Culturali: 35, 49, 93; © 2010 De Agostini Picture Library / Scala, Florence: 45; © 2009 Photo Scala, Florence / BPK, Bildagentur für Kunst, Kultur und Geschichte, Berlin: 50, 60, 76; © Santa Croce, Florence / Alinari / The Bridgeman Art Library: 62; © Akg-images / Orsi Battaglini: 66; © 2010 Photo Pierpont Morgan Library / Art Resource / Scala, Florence: 70; © Harvard Art Museum, Fogg Art Museum, Bequest of Charles A. Loeser / Allan Macintyre / President and Fellows of Harvard College: 74; © Photoservice Electa / Quattrone: 79, 94, 96; © Photoservice Electa / Anelli: 80, 102, 124; © Photo Lensini, Siena: 82, 83, 87, 89, 90, 92, 104, 113, 118, 126; © 2010 Photo Scala, Florence – courtesy of the Ministero Beni e Attività Culturali / Monte Oliveto Maggiore: 88; © Galleria Nazionale dell'Umbria, Perugia / Alinari / The Bridgeman Art Library: 97; Urbino, Ministero per i Beni e le Attività Culturali, Soprintendenza BSAE delle Marche: 100; © 2009 Wadsworth Athenaeum Museum of Art / Art Resource, NY / Scala, Florence: 103; © 2009 Photo Scala, Florence / Fondo Edifici di Culto – Ministero dell'Interno: 105, 111, 127; © Harvard Art Museum, Fogg Art Museum, Gift of Sir Joseph Duveen / Rick Stafford / President and Fellows of Harvard College: 106; © The Detroit Institute of Arts / Founders Society Purchase / The Bridgeman Art Library: 107; © RMN / Gerard Blot: 108; © Robert Kiely: 109; © Akg-images / André Held: 114; © 2009 Photo Opera Metropolitana Siena / Photo Scala, Florence: 119; © 2009 Photo The Philadelphia Museum of Art / Art Resource / Photo Scala, Florence: 121; © 2009 Photo Scala, Florence – courtesy of the Ministero Beni e Attività Culturali: 130; © Stephen Bartlett, Kennesaw State University: 138

General Index

Many Italian artists were known by nicknames (for example, Il Sodoma), or by their Christian names qualified by their place of origin (Leonardo da Vinci). Il Sodoma is to be found under S, and Leonardo until L. Saints (for example, St. Thomas Aquinas) are indexed by their Christian names. Page references in italics indicate illustrations.

Works of Art Reproduced, by Saint